SURF
LIKE
A GIRL

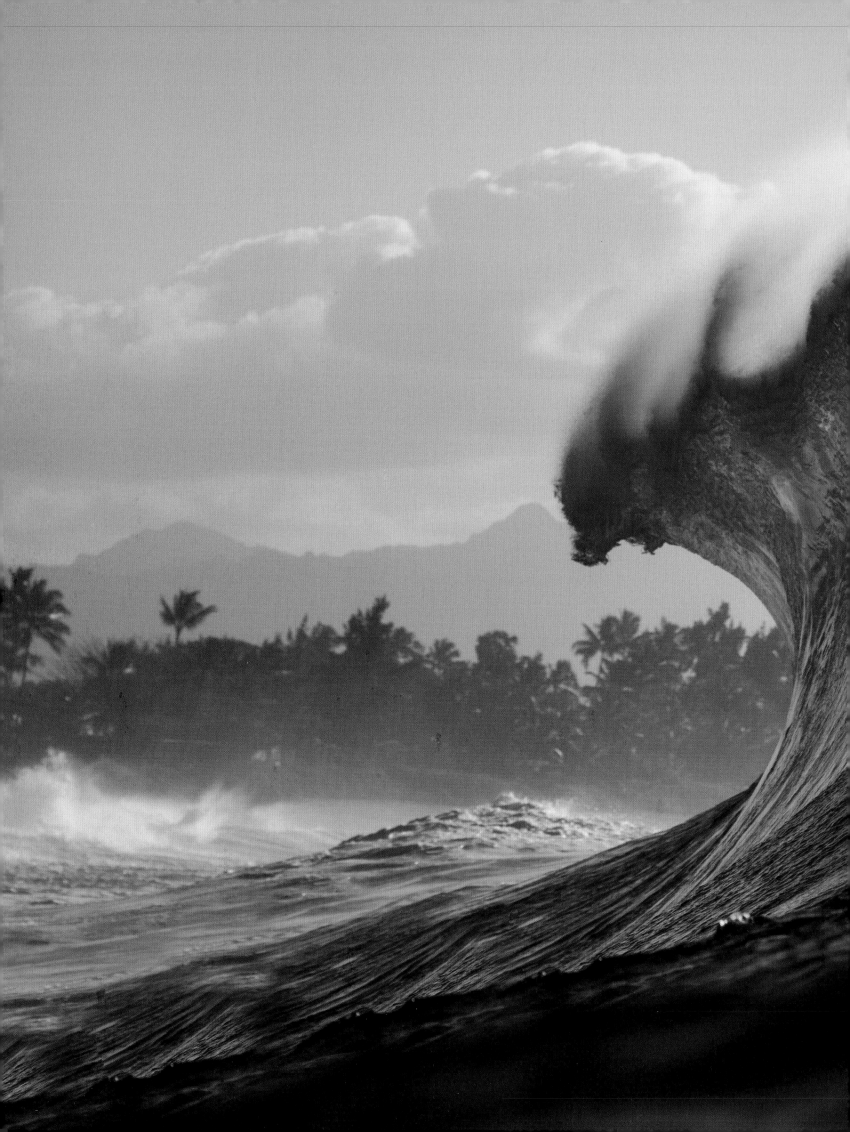

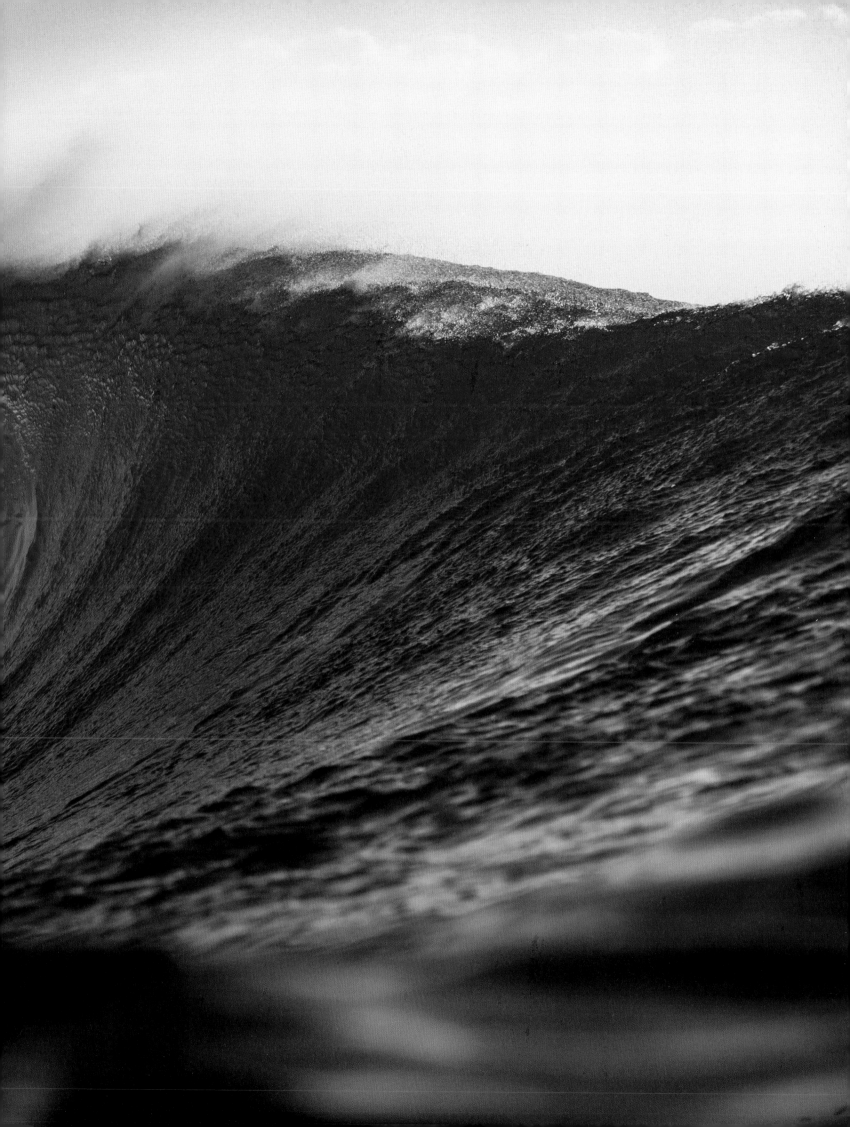

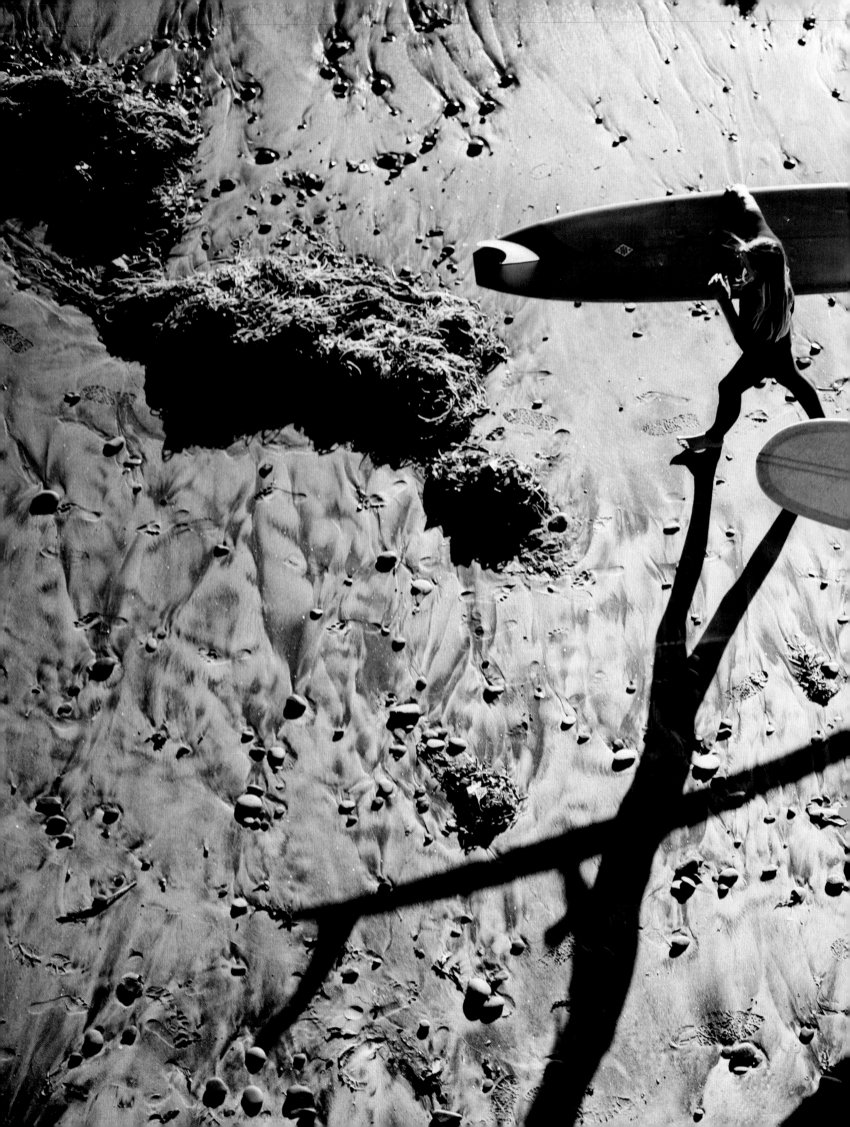

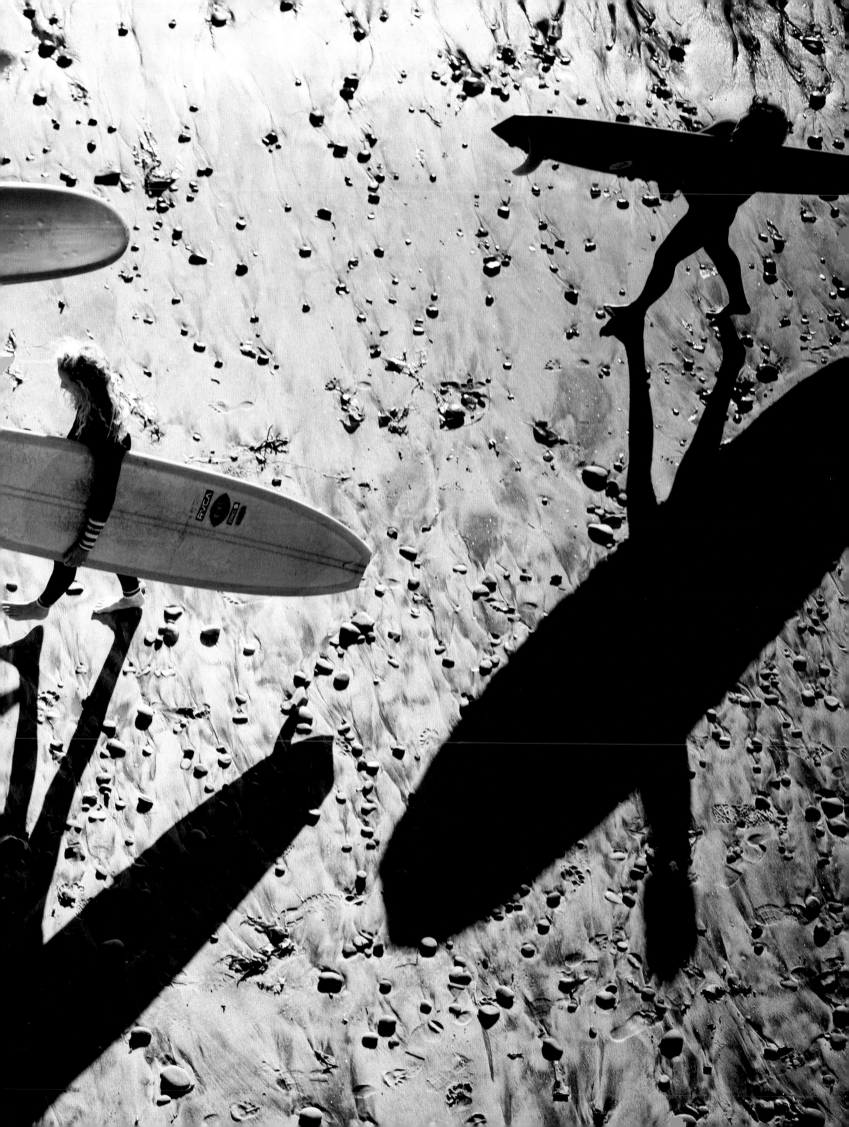

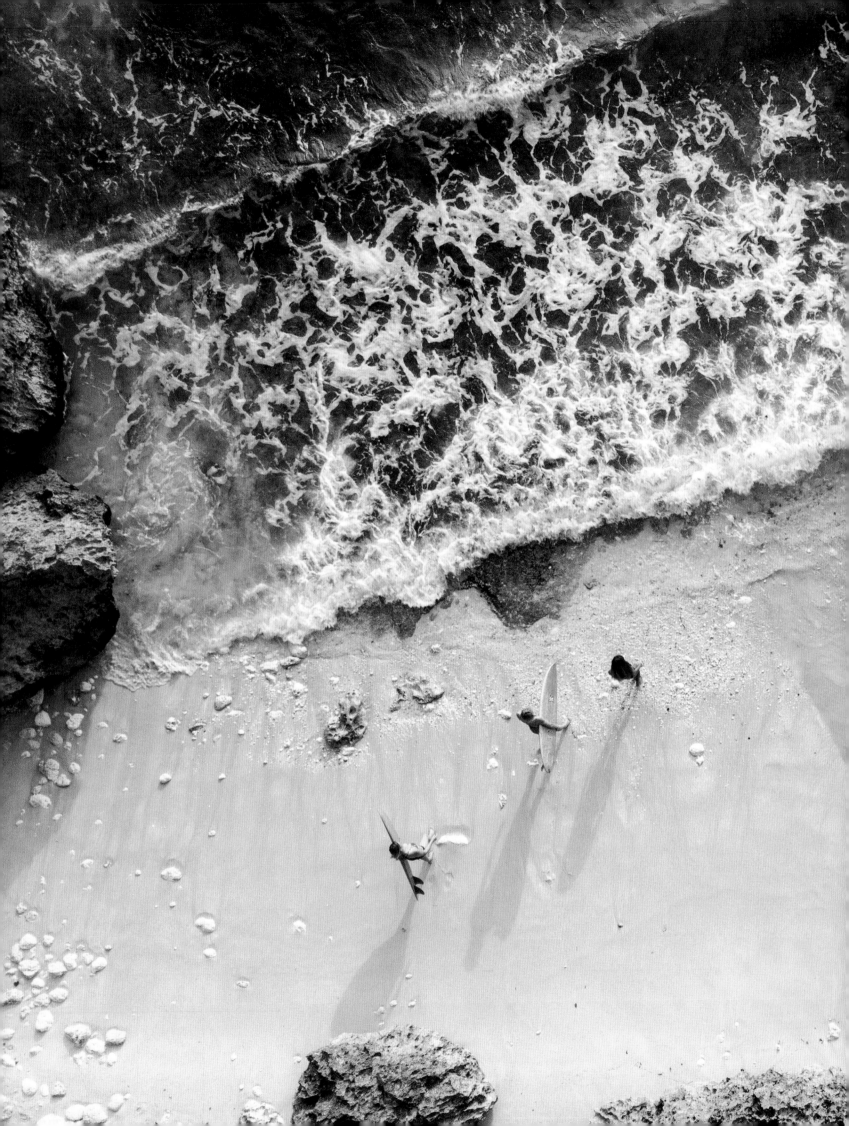

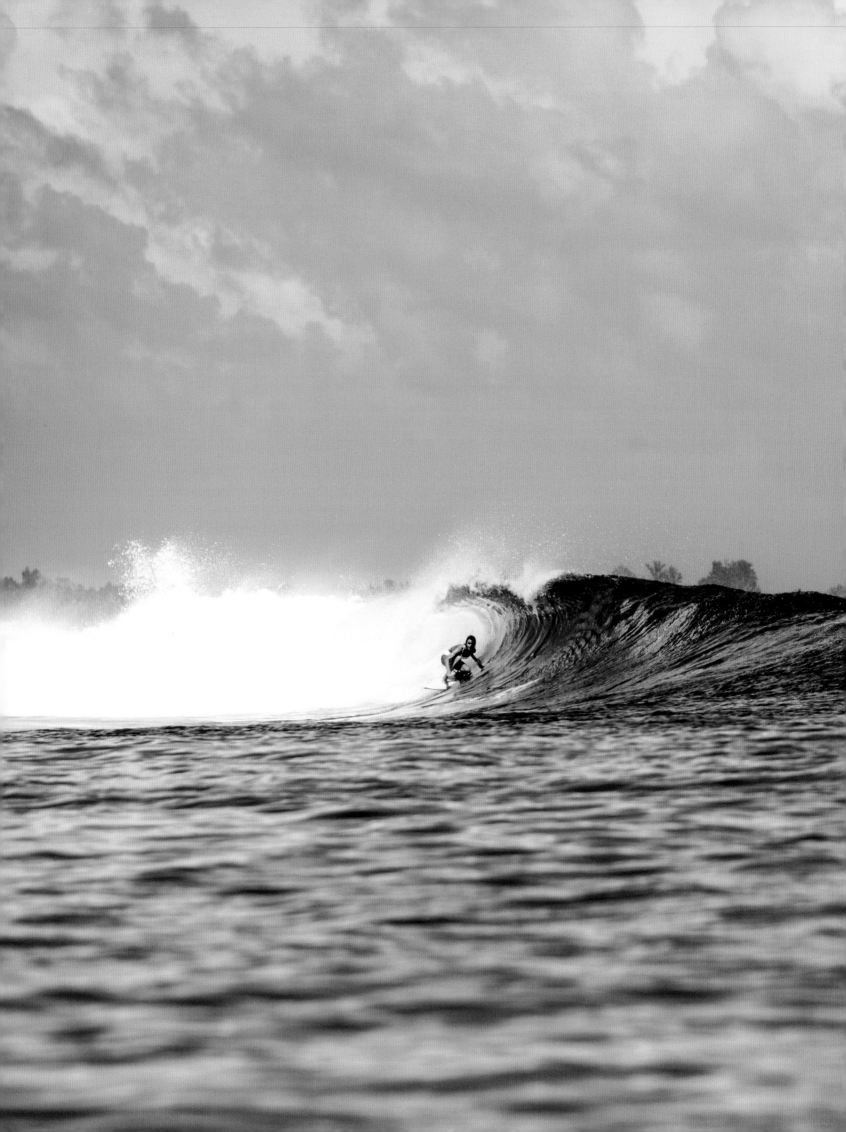

SURF LIKE A GIRL

CAROLINA AMELL

PRESTEL

Munich · London · New York

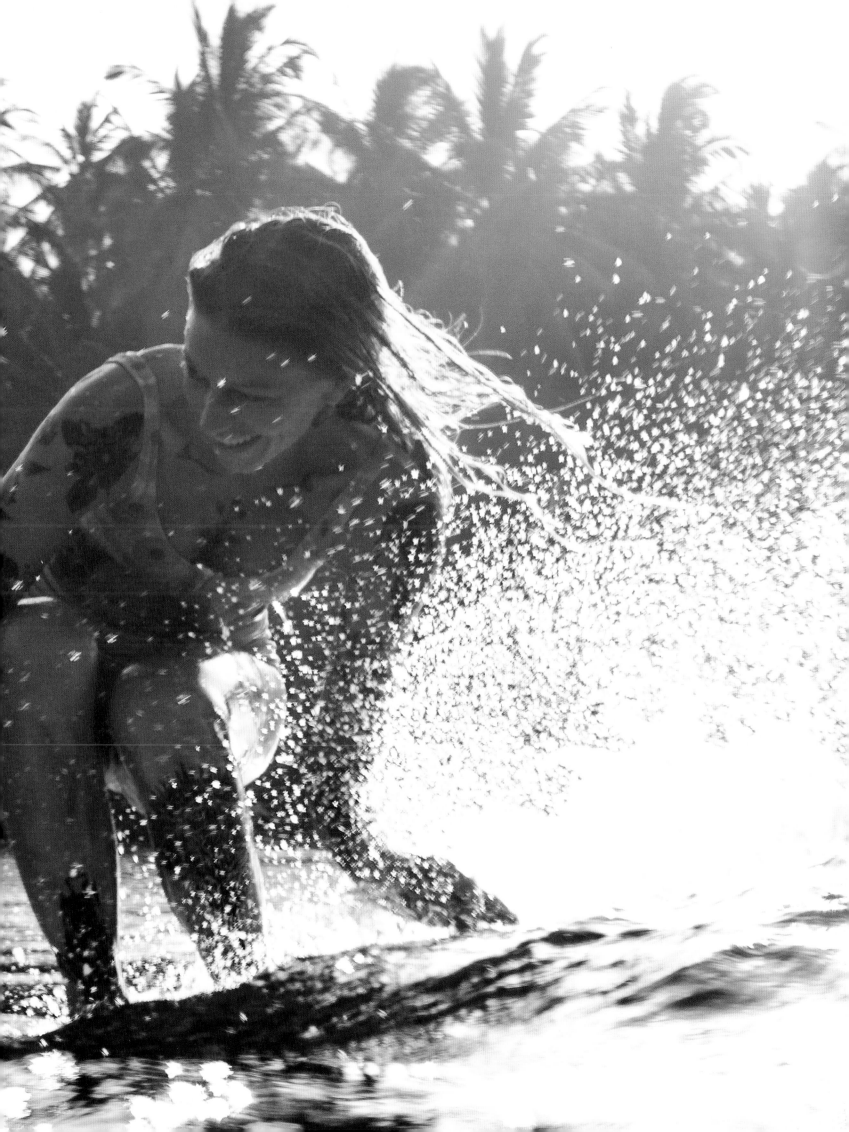

Anaïs Pierquet
Passion for surf

@facingblankpages

We all have our own story, our own path to follow. This path can be bumpy at times and is more peaceful at others. Just like the ocean, life is made of moon tides and waves, storms and quiet flows, silence and noise. Waves of feelings may hit us, waves of joy, waves of sadness, waves of peace. It's a beautiful and breathtaking journey.

I believe in the delicacy of destiny, and I guess what matters is not what's happening in your life, but how you manage to overcome its challenges and find peace within your soul.

My story started with a crash—the kind you least expect and that changes your life forever. I lost my dad twelve years ago, and that was the hardest storm I've ever had to deal with. Losing anyone you deeply love is like tearing apart a beautiful garden, like pulling up every single root of your soul. It has an unforgettable—yet sometimes beautiful—emotional impact that leaves you scared and takes you to some deep, dark, inexplicable places.

But it doesn't end there. We are flowers growing in the sun with the rain, and in any sadness there is a light, a new beginning, a touch of freedom that follows.

I started then to think about my life and how I wanted it to be. I realized that it was too precious and that there was no more time to waste before I began to seek my deeper self. I needed to express myself and find the harmony, the balance in my heart. Setting up a lifestyle you truly love is so important. It shapes who we are and how we live.

I moved to Bali and started surfing every day. I finally reconnected with nature, with the ocean, with my deep inner self. The human soul is meant to let out what she feels, to let go of emotions, and I finally found my way to feel more at peace with life. Surfing became a real means to express myself, a way to disconnect from what I was "supposed" to be, and simply be.

When I'm out lost in the ocean, my mind and thoughts go away. I could gaze at the landscape for an eternity, watching the birds dance with the waves and staring at the endless depth that the sea so generously offers. My restless soul echoes with the beauty of the sky and finds its kingdom of freedom. I'm grateful to the ocean for giving me the opportunity to heal a little more every day.

No matter what we are going through in life, there will always be a strip of sunshine, a shaft of light, a rainbow, that gives us hope and lets us grow. At the end of the day, I chose to let go and trust life, telling myself that everything would be fine.

Our stories are meant to fill the blank pages of the book of our life. Let them be. Freedom, peace, and love are the only things we should run after. Nothing else truly matters.

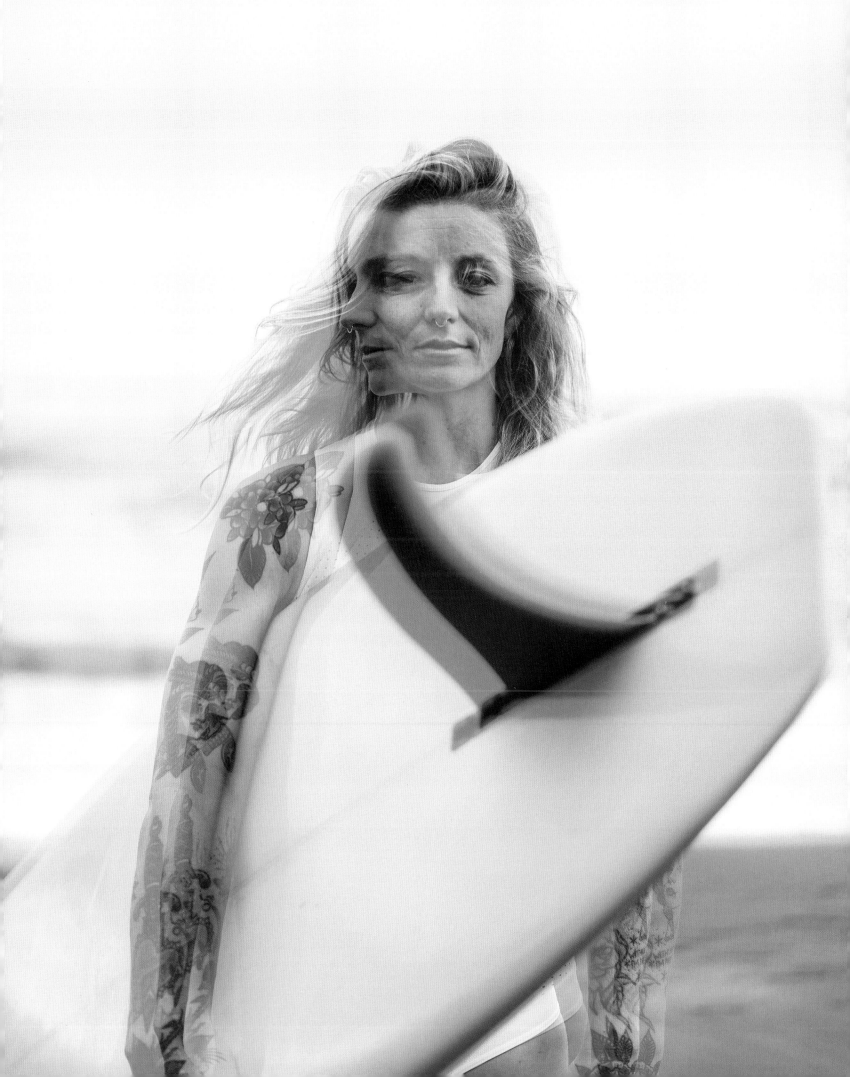

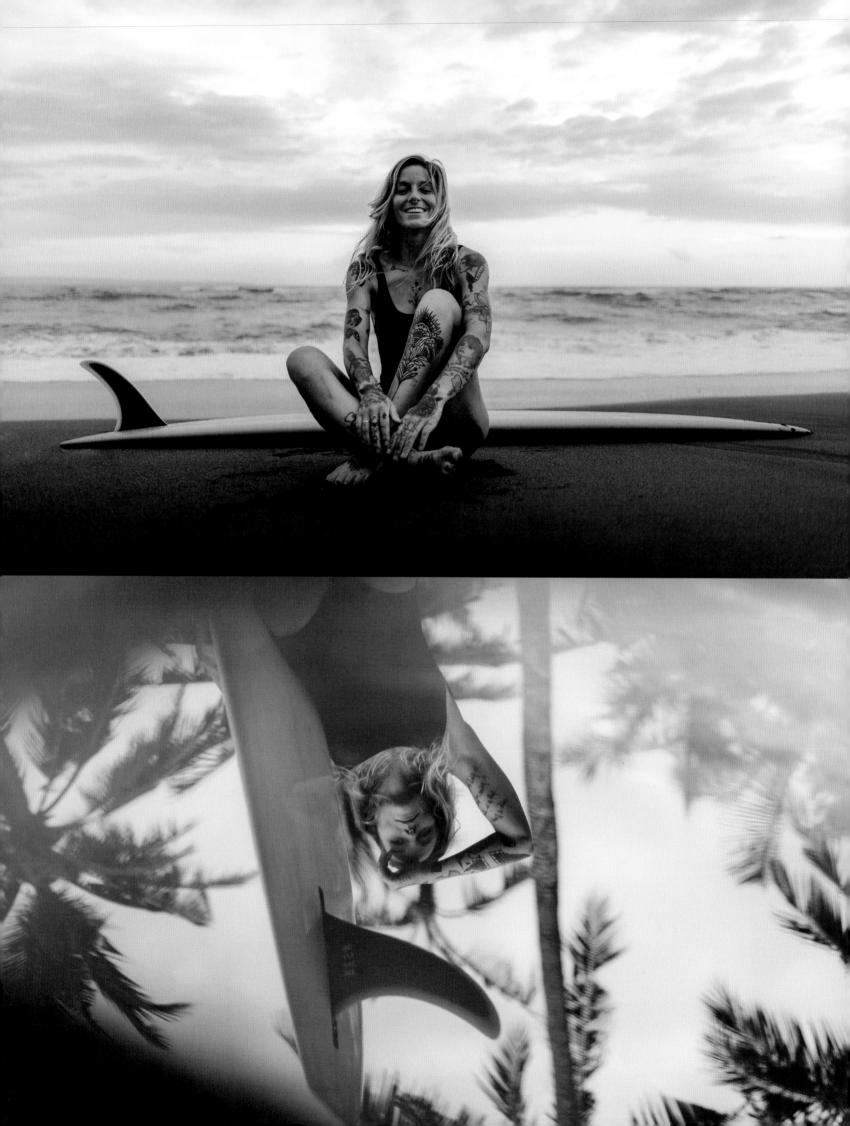

*Freedom, peace,
and love are the only things
we should run after. Nothing
else truly matters.*

ANAÏS PIERQUET

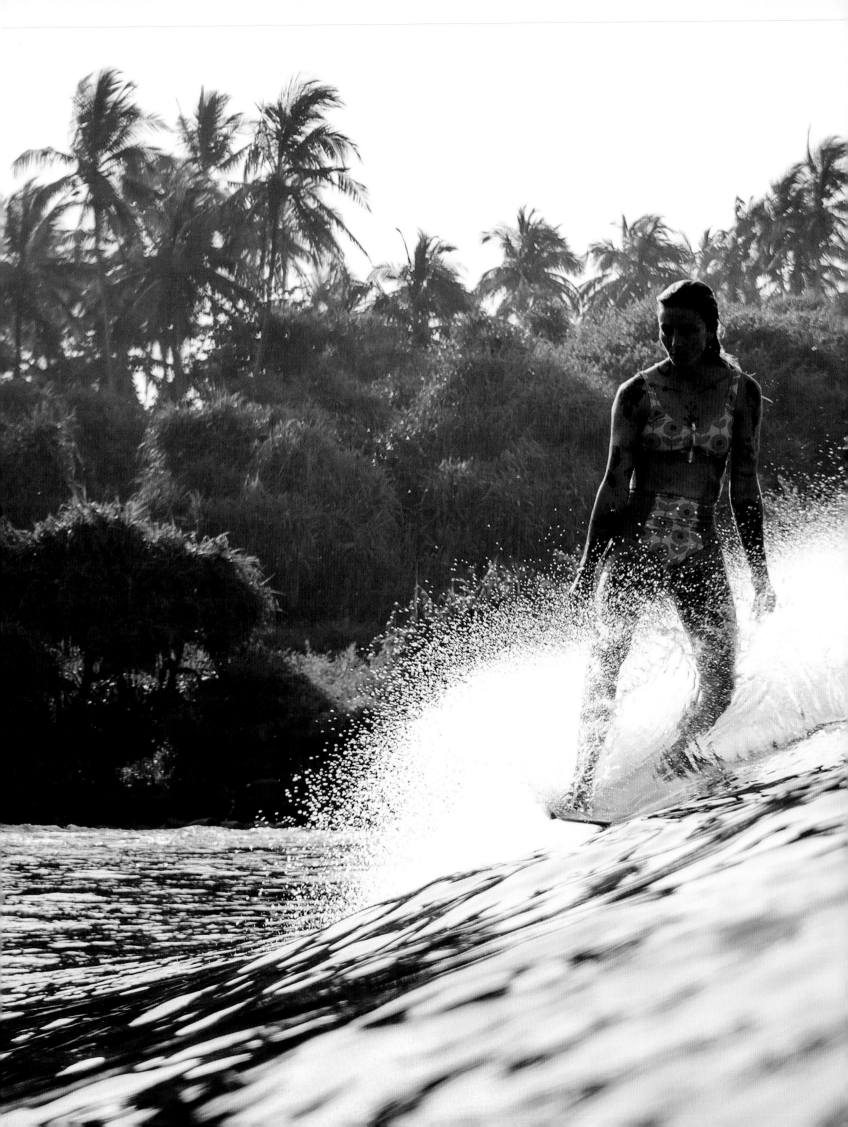

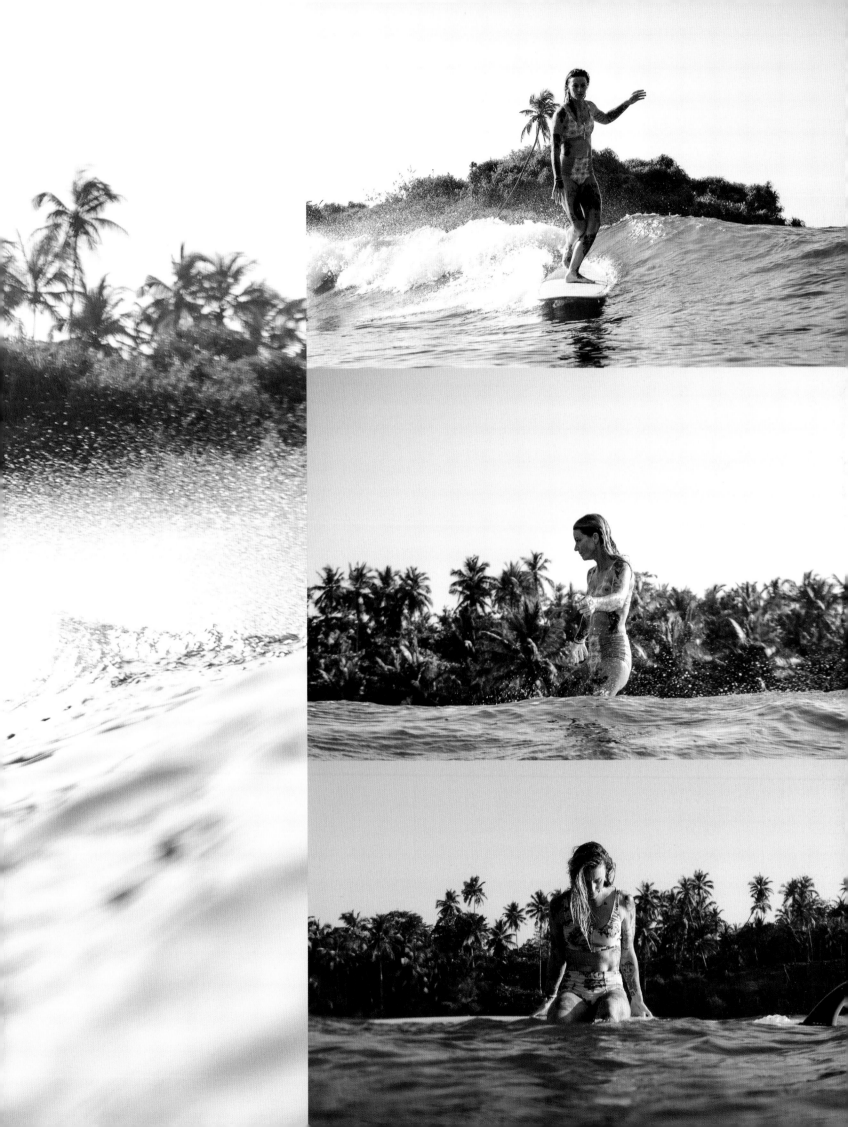

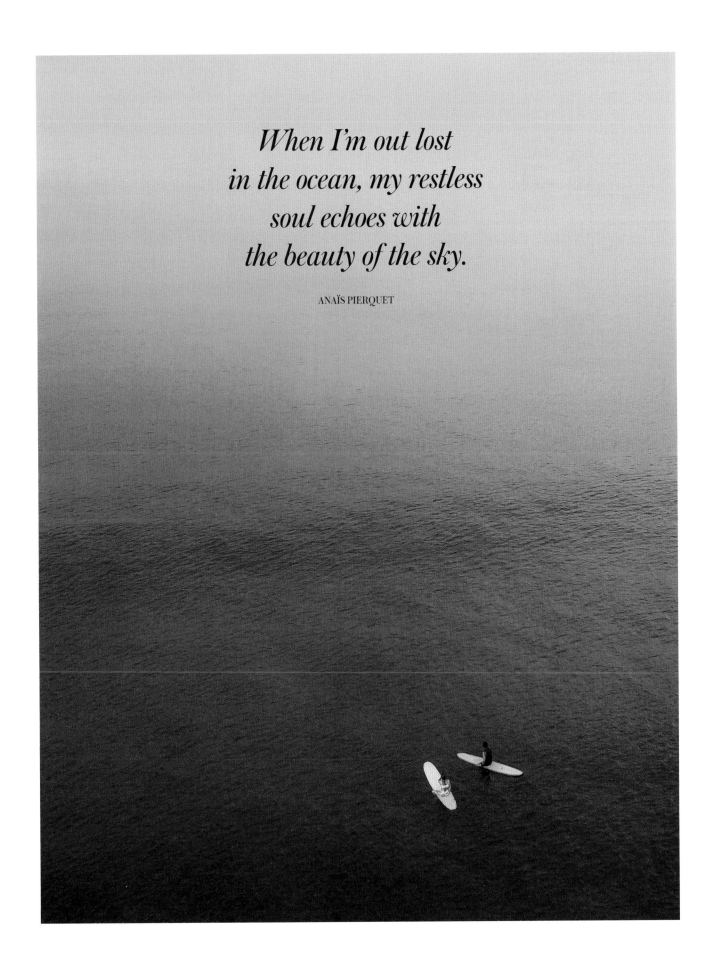

*When I'm out lost
in the ocean, my restless
soul echoes with
the beauty of the sky.*

ANAÏS PIERQUET

Conchita Rössler

*Retreat host, outdoor coach,
and true water soul*

@seasoulstories
@mooana_retreat

I'm a water soul. I'm an ocean enthusiast, surfer, and founder of Mooana Retreat, where we aim to encourage a holistically healthy lifestyle by combining surf, soul, and well-being.

For over a decade now I've called the rugged west coast of Portugal my home. My love for surfing and the ocean is reflected in the fact that I spend most of my waking hours in the water. I have twice won first place in a longboard contest, travelling New Zealand with a simple philosophy: to let the ocean guide me.

I've been sharing unique surf experiences, with a focus on living a healthy lifestyle, with like-minded people across the globe for many years now. I try to provide a platform that not only allows people to reconnect with themselves but also teaches them to build awareness of their surroundings, of nature, the ocean, and our fellow human beings. It's all about achieving the right balance in your personal life to reveal the secrets to being happy, healthy, and content. Mooana combines the three aspects of that: mind, body, and spirit.

*It's all about achieving the right
balance in your personal life.*

CONCHITA RÖSSLER

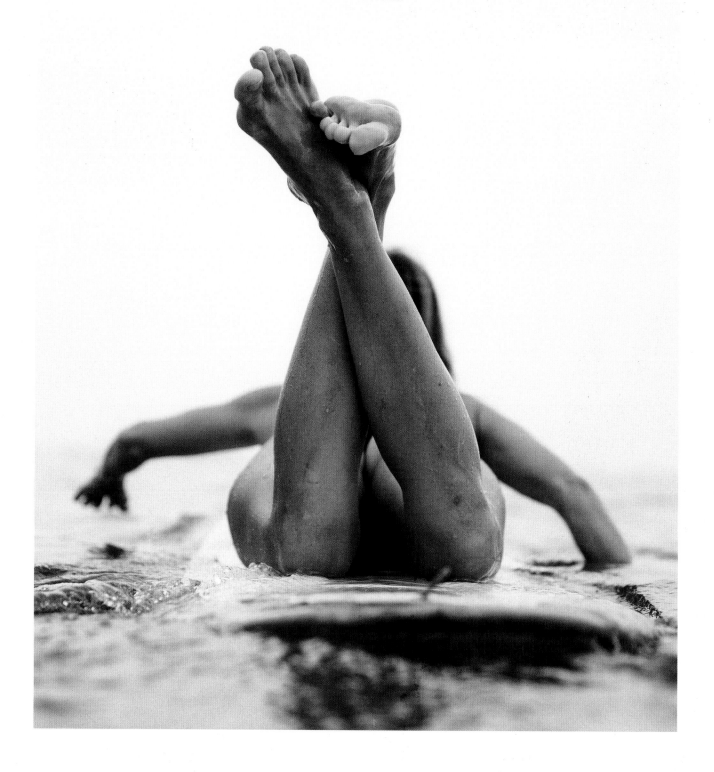

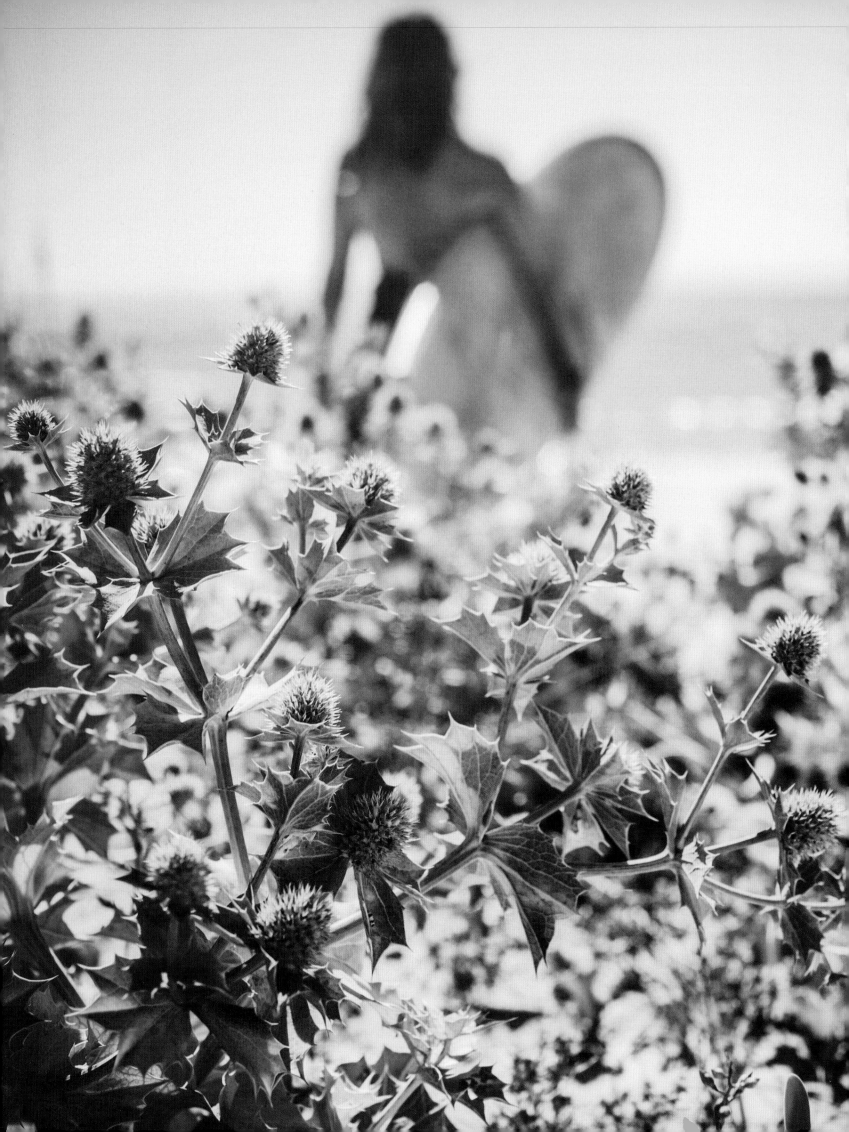

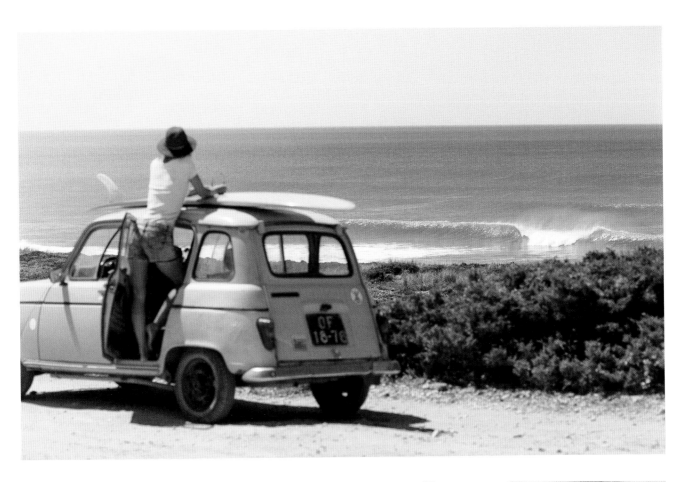

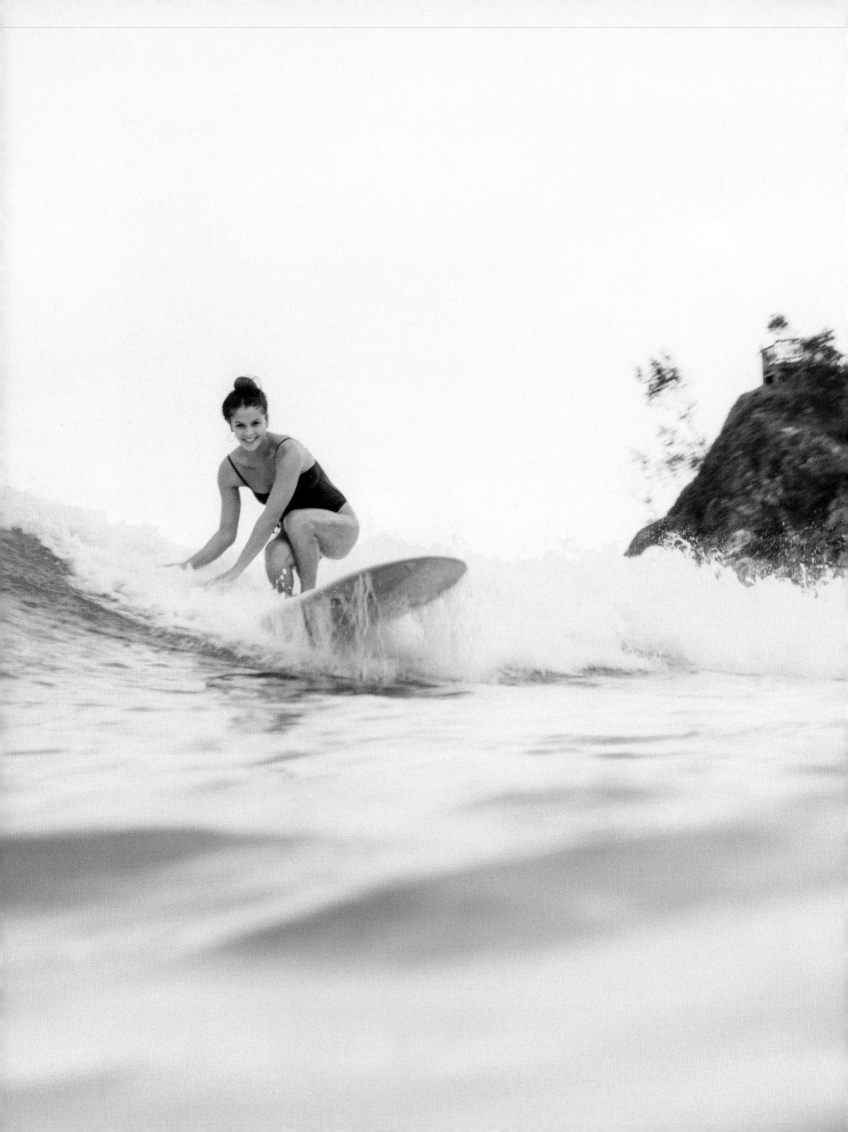

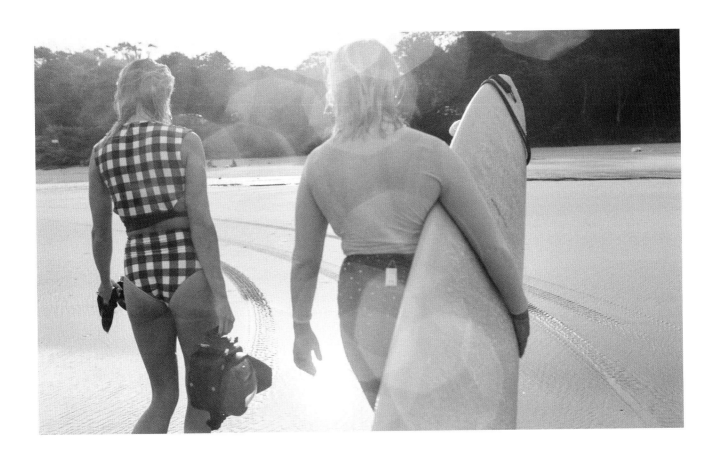

Amber Jones
Photographer

@amberandfriends_photography

It was a fortunate and tumultuous concoction of breakups, adventures and misadventures, a stint in the commercial advertising world, and then the untimely death of my father that led me to question everything.

At the time I was working for one of the largest advertising agencies in the southern hemisphere. I was forced to ask myself why I was aiding in the health crisis we have here in New Zealand by selling fast food to an obese nation. Then the whole consumerism thing really started to bother me: we don't need all these things, they're just fluff. I wanted to start telling meaningful stories—about

what matters in the world, about people who are doing worthwhile s**t. Our oceans are in such a dire way right now, and they face a truly miserable future if we don't start talking about it and inspiring people to make changes as soon as possible.

The ocean is my workplace, my education, my food source, my playground, and my muse. Without her I'm nobody. If I can inspire others to make even tiny changes in their lives, whether it be fashion-related, or to do with food or lifestyle— anything with social and environmental responsibility in mind—then I'm doing my job right.

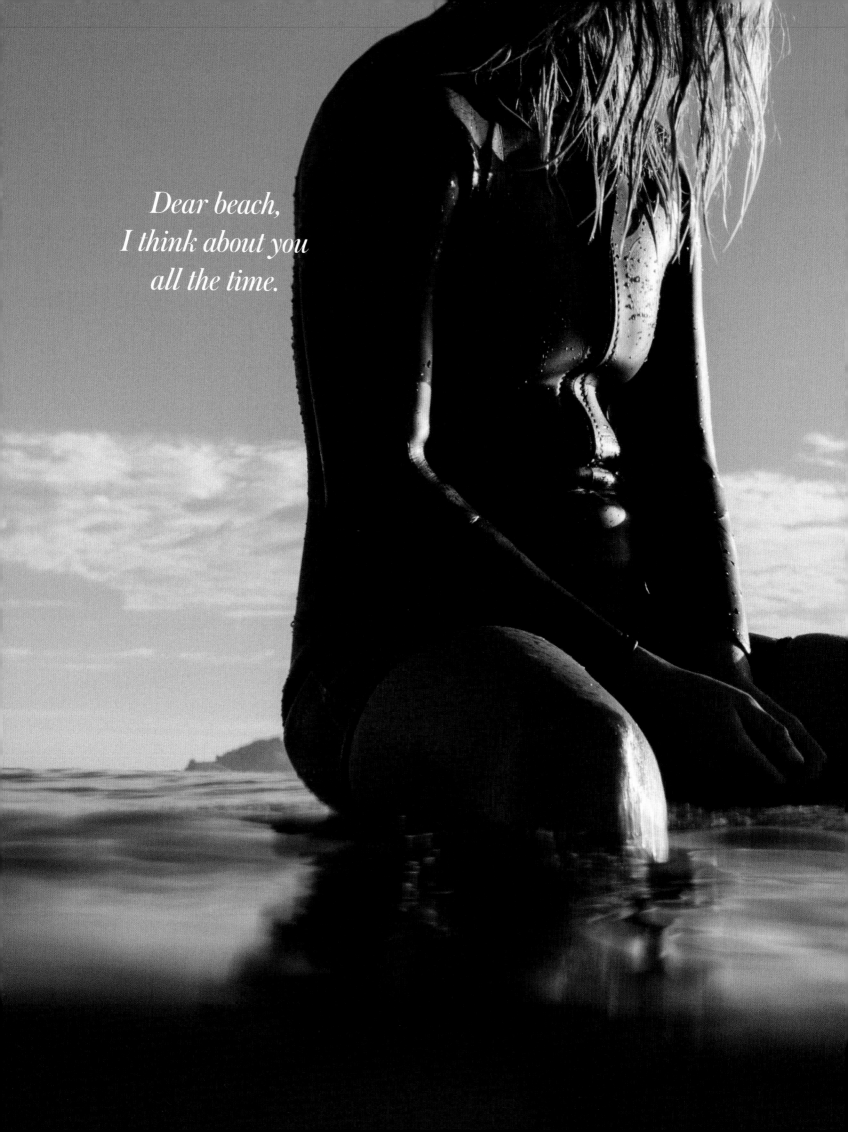

Dear beach,
I think about you
all the time.

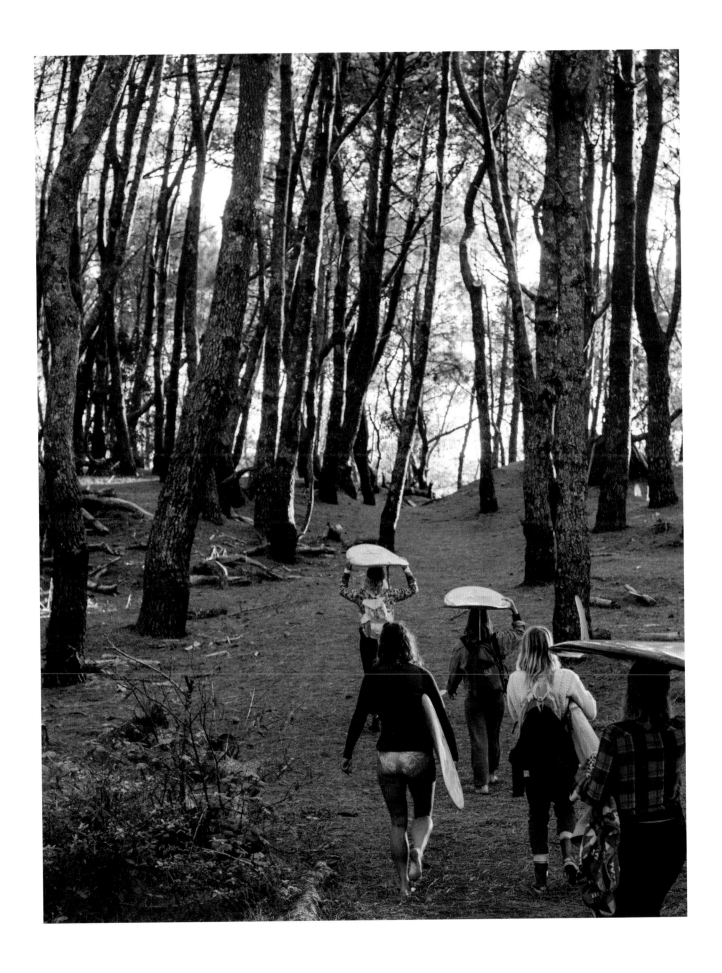

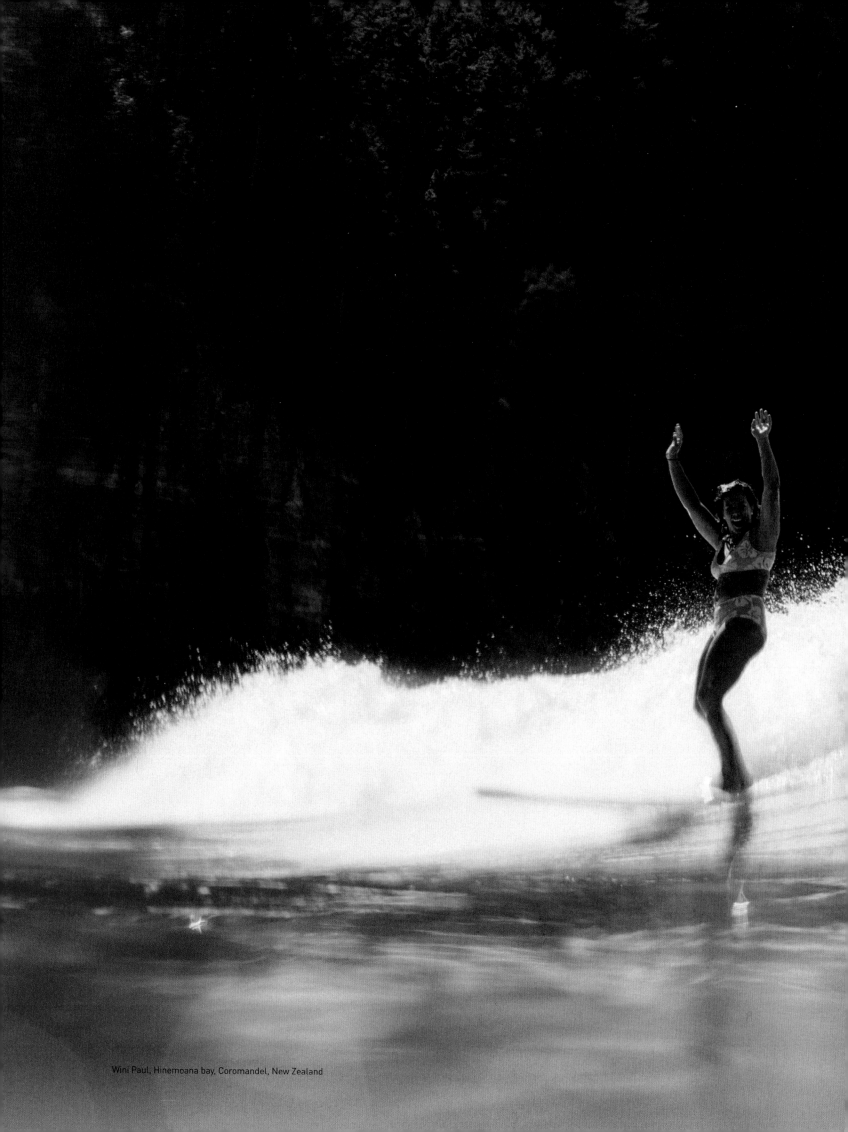

Wini Paul, Hinemoana bay, Coromandel, New Zealand

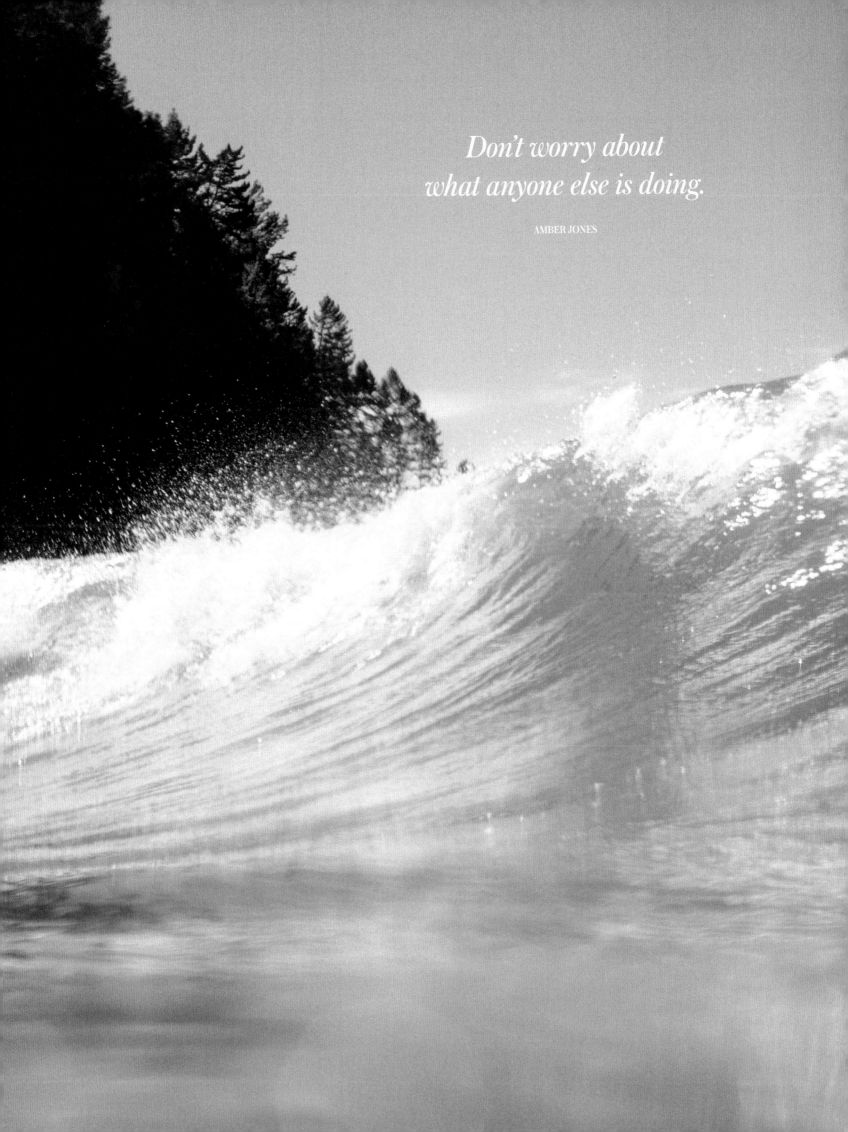

*Don't worry about
what anyone else is doing.*

AMBER JONES

Ming Nomchong
Photographer

@ming_nomchong_photo
@thedrifterblog

I'd completed a fine arts degree in photomedia at the University of Sydney, but I quickly found that in the real world I wasn't going to walk into my dream job as a photographer for *National Geographic*. So I worked as an assistant to more established photographers and would shoot small jobs of my own. But then I took a three-year hiatus from photography and traveled the world by boat, ending up in Fiji, where I discovered underwater photography.

I moved to Byron Bay and began experimenting with water photography. I didn't realize at the time that there weren't many girls doing it, so that wasn't a factor. There's a massive community of women surfers in Byron, and I pitched a story about it to a surf magazine. I ended up getting twelve pages for my first ever editorial. I guess that's how my career really started—the rest really rolled on from there, with a lot of hard work, long hours, and a determination to make something of this passion.

Photography is my full-time gig. I shoot for a pretty wide client base, but my work is mostly in fashion and surf lifestyle, which I love. I also co-run a studio space called Studio Tropico with another local photographer, Francisco Tavoni. Tropico is now a full-time studio and gear-rental business serving a lot of the local fashion brands around town as well as labels, photographers, and fashion magazines from Sydney and Melbourne who come up to shoot in Byron.

And finally, just to add to the workload, my friend Danielle Clayton (owner of surfwear brand Salt Gypsy) and I saw a gap in the female surf/lifestyle industry and decided to open a retail shop in Byron, focusing on local labels, sustainability, design, women in business, and surf and salty lifestyles. We called it Sea Bones, evoking remnants of things that belong in or near the sea.

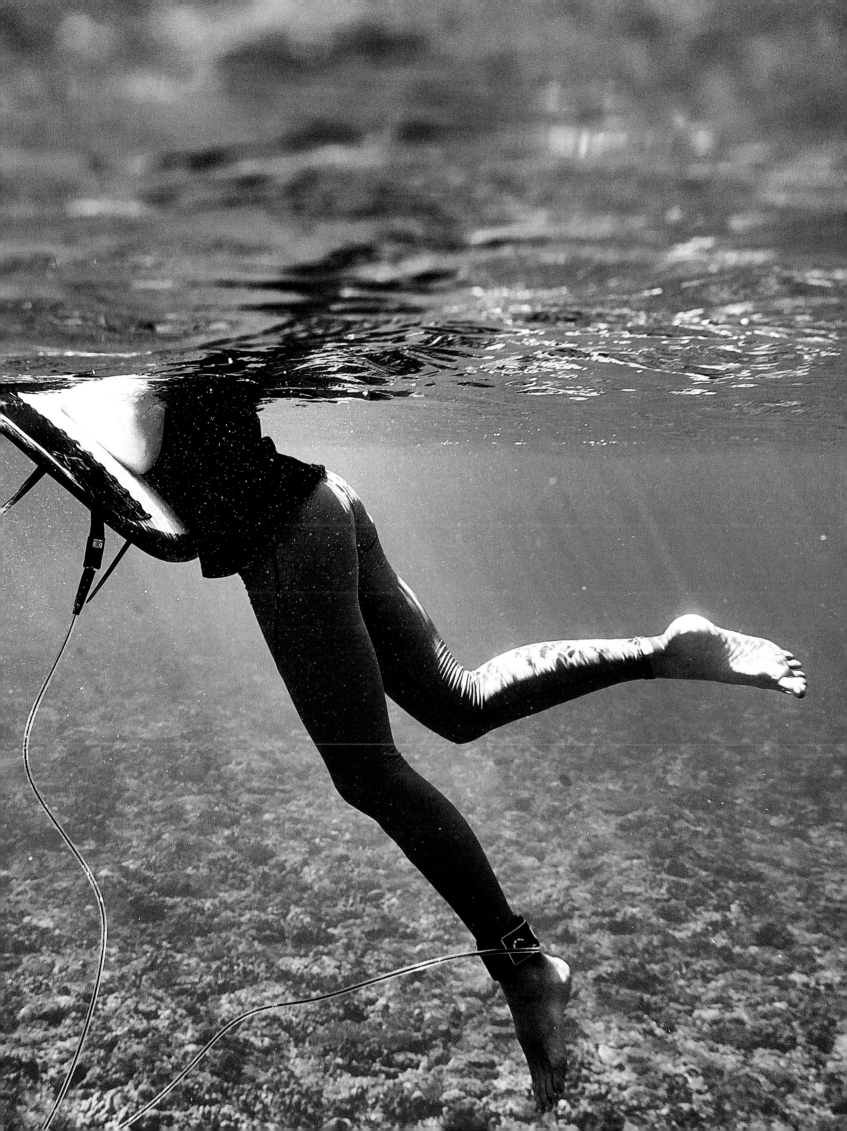

Find your own style!

MING NOMCHONG

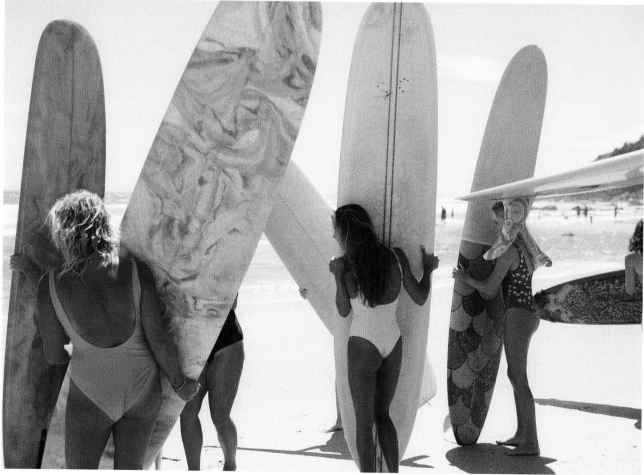

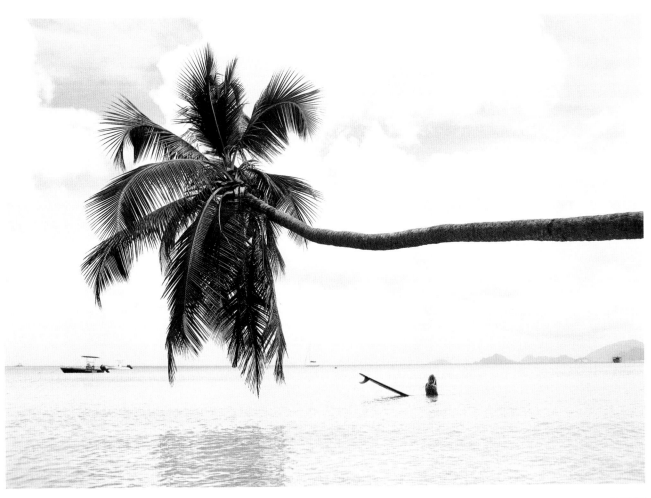

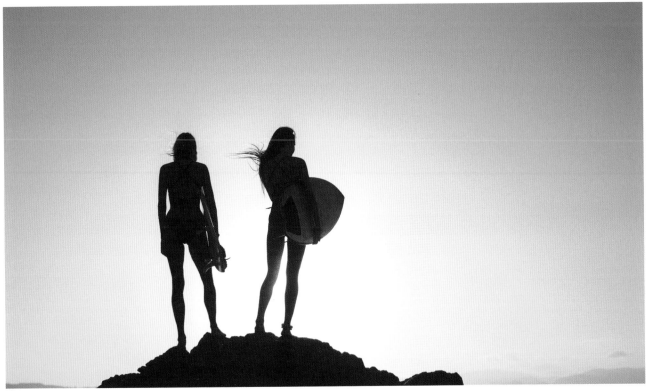

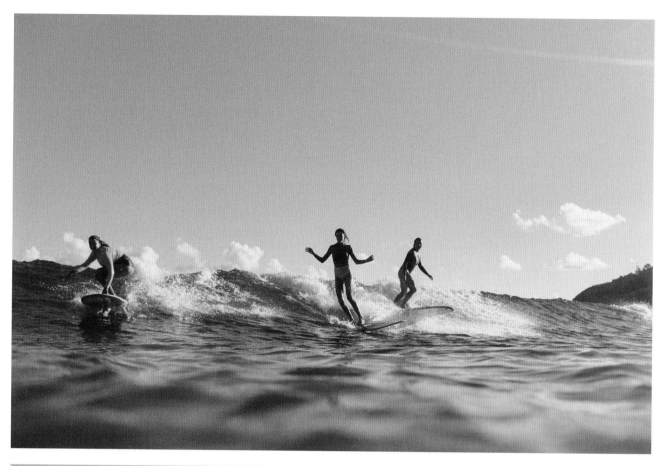

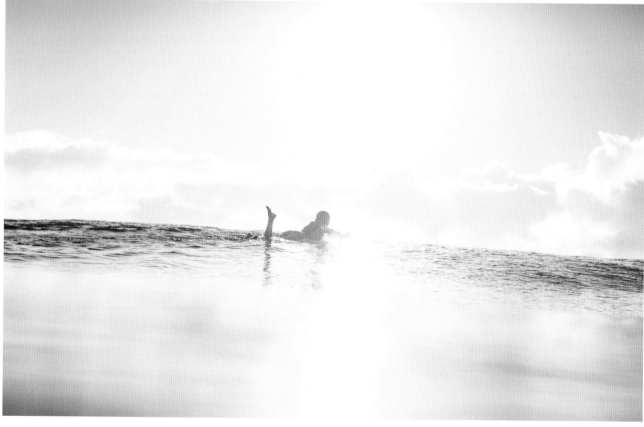

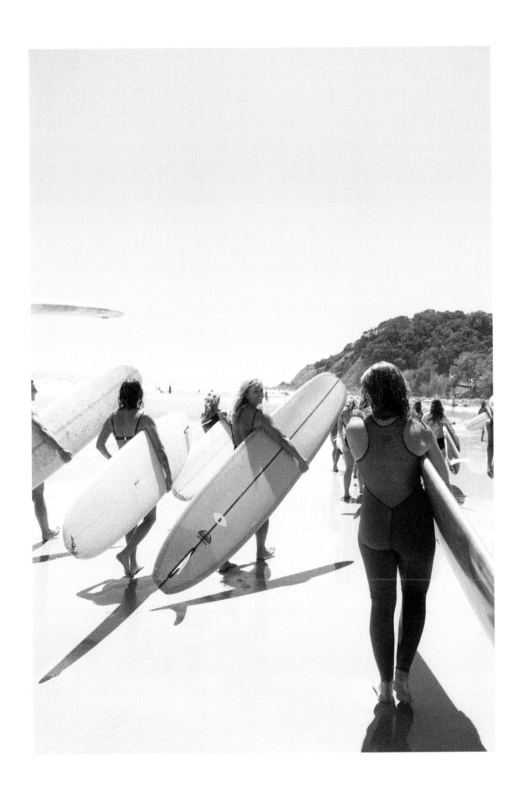

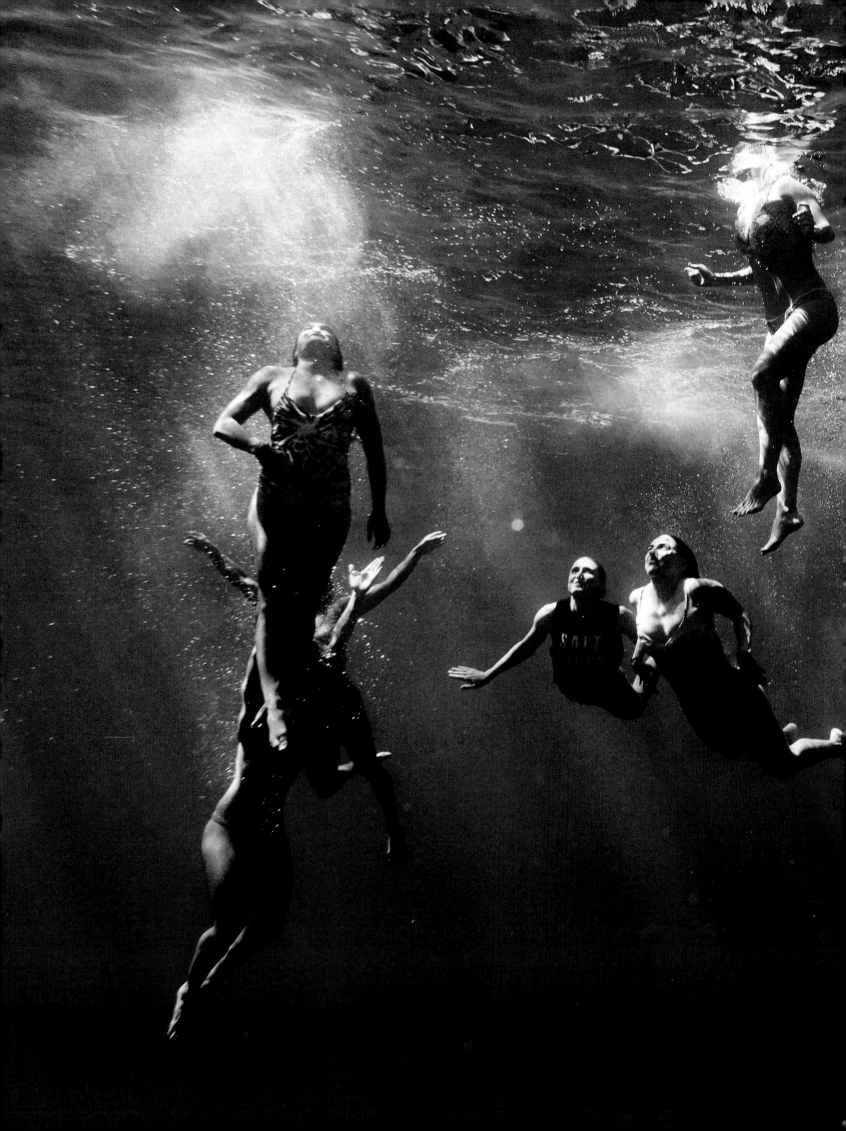

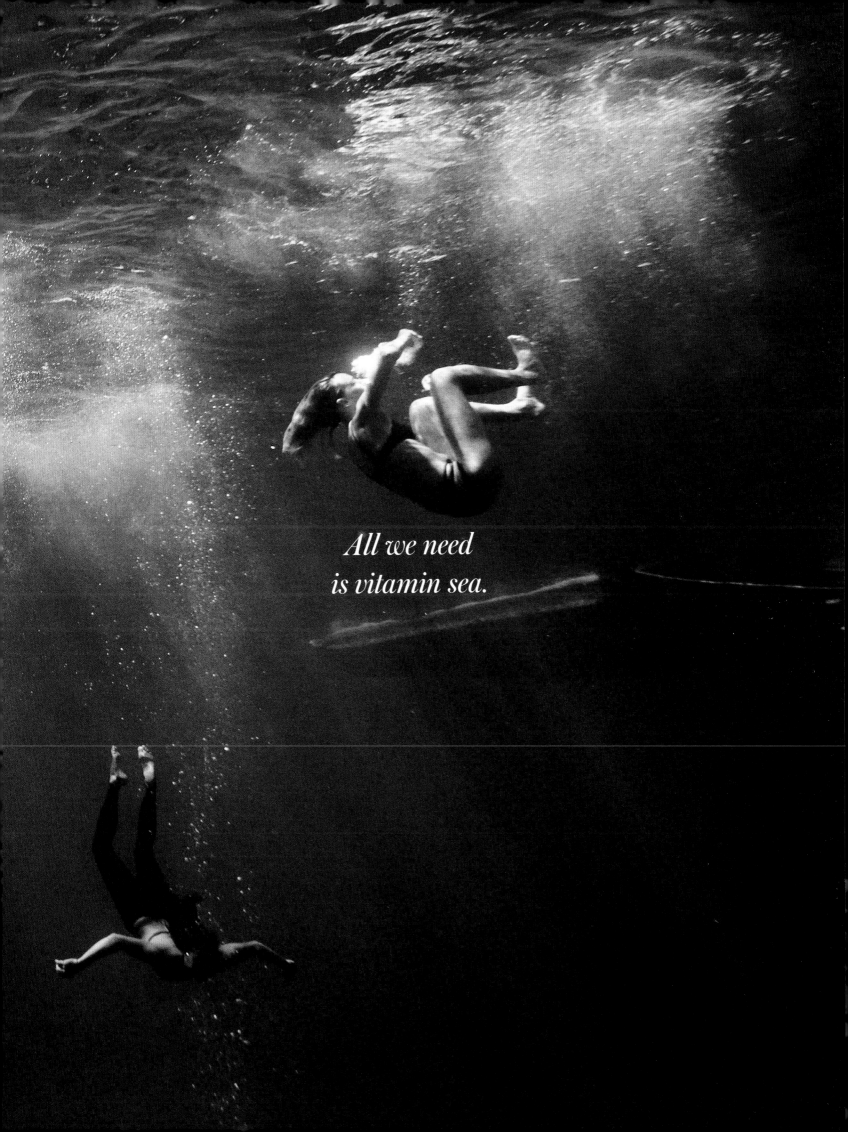

All we need
is vitamin sea.

Leah Dawson
An influential voice

@leahloves

Since I was a little girl I've known that I have to dedicate my life to making the world around me better, not worse. I'm now a woman, and the extreme environmental crisis has grown out of all proportion in my lifetime. I've long known that surfing can be a great platform for getting people interested and listening, and today more than ever we need surfers all over the globe utilizing this "megaphone" with voices of empowerment, of respect, of love. In my eyes, being a surfer comes with an innate responsibility to be a steward for the earth, to make daily choices with consciousness more than straight desire.

A group of my dear friends and I created the Changing Tides Foundation, in order to implement our dreams of helping the world around us. We work in various sectors, with our main focuses being female empowerment, composting, the waste crisis, and providing clean water. We seek to encourage travelers to give back along their journeys in natural ways that can benefit local people.

Adventure consciously, serve naturally. We are all lucky to live on this great earth, and the planet deserves our gratitude combined with action.

Scorpion Bay, Mexico

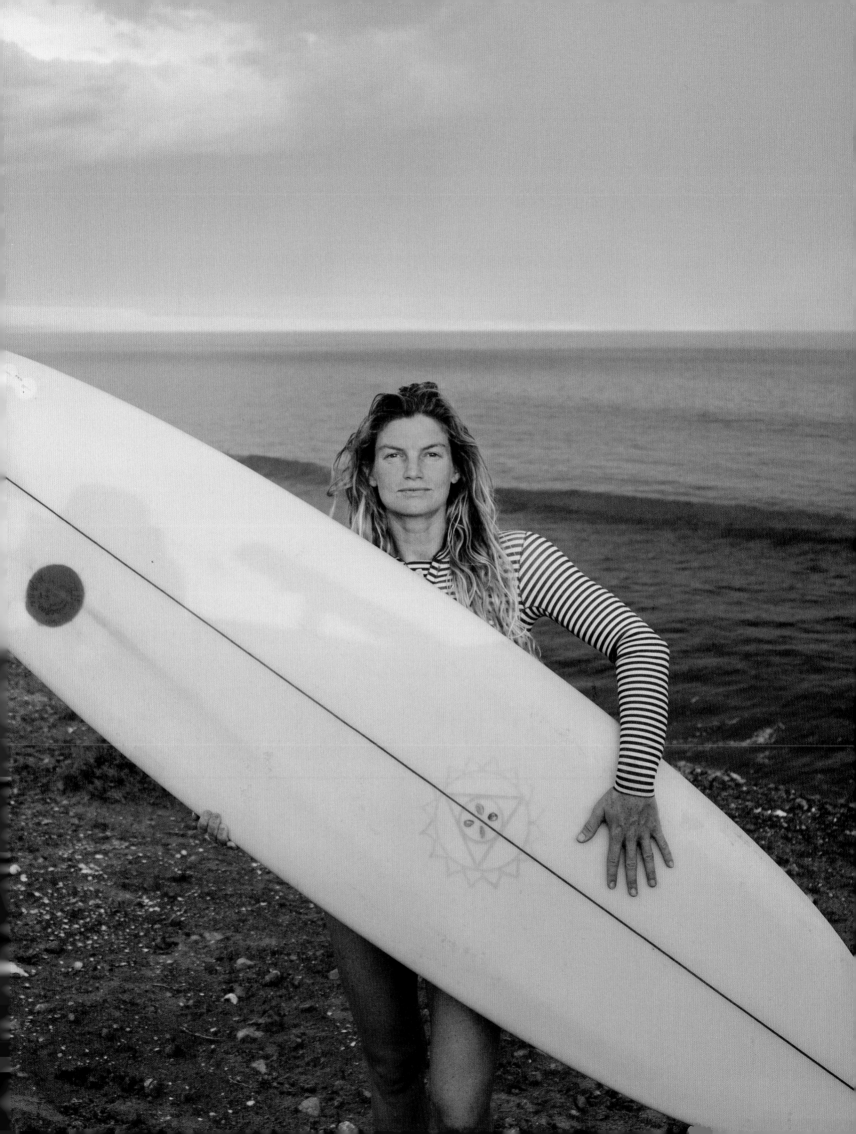

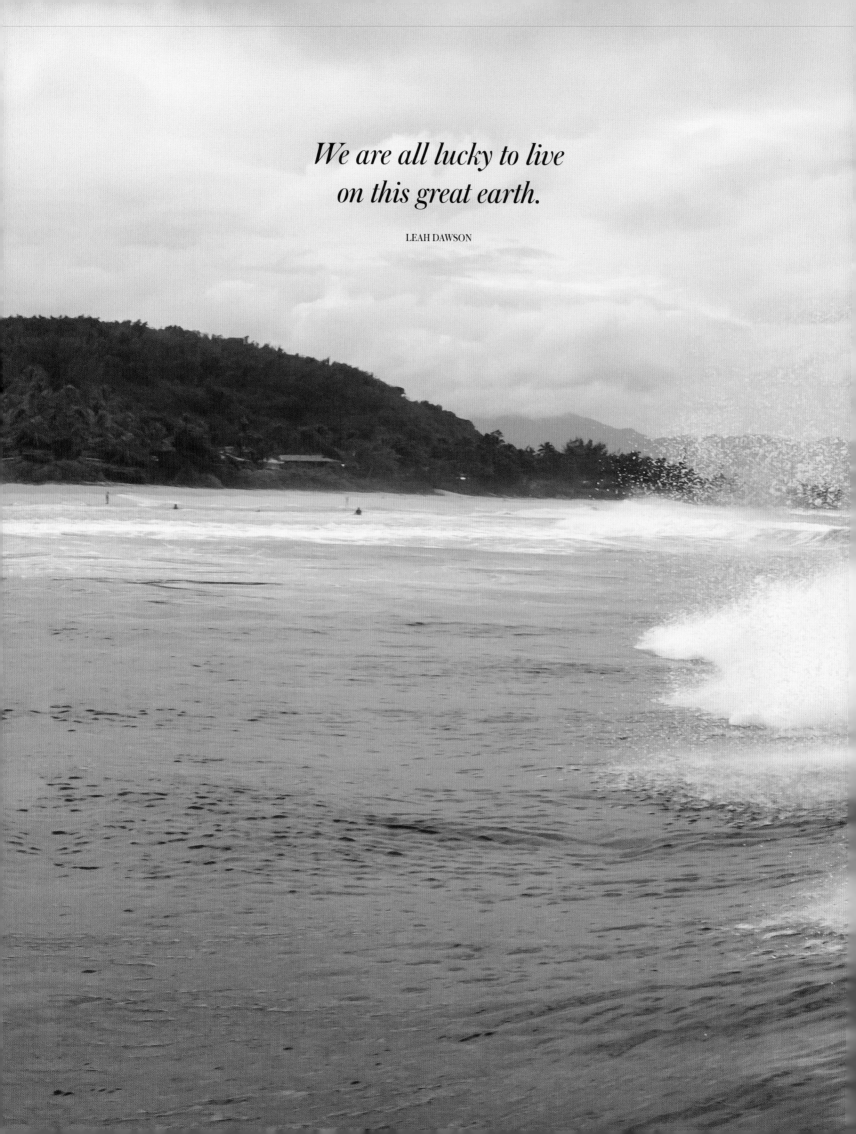

*We are all lucky to live
on this great earth.*

LEAH DAWSON

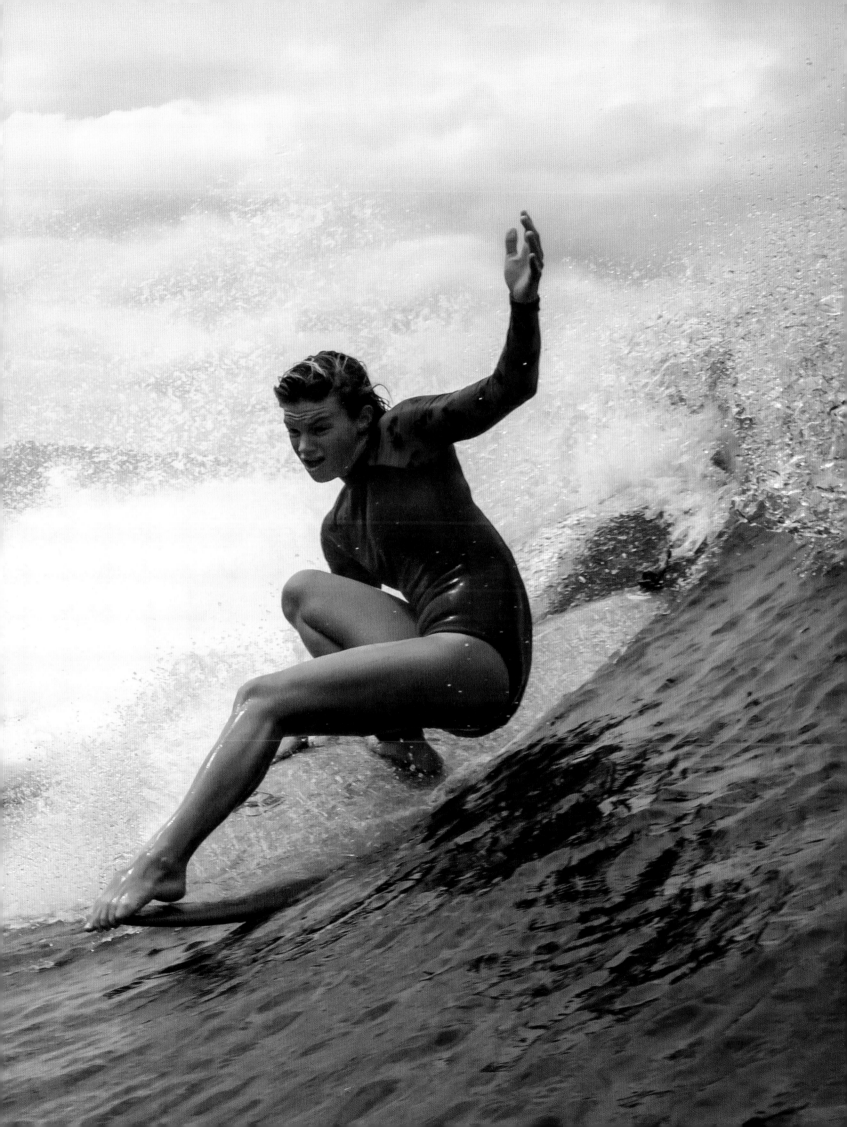

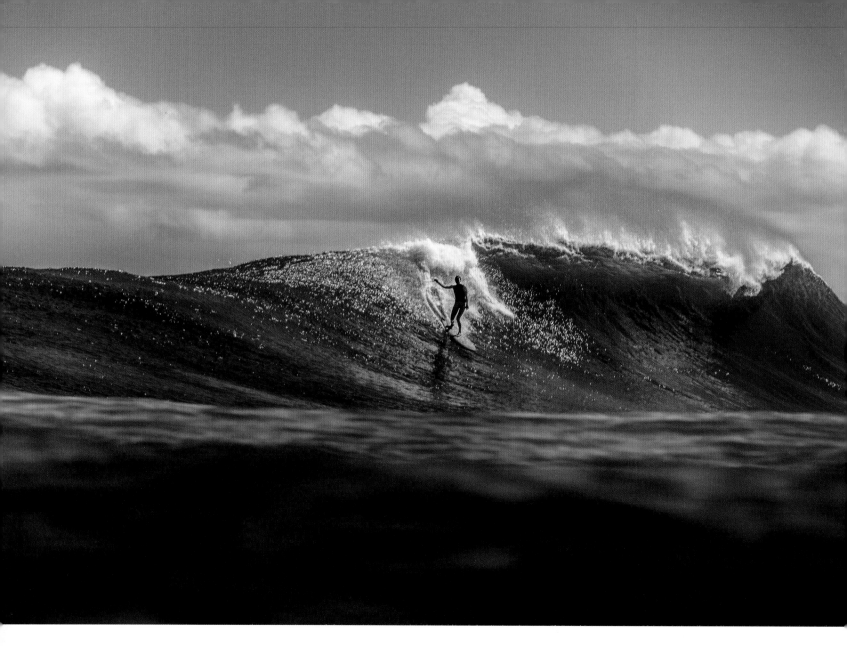

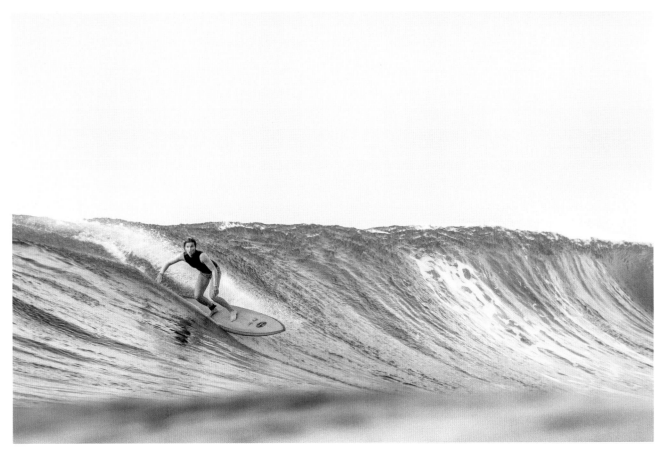

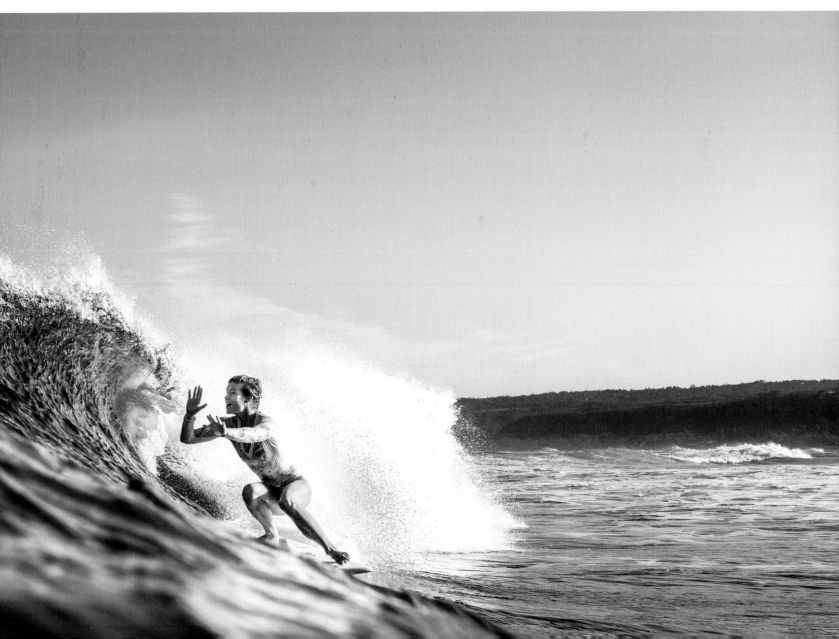

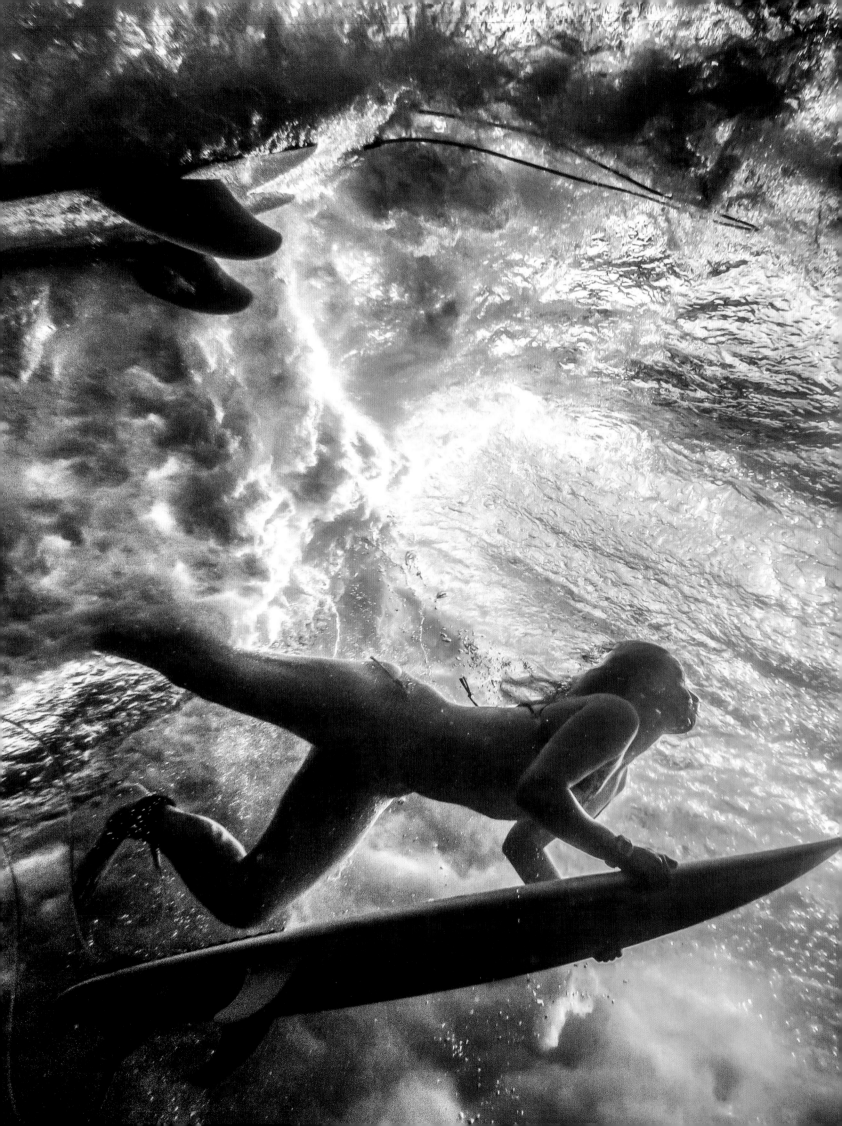

Christa Funk
Surfer, free diver, swimmer, photographer

@instaclamfunk

I love the ocean and photography, and being able to combine the two is wonderful. Having grown up in Colorado, I currently reside in Oahu, Hawaii. My love for the water started at an early age: I learned to walk and jumped right into the pool! That eventually led to me swimming competitively for fifteen years. When I wasn't in the pool, I had a camera in hand—I've been shooting photos for the past thirteen years.

On graduating from high school in 2008, I spent four years at the US Coast Guard Academy studying marine environmental science. After receiving my commission, I was stationed in Hawaii. I served aboard USCGC *Rush* for two years and was a contingency planner at Sector Honolulu for three years. I spent my downtime surfing, body surfing, free diving, swimming, and shooting photos. All of my passions came together in the form of water photography.

Carly Wilson, Rocky Point, Hawaii

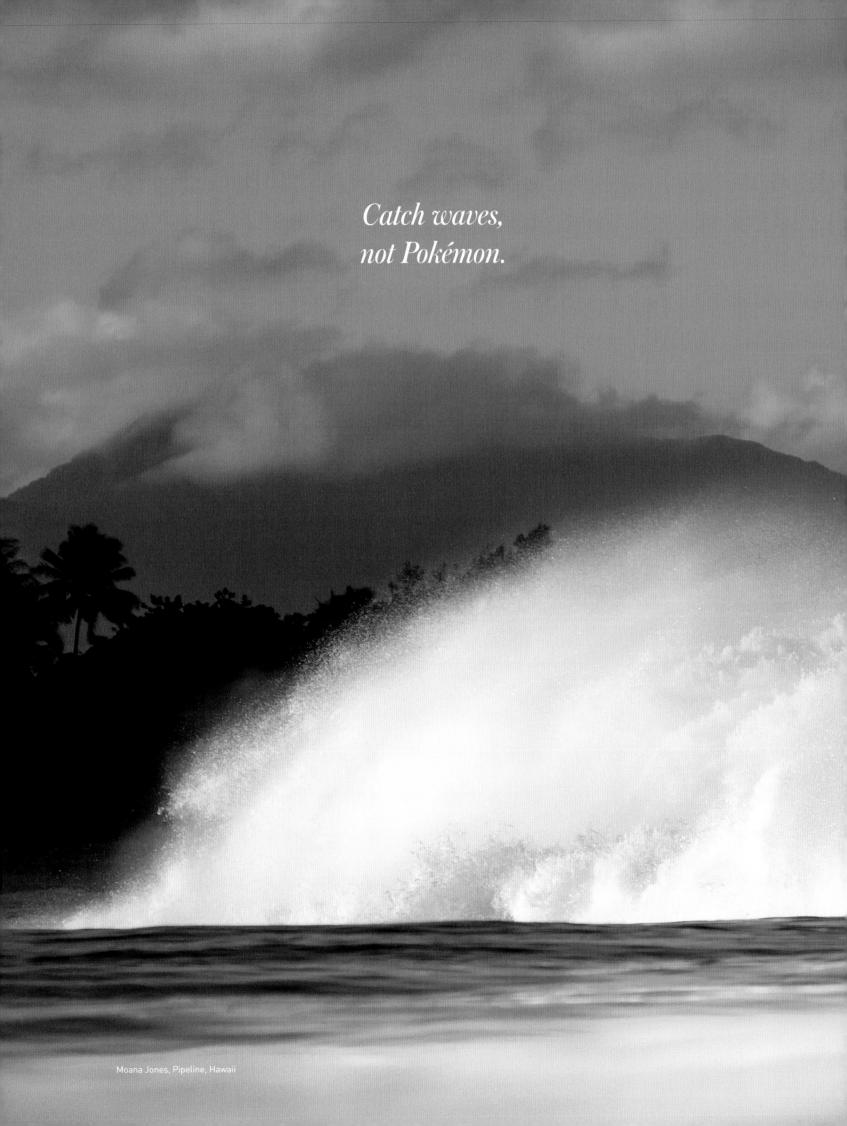

*Catch waves,
not Pokémon.*

Moana Jones, Pipeline, Hawaii

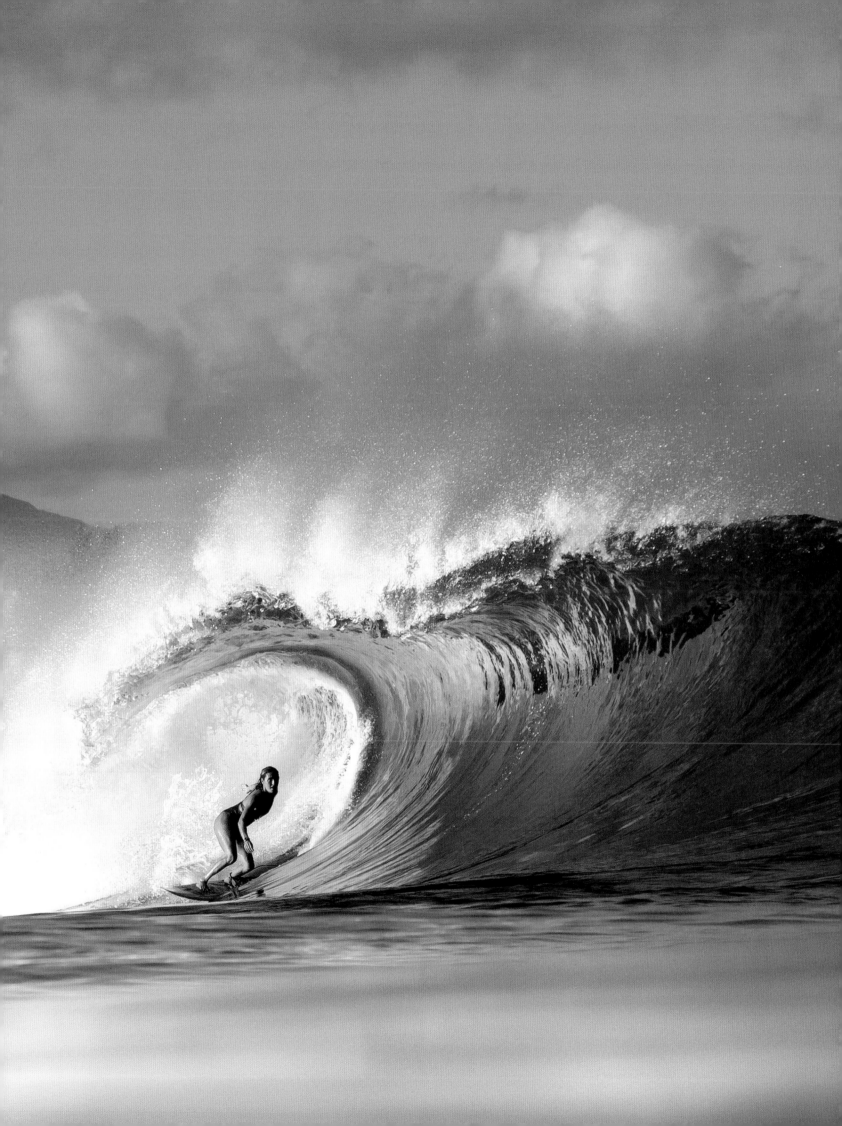

Maria Fernanda

*World's only female Mexican
big-wave photographer*

@mariafernandaphoto

I'm surf photographer born and raised in Mexico City. I was a competitive swimmer from the ages of seven to nineteen.

I've always had a passion for the water—it was part of my daily routine from a young age. I fell in love with surf culture almost ten years ago, but it wasn't until I traveled to Hawaii some years later and met and learned from the photographer and videographer Peter Sterling that I decided to leave the city lifestyle behind and exchange it for the ocean and the waves.

Surf photography is an extreme, high-risk activity requiring training and discipline, and because of this there aren't that many women practicing it. I'm one of the few women worldwide to take photos from the water in big waves, and the only Mexican woman to do so. It hasn't been an easy path, but I wouldn't change a thing. There's something truly special about following your dreams, no matter how big or distant they seem: it's always rewarding. In sharing my story I hope that it will inspire a new generation of women to not give up until they achieve their goals.

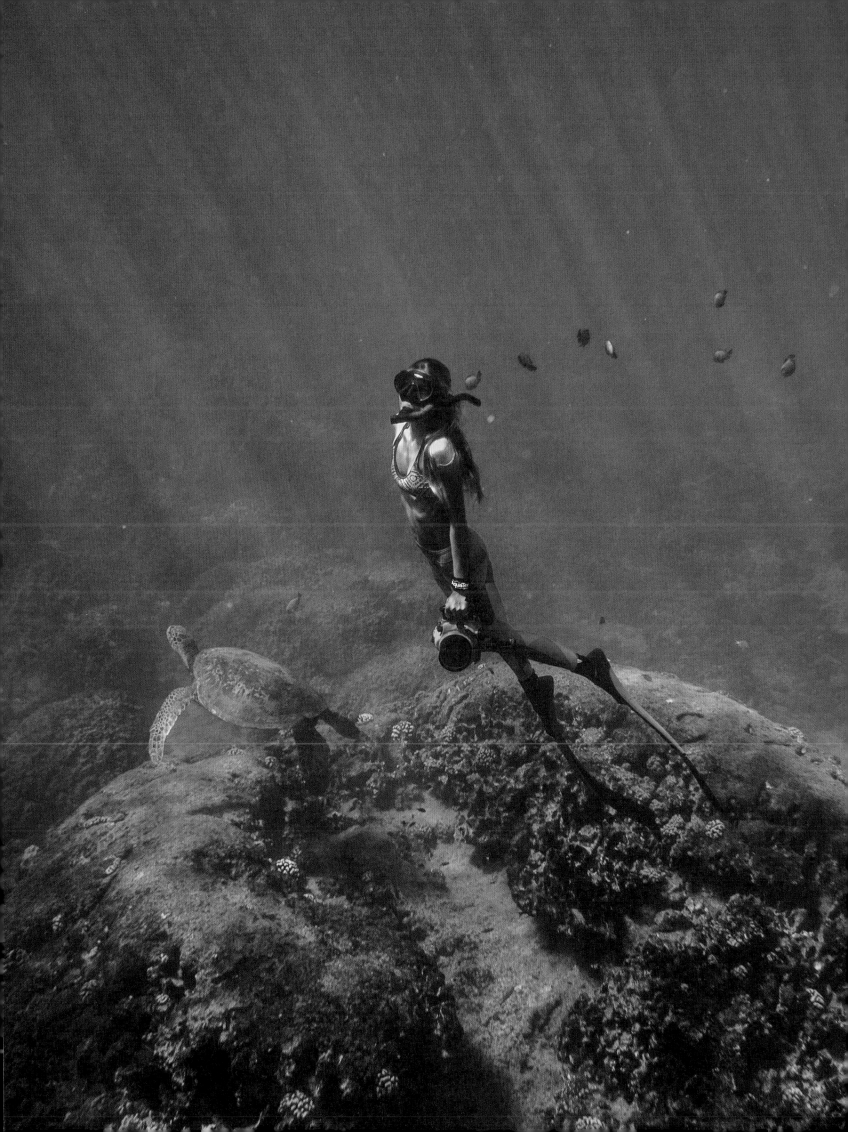

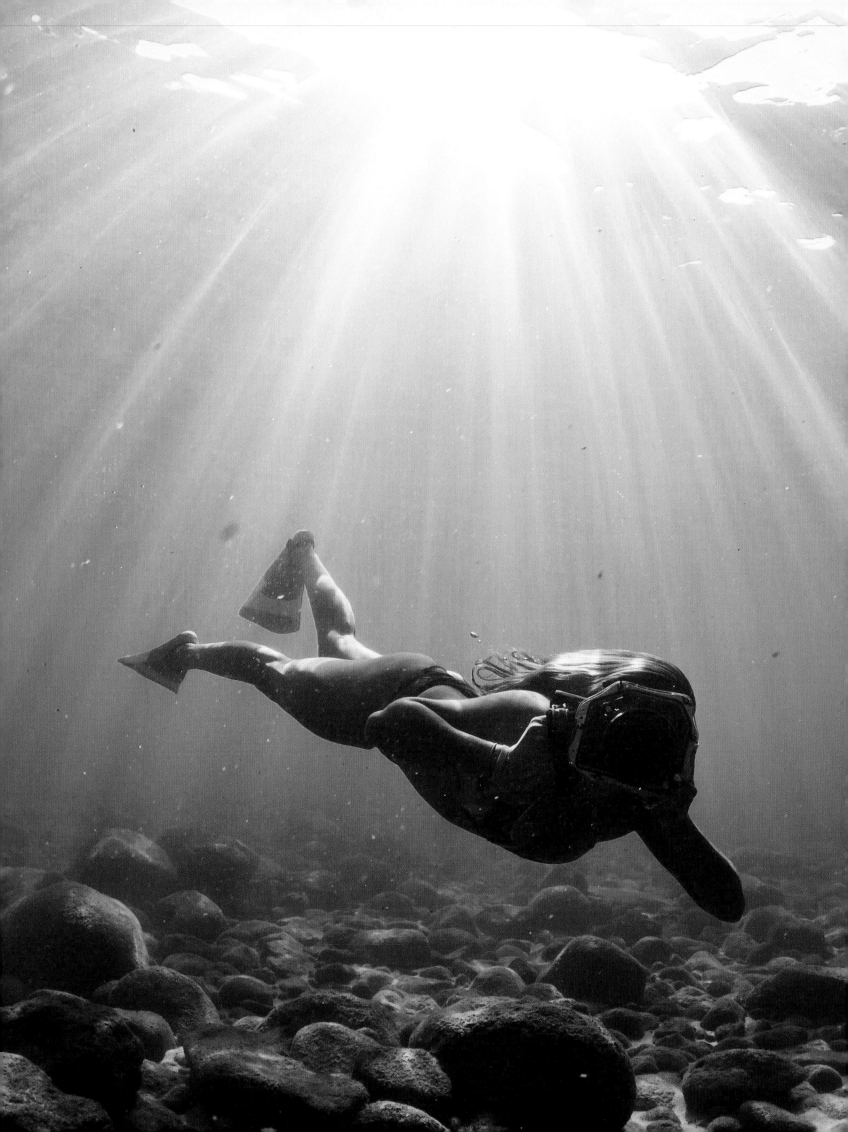

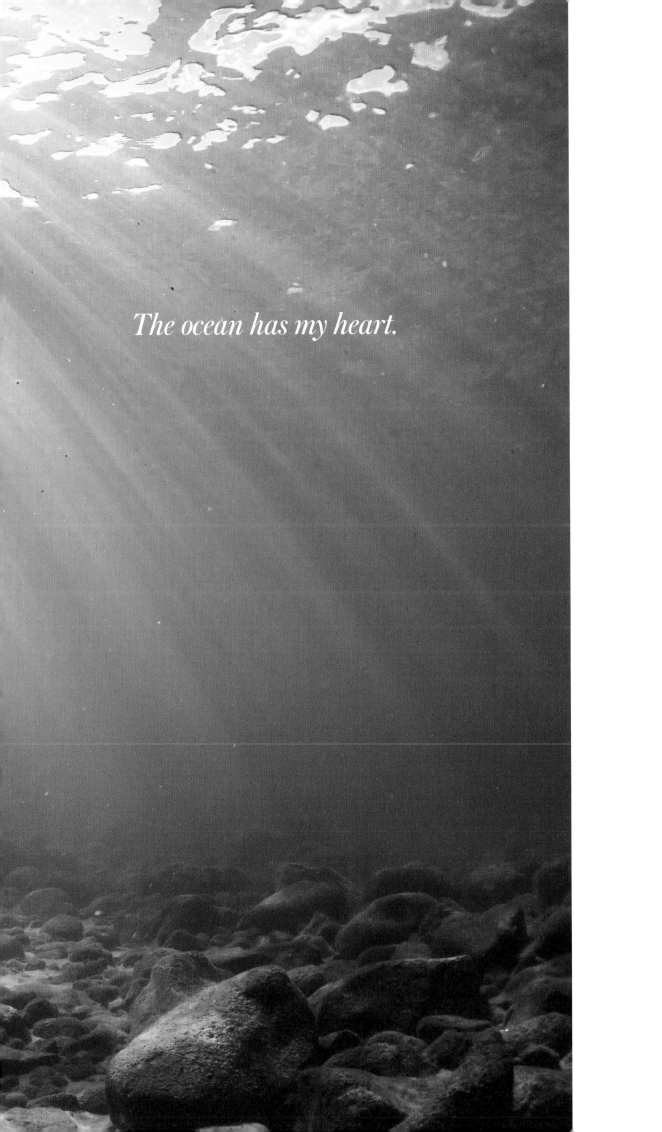

The ocean has my heart.

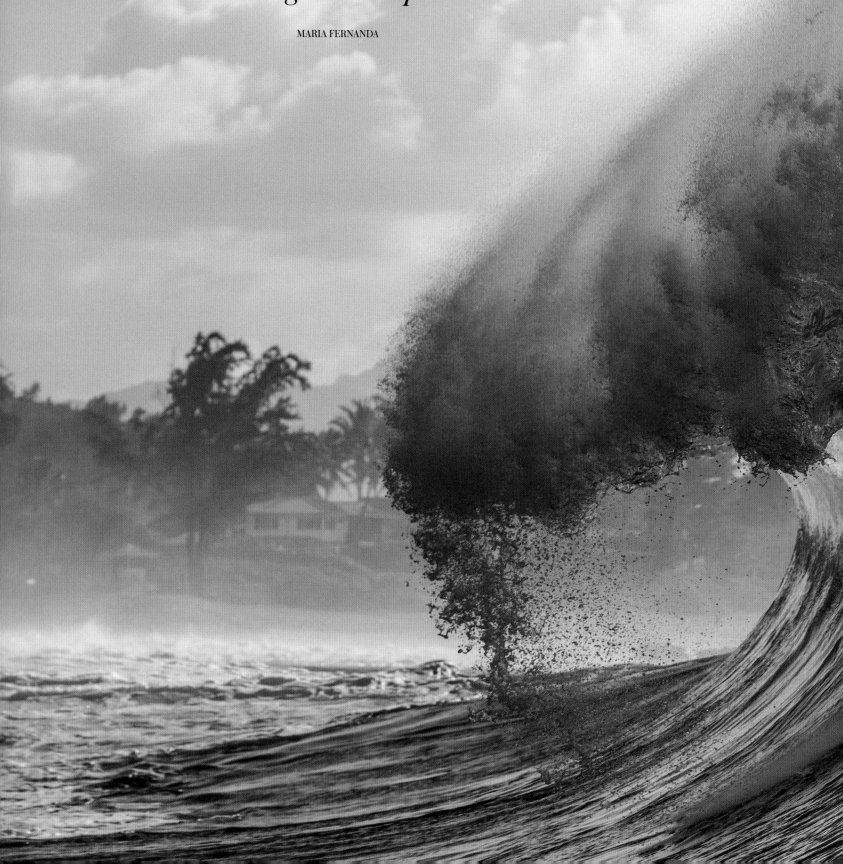

*Surf photography
is an extreme, high-risk
activity requiring
training and discipline.*

MARIA FERNANDA

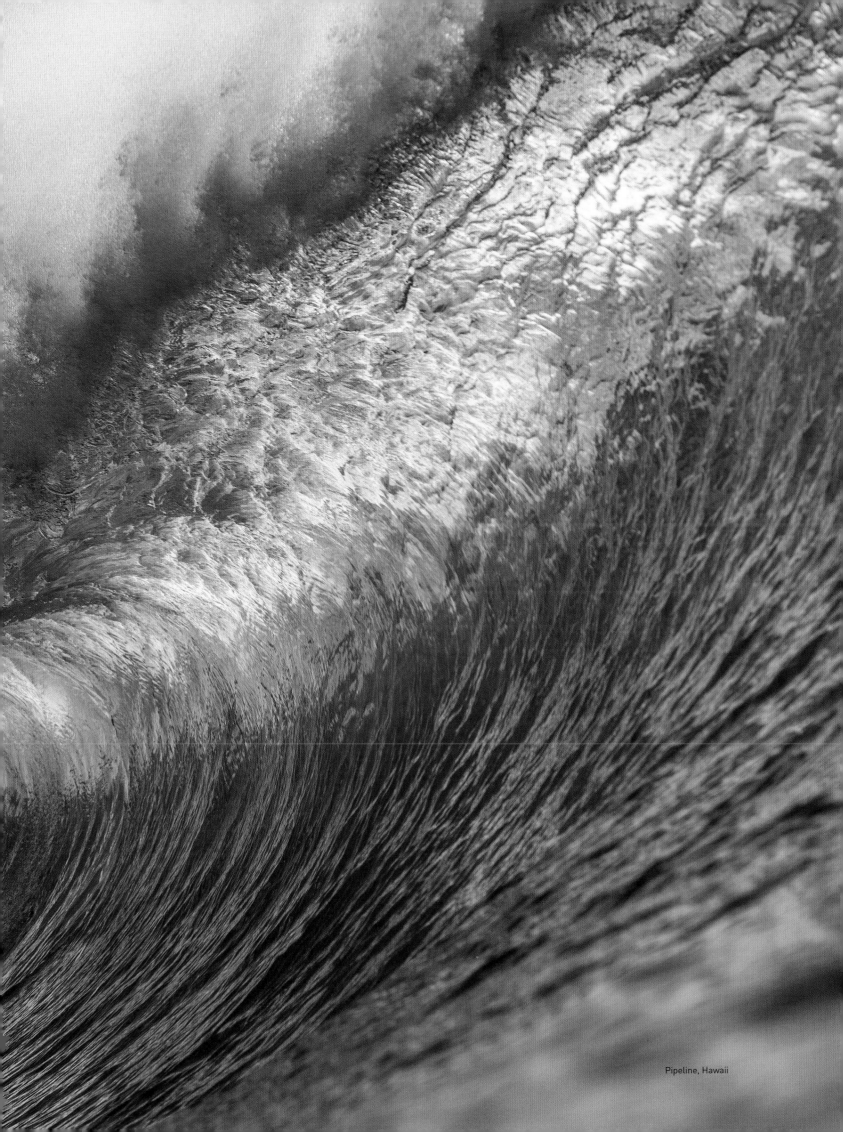

Pipeline, Hawaii

Easkey Britton

Surfer, scientist, creative

@easkeysurf

My name, Easkey, has its origins in the Irish word for "fish." It's also the name of my parents' favorite wave, in County Sligo on the west coast of Ireland.

I've been a surfer for as long as I can remember. I was born into a pioneering surfing family in the northwest of Ireland and was standing on a board from the age of four. In a way, surfing is my creative process. What I keep returning to in my life and work is the power of the ocean to connect. I'm interested in understanding the relationship between people and the environment and facilitating (re)connection with nature, especially water. Something that helps me connect is having an awareness of the cycles of the female body, the moon, and the tides. This helps me reconnect with my body in nature, understand my own inner ebb and flow, the high cost of being always "on" in a society that rewards busyness, and the equally important need for stillness and reflection.

As a woman who surfs, I naturally move with the tides. Cycle awareness has always influenced every aspect of my life. I was born on a new moon, and being conscious of the lunar cycle and its influence on me and my environment was instilled in me from an early age. My inner cycle is also inextricably linked to the sea and the ebb and flow of the tides. Beginning to chart my menstrual cycle alongside my experiences of surfing this last winter was profoundly powerful—noticing when and how the outer seascape might mirror my inner cycle. The lunar cycle became a vehicle for me to give this experience creative expression, in the form of an abstract short film fusing surfing, dance, and poetry. Making the film allowed me to explore what it would be like to let the energy of the different phases of my cycle express itself through how I surf.

A lot of my work is cross-cultural and I have found cycles to be a unifying experience shared by all women; it can create a sense of sisterhood, and yet our experiences of them vary wildly and are greatly influenced by societal and cultural rules and norms, and social justice issues. When I think of what it is that connects all women across borders, beliefs, time, and space, it is the wisdom of our bodies.

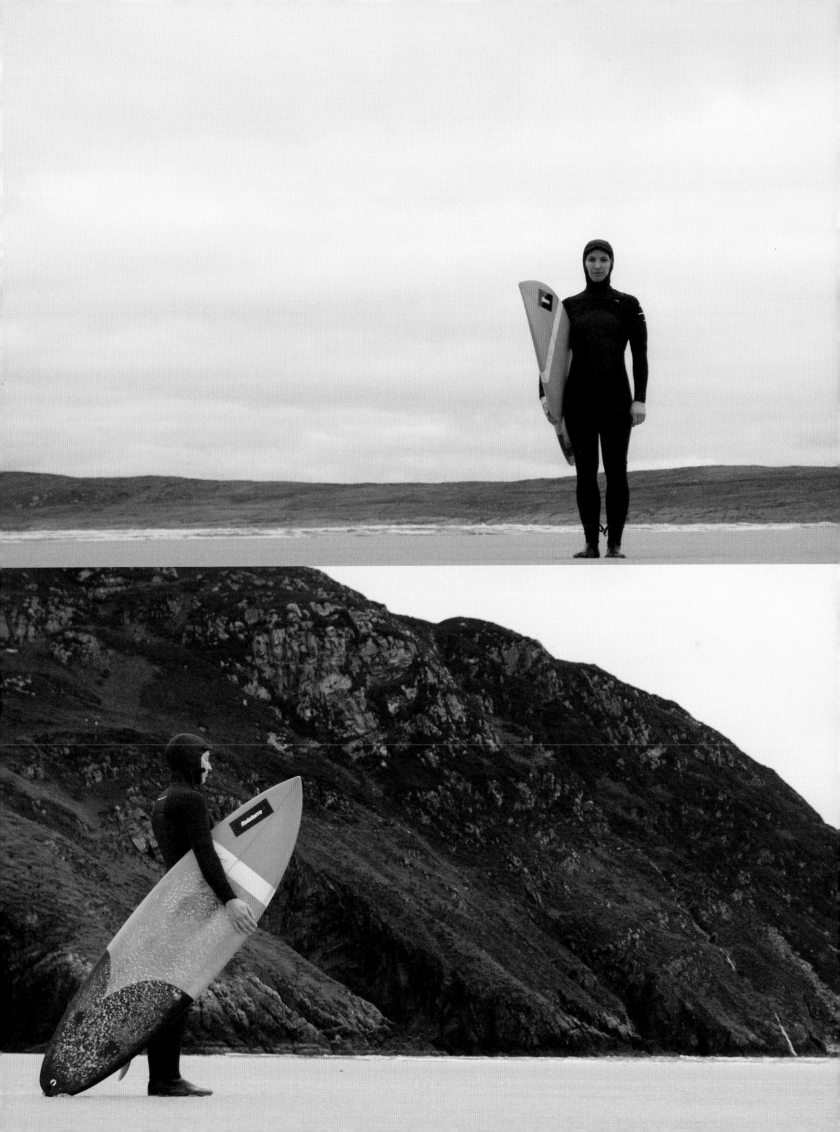

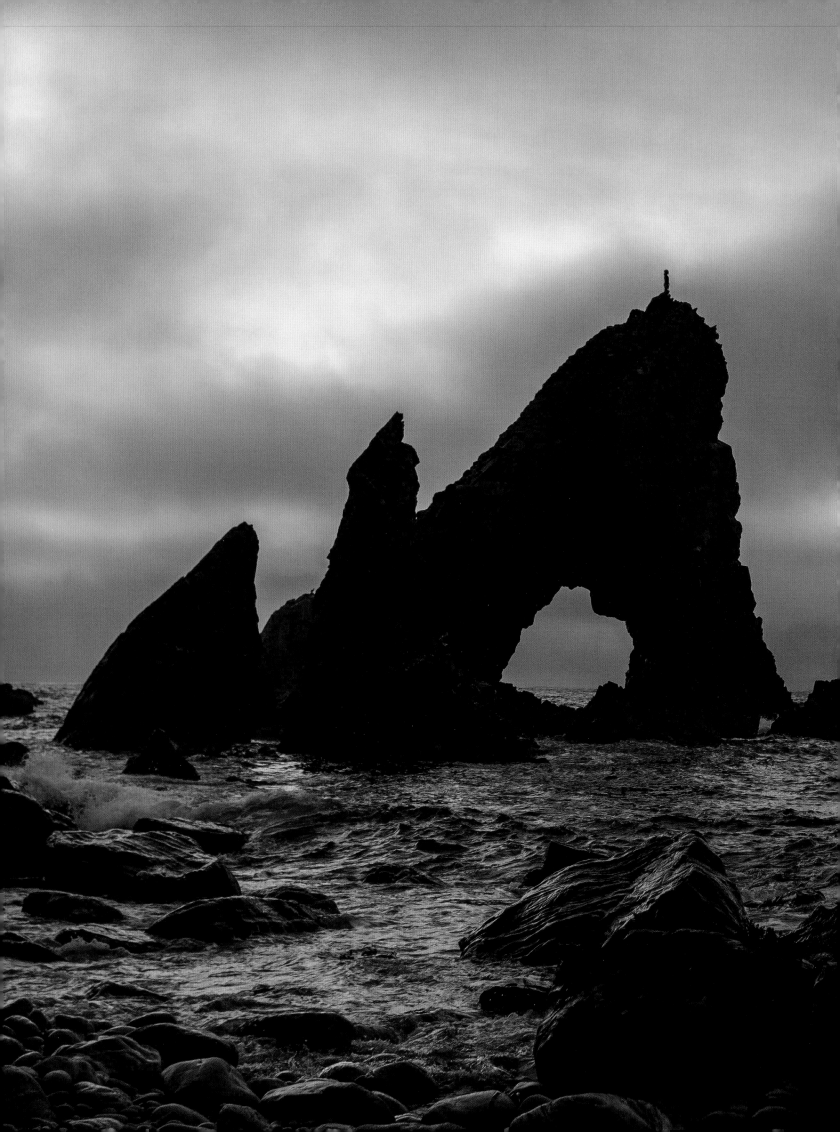

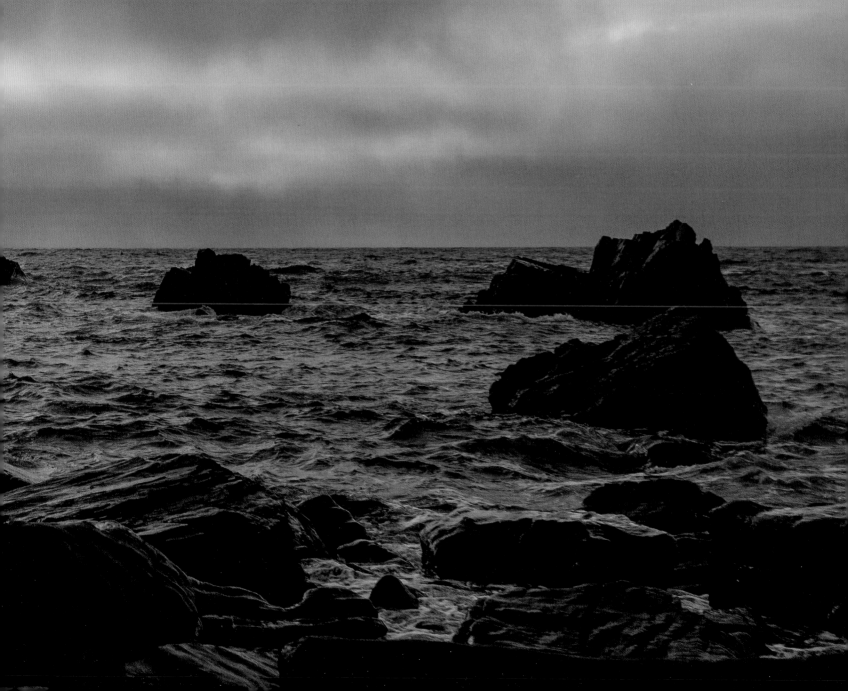

*When I think of what it is that
connects all women across borders,
beliefs, time and space,
it is the wisdom of our bodies.*

EASKEY BRITTON

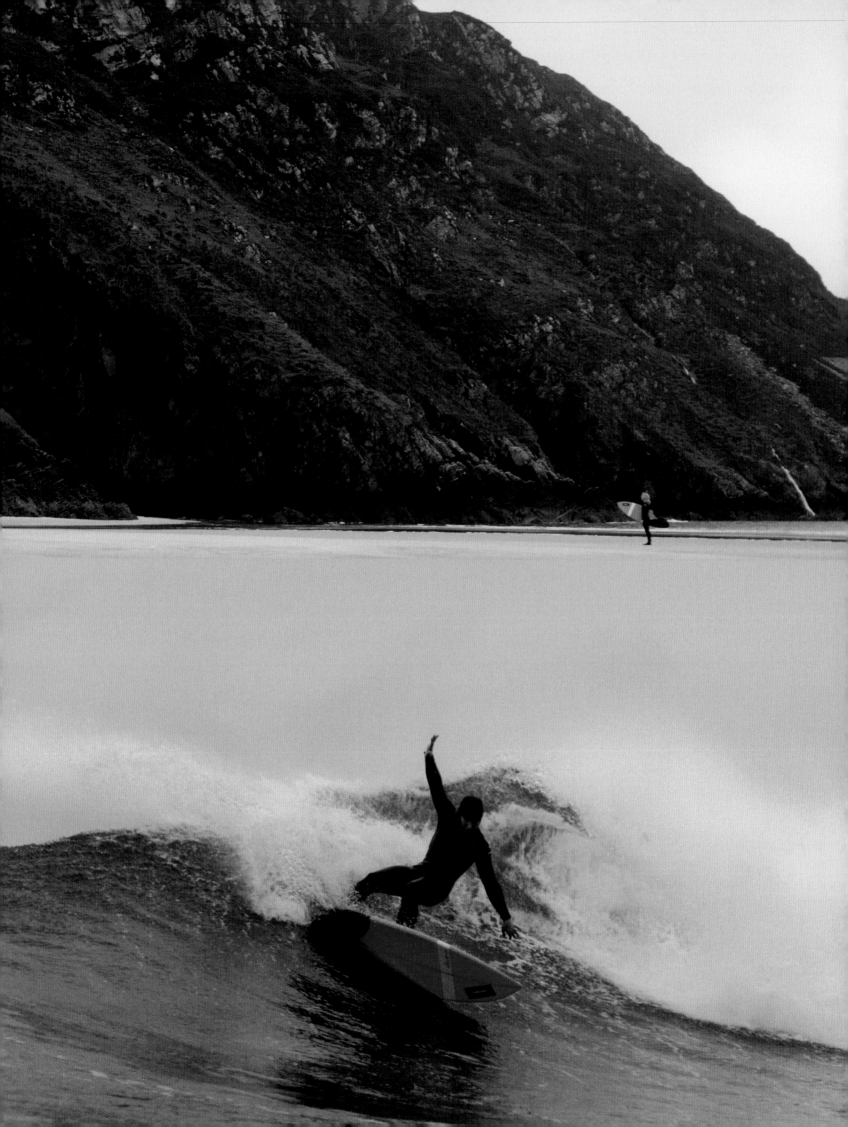

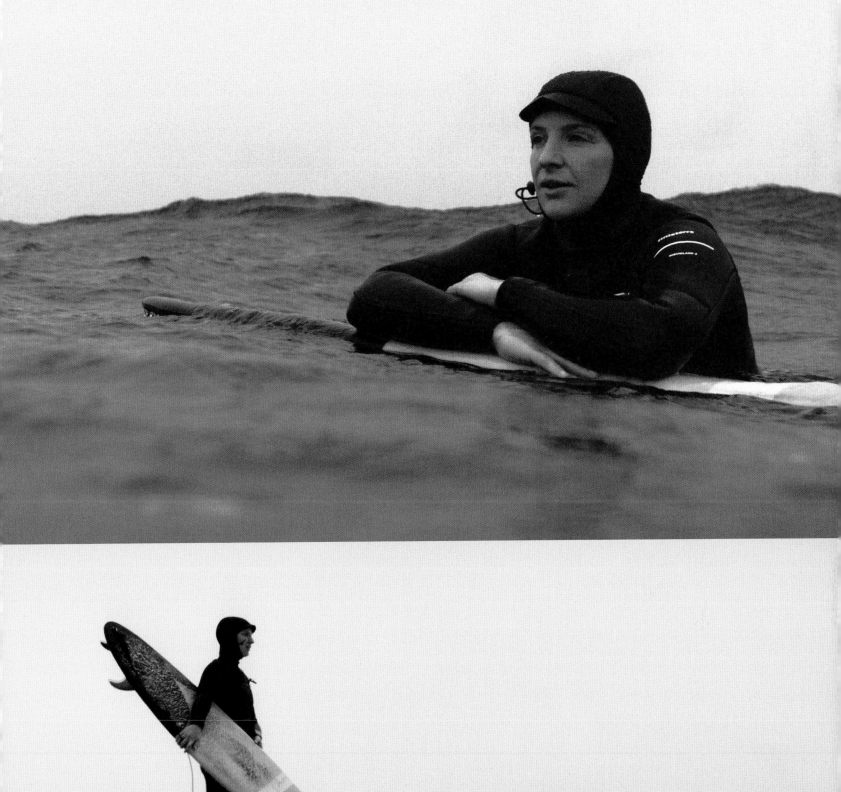
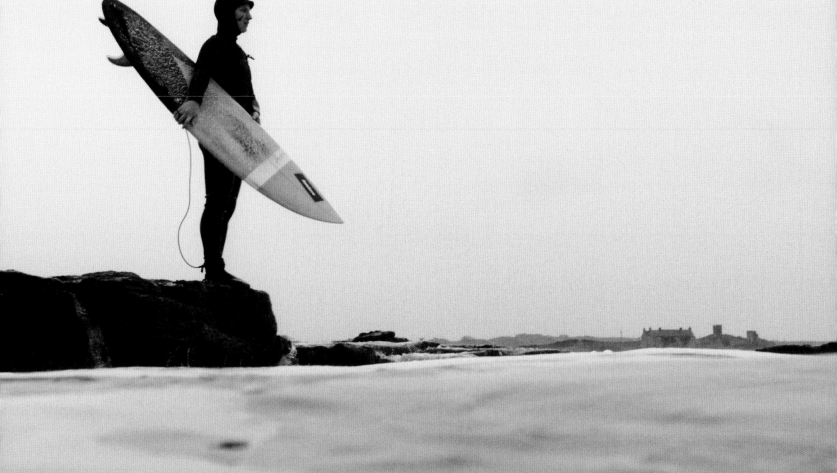

Fiona Mullen
Photographer

@fionakatephoto

Photography was my gateway to a life of surfing and time spent in the ocean. Growing up in northern New Jersey—an hour from both New York City and the beach—I was always inspired by creative fields and the water. I have an extended family who exposed me to surfing in Rhode Island and California; as a kid I could spend hours playing in the water.

I've been interested in anything with a lens ever since I could walk. But when I was fifteen I was gifted a DSLR, and that's where it all really began. I would force my mom to take time out of her busy schedule to drive me down to the beach in time for sunrise whenever there was a big swell. I was obsessed. If I missed documenting even a single swell in New Jersey, it seemed like the end of the world. This drive and devotion to my work led me to start making contacts at surfing publications at quite an early age. I started documenting more professionals, saved up for a water housing, and began swimming on the coldest of winter days.

The feedback I would receive from strangers on the beach or people on social media pushed me to get better. Light and colors are everything for me, and I believe my style reflects that. In recent years it's been a struggle deciding whether to pick up my board or bring out my camera. Now I'm in my last year studying at university and can't wait to ditch the textbooks and spend more time doing what I really desire— bringing people closer to the ocean through my images. My own journey as a photographer began with wanting to get closer to the ocean, and now that I'm here I look forward to more travel and pushing my comfort levels even more.

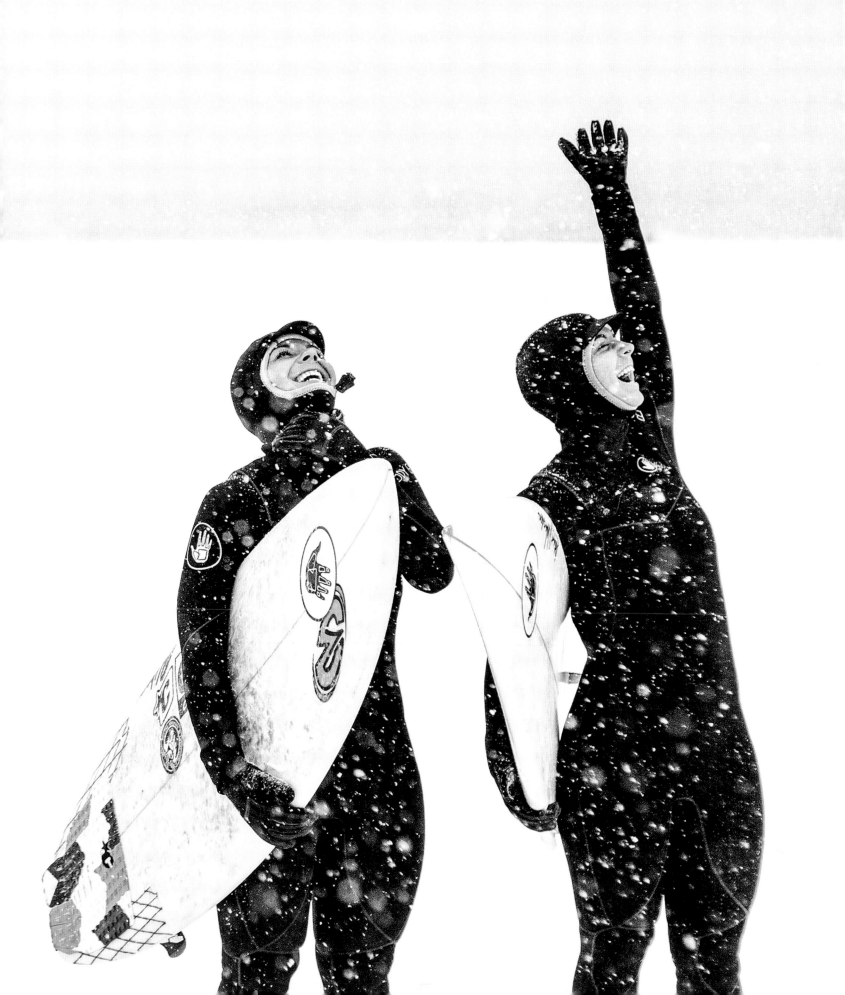

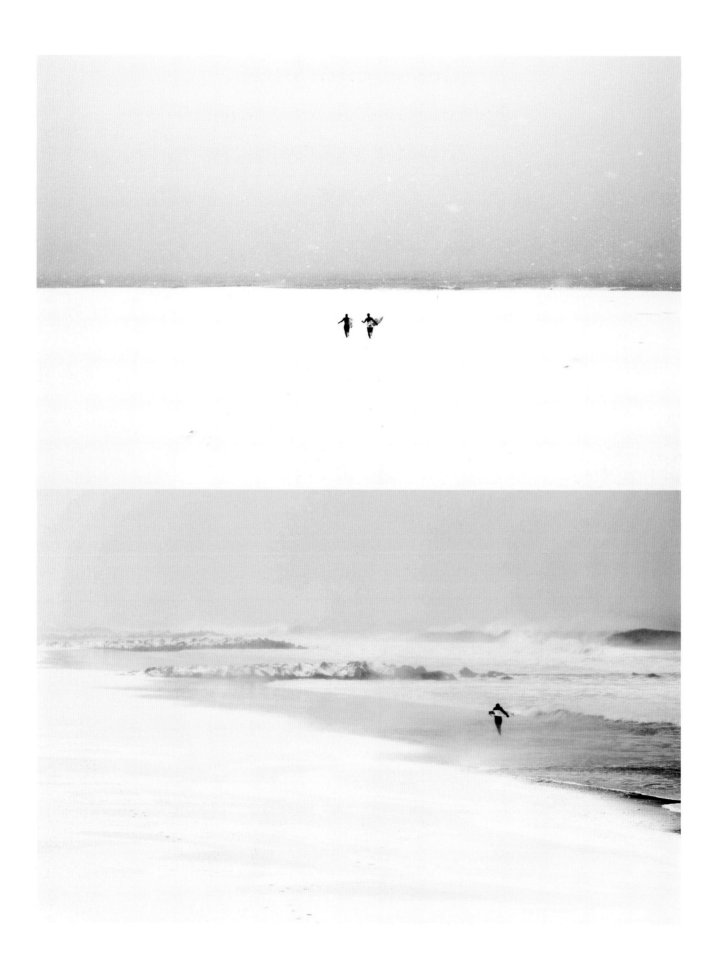

New Jersey, USA

*My desire is to bring
people closer to the ocean
through my images.*

FIONA MULLEN

Bryanna Bradley
Photographer and cold-water mermaid

@bryannabradleyphotography

My relationship with my camera has been an adventure in itself. Diving into a world of photography inspired by the ocean has led me to find the place where I feel most alive. The beauty I'm surrounded by is abundant, and my desire to freeze time and moments while my friends dance along the Pacific Northwest's rugged, cold coast is endless.

I have always loved to shoot among chaos. Being fully submerged in water while trying to capture a glimpse of grace born from an action sport can be challenging, but it's rewarding in equal measure.

The physical photos I take are not comparable to the experiences that engulf my senses: the cold Canadian water, the sweet smell of kelp, the many hues of my favorite turquoise and greens, the variation of the silence that accompanies the ocean, or the overwhelming sound of endless gallons of water exploding into each other as surfers paint the canvas Mother Nature has to offer. It is these moments that take my breath away, that become so deeply imprinted in my brain and leave me continuously yearning for more.

My photography is fueled by my raw desire to submerge myself in an environment that makes me come to life. I can only hope that speaks true to those who, through my work, my photographs, get to share these slivers of magic I experience.

△△ Hanna Scott △ Carly Seibel ▷△ Emily Grubb ▷▷ Lydia Ricard | Vancouver Island, Canada

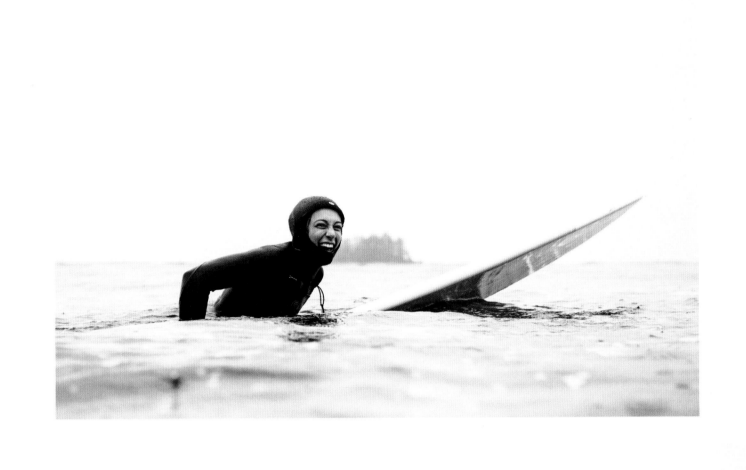
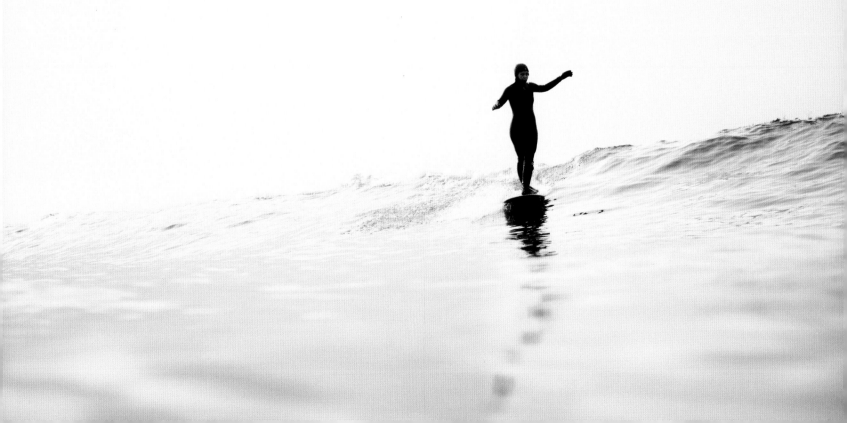

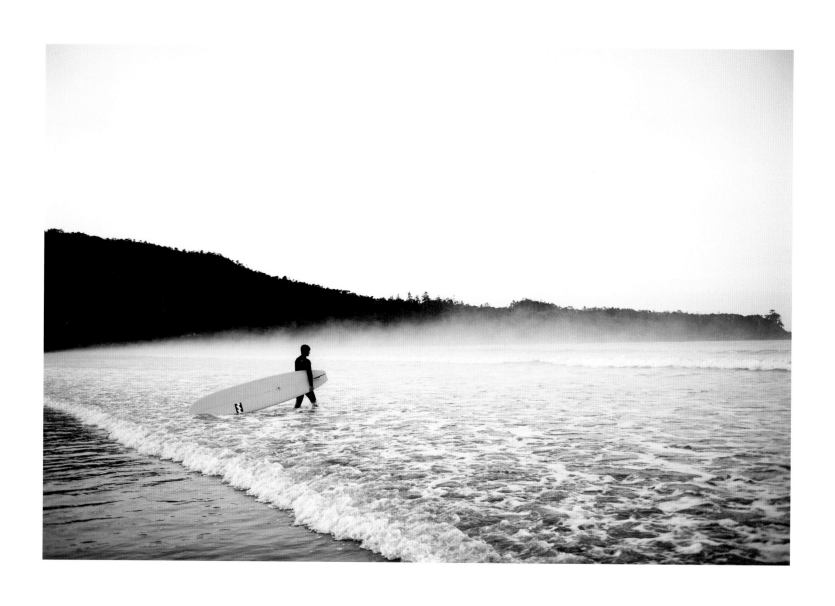

△ Lydia Ricard ▷ Tiffany Olsen and Kate Prothero | Vancouver Island, Canada

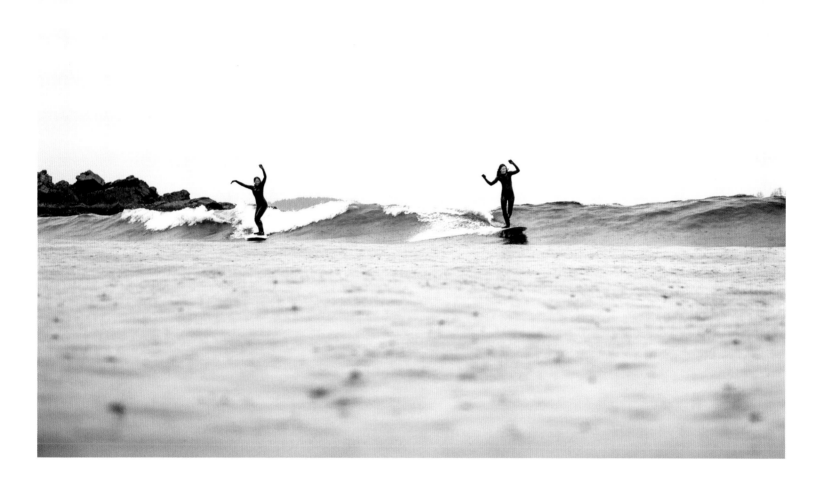

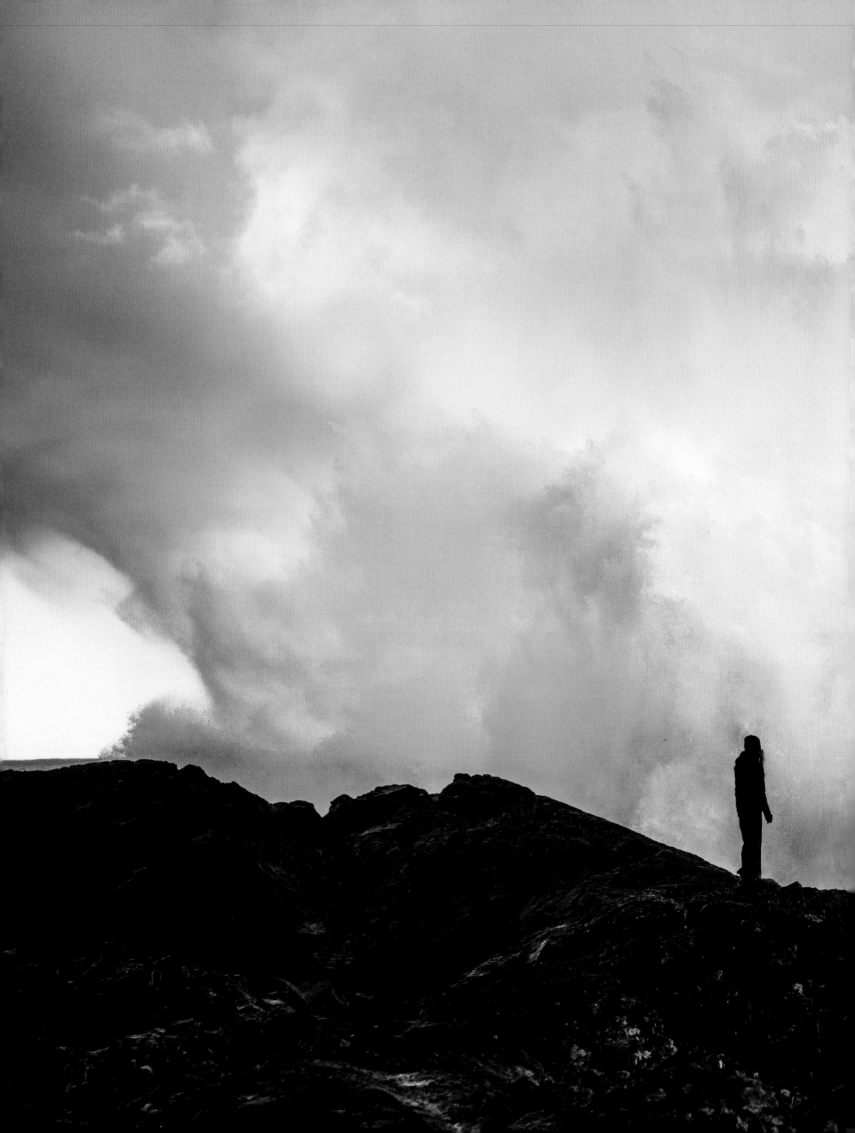

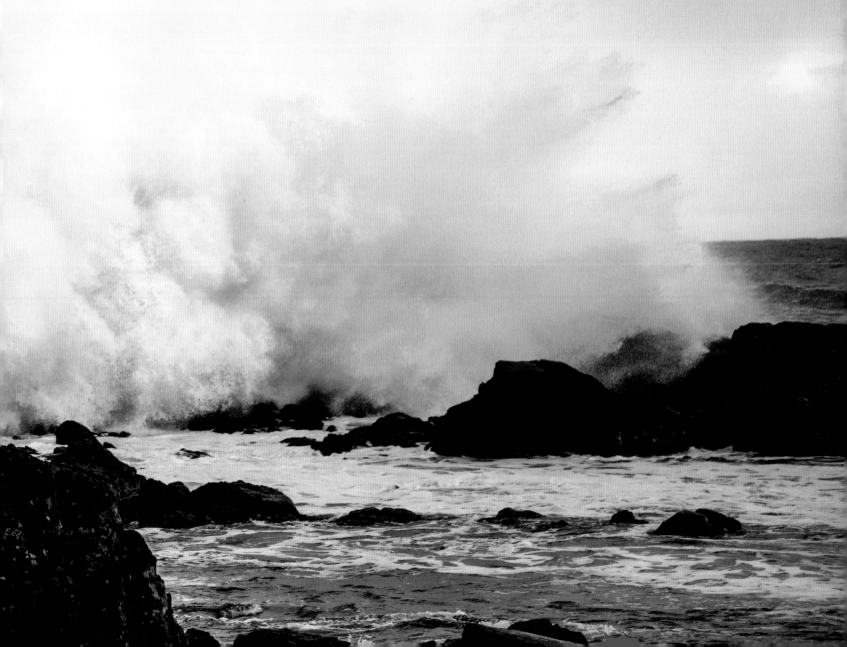

*The physical photos
I take are not comparable
to the experiences
that engulf my senses.*

BRYANNA BRADLEY

Sara Guix
*Traveling with a camera
and a drone*

@sguixs

I am originally from Barcelona and landed here in New Zealand, where I work as a cinematographer and photographer, more than three years ago. I fell in love with this country on day one. I live in Raglan, the coastal town where I discovered the surf and became fascinated by the beauty of the waves—each and every one.

With a water housing I discovered a whole new perspective. I'm getting more and more confident with it every day, and even though I still find it hard, when I get the image that really captures what I want I am happy for weeks.

I'm lucky to be able to say that I love what I do. It's never easy to achieve stability in this industry, and you have to keep fighting constantly—anyone who says the opposite is lying! On the other hand, it's extremely rewarding to be able to see your own project come to fruition and to think to yourself: someone watching this somewhere is feeling what I felt when shooting it. And even if only one person out of thousands feels that, it's worth it.

It's hard to put into words the reasons I left Spain or even why I continue to travel all the time. After I first left, I kept changing my response whenever my parents asked me about it. But those were all excuses—I eventually realized there was never a single answer. And the ones I found were constantly evolving thanks to the experiences and people I was meeting along the way.

I was so curious about this that I even started a project called "Why Did You Leave?", which is a YouTube documentary series where I interview people I meet along my travels. People who, like me, left home and started a new life somewhere else.

Hanalei Pier, Hawaii

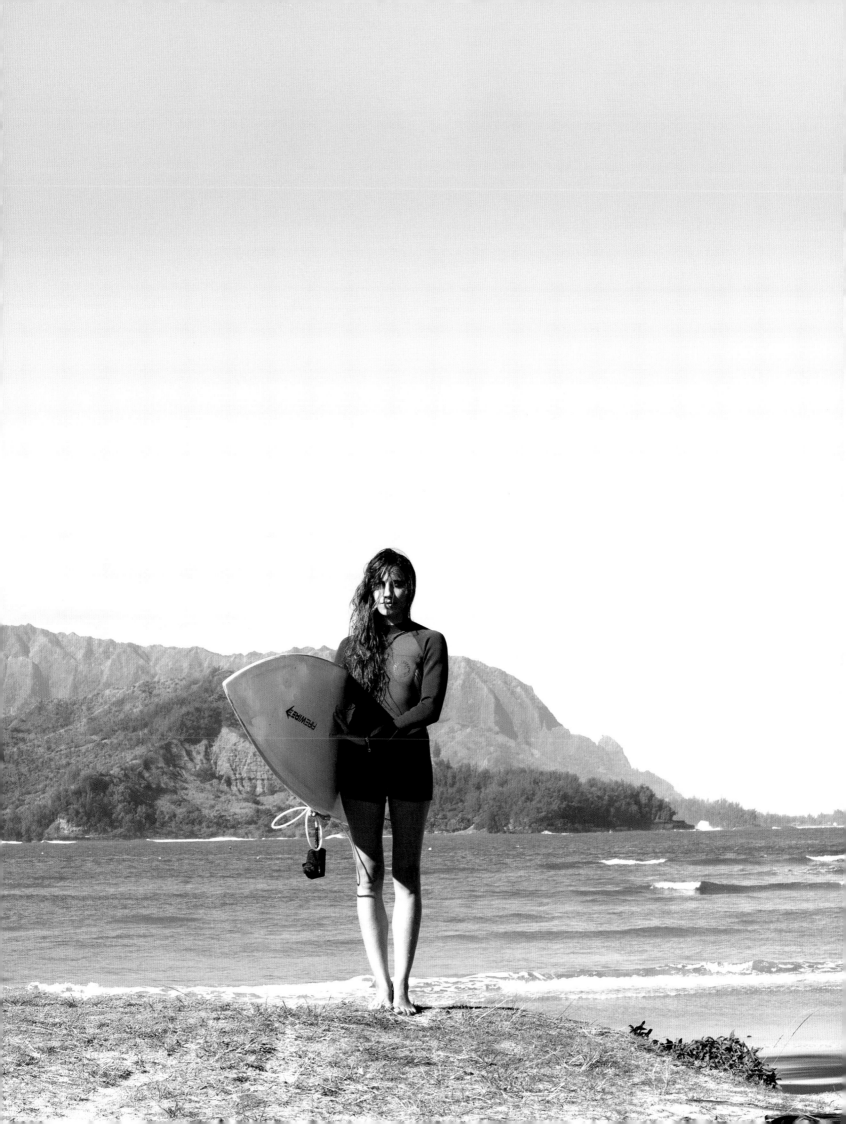

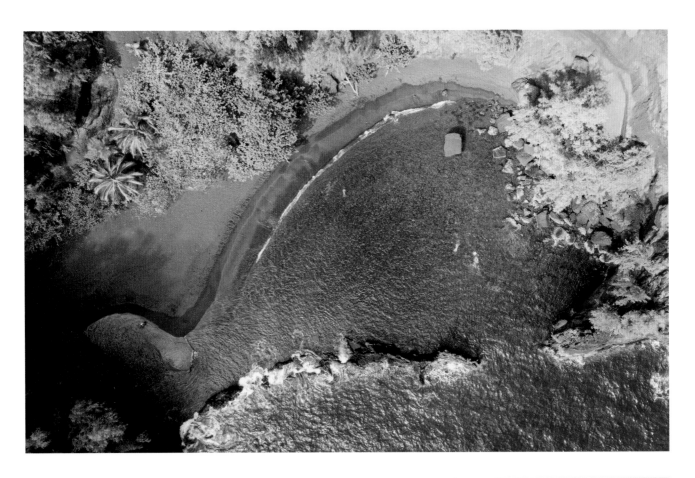

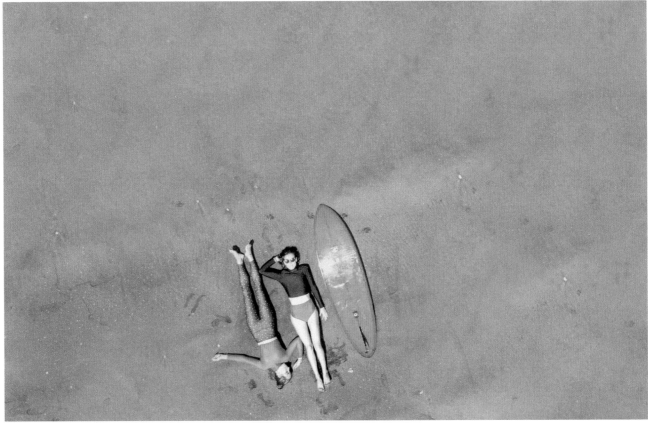

△△ Hana beach, Hawaii △ Ngarunui beach, New Zealand ▷ Mentawai Islands, Indonesia

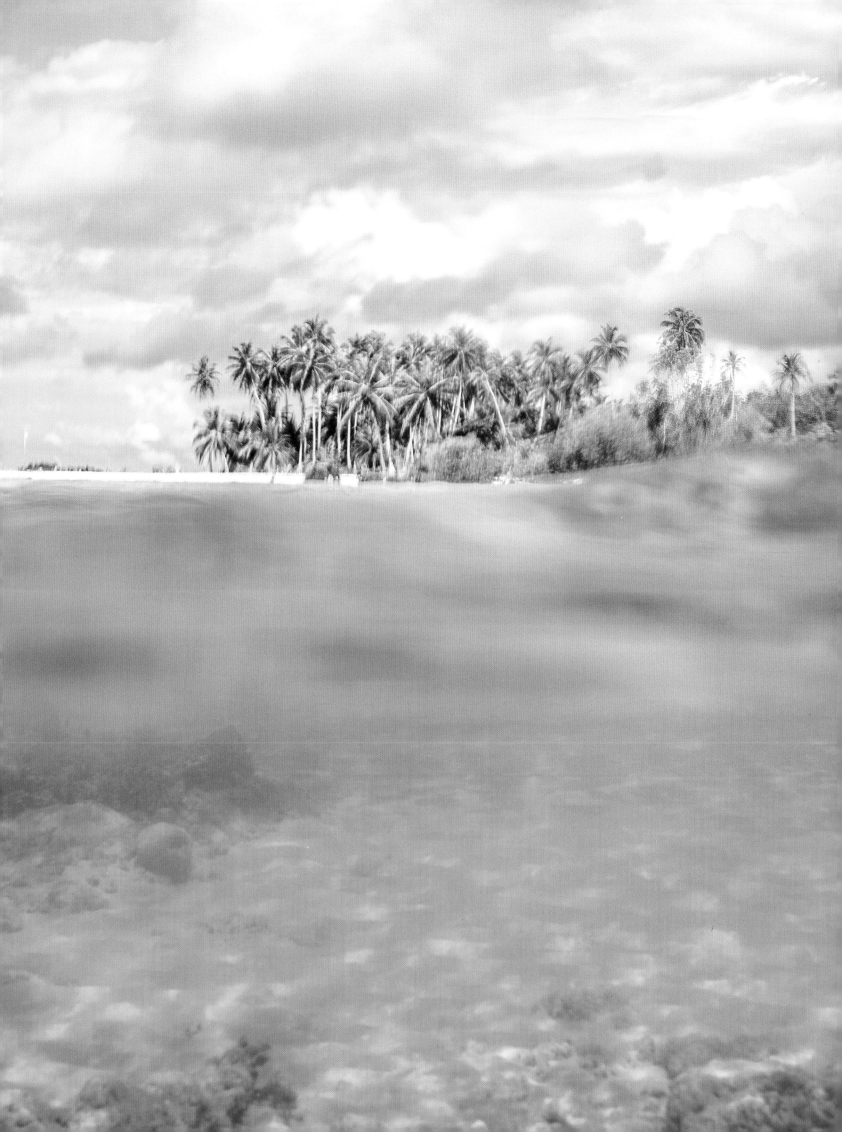

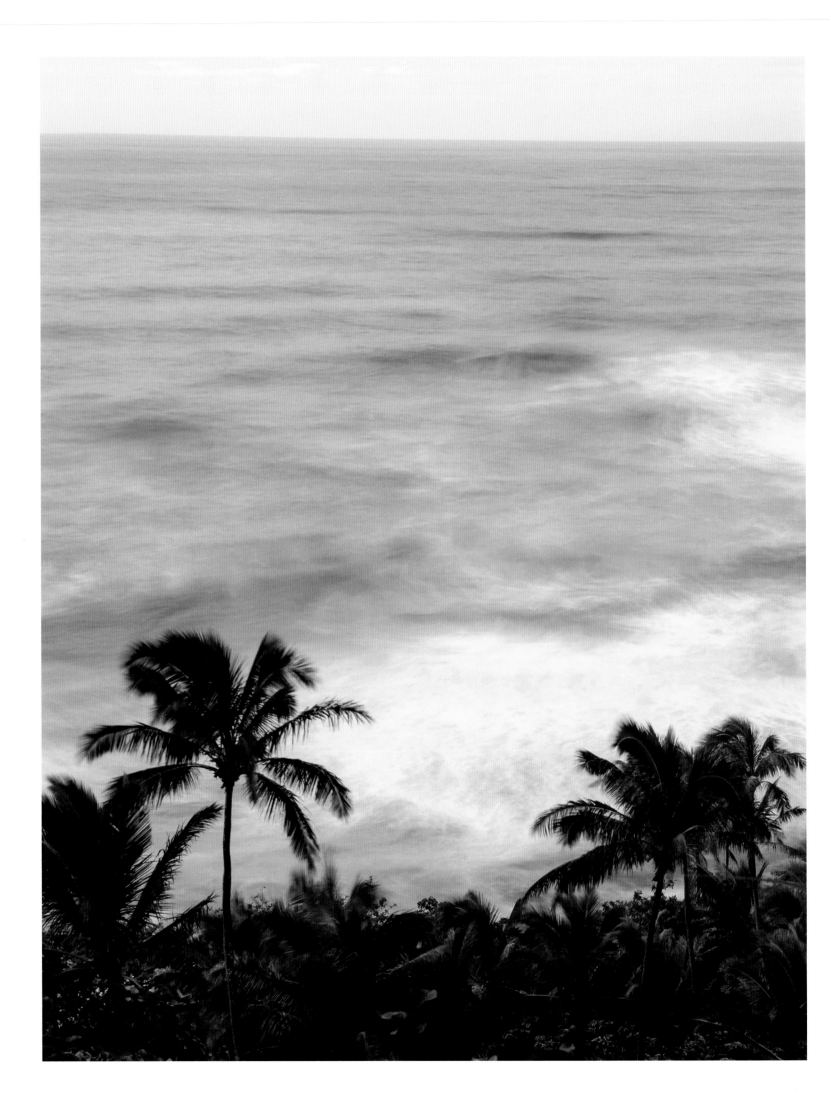

I left home and started a new life somewhere else.

SARA GUIX

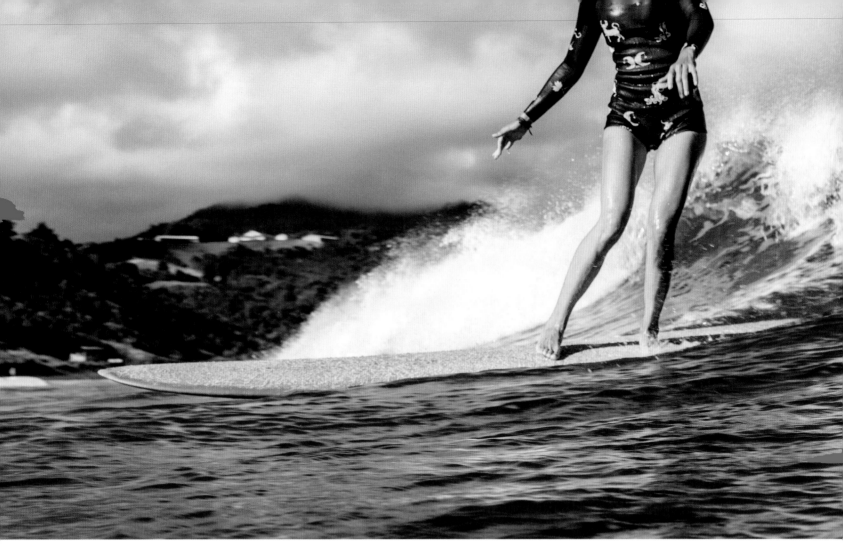

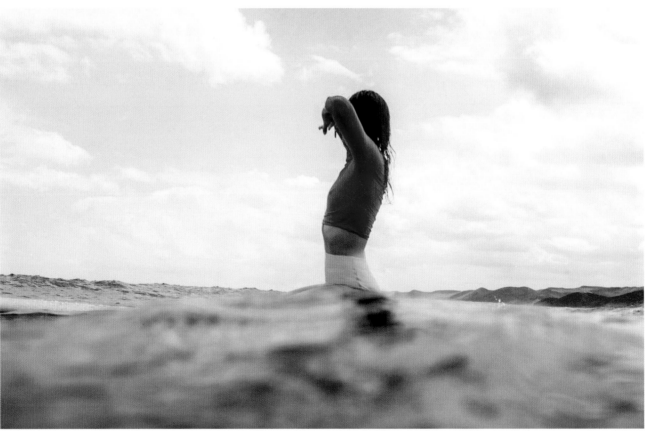

▷ Ho'okipa, Maui, Hawaii

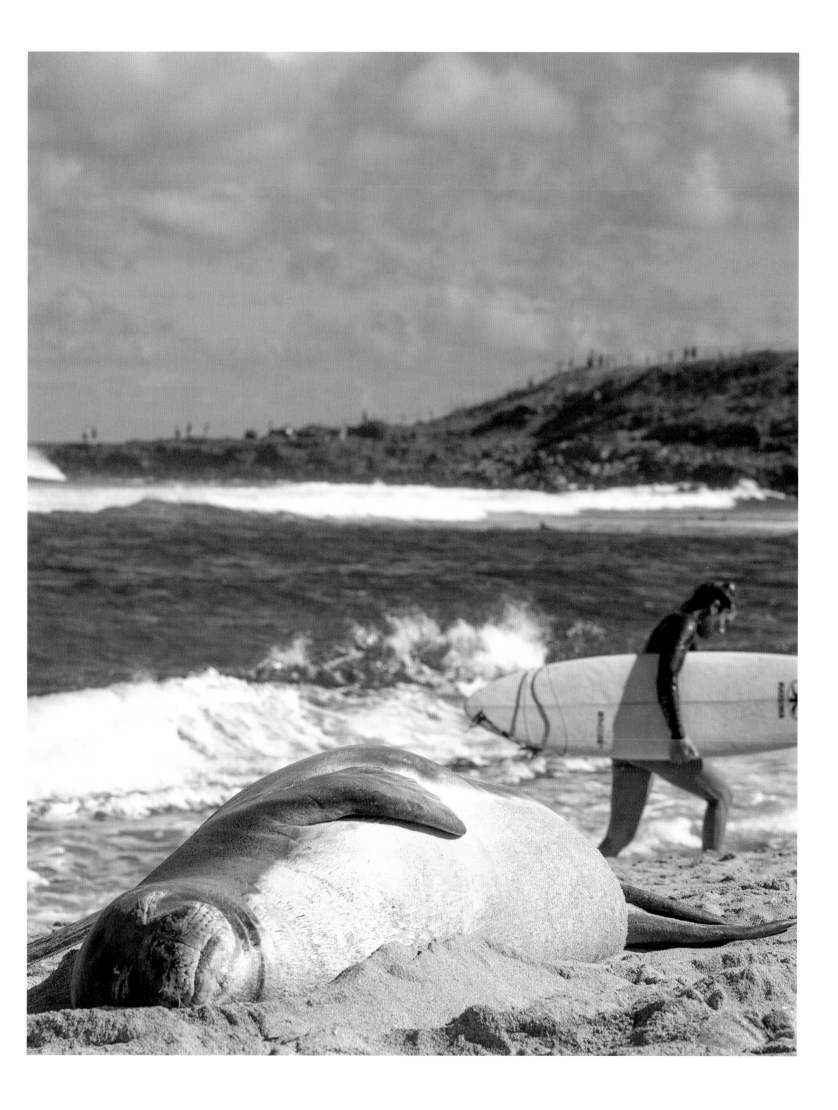

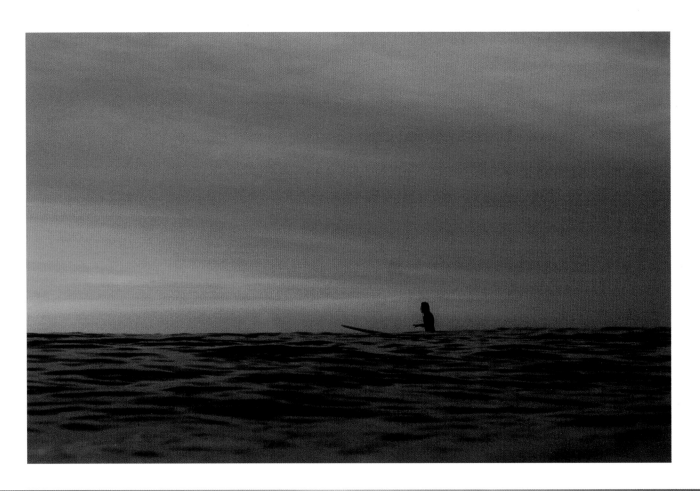

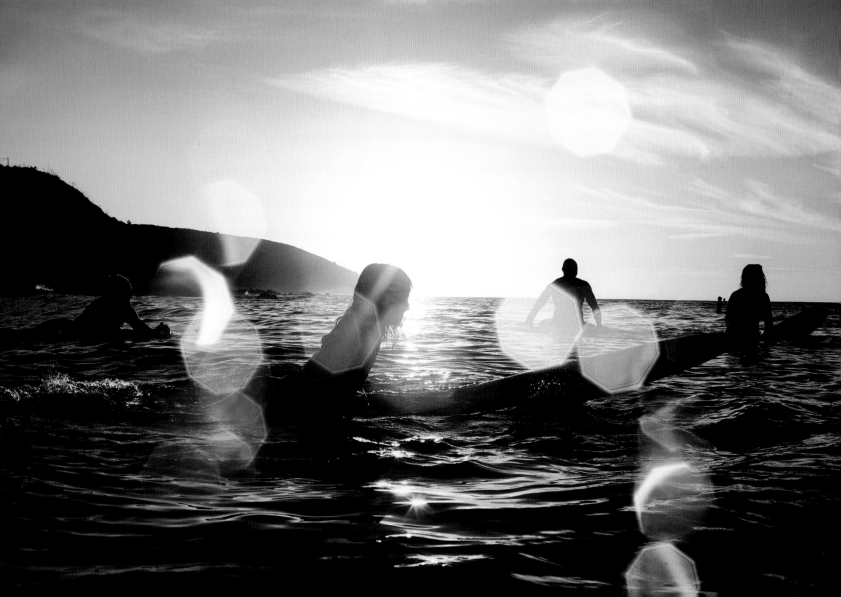

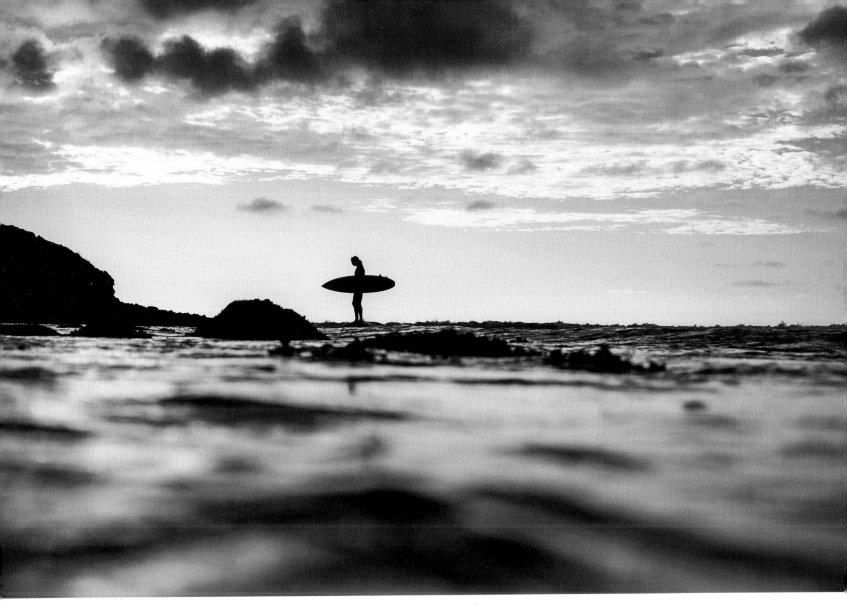

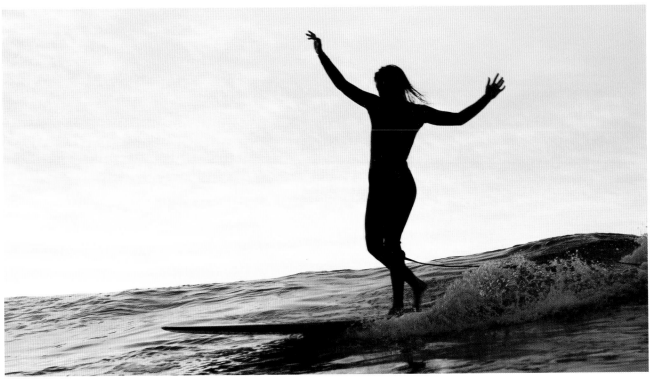

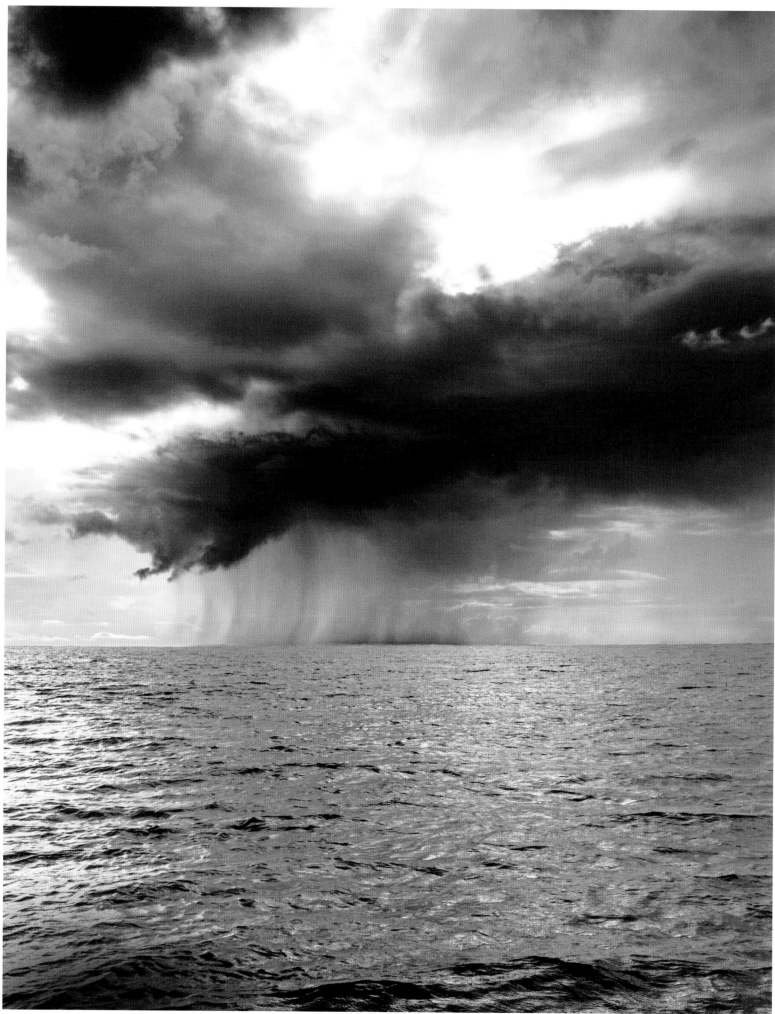

Mentawai Islands, Indonesia

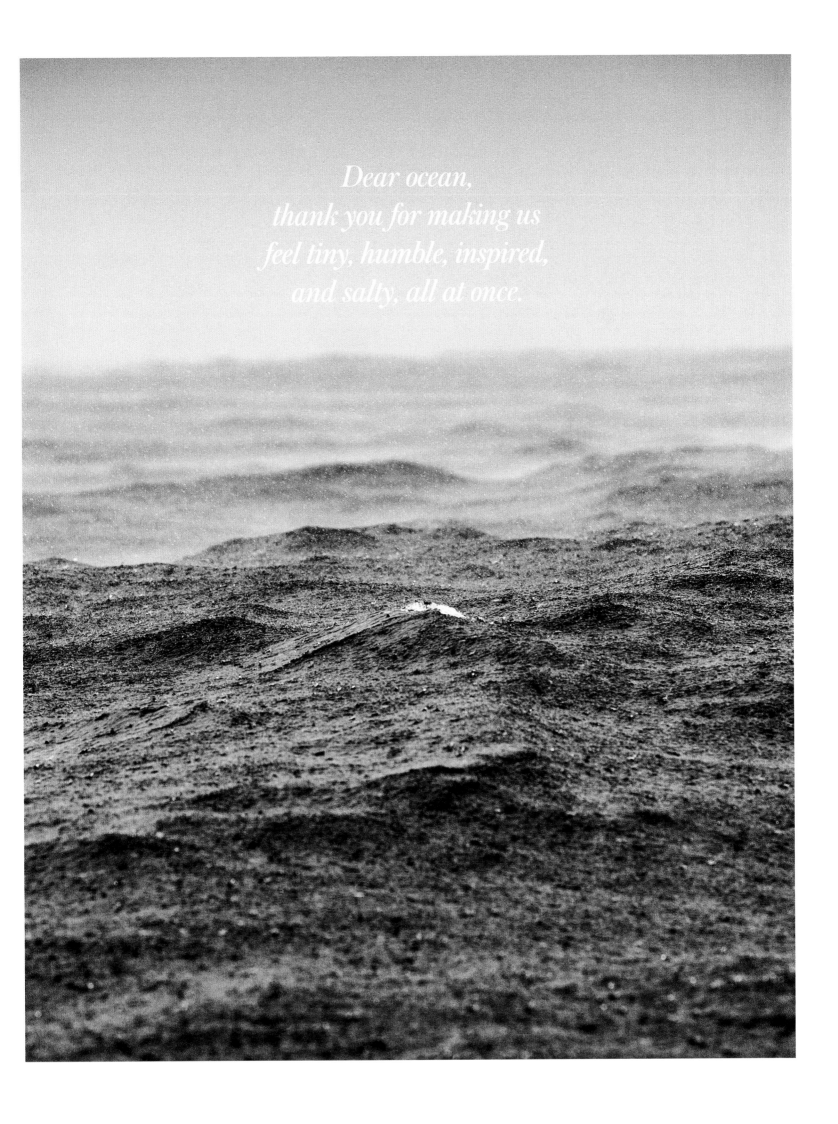

*Dear ocean,
thank you for making us
feel tiny, humble, inspired,
and salty, all at once.*

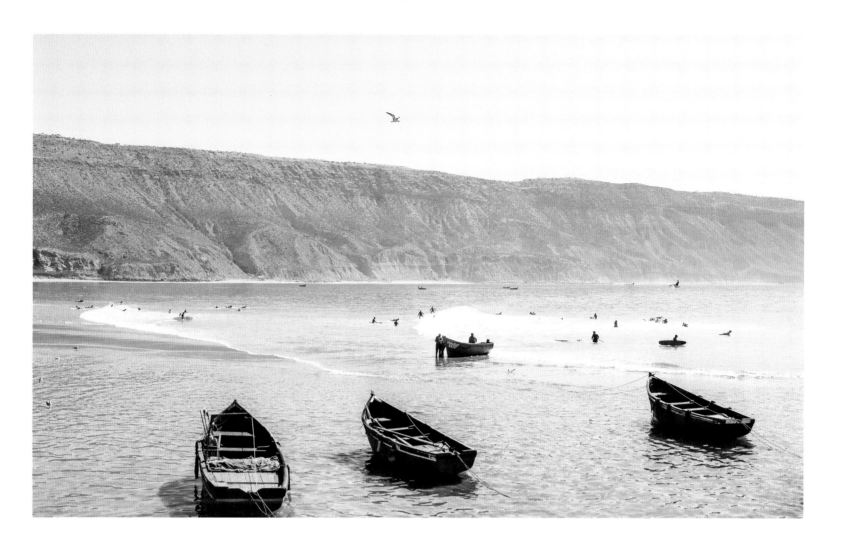

Naomi Eva Fassaert
Visual storyteller

@naomi_eva
@nf_design.studio

I've always enjoyed observing the world around me, ever since I was a young girl. Curious to discover the world, I started traveling and fell in love with the surfing lifestyle.

I began to capture my travels, to tell stories through photography. My hope is that my creative work will inspire people—push them to be brave, to chase their dreams and passions, to live life to the full. For me it's not just about the photograph but about the story behind the image. I want my photos to make you feel something, anything. That's why I call myself a visual storyteller. I capture images of Mother Nature, my travels, cultural details, the surf lifestyle, portraits, and anything beautiful that catches my eye.

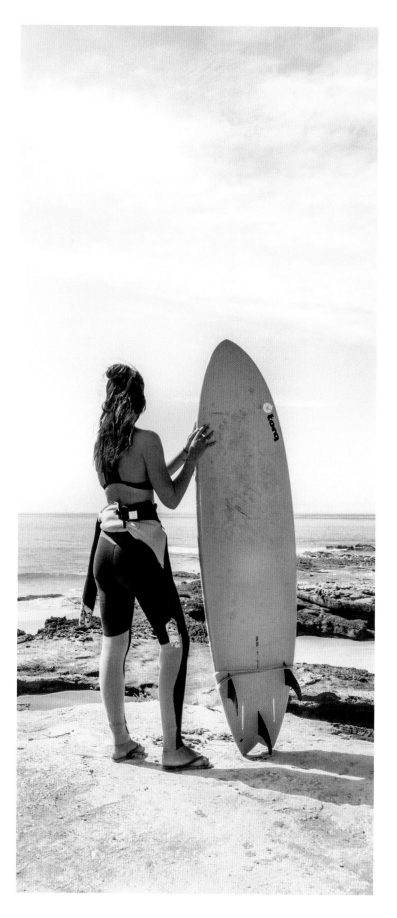

▷ Agadir, Morocco ▷▷ Imsouane, Morocco

ASS. TAYOUGHT

YOU CA
THE WA
YOU CA
TO S

'T STOP
'E BUT
I LEARN
URF

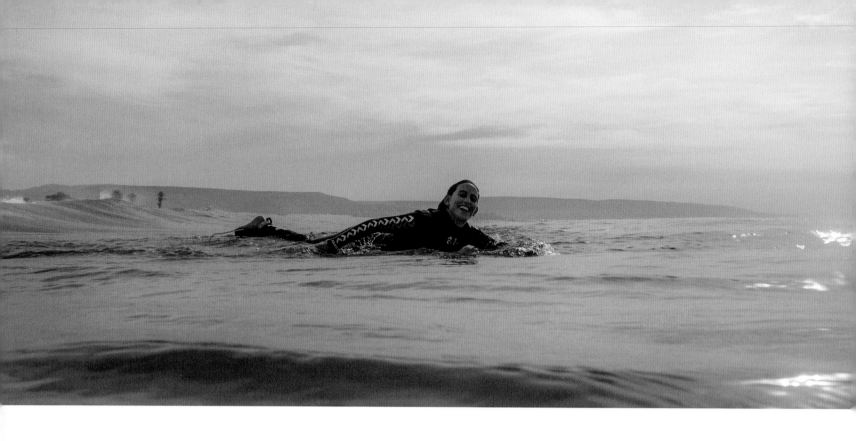

Meryem El Gardoum
Leading the way in Morocco

@meryemelgardoum
@merysurfcoach

I started surfing at the age of eleven. I was just playing around with a bodyboard, and I started noticing surfers getting up on their boards and catching waves. They did it so gracefully, and my curiosity pushed me to try and stand on my bodyboard. Which I did—and from then my interest just grew and grew. Some of my brother's friends saw me on the beach and were so impressed that they gave my brother a shortboard, telling him to push me to try it and see what happened. My first experience on that board wasn't very successful—the board was too small and I couldn't secure a proper takeoff on it—but it was so much fun! The next day my cousin gave me some tips, and thanks to him I successfully surfed for the very first time. I'll always acknowledge the part he played in my surfing and I'll be forever thankful to him.

Surfing is hands down my first love; I can't imagine life without it. I've learned a lot from it: how to be patient, how to fight for what you want, how to break the stereotypes that people have about women in Morocco, and that as soon as you reach the lineup there's no gender separation—what matters is who's going to catch the wave of the day.

I'm currently in the middle of a new project: Mery Surf Coach. My aim is to see more girls surfing, to give girls who want to surf an opportunity to start, and to share this experience with them, gently pushing them to do it more. My hope is that eventually I'll be able to offer girls' surf days where girls can have beginner lessons for free, as an introduction to surfing. Good coaching can go a long way—the way my cousin helped me is the perfect example of this.

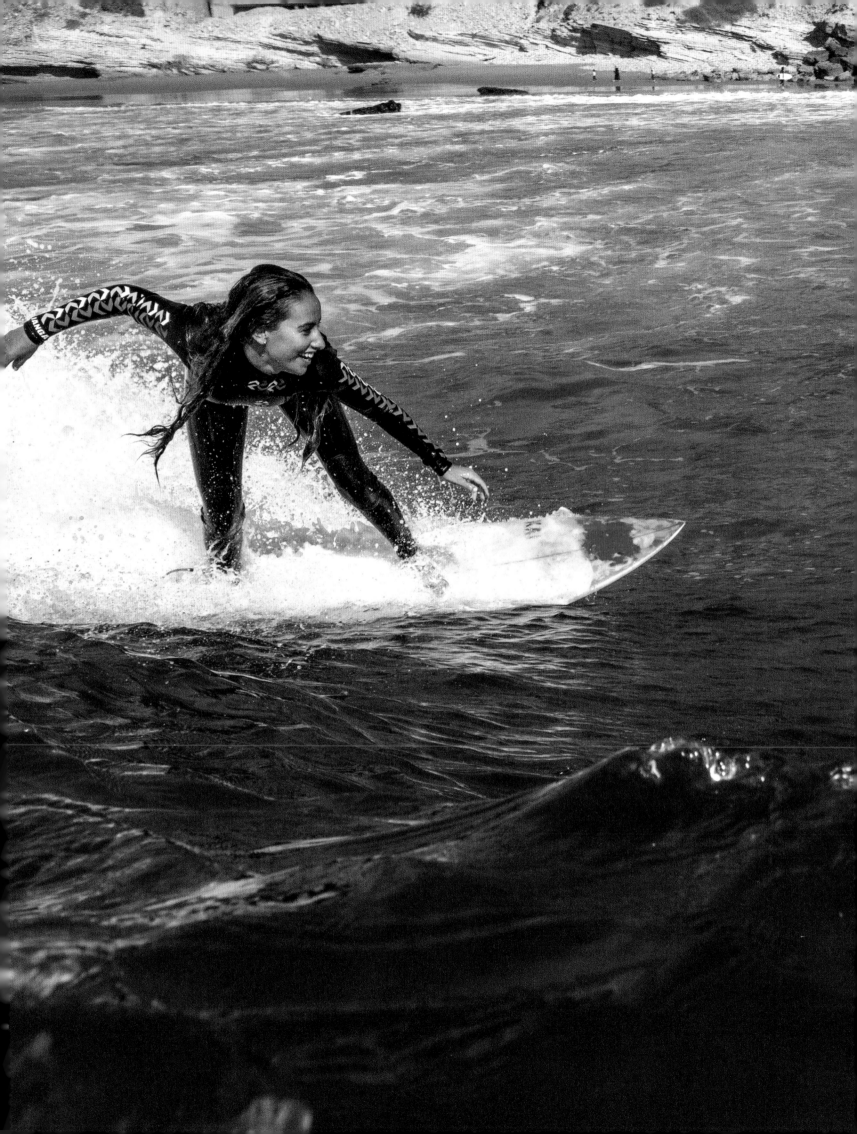

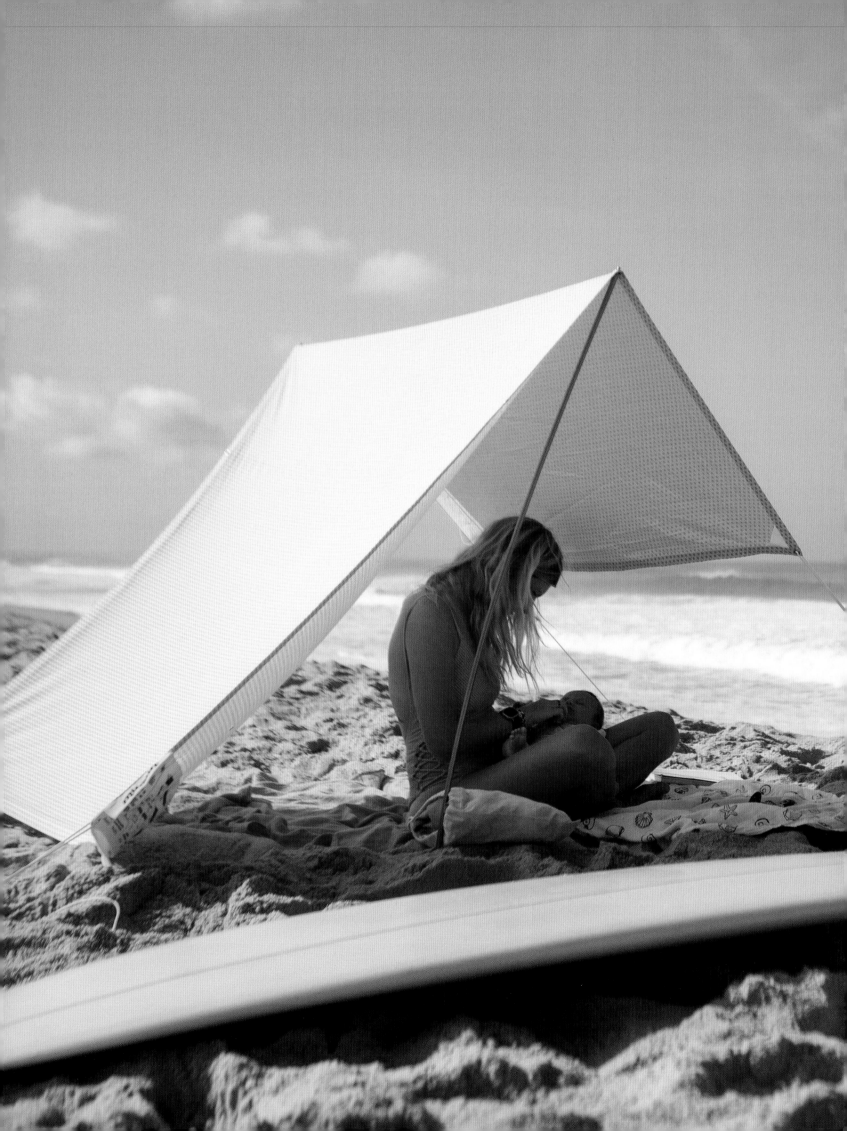

Stéphanie Goldie
Mom and surfer

@goldie_blondie
@ellessurf

I live in Hossegor in the southwest of France, but I was born in the countryside near Paris, far from the ocean and waves that I couldn't do without today.

I created my blog, Goldie Blondie, in March 2015, around the time my first son, Nathan, was born. The idea was to share my lifestyle as a surfer and active mom—but also and especially to show that life doesn't stop at the birth of a child.

I'm now a mother of two boys: Anton, my second child, was born in August 2018. I continued surfing until I was eight and a half months pregnant with him, which was a wonderful experience. I even paddle surfed on a lake the day before delivery. I never imagined being able to surf while pregnant, but it happened naturally. I was in good company since my midwife was also a surfer; she warned me of the risks and made clear to me what I could and could not do. We surfed together often. I don't want to push anyone to reproduce my path—I just think that anything is possible when we listen to ourselves rather than to the rules of society. Pregnant surfing is viewed like breaking the law: it's considered exceptional and abnormal in the eyes of most people. But I'll never forget that special sensation and the incredible moments of shared experience.

In 2017 I created the Elles Surf association with four girl-friends. Our goal is to create social bonds between women who share the same passion. Today we have more than four hundred members who come together to surf and for many other activities and trips.

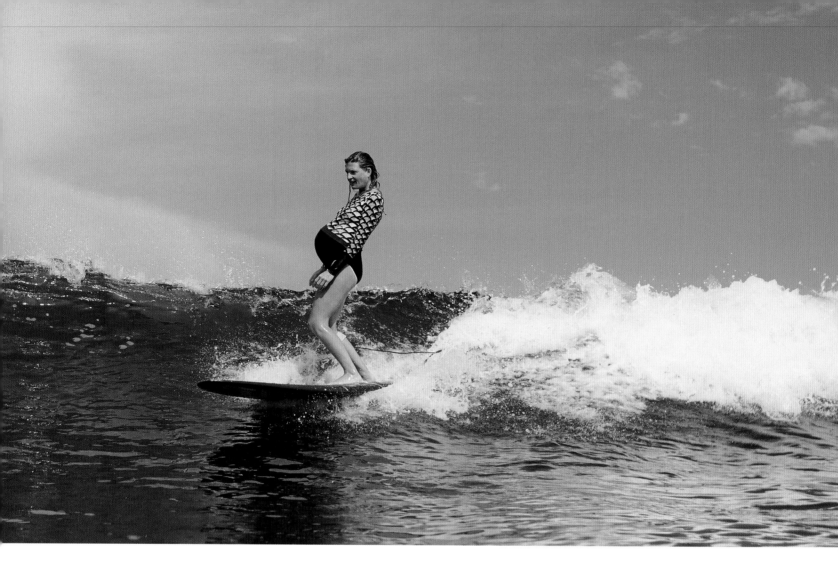

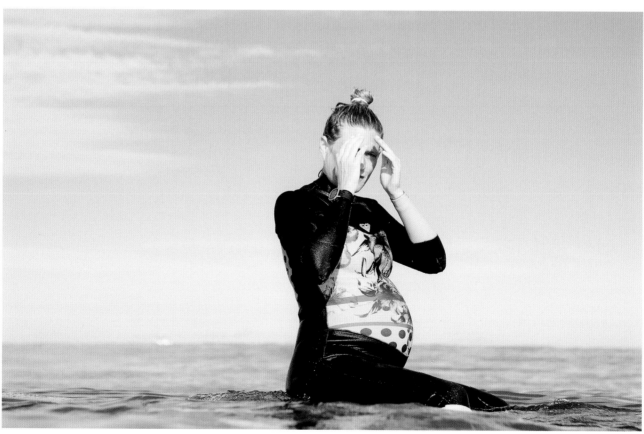

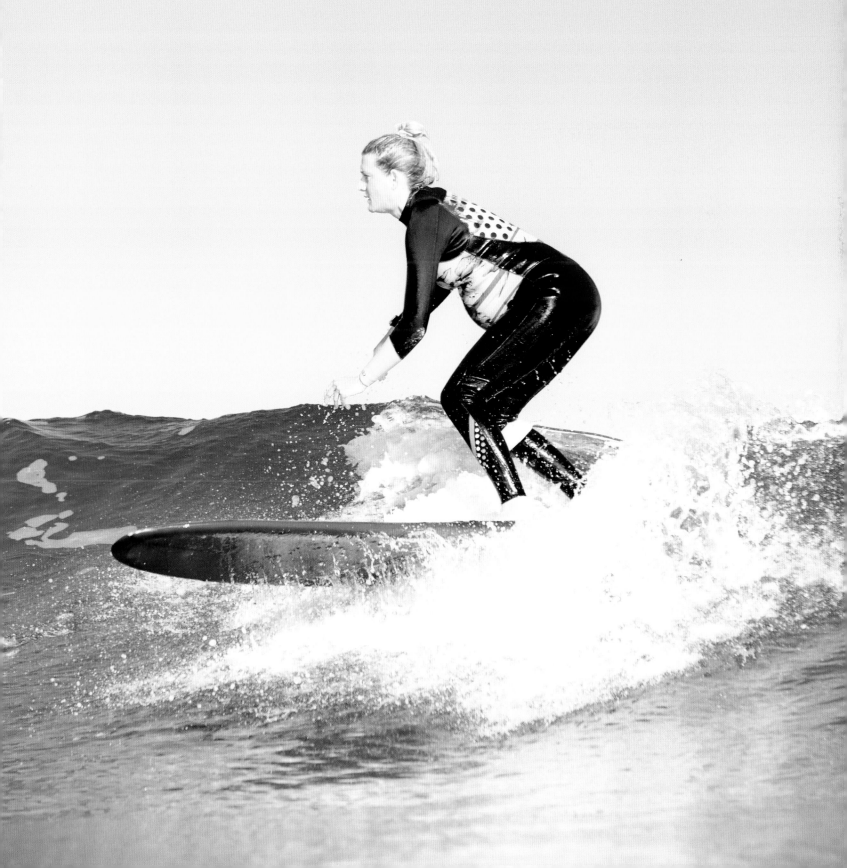

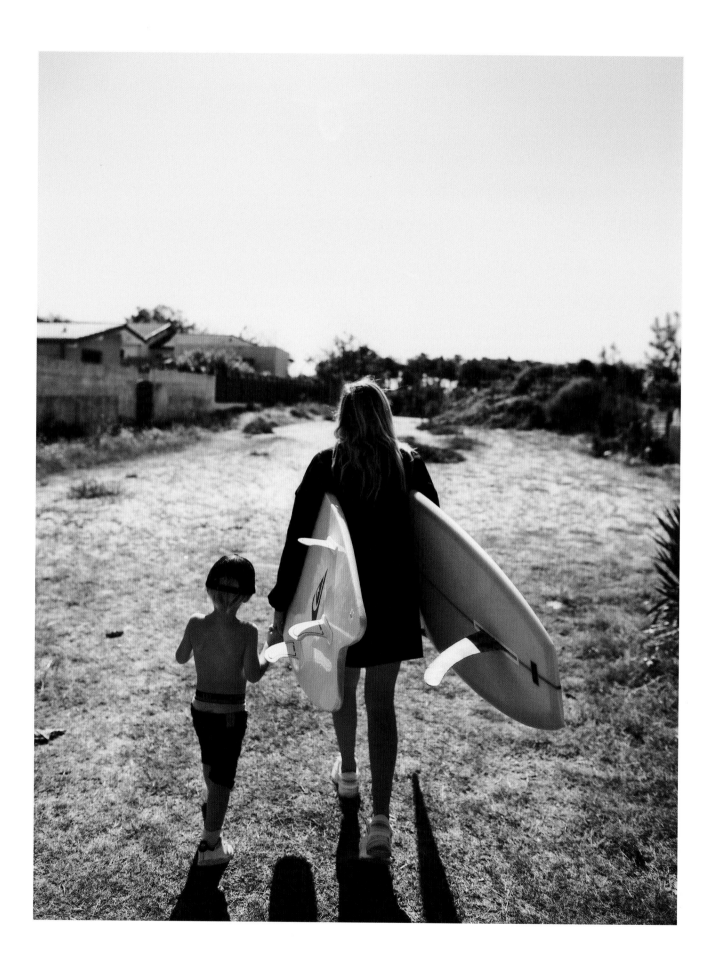

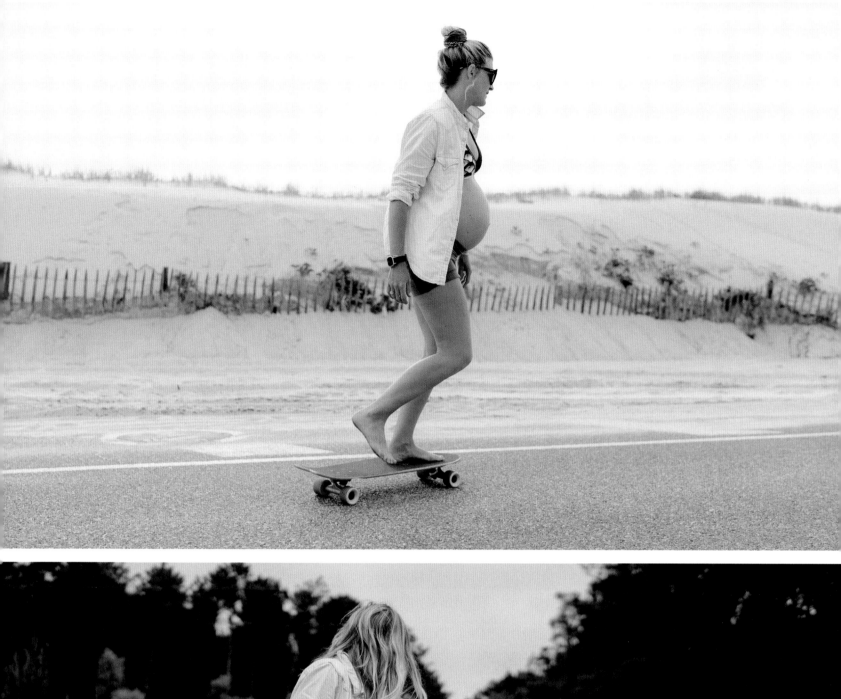
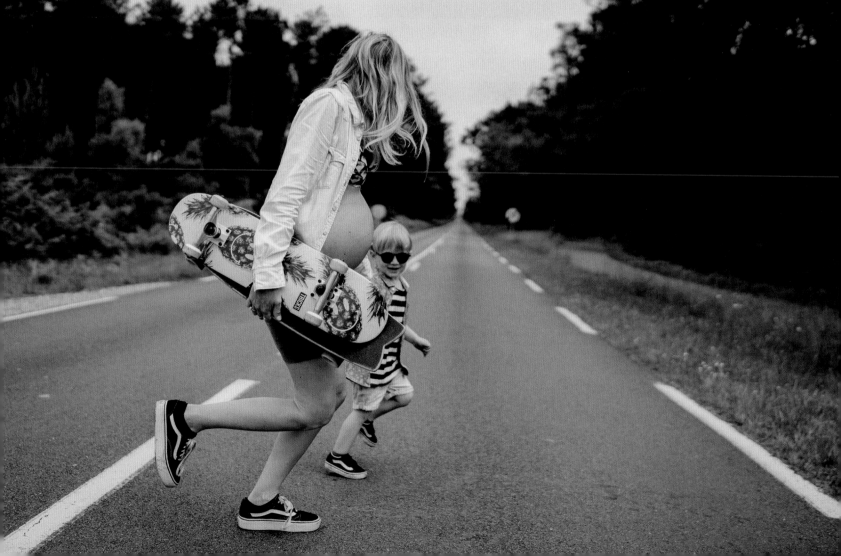

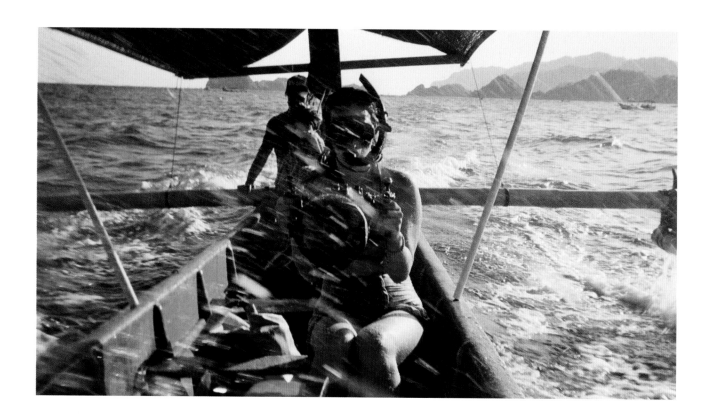

Nicole Gormley
Filmmaker and ocean lover

@gromlet

I'm interested in telling stories that inspire people to care about and protect the outdoor world. I've always loved the mountains but have a special place in my heart for the ocean; of every place in the world it's the one where I continually feel a sense of belonging, fulfillment, and gratitude, even in the smallest of doses.

I have a degree in marine biology from the University of California, and I currently work as a freelance filmmaker and television producer, and at times as a photographer. But no matter the outlet I believe that powerful images along with a well-told story can leverage change and inspire action.

Growing up in California, I fell in love with the outdoors through snowboarding, surfing, and fishing. In the process of these activities I realized I was learning lessons that went well beyond my time spent in nature.

In today's world, the sense of connectedness and intimacy that comes from going out and catching your own food, surfing with your friends, or climbing in the mountains is more important than ever, and I hope to be able to share that feeling through my work. My mission is simple: to leave the world a better place and motivate people to protect our natural environment.

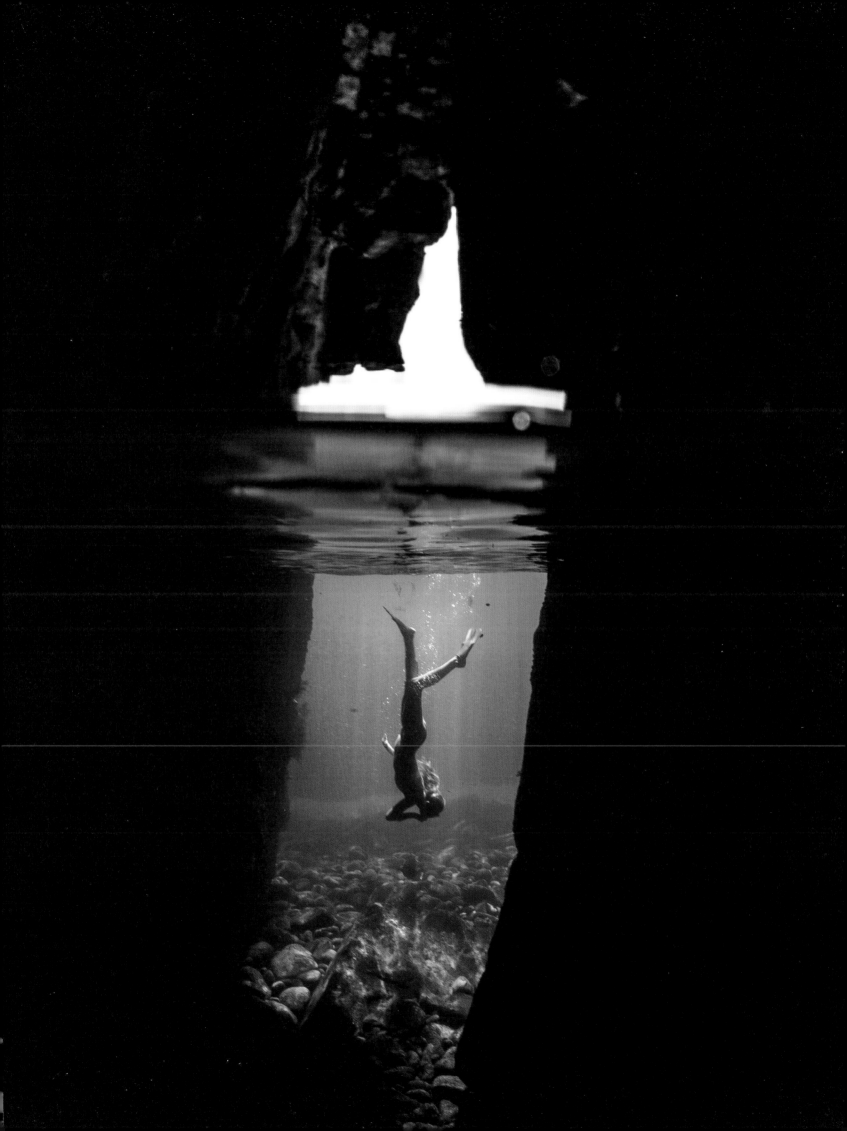

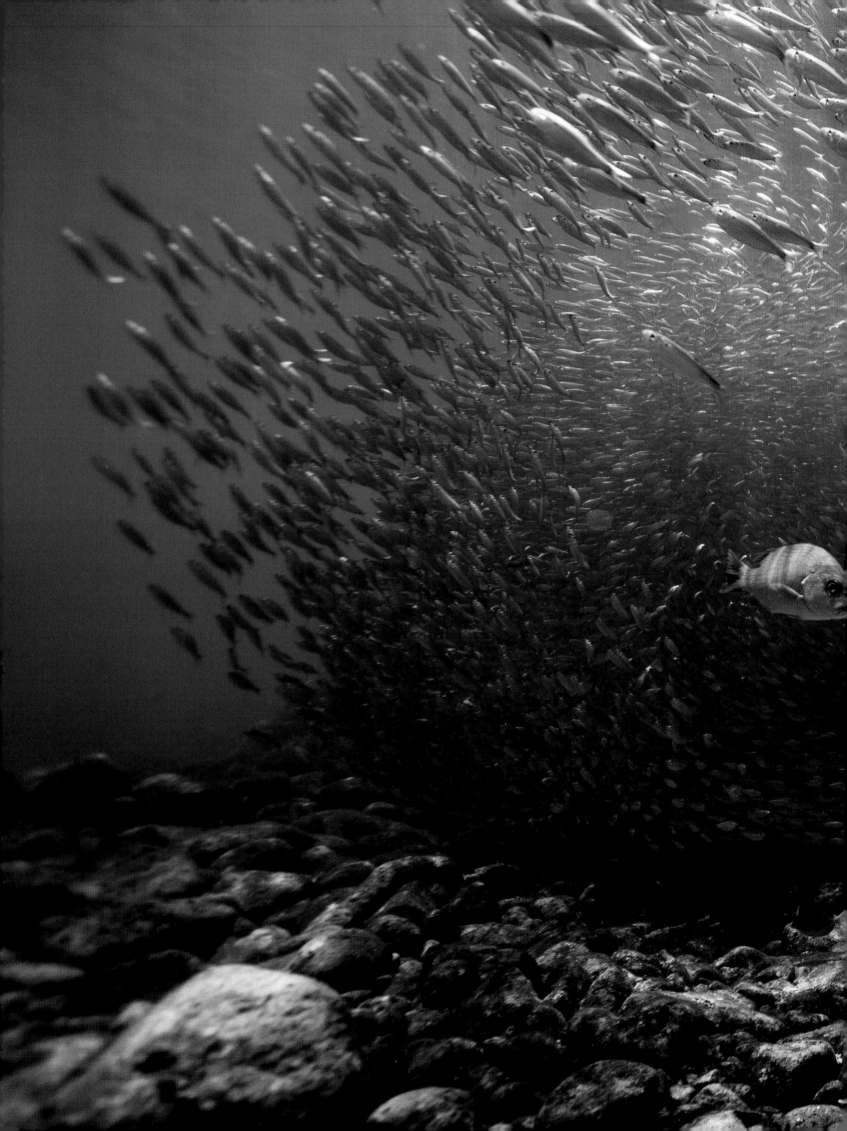

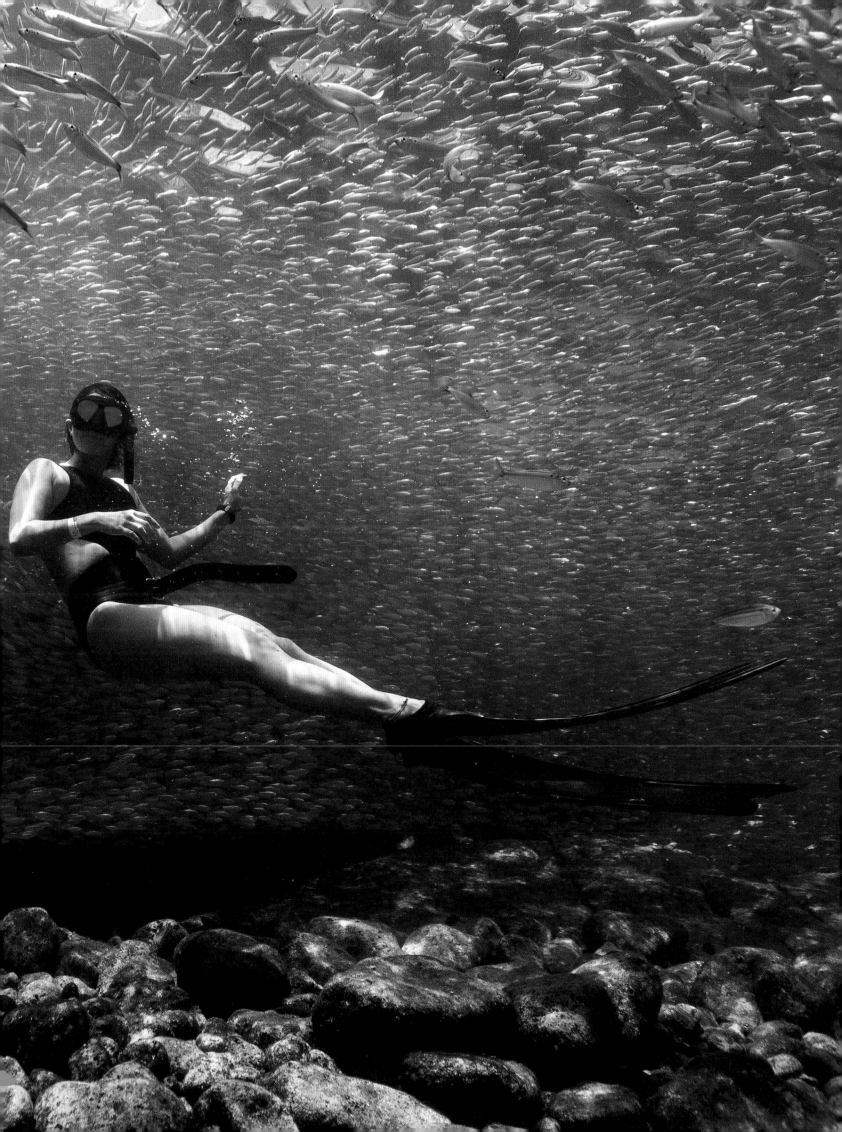

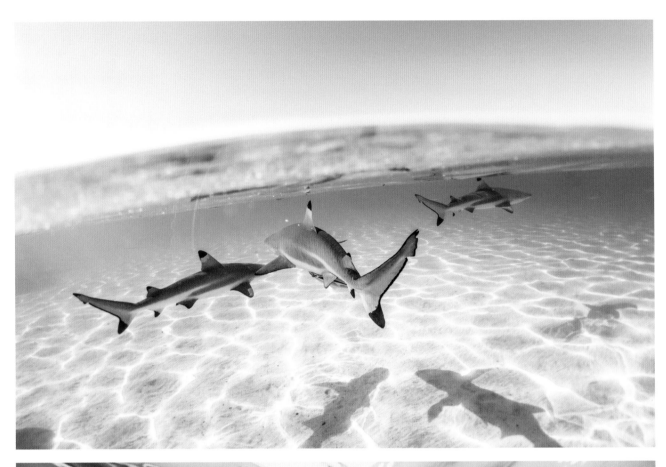

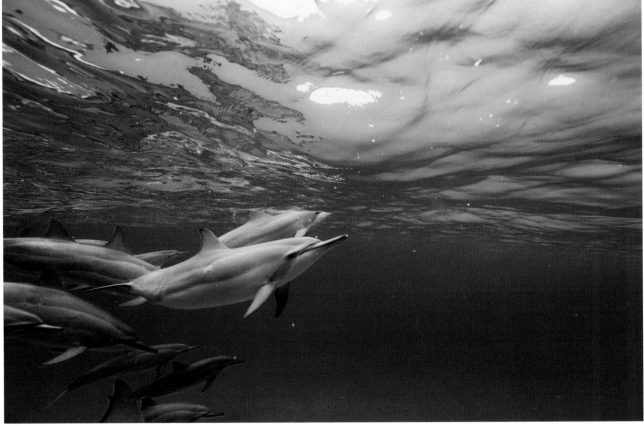

△△ French Polynesia △ Hawaii ▷ Indonesia

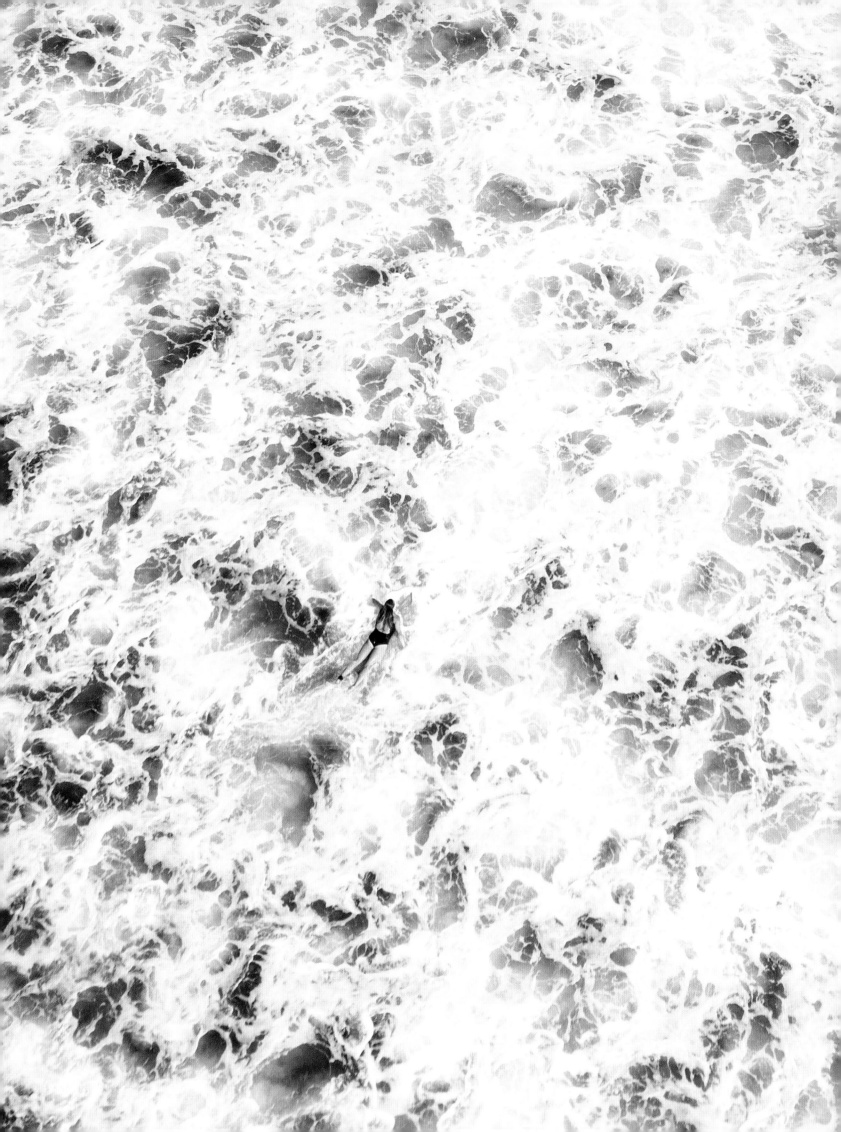

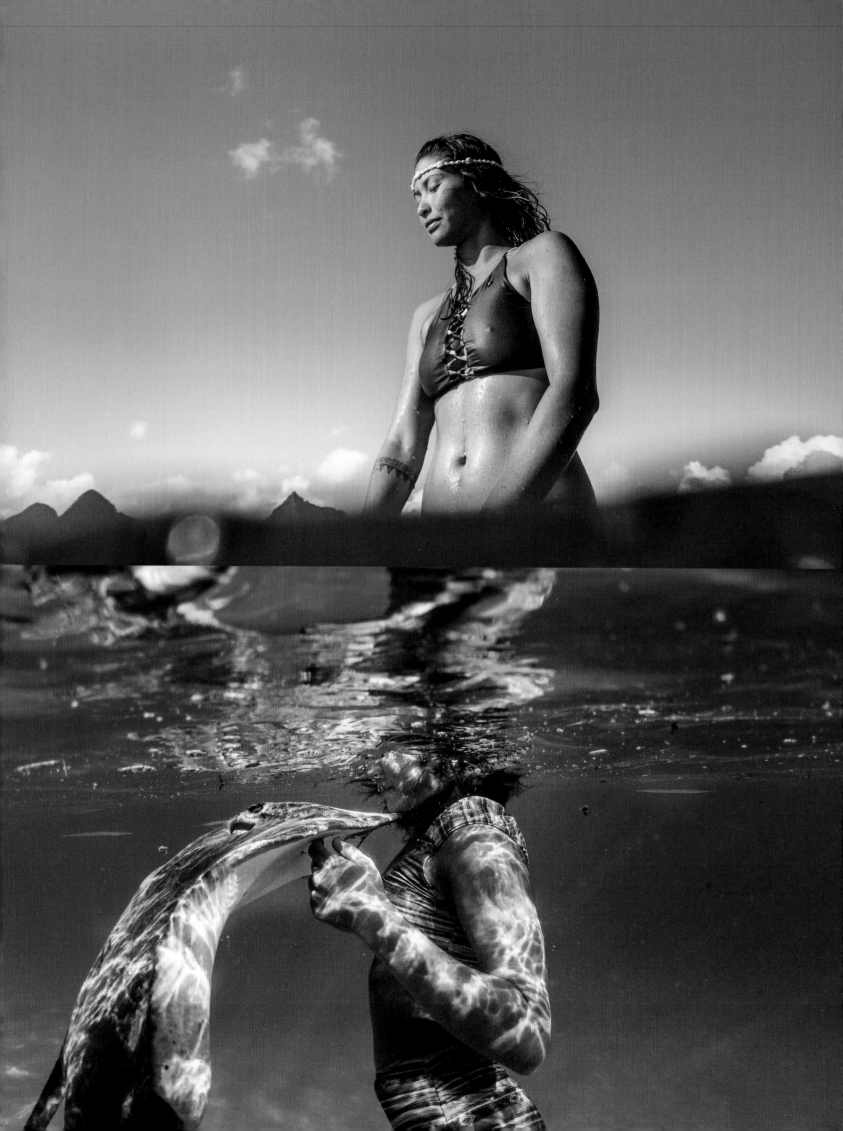

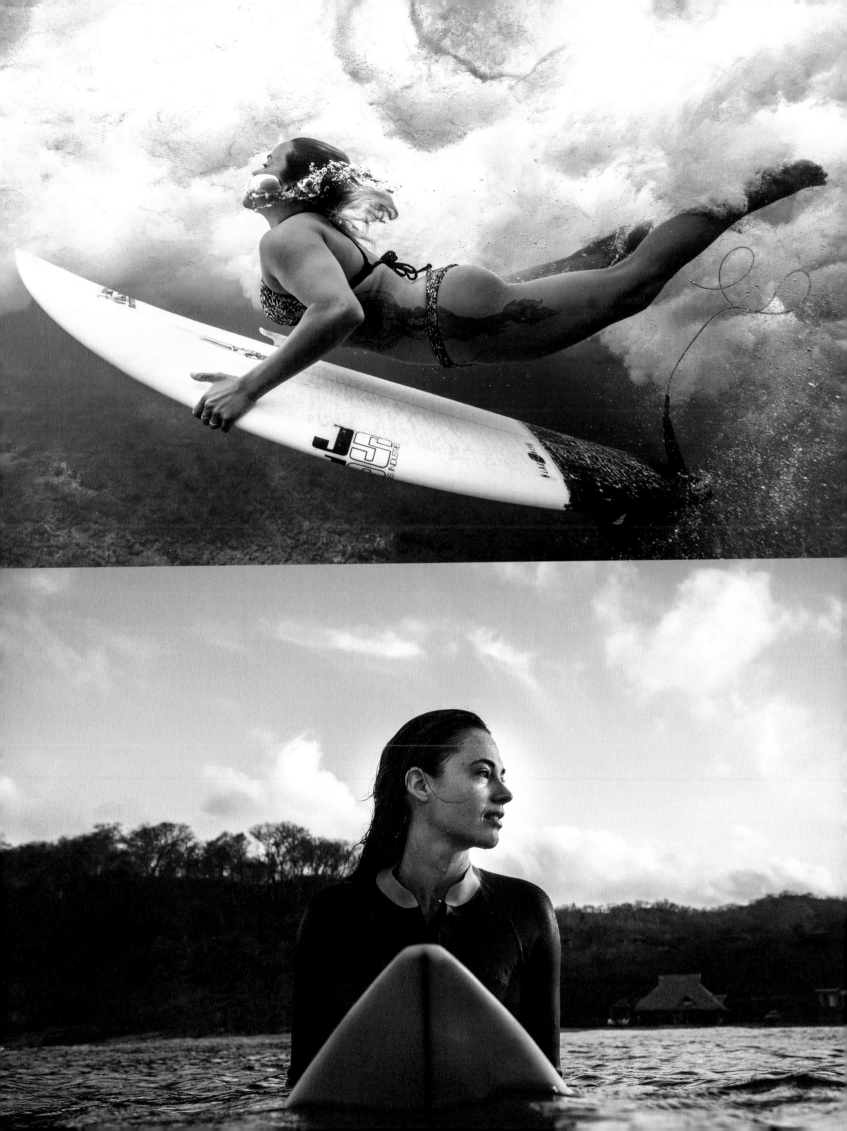

Stay salty.

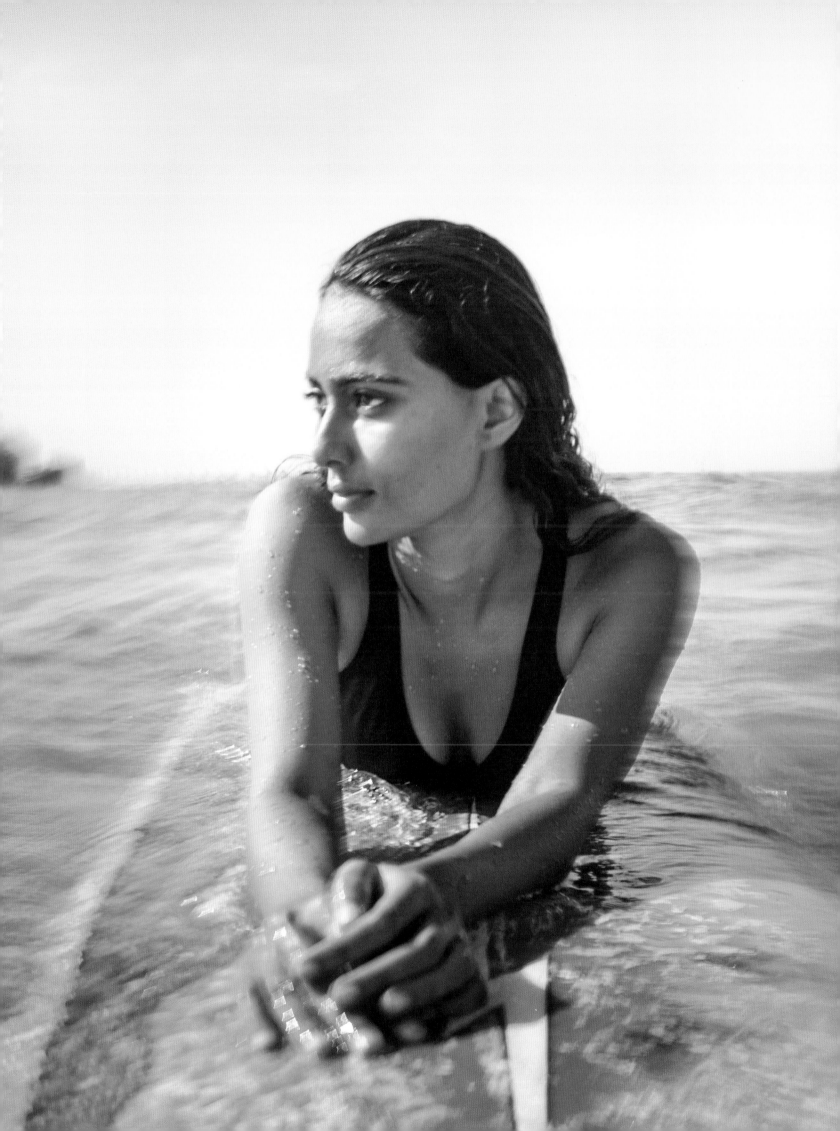

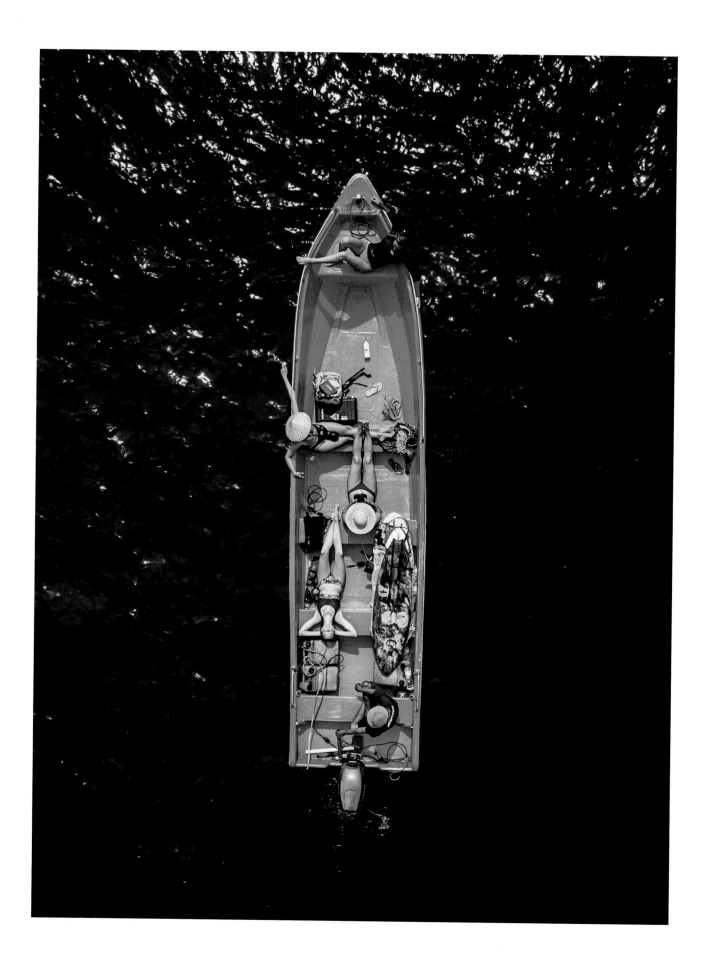

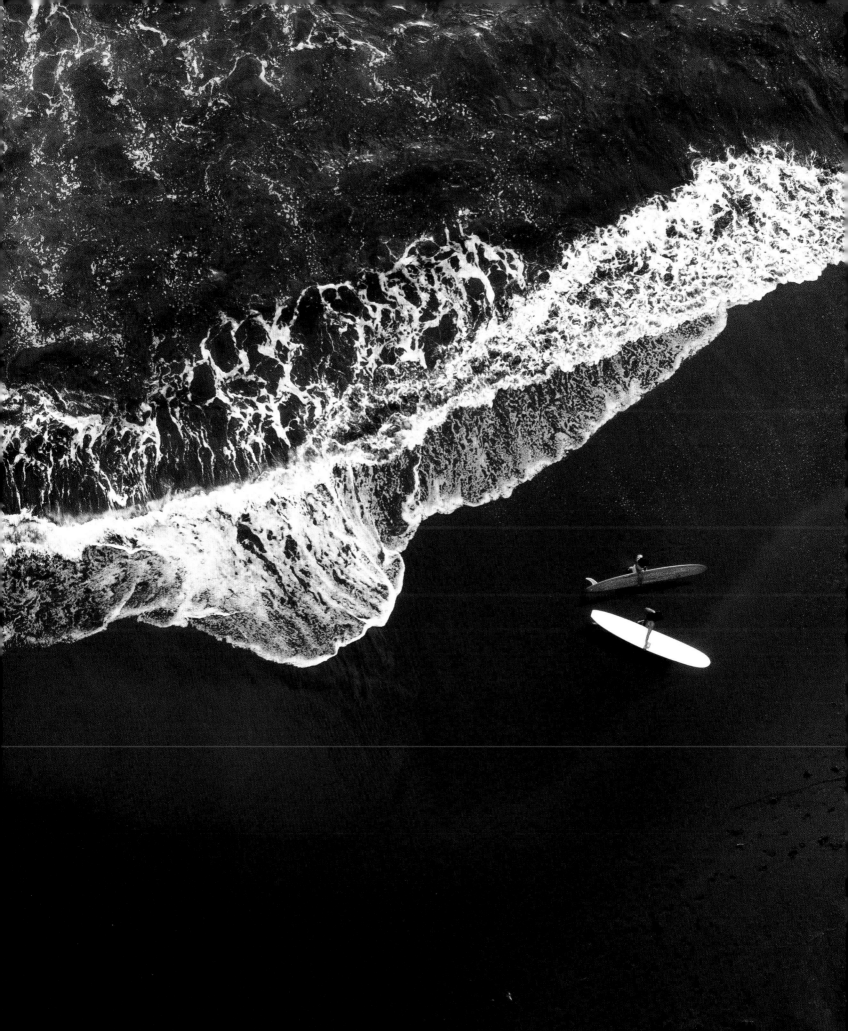

Elle Sampiere

Pro surfer

@elle_sampiere

My aim is to pursue my professional career as a traveling competitive surfer while also exploring my love for art. I'm passionate about what I do and am a true advocate for believing that you can achieve whatever you set your mind to.

I thrive off the motivation and drive to achieve my goals and not giving up until they're a reality; living in the moment and not taking a single opportunity or moment for granted; realizing the positives taken from each and every experience or situation; and hearing other people's stories about pursuing their dreams, or seeing your own path inspire others first-hand. Realizing all this happened to me like a domino effect when I first decided to go for what I really wanted, rather than follow a safe route out of fear or because of our cultural and social norms. When I decided to pursue surfing, I had no idea of the opportunities that would arise, and I never would've guessed that it would also reveal to me all the other things I love about life and what I want in my career.

Looking back, this was the most important decision I ever made and I feel blessed to have discovered this at such an early age. I didn't realize the impact that moment would have on me and my life. You'd expect the things you want most in life to be clear, pure thoughts, but it's really not that simple.

The experiences I've had and the people I've met as a result of simply deciding to let go of all forms of fear and go after my passion have truly made me the person I am today, shown me what matters most in life, and made me the happiest I've ever been.

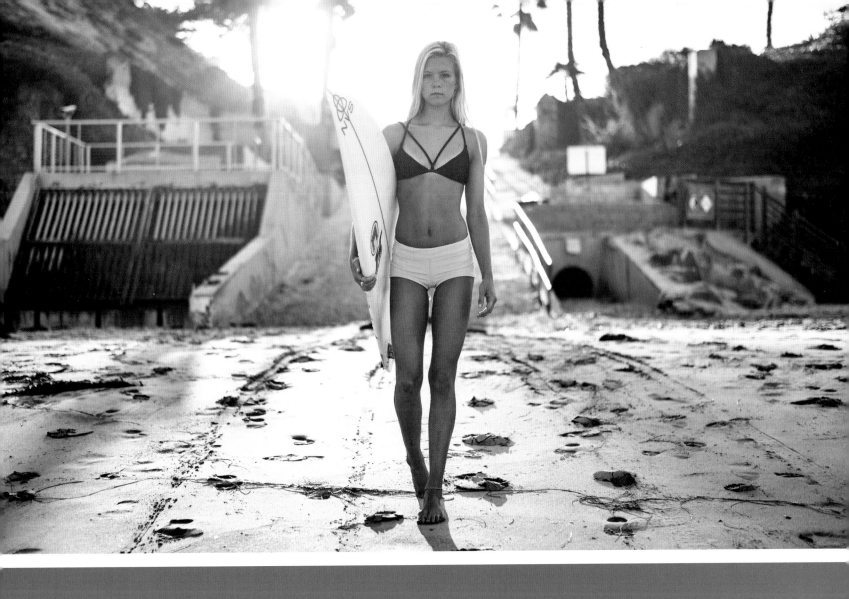
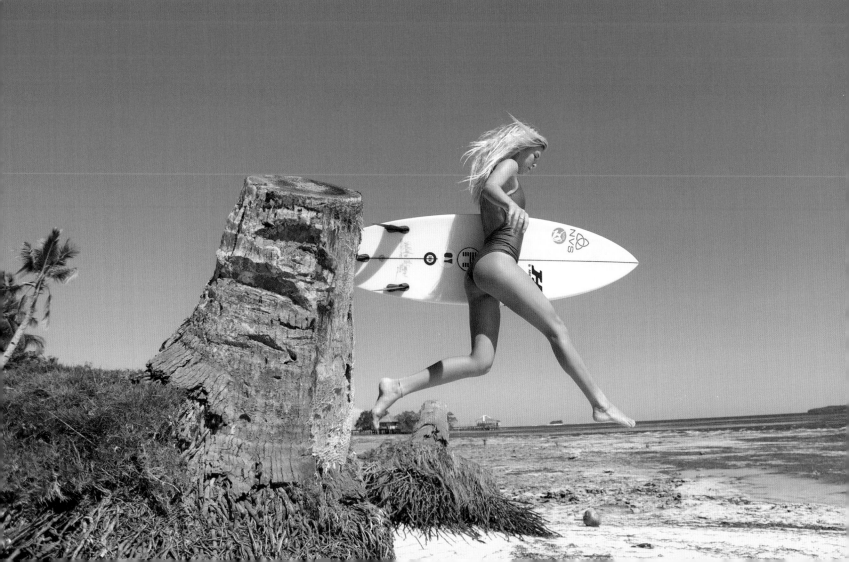

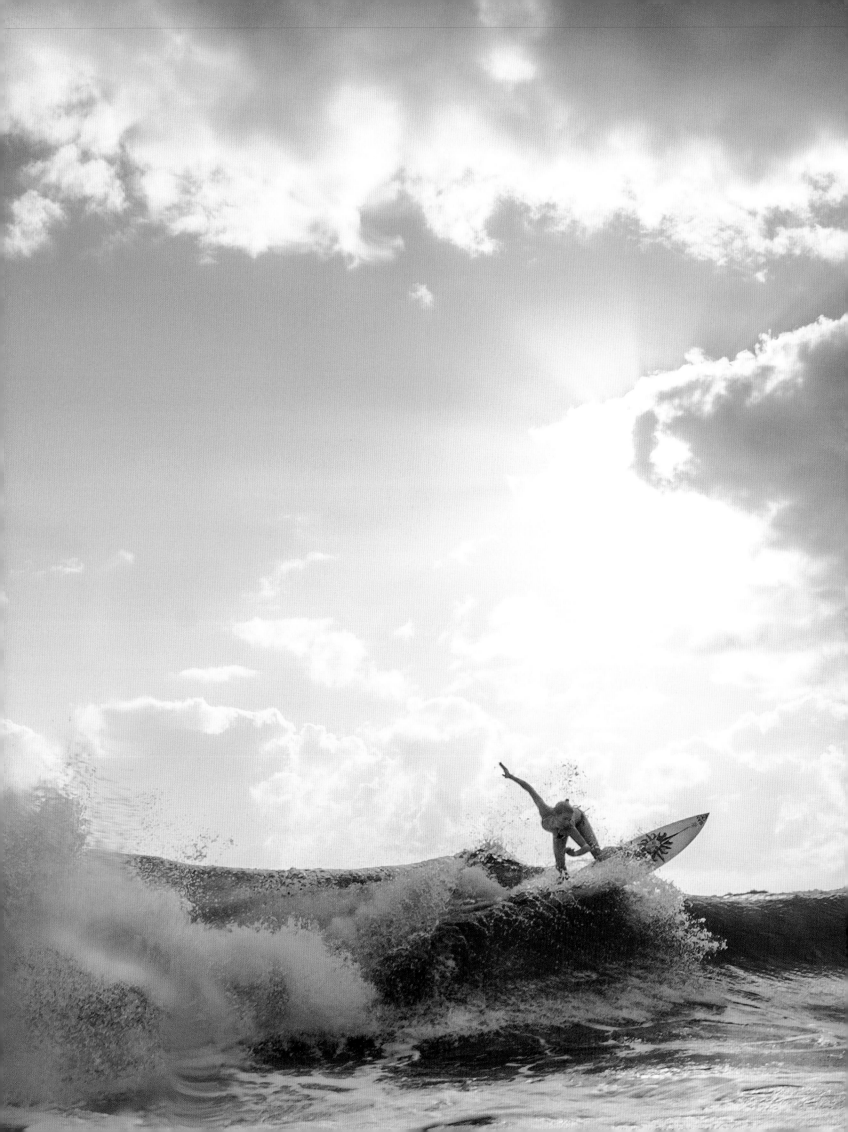

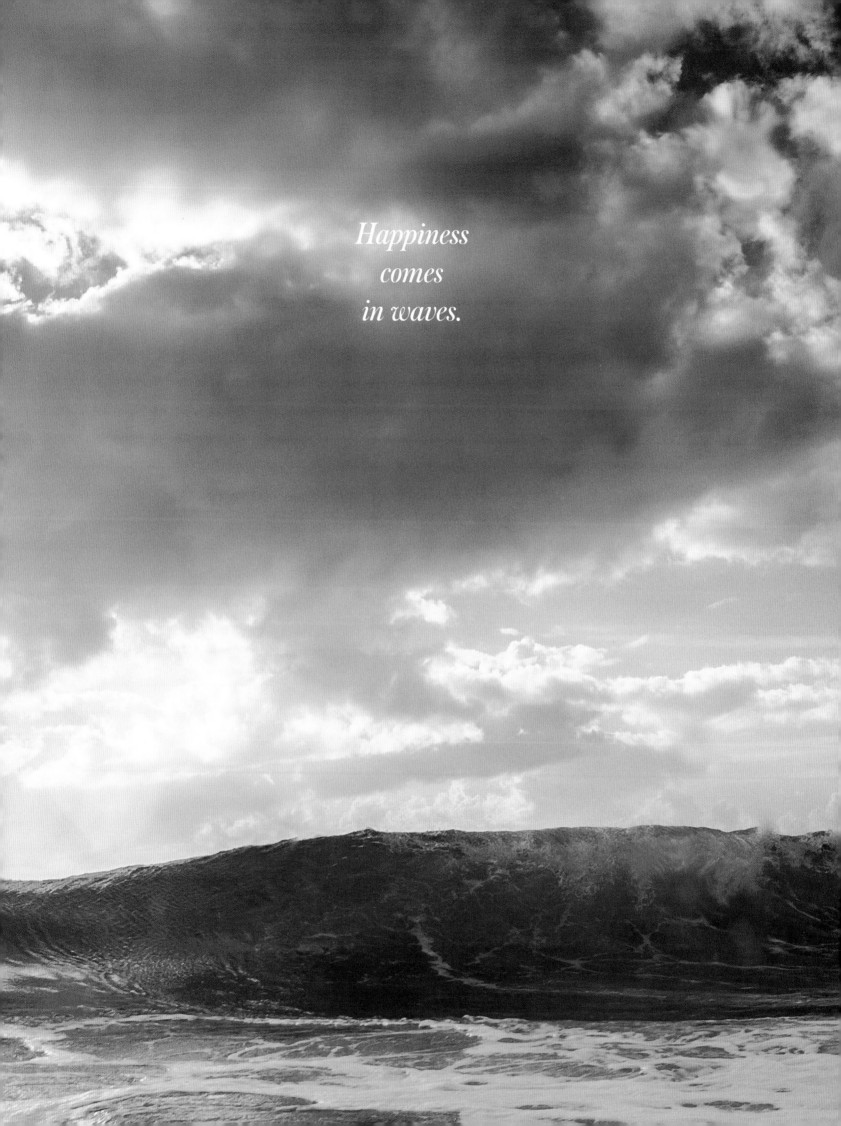

Happiness comes in waves.

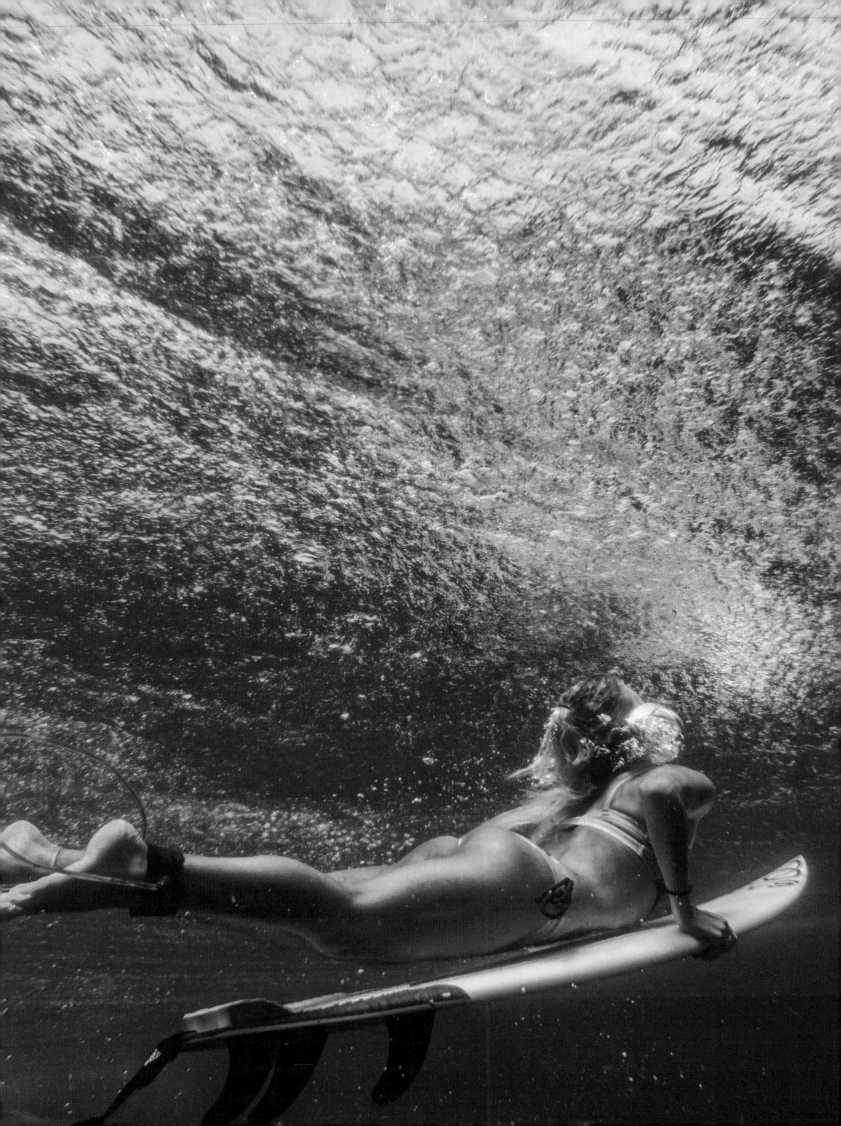

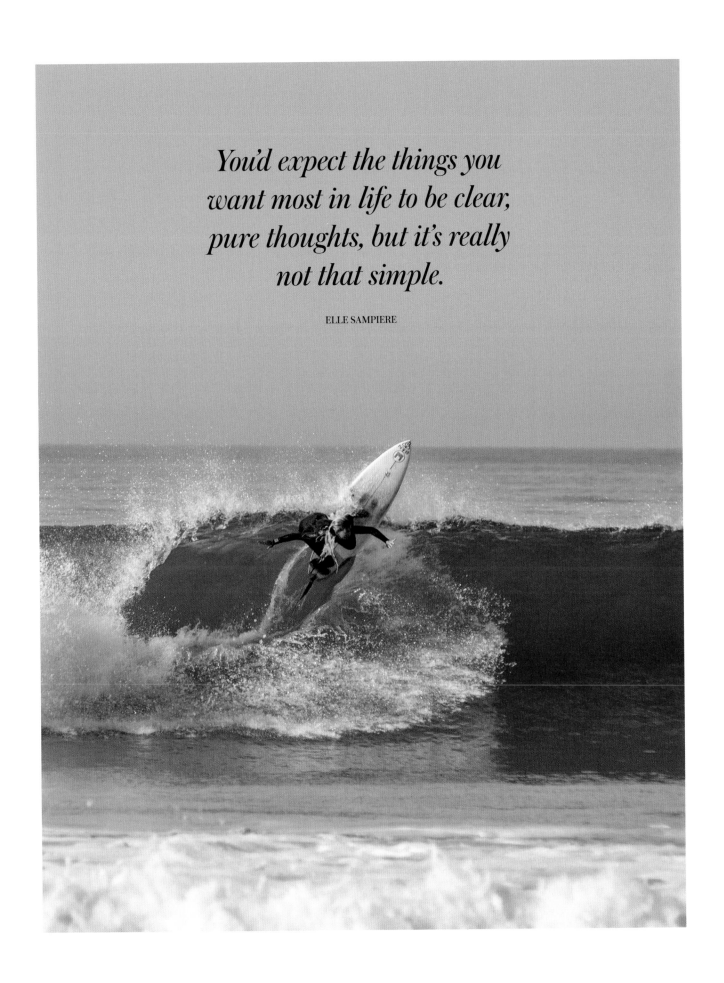

You'd expect the things you want most in life to be clear, pure thoughts, but it's really not that simple.

ELLE SAMPIERE

Anne Taravet
Leading the wave

@taravetanne

I started surfing when I was fourteen years old in Morocco, where I was born—that was back in the 1970s. Today I am 61. I was the first surfer girl in Morocco, and when we moved to France there were only ten French girls who were surfing at that time.

I worked for an airline, so I've been able to travel and surf in many different places. In 1980, the World Surfing Championship was held in France for the first time, in Biarritz. I wanted to go just to show my parents that I was of a good standard. They never wanted me to surf; they used to say that surfing was a sport reserved for "junkies"! But that year I became the French champion and came second overall in the world contest.

I met some lovely professional female surfers in that contest, but after taking part I stopped competing because I really don't like that world. For me surfing is about friendship, sharing in beauty, good times, quietness, and respect for the ocean and the planet.

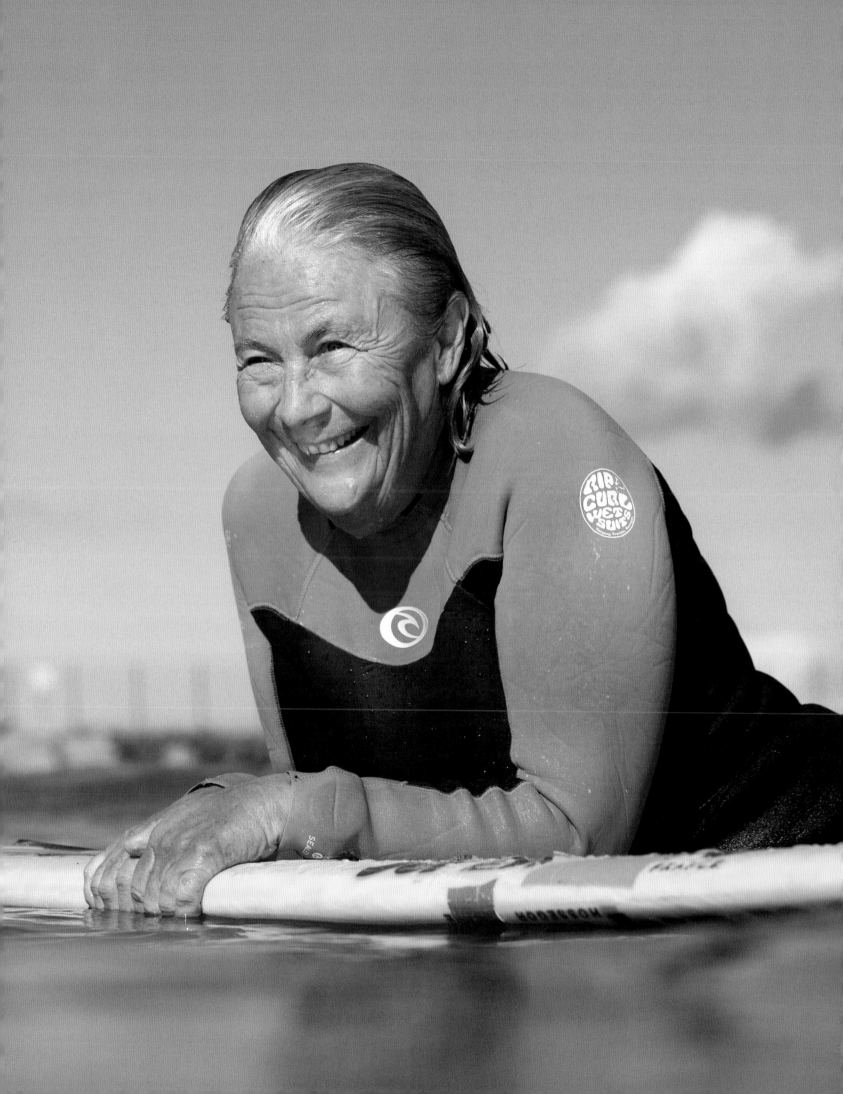

*Surfing is about friendship, sharing in
beauty, good times, quietness, and respect
for the ocean and the planet.*

ANNE TARAVET

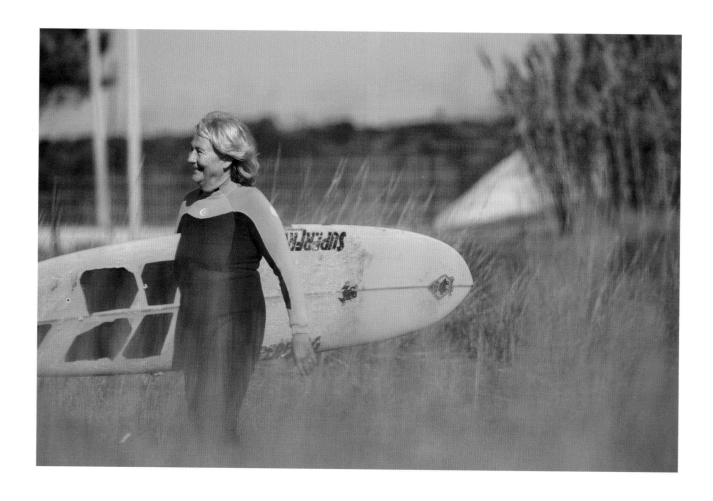

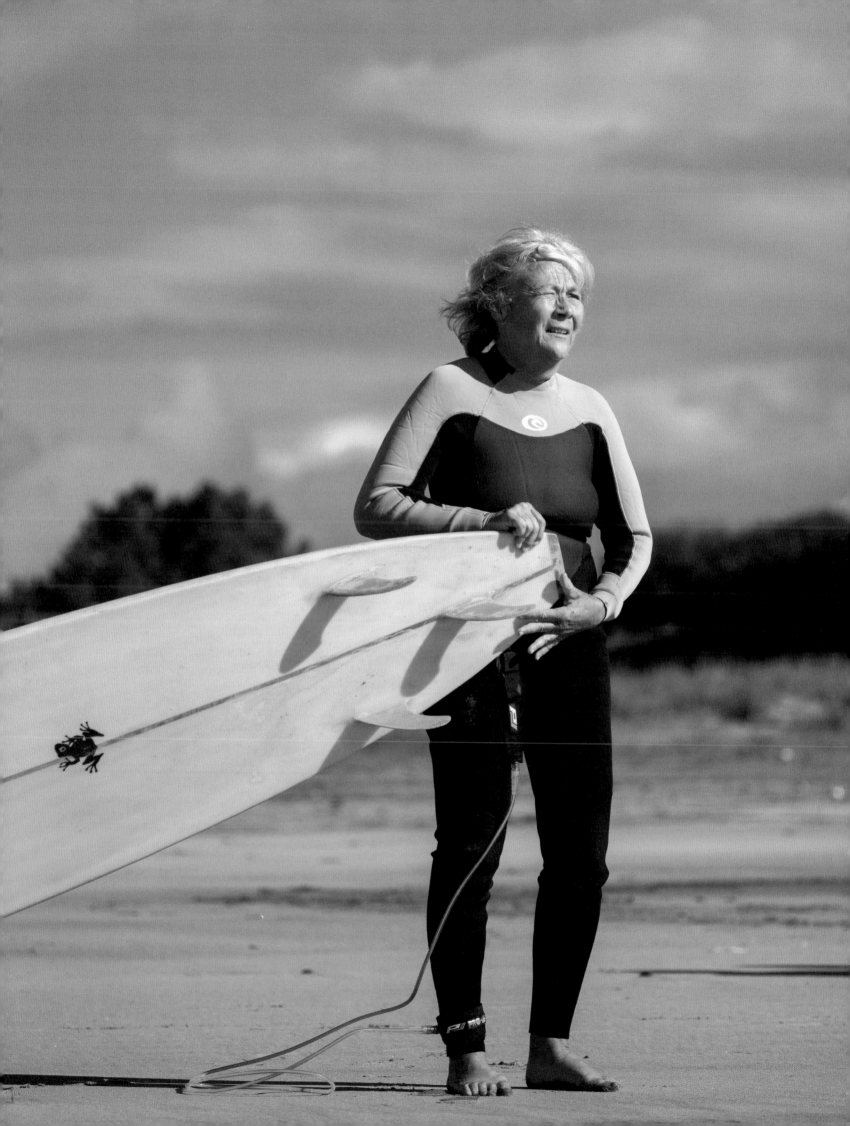

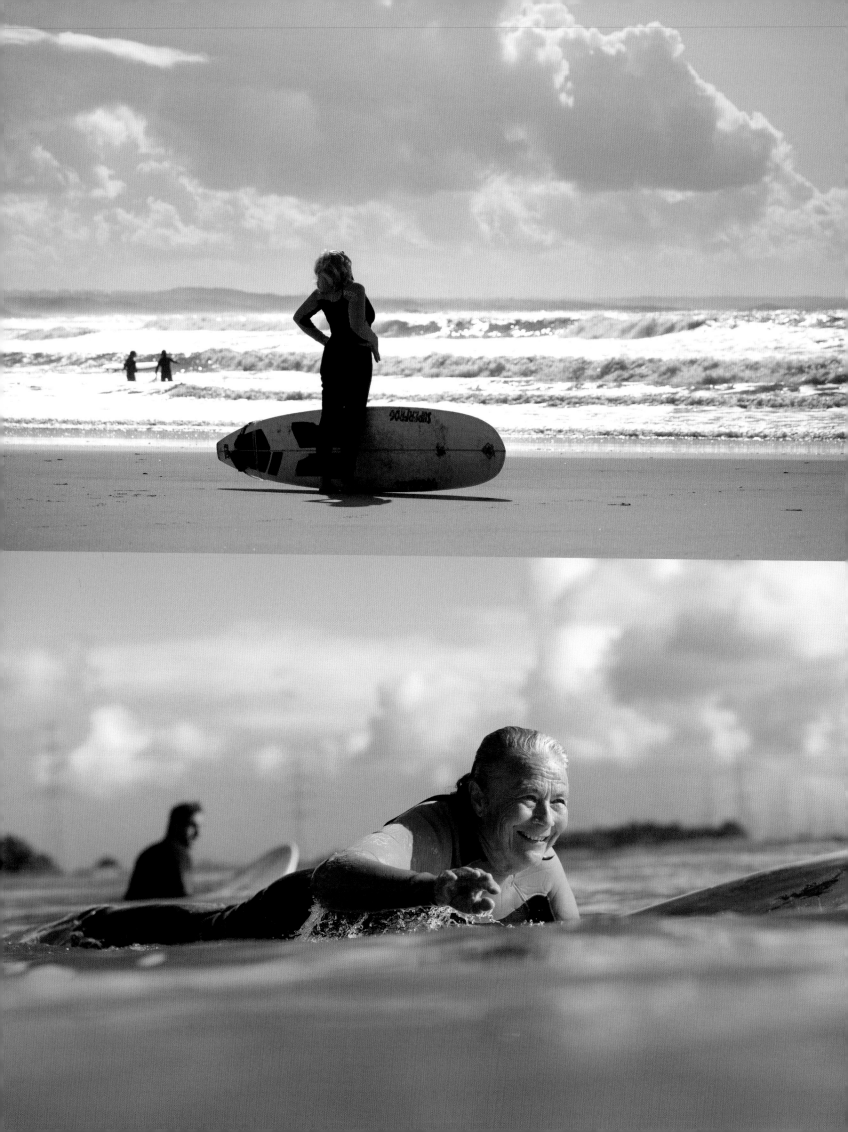

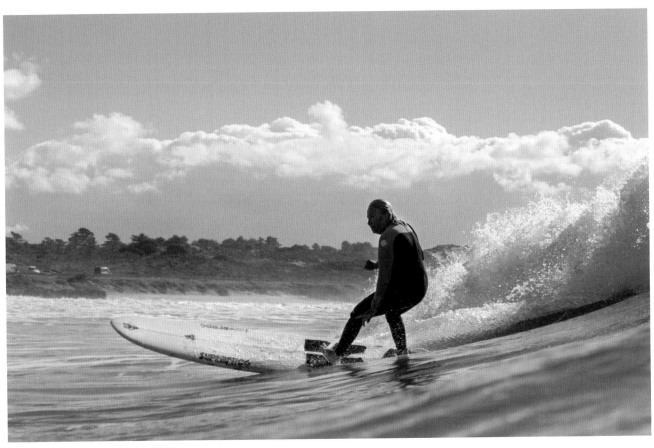

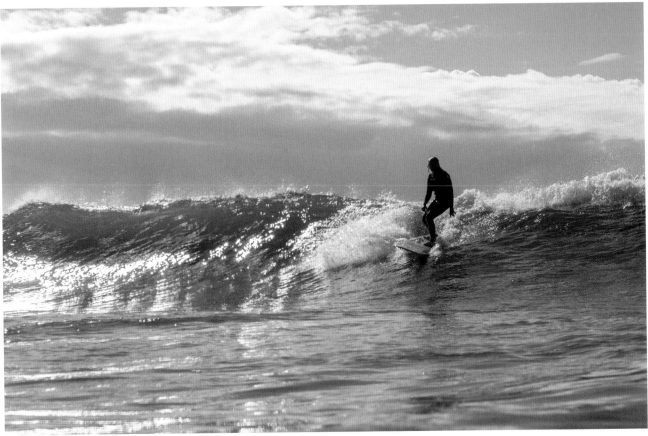

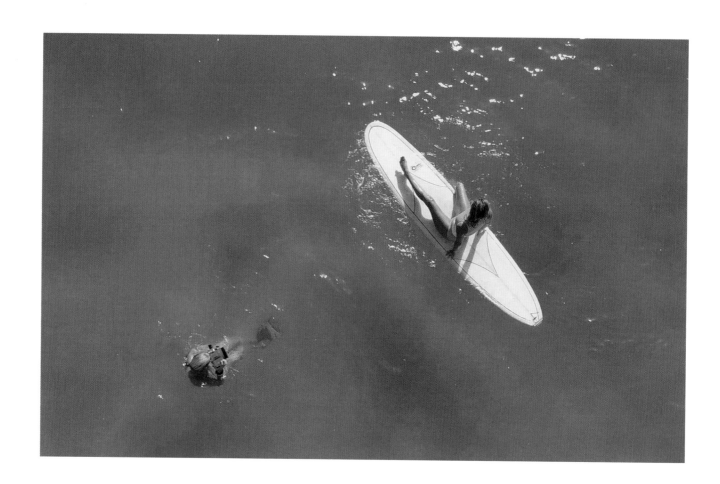

Karo Krassel
Everyday explorer and visual storyteller

@karokrassel

I'm an everyday explorer, a dreamer and adventurer, and a visual storyteller with a fiery passion for the ocean, Mother Nature, and all things outdoors.

I found my voice in water photography when I swapped my shortboard for a longboard, finding my place in the sea on a nine-foot single fin. I love to play with the waves, the ease of the longboard style, the beautiful dance, the softness and calmness, the peace within. Follow the flow of the ocean and let the energy of the wave move you along: it's like poetry in motion.

I love to capture the action from the water but also the whole longboarding lifestyle and story: the close connection to nature, the lightness and the presence in the moment, lives lived with passion and joy.

Longboarding and the ocean are where I feel at home, where I can express myself and share my vision of life and freedom. I've found a way to share my soul. I want to inspire others to live a life that's close to nature as well as to their own true nature—a life lived from the heart—and to follow their dreams and passions.

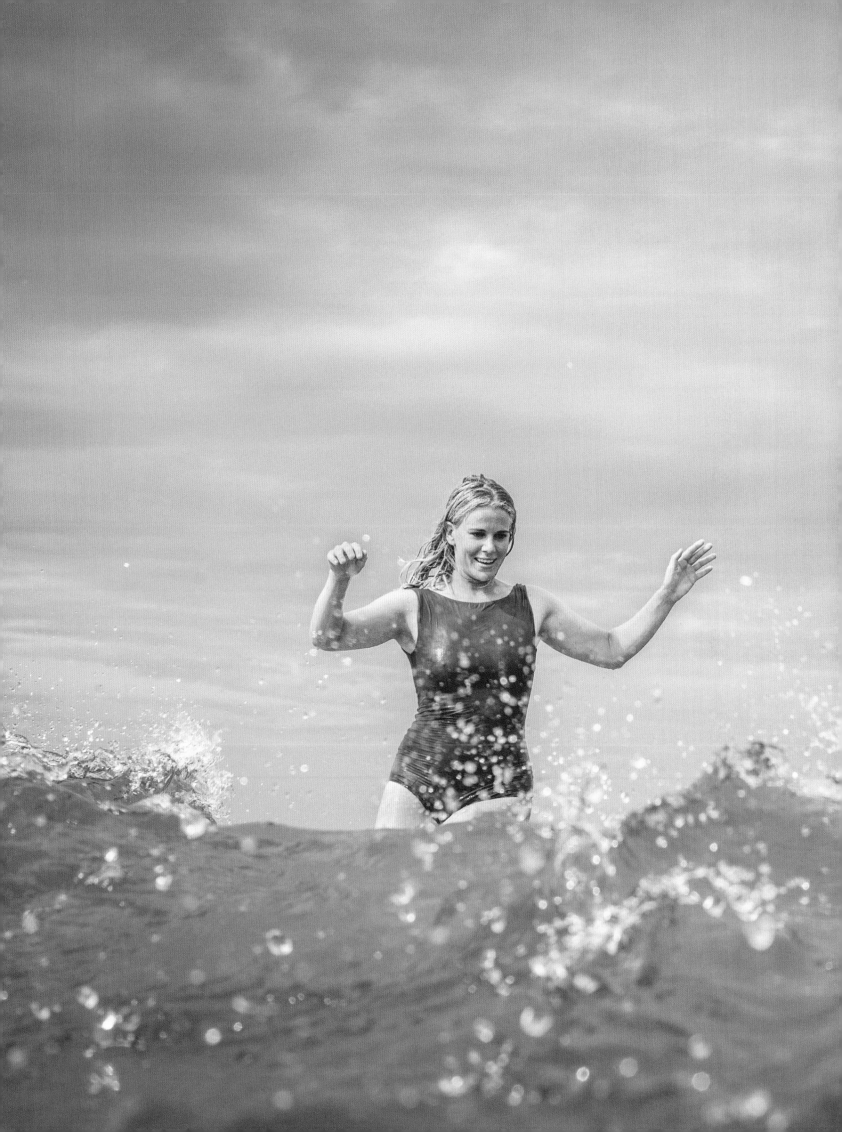

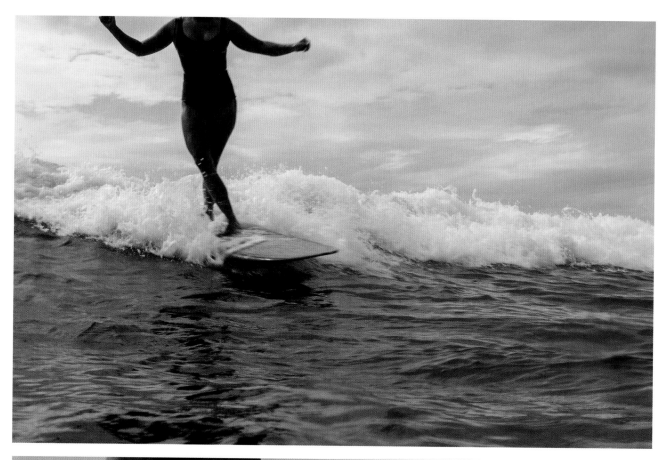

△ Johanna Kjellström ▷ Vera Nording | Sri Lanka

*Longboarding and the ocean
are where I feel at home.*

KARO KRASSEL

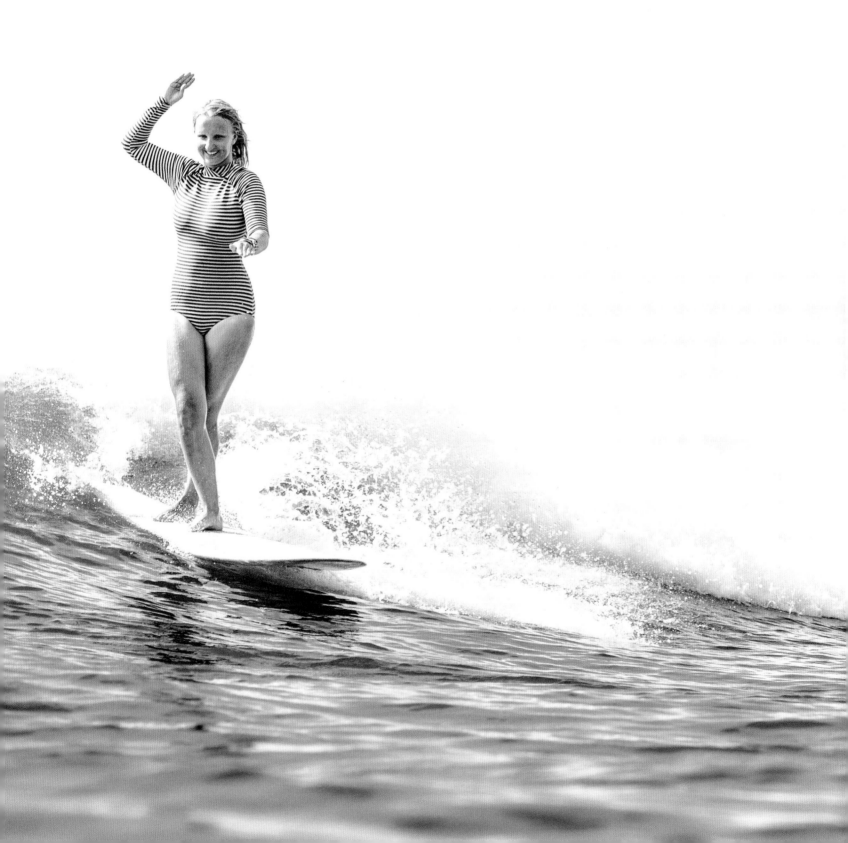

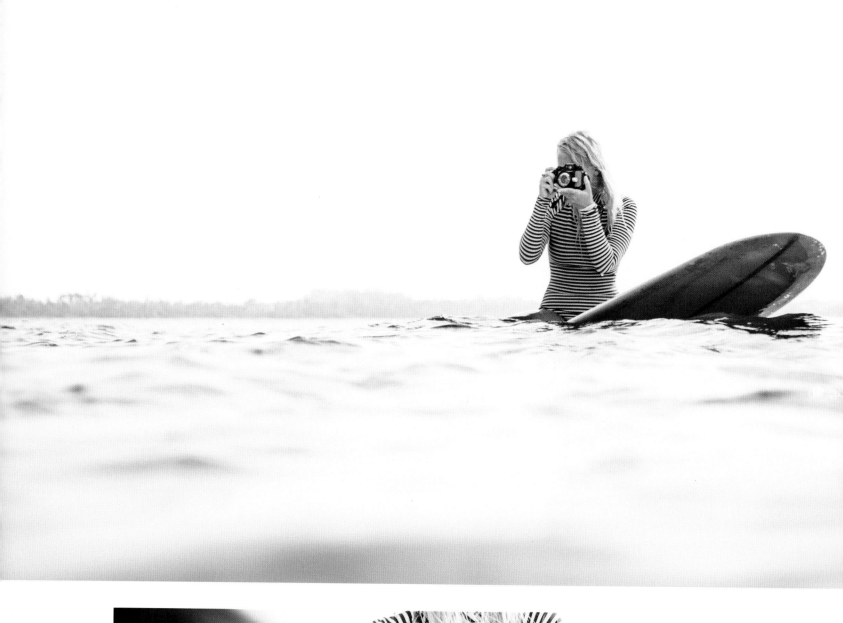

△ Vera Nording ▷ Moa Machado | Sri Lanka

Conchita Rössler, Alentejo, Portugal

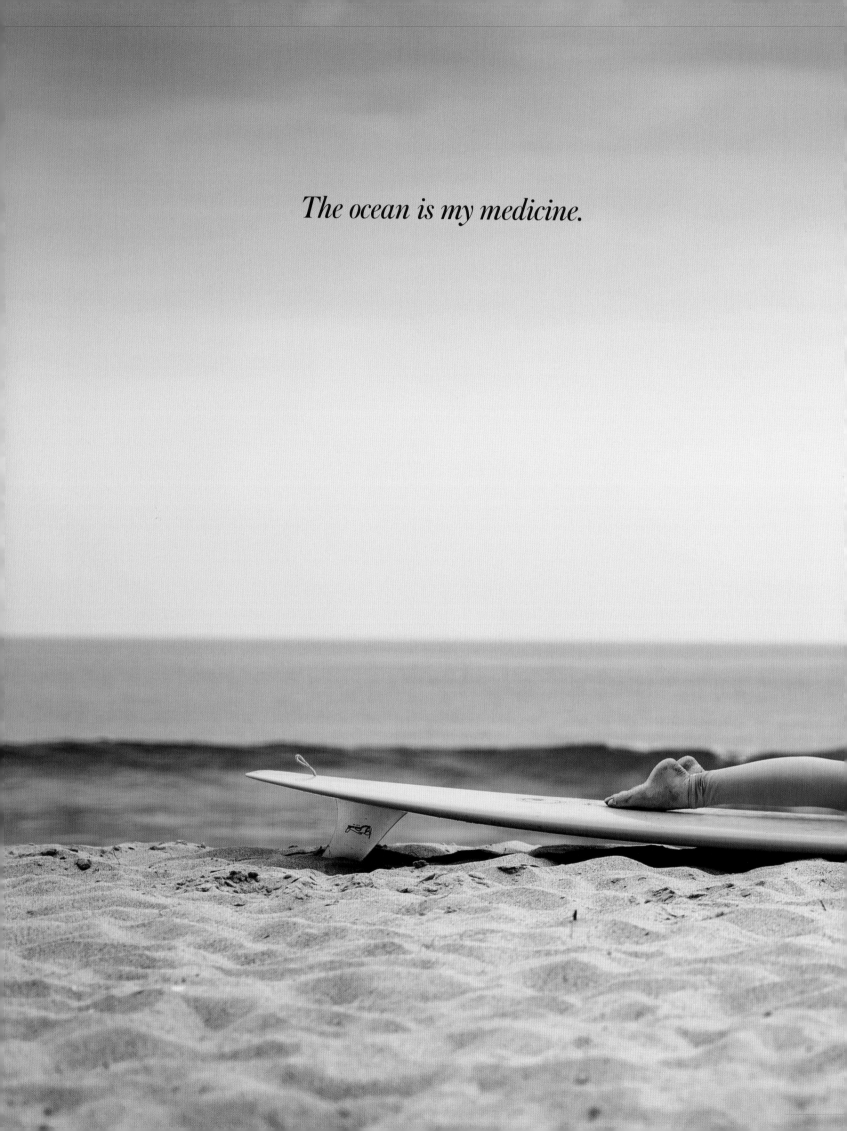

The ocean is my medicine.

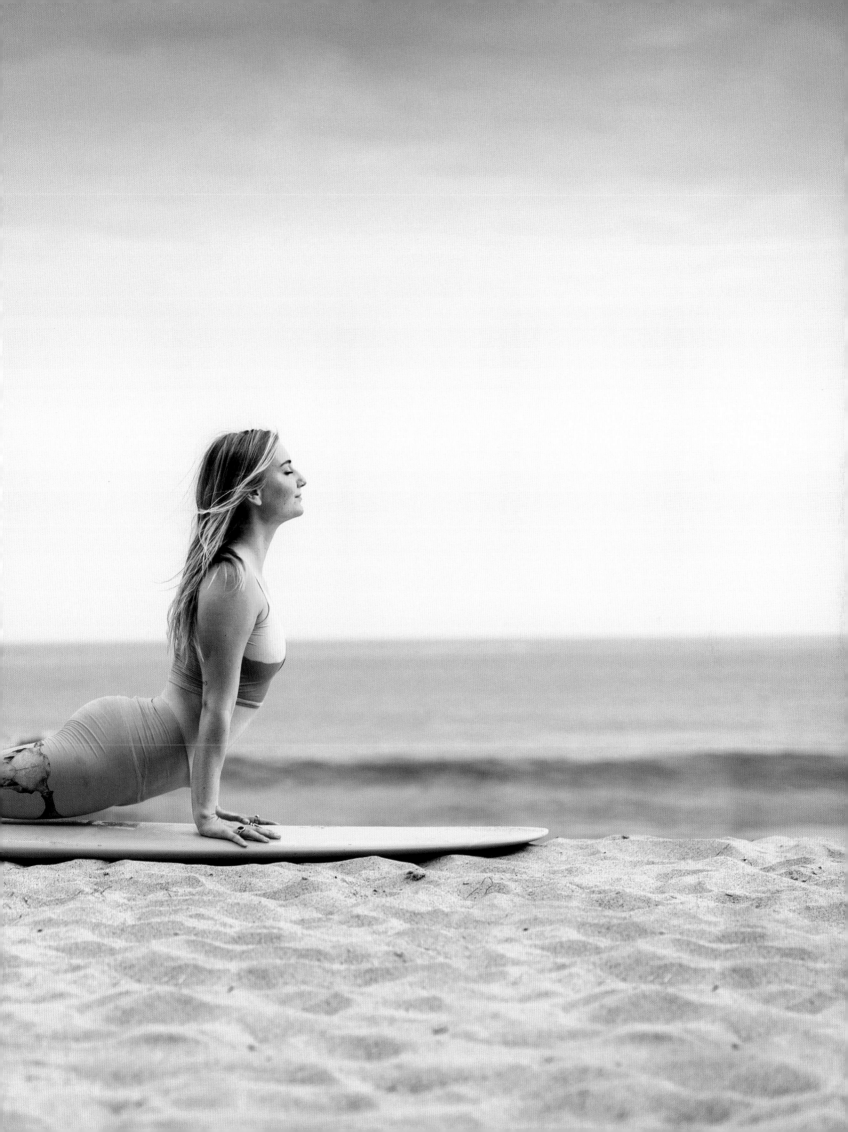

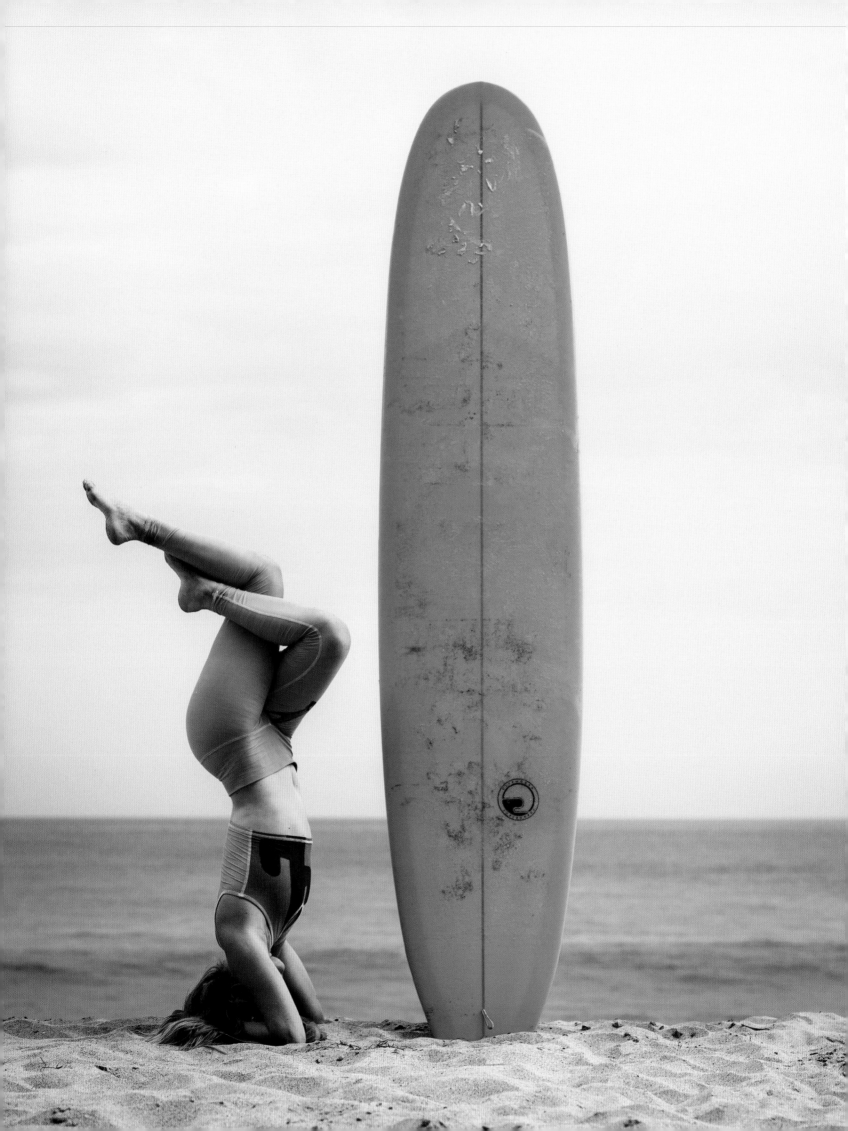

Leia Marasovich

Surf artist, yogini, water child

@leia_vita

There I was, treading water with camera in hand as a massive Maldivian wave was on the cusp of swallowing me whole, fully equipped with surfer in pocket. Wide-eyed, I completely lost myself as I dissolved into presence: me, surfer, wave, and camera became one in a timeless space of breath. In this moment it all hit me: I've been training for this my whole life.

I come from a Slovenian and Croatian family of artists. I grew up in Los Angeles, California, as a competitive long-distance swimmer. Little did I know, my more than fifteen years of endurance training would merge with my intrinsic desire for artistic expression to prepare me for my career as a surf artist.

My first experience with photography was capturing the stories of Ecuadorian children and elders in the Amazon and Andes amid an ever-changing globalized world. By doing a fundraiser, following my heart, and trusting in my intuition, I found my purpose, and through my process,

photography found me. I had no prior photography experience, but I soon found that the camera was my method of sharing a message, creating value, and expanding people's perspectives and concepts of beauty.

In 2015 I officially began my photography career, shooting food, lifestyle, and retreats in LA. I had just started surfing at this time: I was immediately hooked. With no prior experience or equipment for water photography, I was asked to shoot a surf retreat in the Maldives. This Maldivian week of "training" kickstarted my journey into water photography and film, and within two months I was well on my way to shooting surf full-time. I do this in Morocco, where I'm currently living in a small fishing and surf village, and where I also teach yoga.

I choose photos that evoke a sensation of flow, surrender, and grace. To me, surfing is a dance, a profound communion with the ocean, and a deeply personal connection to the magical forces of nature.

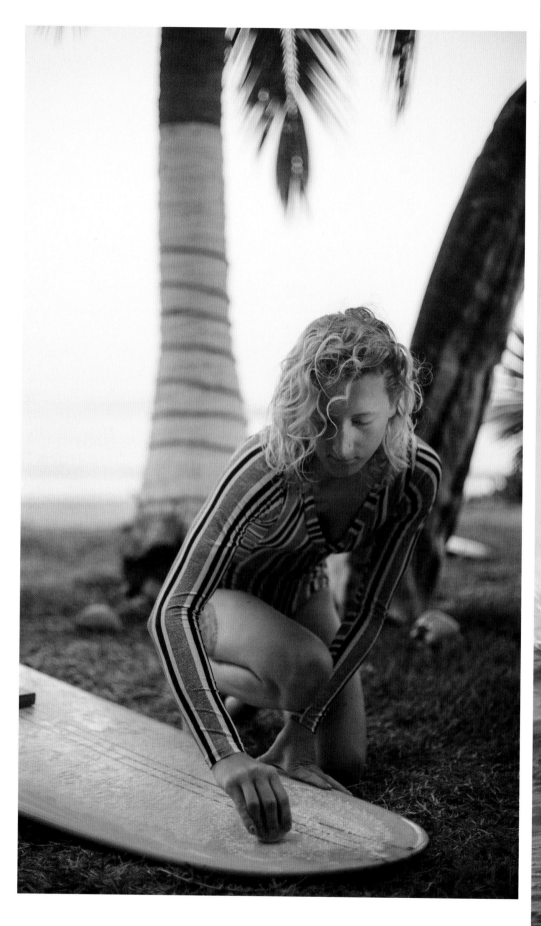

△ Mexico ▷ Maldives

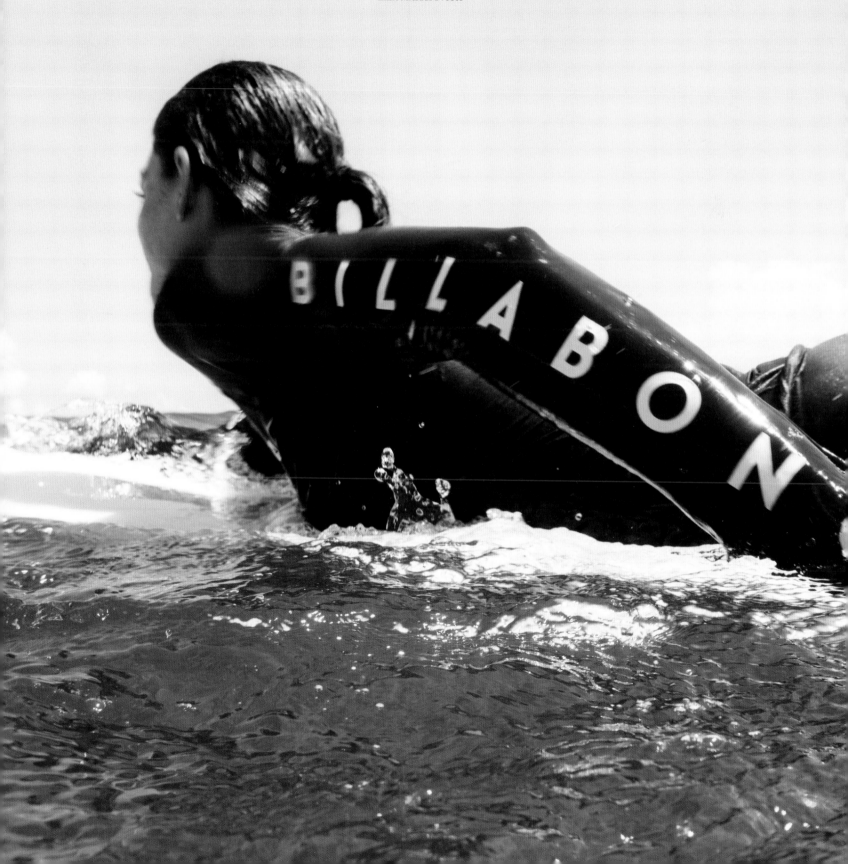

*I shoot surf because it captures people
in their strongest, most courageous,
and vulnerable moments.*

LEIA MARASOVICH

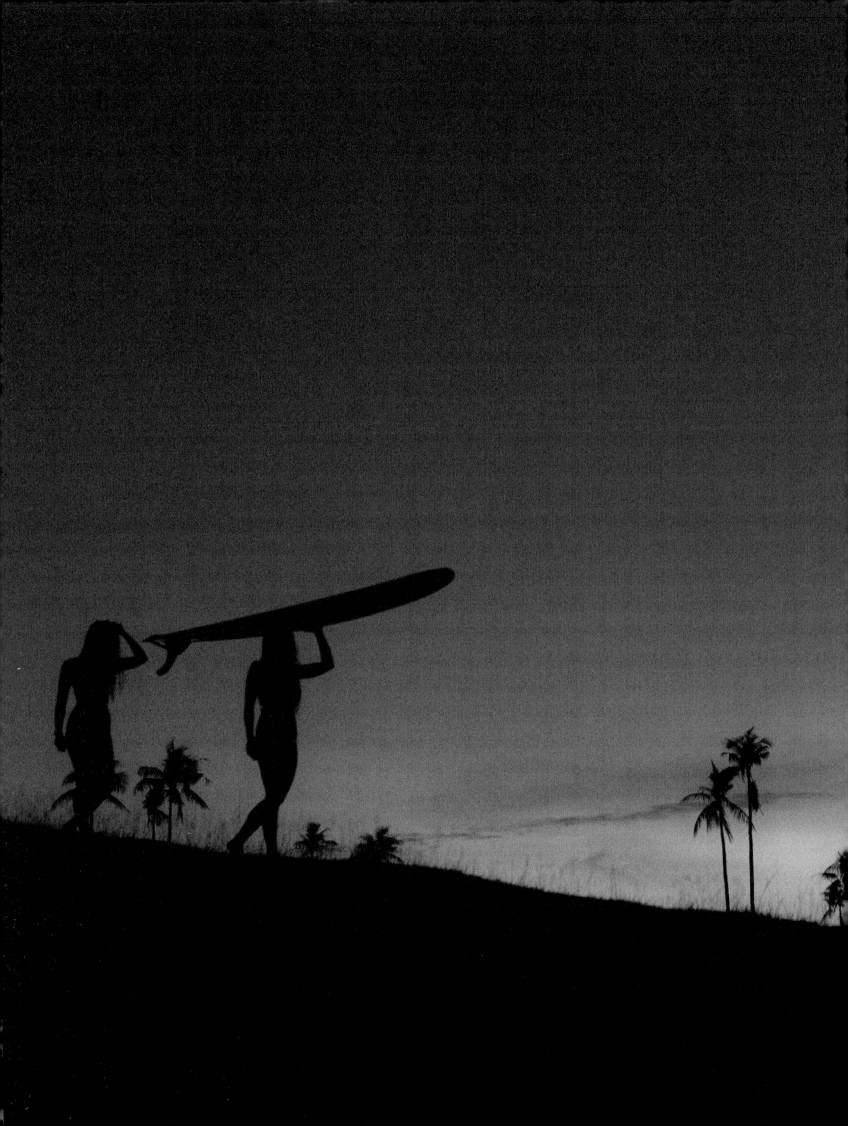

Camille Robiou du Pont
Photographer and filmmaker

@camillerdp

I'm a French-born photographer and filmmaker and have been based in Asia since 2012. I find inspiration in nature, femininity, the ocean, and the sky, and my body of work is a nod to these influences.

I've been living in the Philippines for the last three years. In my photography I want to present a poetic and ethereal view of the surf life. My emotional highs and lows inspire me; I find creative energy in my daily feelings.

I center my work on female subjects as a reflection of my own vision, and as a way to communicate through them. Through my dreamlike images I want to highlight the beauty of women from all around the world and share their talent with others.

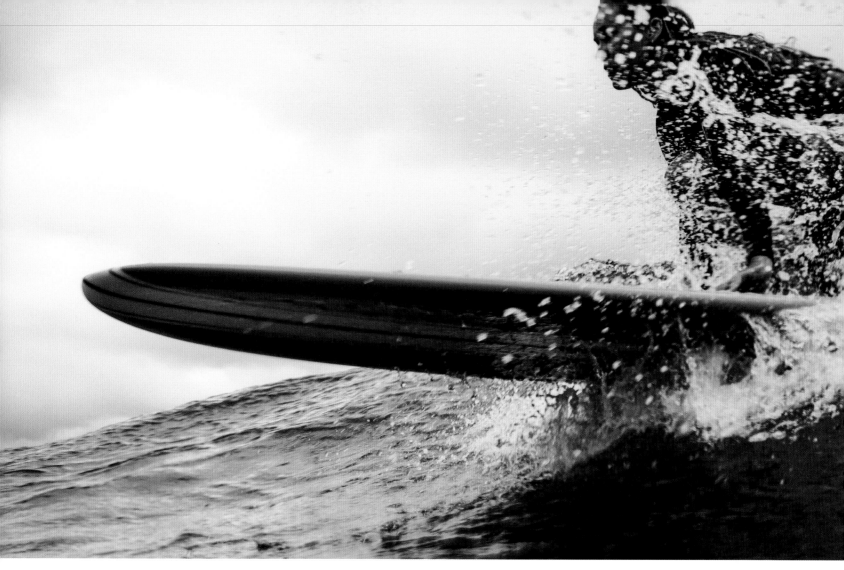

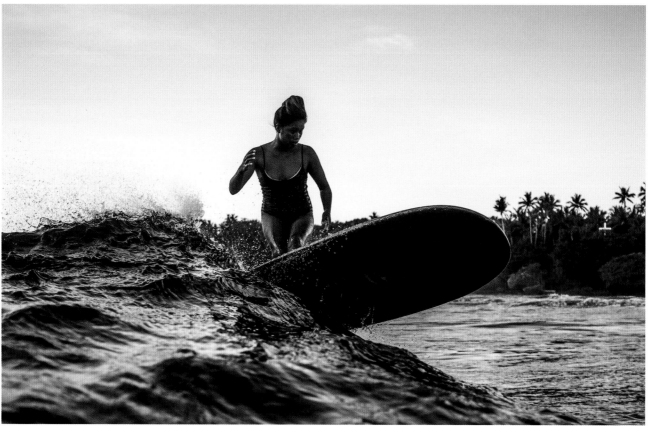

△△ Dorothée Kty △ Maricel Parajes ▷▷ Ophélie Ah-Kouen | Philippines

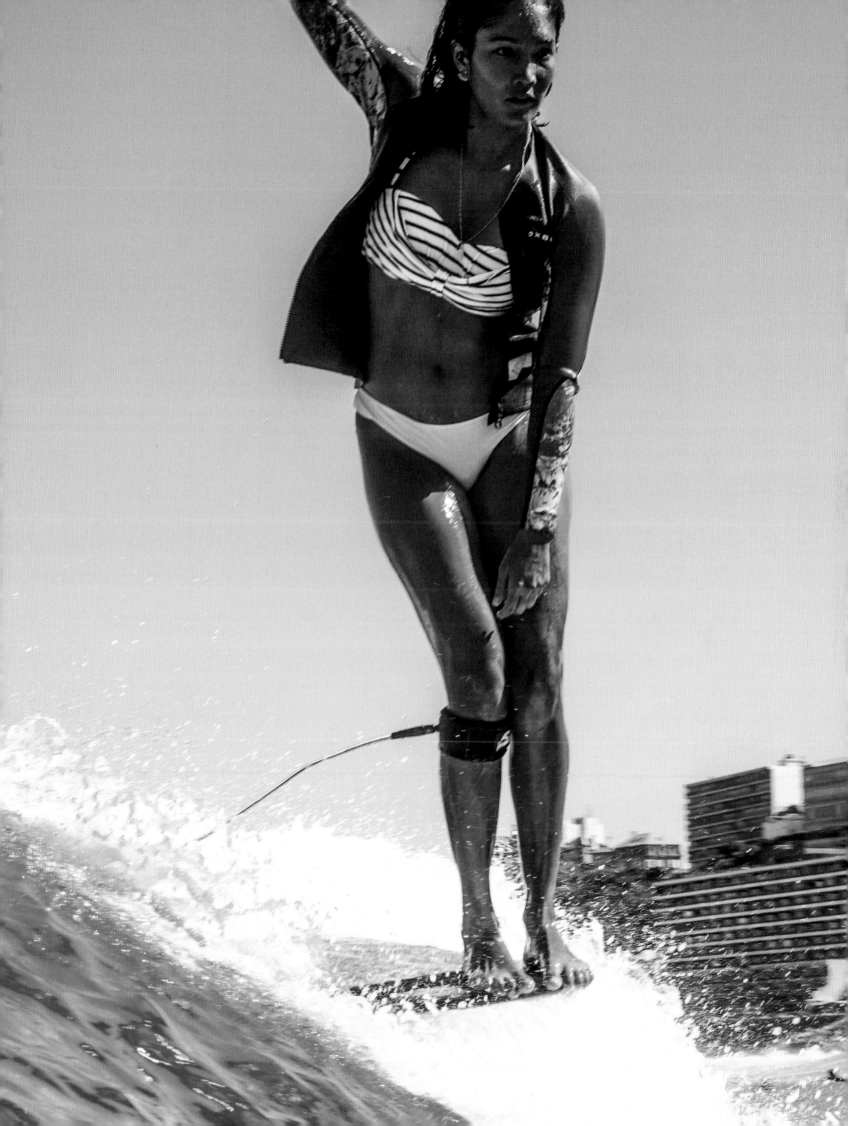

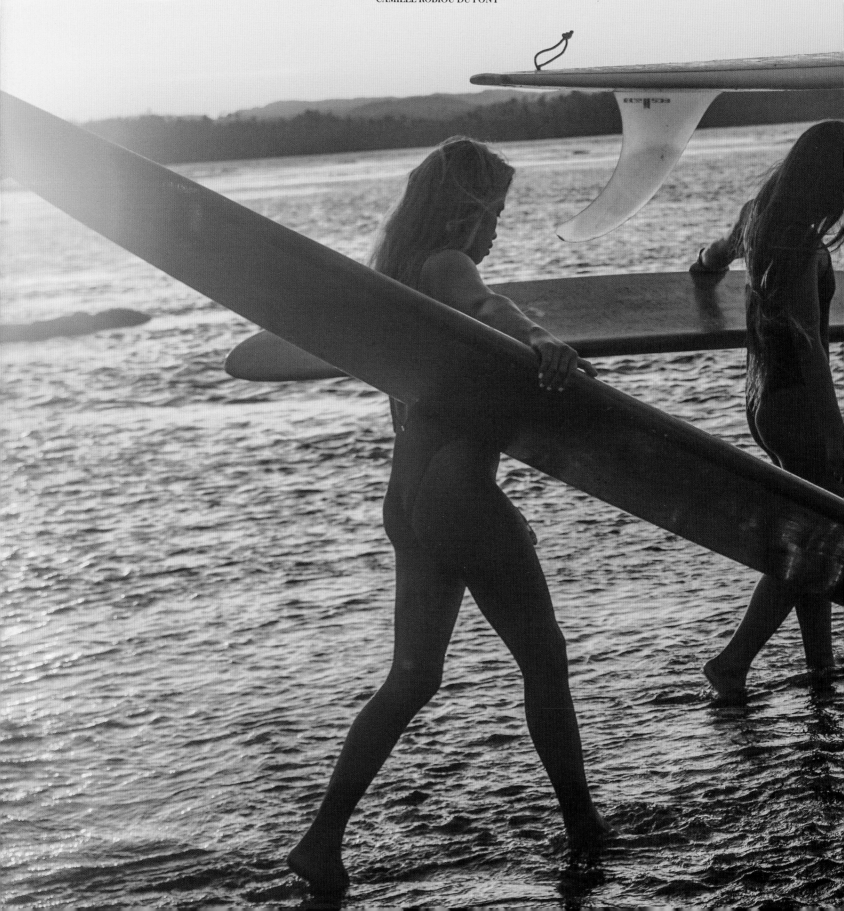

My emotional highs and lows inspire me;
I find creative energy in my daily feelings.

CAMILLE ROBIOU DU PONT

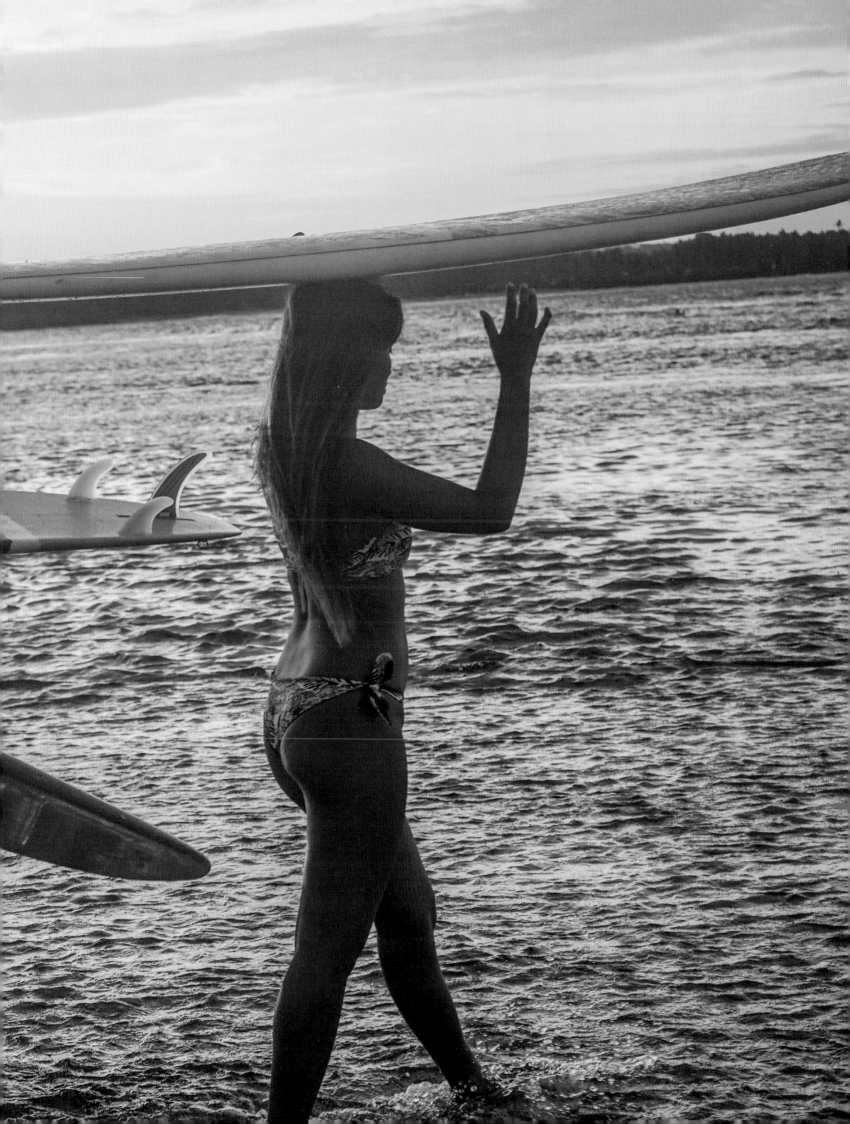

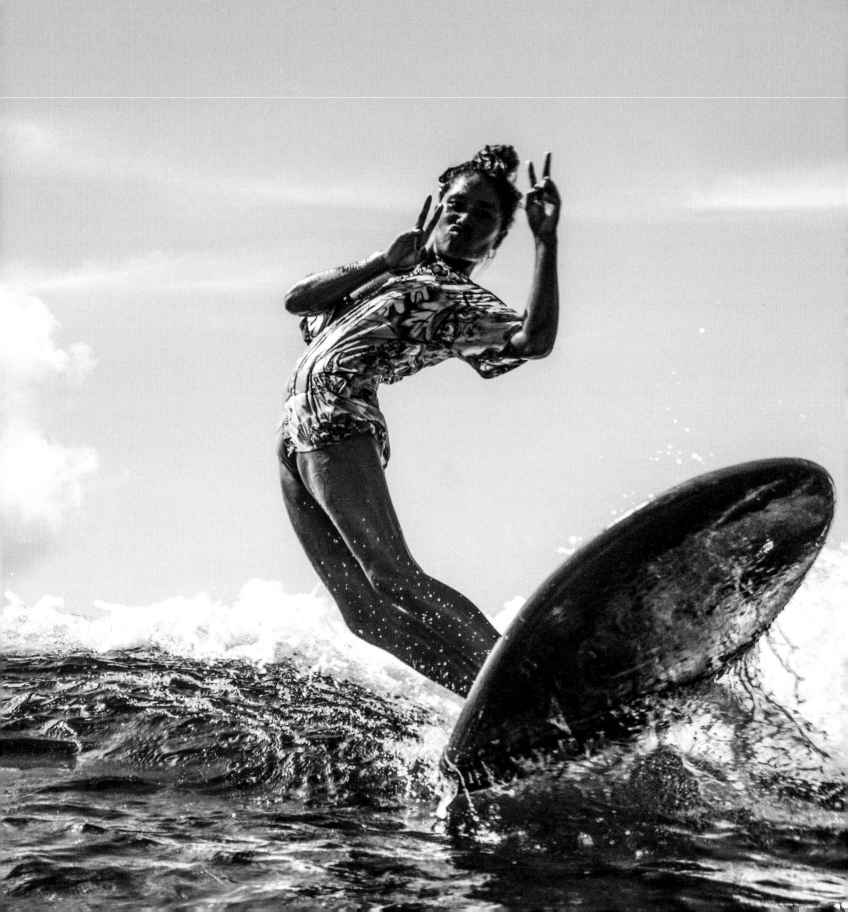

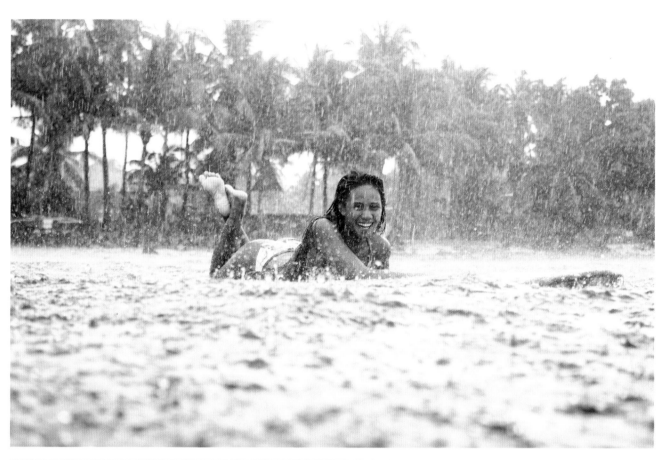

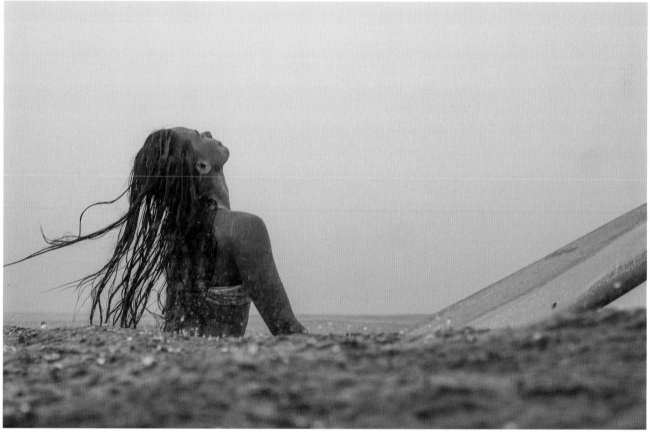

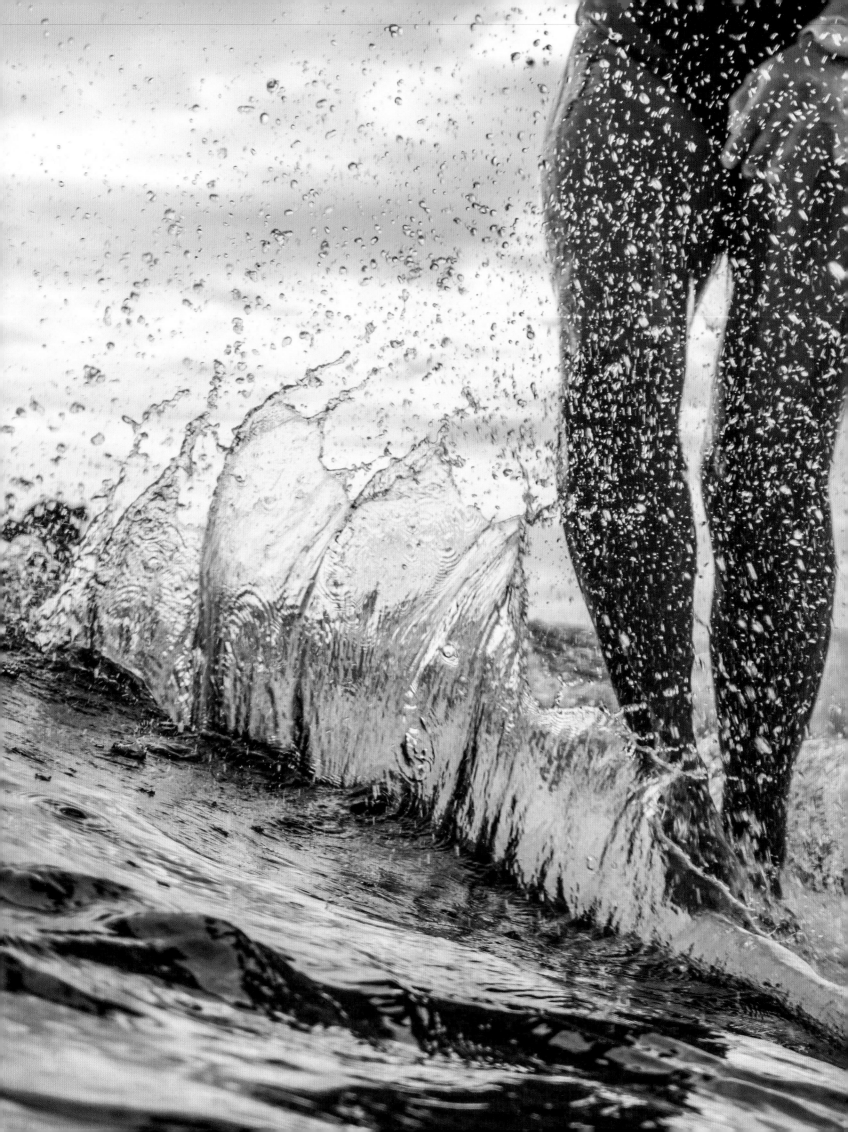

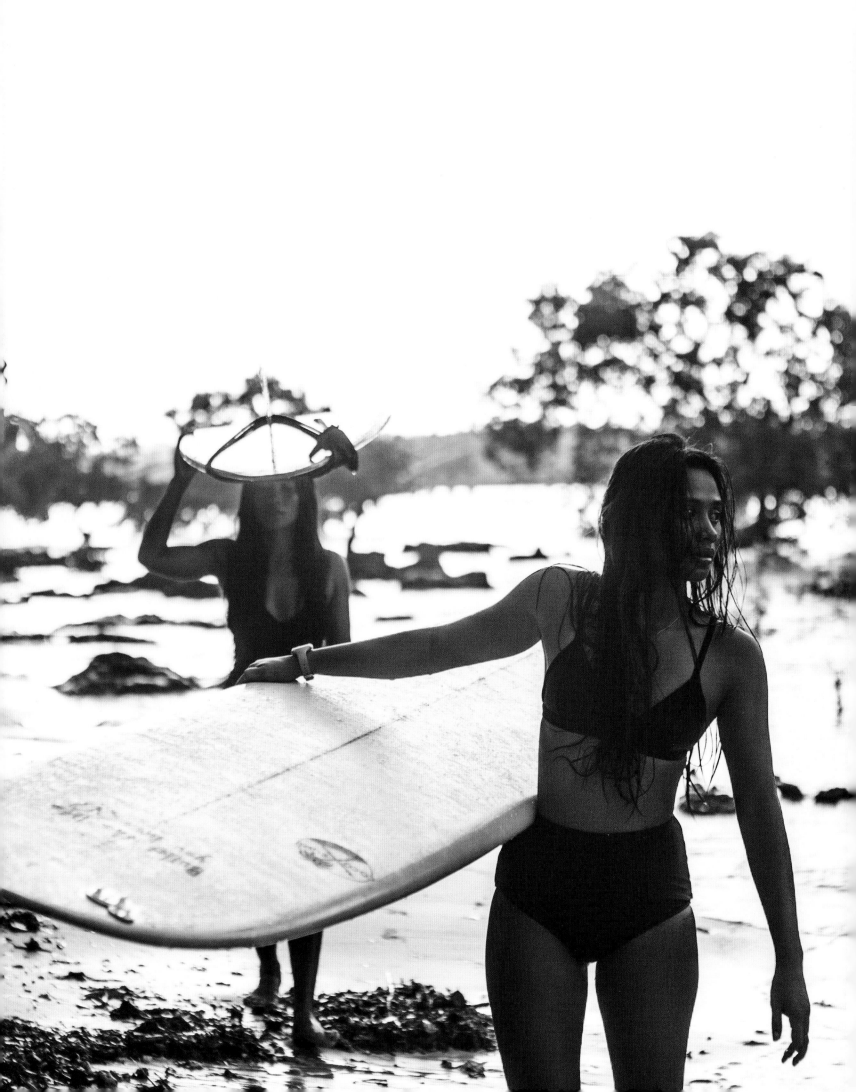

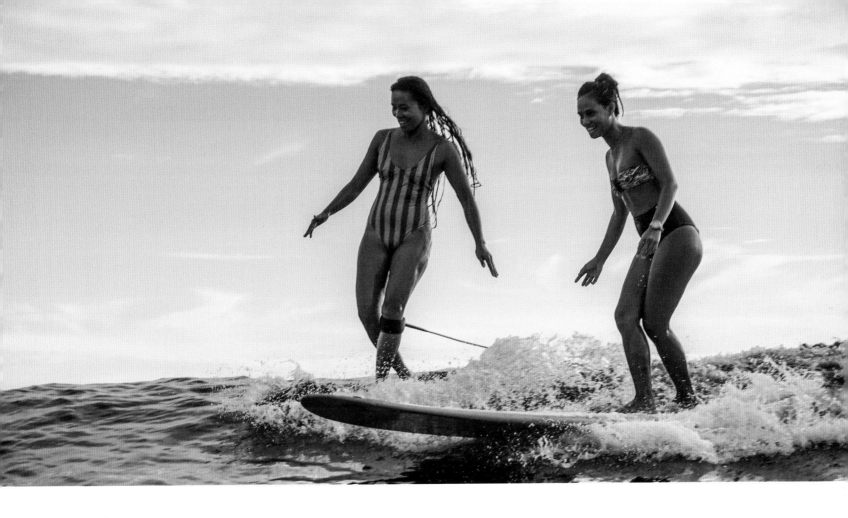

Ikit and Aping Agudo
Surf and sisterhood

@ikit_agudo
@apingagudo

We were born on Siargao, an island in the Philippines. It's a small paradise. We grew up as part of a large family and lived a very simple life: going to school, helping our father in his fishing boat, and planting rice on our farm. When we were younger, we were both afraid of big waves. But our father and four brothers would take us to hidden, quiet spots and we'd all surf together; that's how we overcame our fear. We still love to go surfing with our family, it's so much fun.

Since then, we've both switched to longboarding and taken part in surf competitions. We've been able to help and give back to our family—they've always been so supportive of us.

But that's not the only reason we surf: we also want to lead the way as proud Filipinas, confident in our own skin.

We embrace our Filipino identity and skin color and would like to encourage our fellow Filipinos to do the same. We are proud dark-skinned girls. Nothing can ever change that. It hasn't hindered us in chasing our dreams. We've continuously challenged ourselves for the better and stepped out of our comfort zones. Don't let what other people say affect you—just be proud of yourself and whatever you've accomplished in your life. Always have a heart that sees the goodness in others, keep your feet on the ground, and be grateful every day.

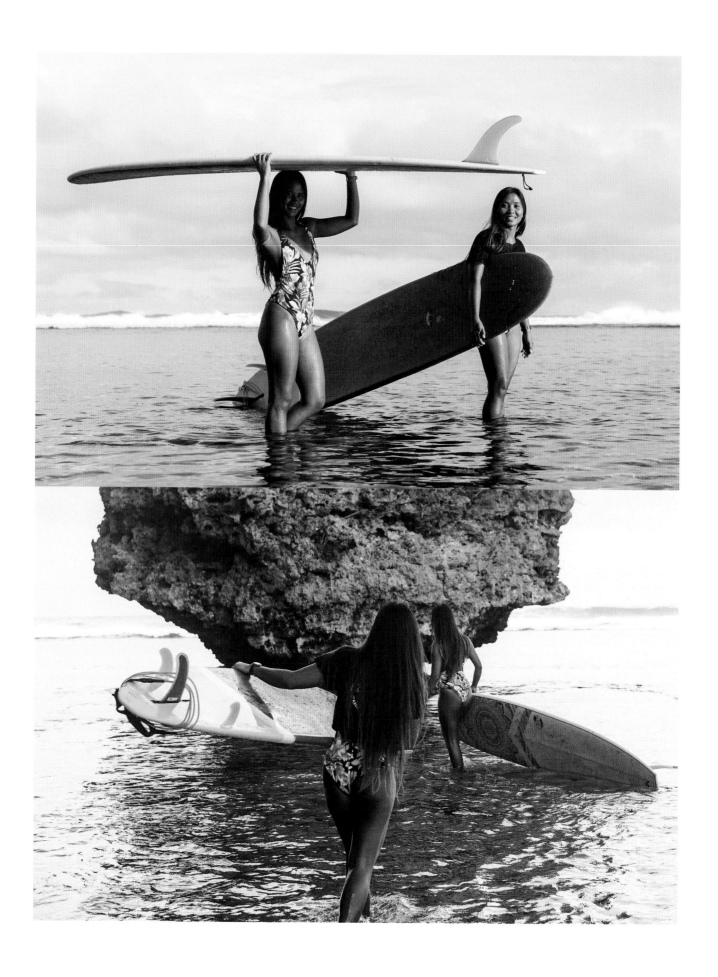

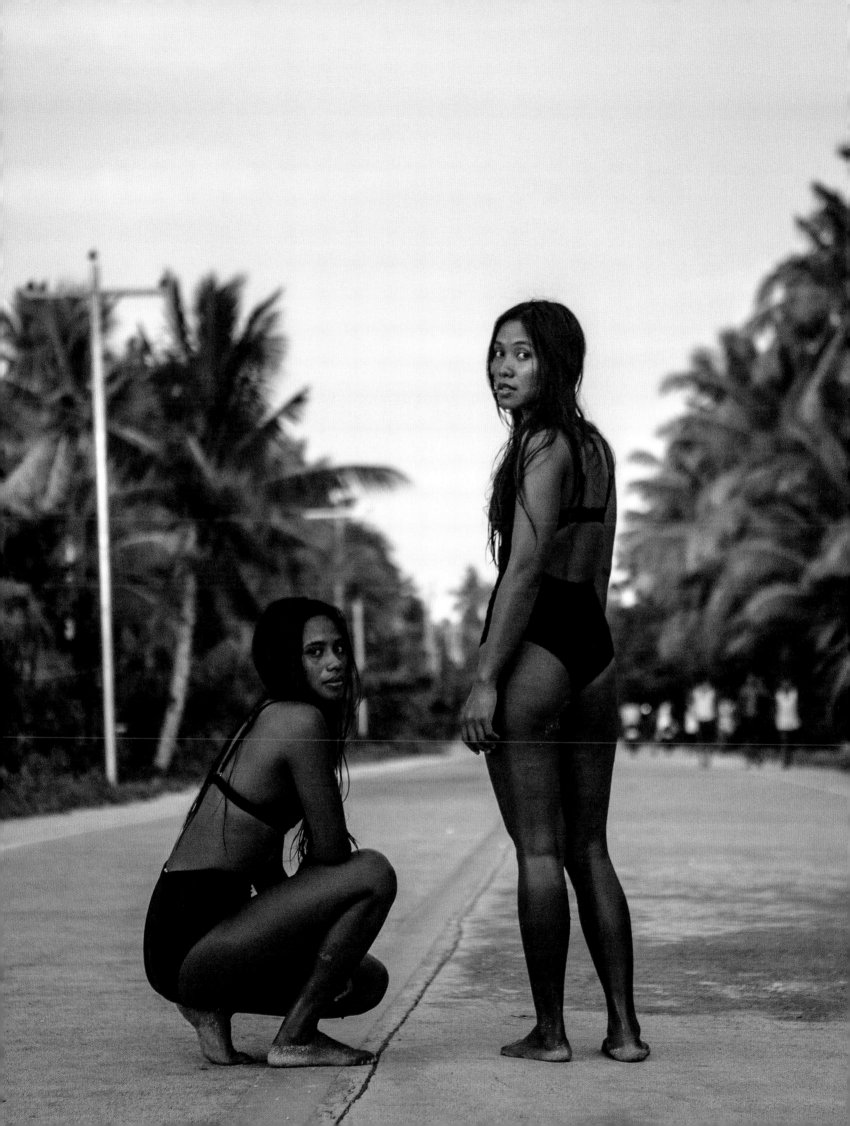

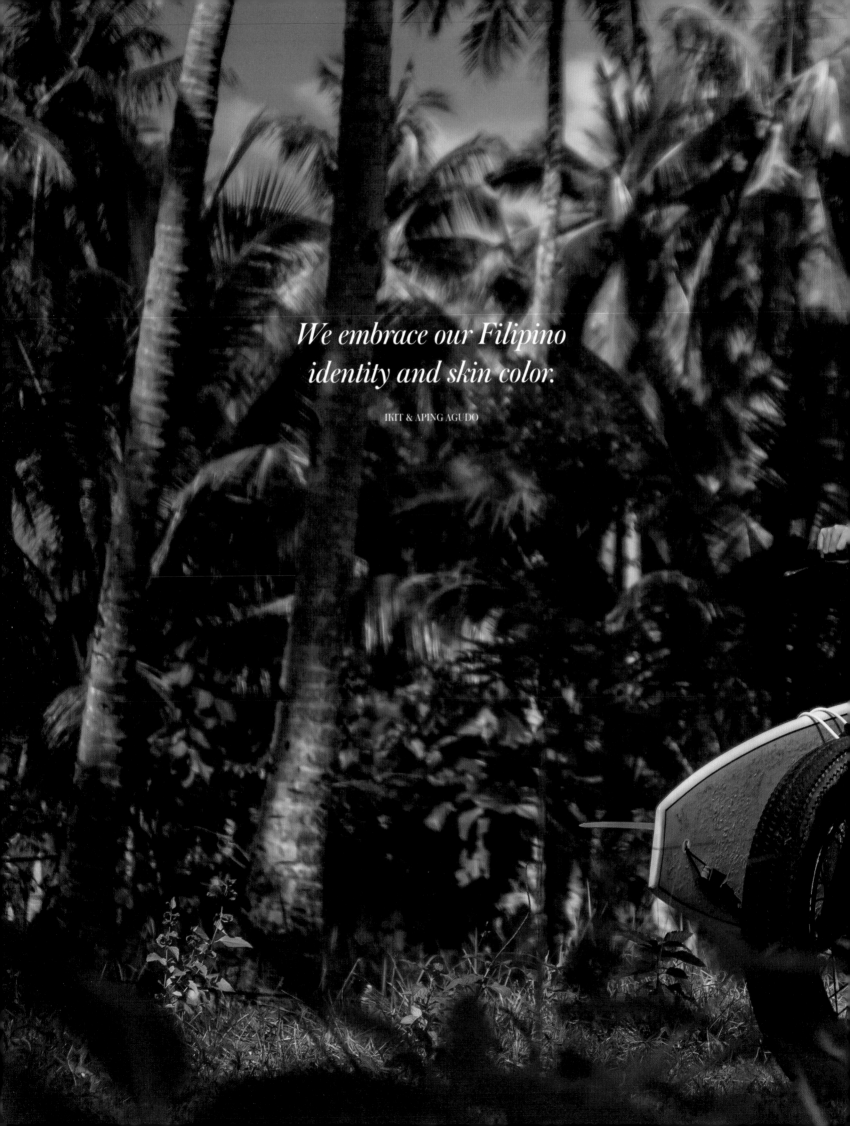

*We embrace our Filipino
identity and skin color.*

IKIT & APING AGUDO

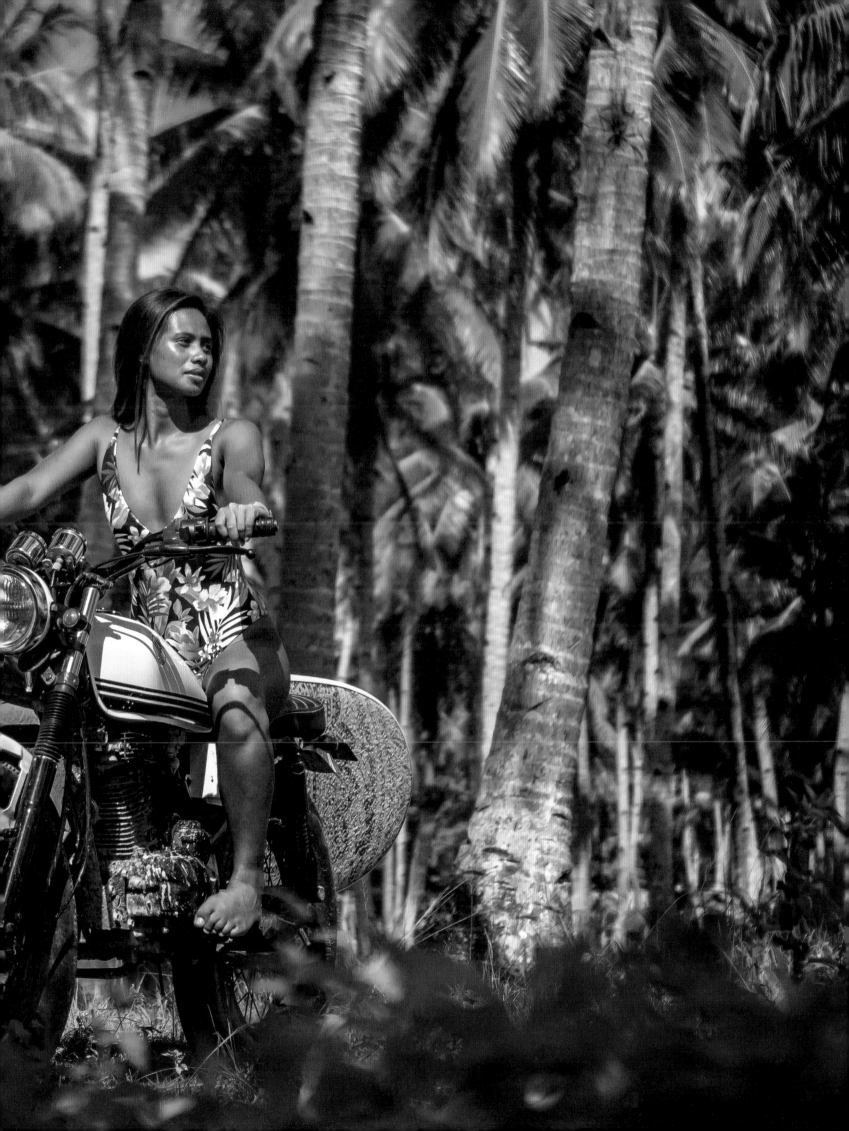

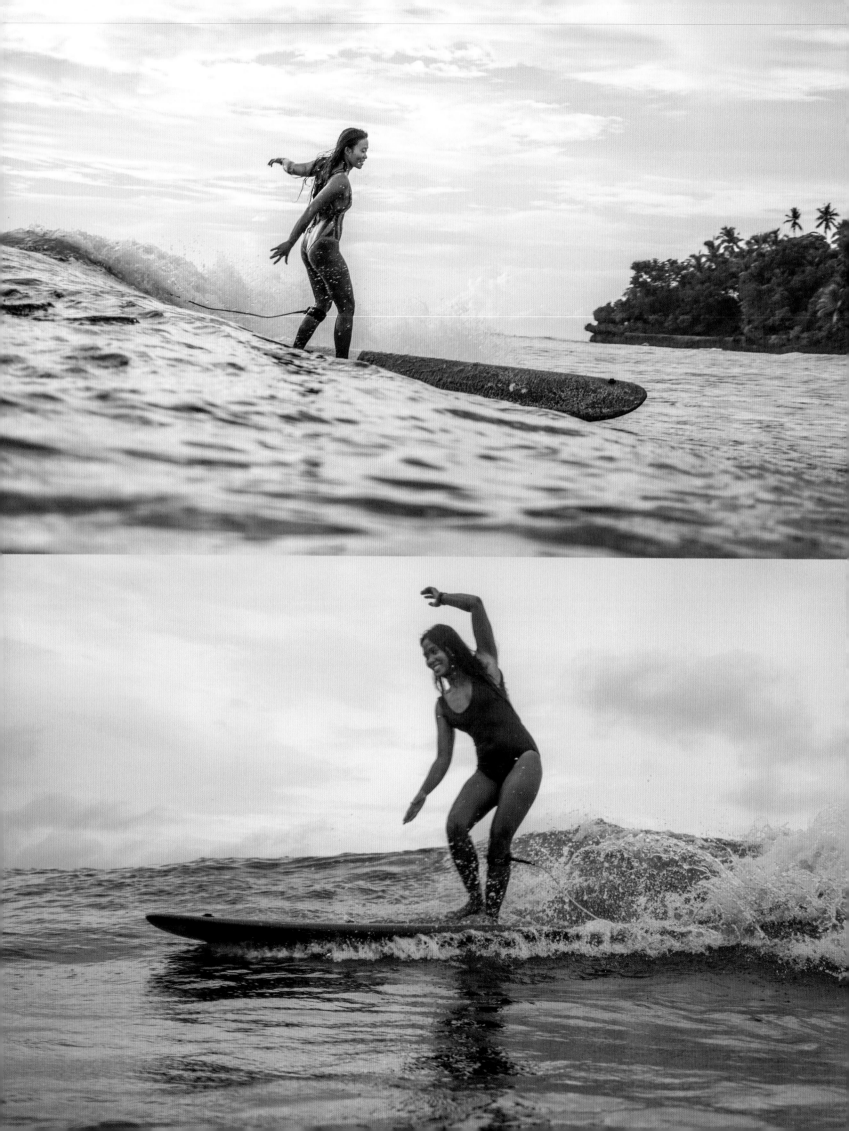

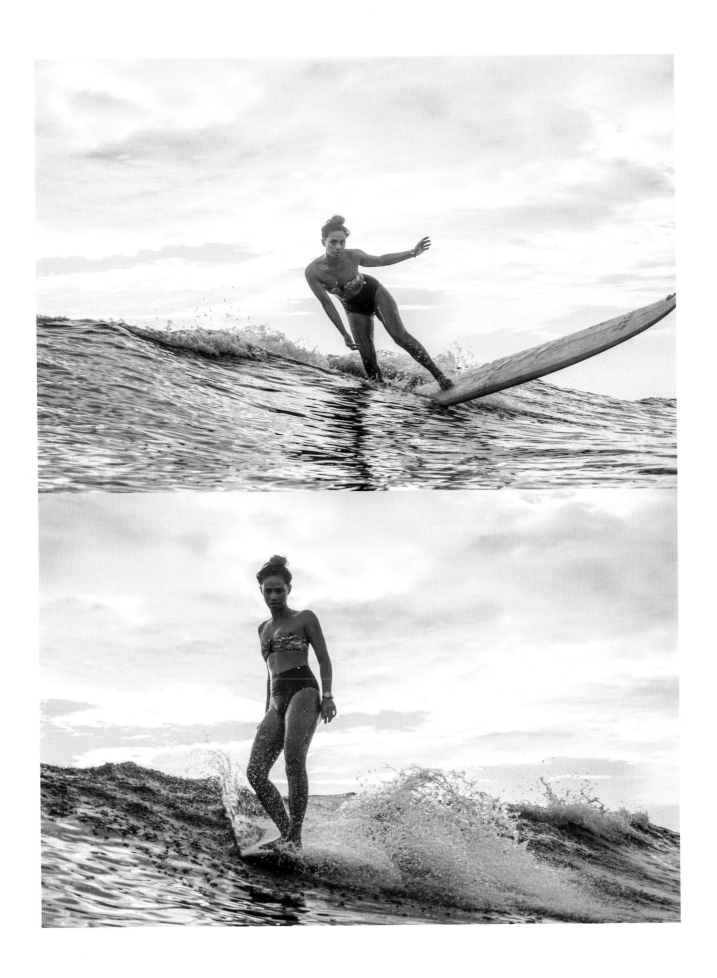

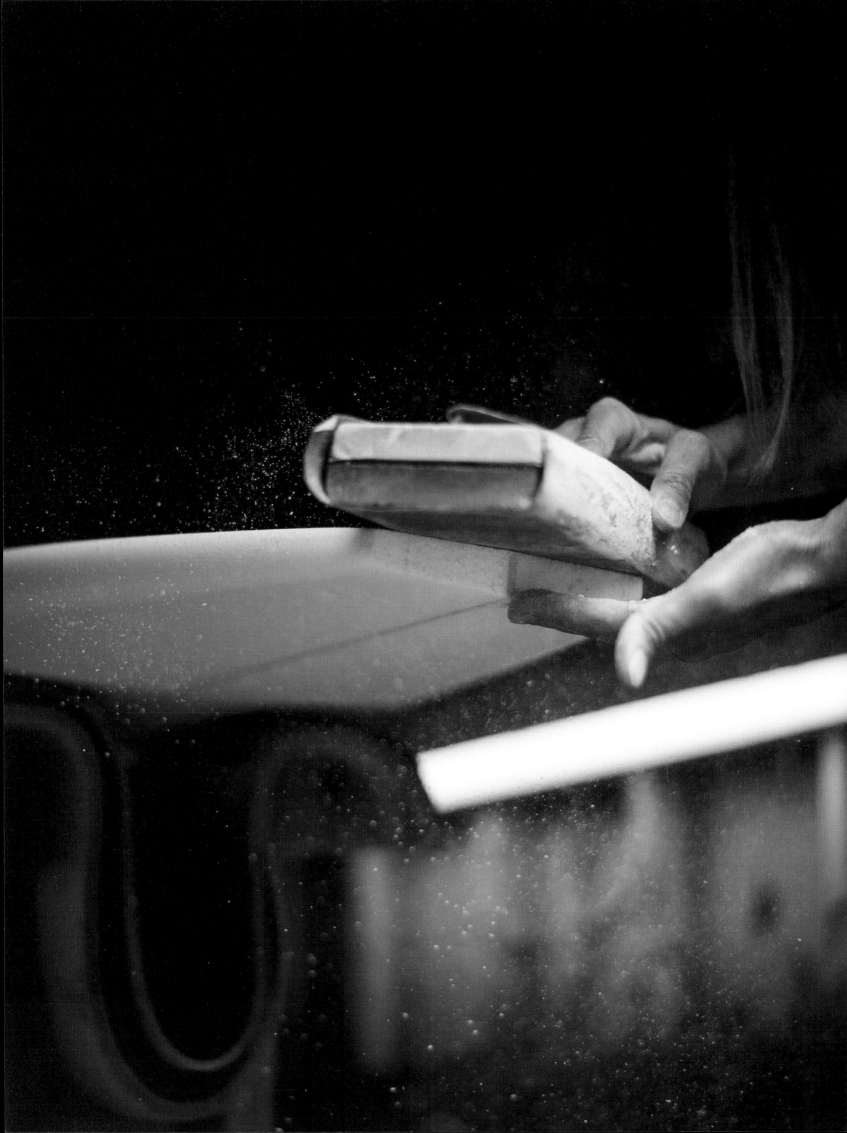

Valerie Duprat
Shaping with purpose

@meremadesurfboards

My hobby is making surfboards. Some people sculpt in clay; I sculpt foam. Usually artistic creativity isn't gender-specific, but surfboard craftsmanship is an exception. Until quite recently, this art was exclusively mastered by men; this was for cultural reasons, as surfing itself began as a male-dominated activity, and men liked having girls in pretty bikinis watch them surf from the shore. But guess what: women have not only proved they can surf too, but they've also proved they can shape!

So there I was back in 2010, starting to shape my first surfboard in my backyard using a few borrowed tools, the help of a "shaping 101" DVD, and the unconditional support of my husband. The board was hideous—as it should be for a first try. But I was proud and, more importantly, totally hooked. I was totally unaware of the rarity of being a female shaper, since to me it was just a relaxing, craft-based activity that used the right hemisphere (creative side) of my brain and that was something I was doing for myself. However, my production soon ramped up, spreading quickly from family, to friends, and friends of friends. At the same time, I started to draw attention on social media, and that's when I began to realize the singularity of my hobby.

If the vast majority of people were ultra-supportive of a woman shaper, and even if some famous shaping room doors opened up for me, there was still a residual reluctance—close to disrespect sometimes—from purists or machos or both. Nothing that I couldn't handle, though!

Social media also led me to discover other female shapers, like Cher Pendarvis (the pioneer), Ashley Lloyd, Whitney Lang, Christine Brailsford, Marion "Surfsista," and Jawel Souak. And from the enthusiastic messages I receive periodically from women around the globe, it seems more and more are ready to give shaping a try. Yes, girls shape too!

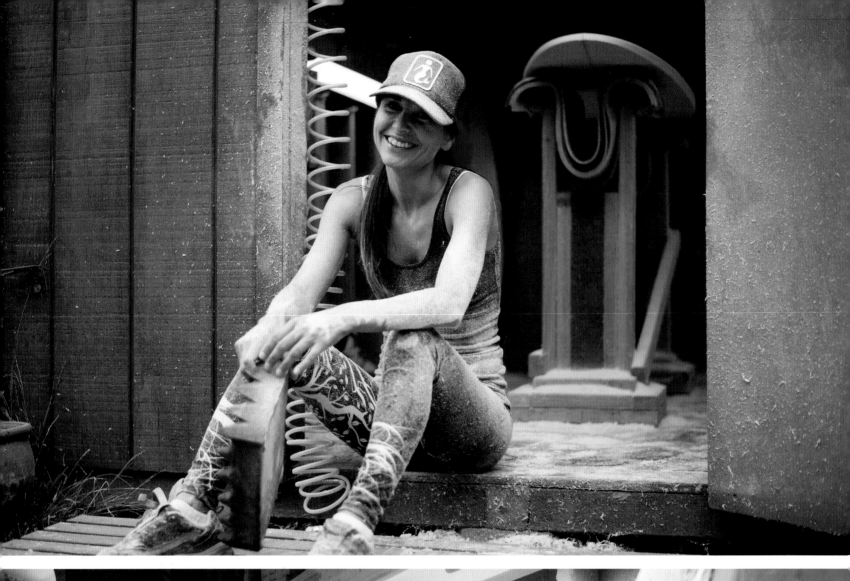
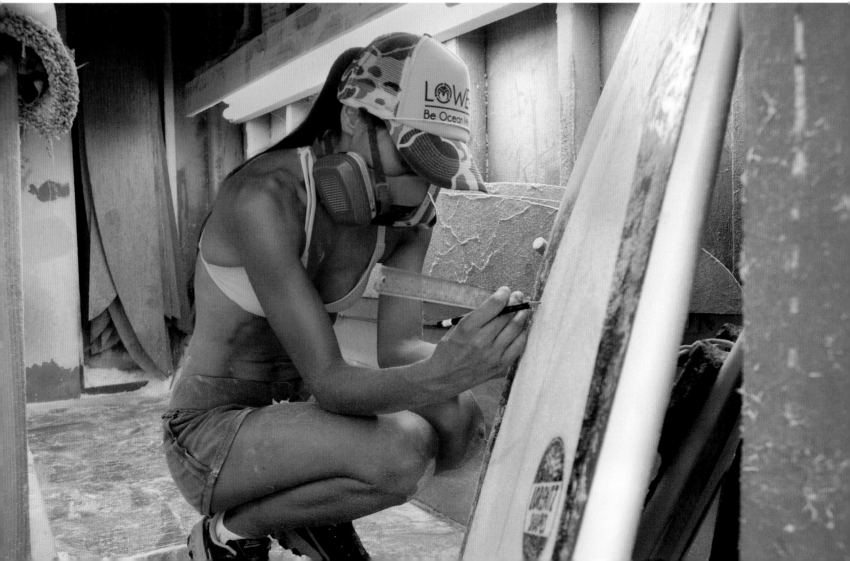

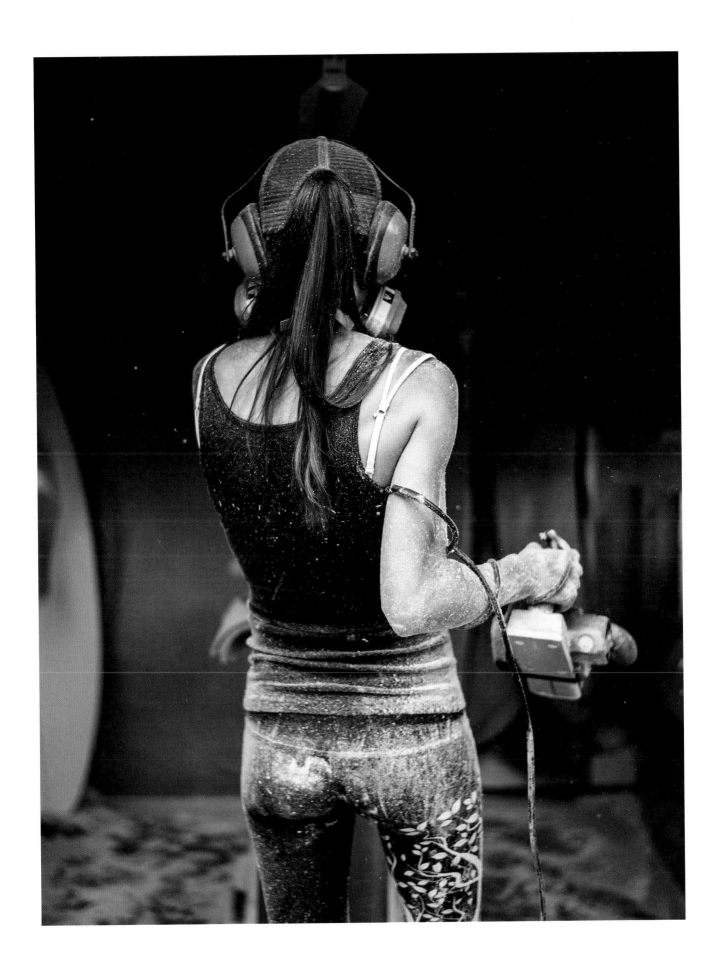

Girls shape too!

VALERIE DUPRAT

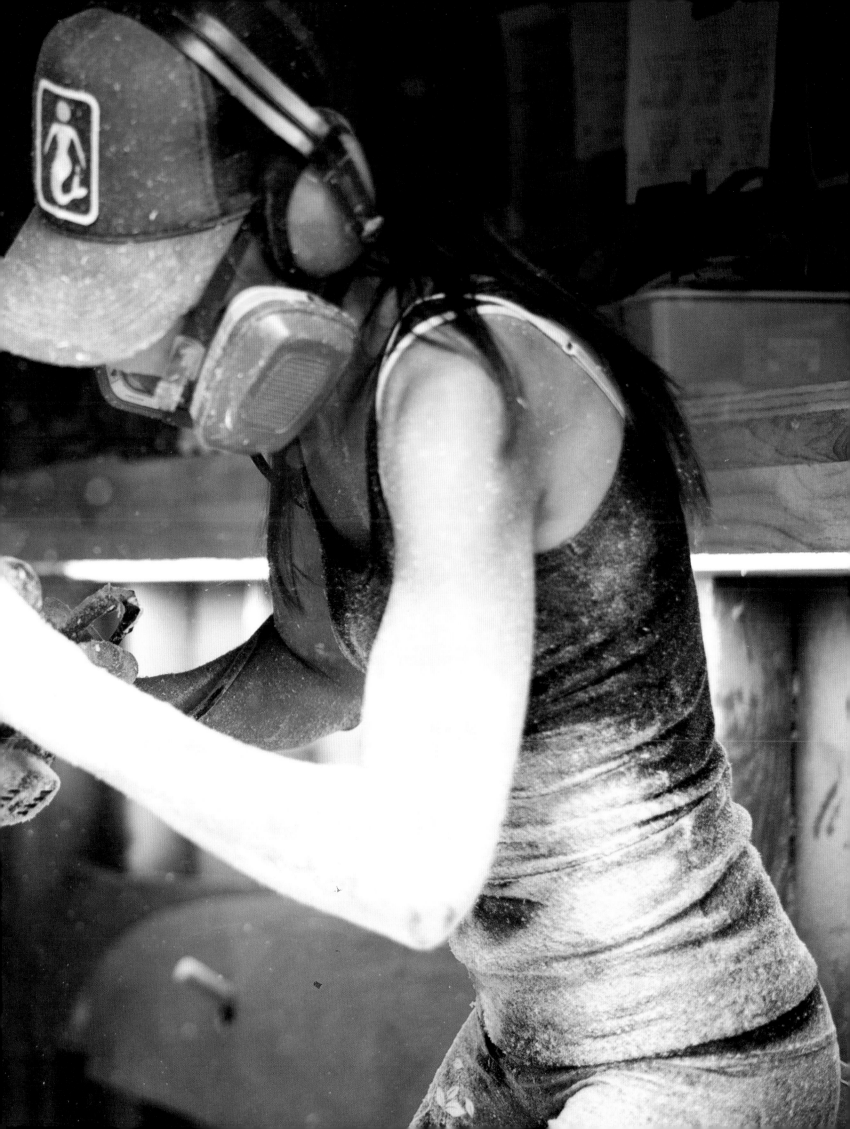

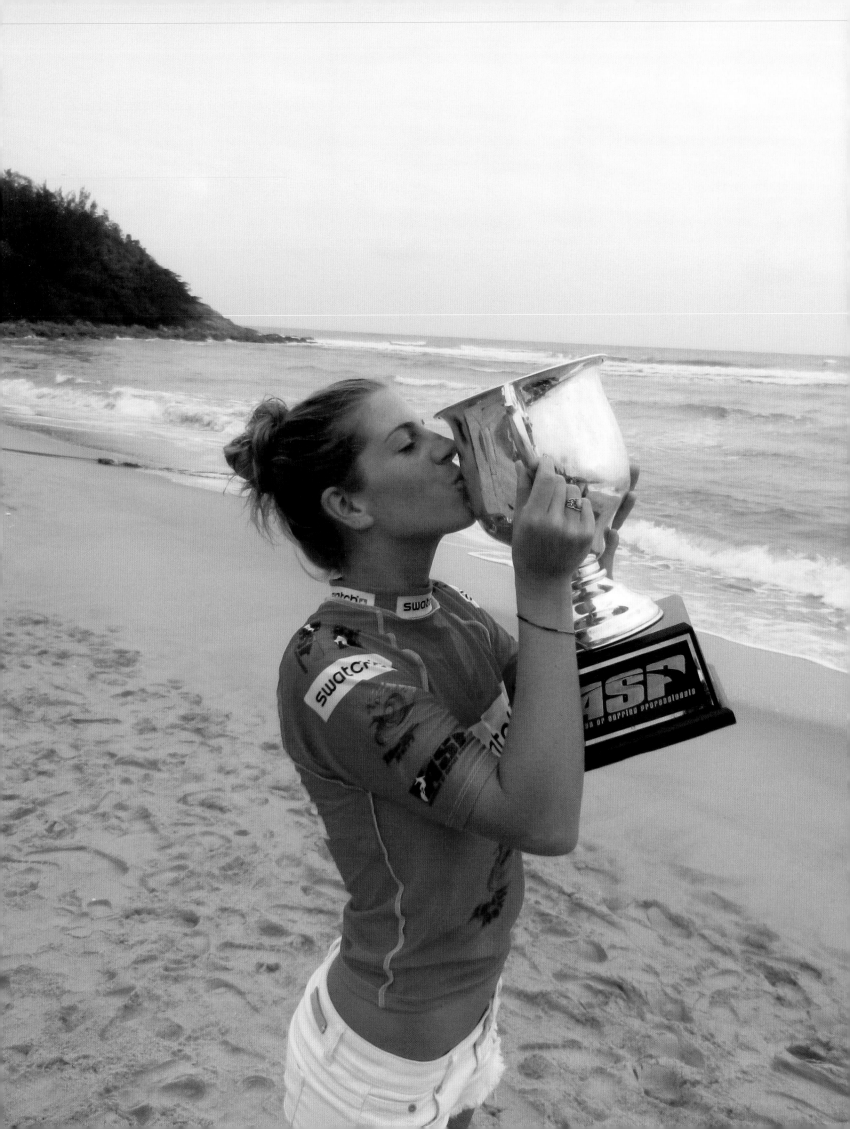

Lindsay Steinriede
Surfer

@lsteinriedee

I was born and raised in Dana Point, California, alongside my two older brothers. My mother passed away two weeks shy of my first birthday, so it was my father who raised us and became my greatest role model, mentor, friend, and fan. I grew up at the beach and started surfing around the age of six. At twelve I fell in with a crew of friends who surfed at Doheny beach, and we became known as the jetty rats of our generation—spending endless days surfing, skating, and hanging out on the jetty. I entered my first contest that year at Doheny—the 1998 Menehune. Shortly after, I started competing up and down the California coast with the Doheny Longboard Surfing Association.

Focused on school and other sports, it wasn't until 2003 that I entered my first professional surf competition, which was in Cocoa Beach, Florida. That year I would also win my first ASP North American tour event in Oceanside, California. Also in 2003 I received a soccer scholarship to the University of California, Santa Barbara. I had to put my surfing career on hold, only competing when I was available to. I managed to win my first North American championship title in 2006, but it wasn't until a few years later that all my patience, dedication, hard work, and resilience would pay off.

In 2010 I won my second North American tour title, qualifying me for the Women's World Longboard Championships

the following year. My father passed in the fall of 2010 and I entered the darkest time of my life. Perhaps needless to say, I felt in no state to travel and compete. However, before my father passed he made me promise that if I qualified for the world title event, I would go and compete. This wasn't because he was trying to push me in competition, but because he knew how rare and special the opportunity and experience would be. So I did. And I won.

Surfing a twenty- to thirty-minute heat with one other person in the water, in a beautiful location, is a blessing. There are no "hard heats" when you compare it to the loss of a loved one. This was the new perspective I gained, and it wiped away all the pressures of competition and left just the ocean, my board, and me, doing what I love and what I do best.

Nearly ten years later, I have accomplished many more victories in my professional surfing career. However, I don't continue to compete for the stats. I do it for the love of traveling and sharing amazing experiences with my friends from around the world. No matter what I go on to achieve, winning that world title in 2011, when I was at the lowest point in my life, will always be the peak of my career. You never know how strong you are—mentally, emotionally, physically, spiritually—until you have to be, and even then you're stronger than you think. I promise.

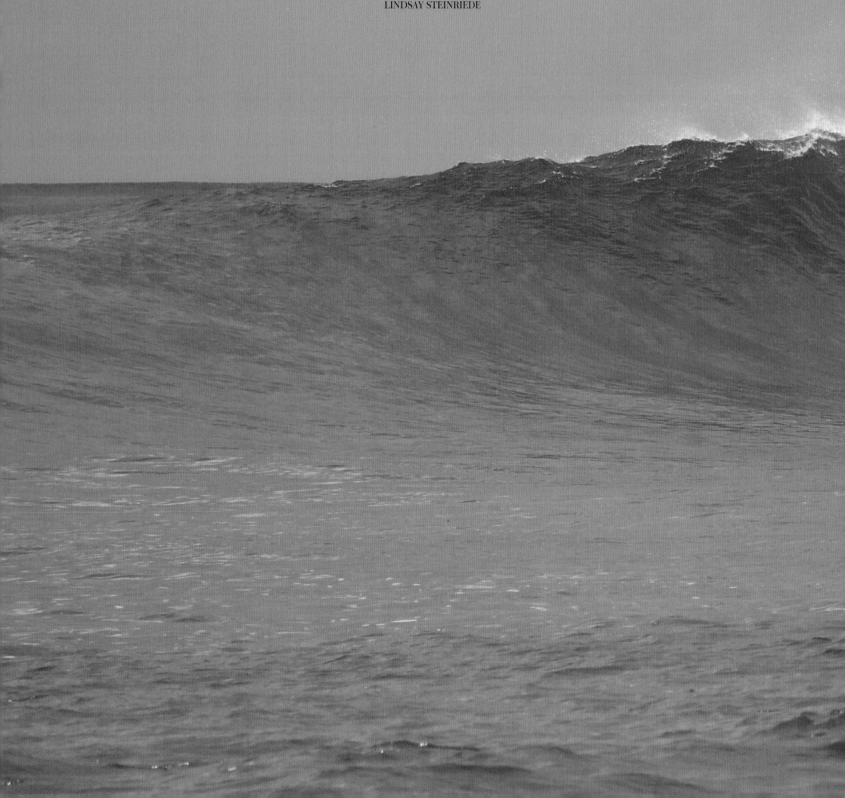

*I compete for the love of traveling
and sharing amazing experiences with my friends
from around the world.*

LINDSAY STEINRIEDE

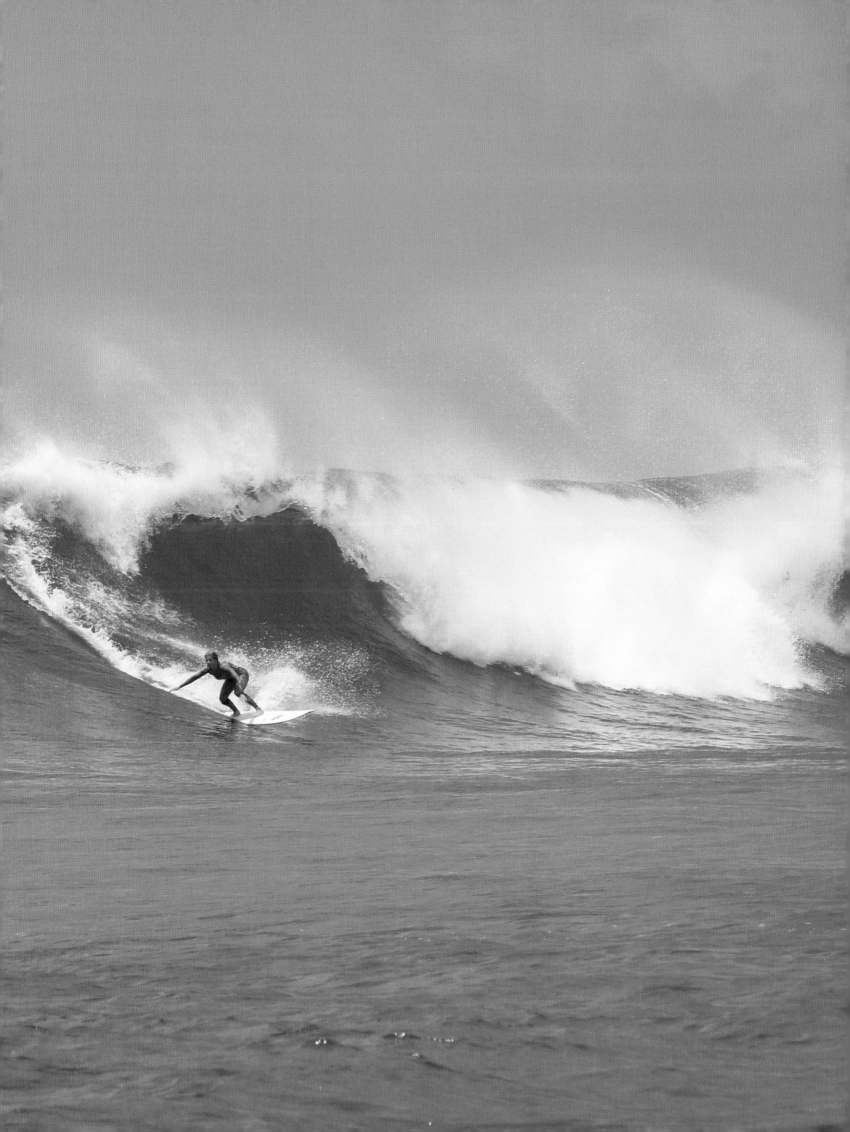

Samia Lilian

A pioneering longboarder in Sri Lanka

@samiathulin

Born to a Swedish father and Sri Lankan mother, and growing up in the desert lands of Kuwait, where waves are nonexistent, I found my soul in Sri Lanka, where surfing has made me who I am today.

Having surfing become part of my life has changed the way I think, allowed me to create strong connections with like-minded people, and inspired me to appreciate Mother Nature and the power of the ocean. Being the first female local longboarder in Sri Lanka has given me the opportunity to break the taboo of local women surfing.

It was inevitable that I would leave my nine-to-five job in the city and move to the coast to be closer to the surf. Leaving behind friends and giving up my city job wasn't easy, but

I instantly felt like I belonged in the slow-paced, lush environment. Sandy hair and salty skin was what I wanted to feel every day, and for a very long time.

Since surfing has had such a big impact on my life for the past four years, there was no doubt that it would become part of my career too. Giving back to the surf community in Sri Lanka has always been a priority for me, so I'm lucky to be working as the head designer of *Surf Sri Lanka* magazine, the first surf magazine on the island.

Surf has made me who I am and will shape me into the person I want to be. What inspires me most is being part of a very small group of local women who are feeding their souls.

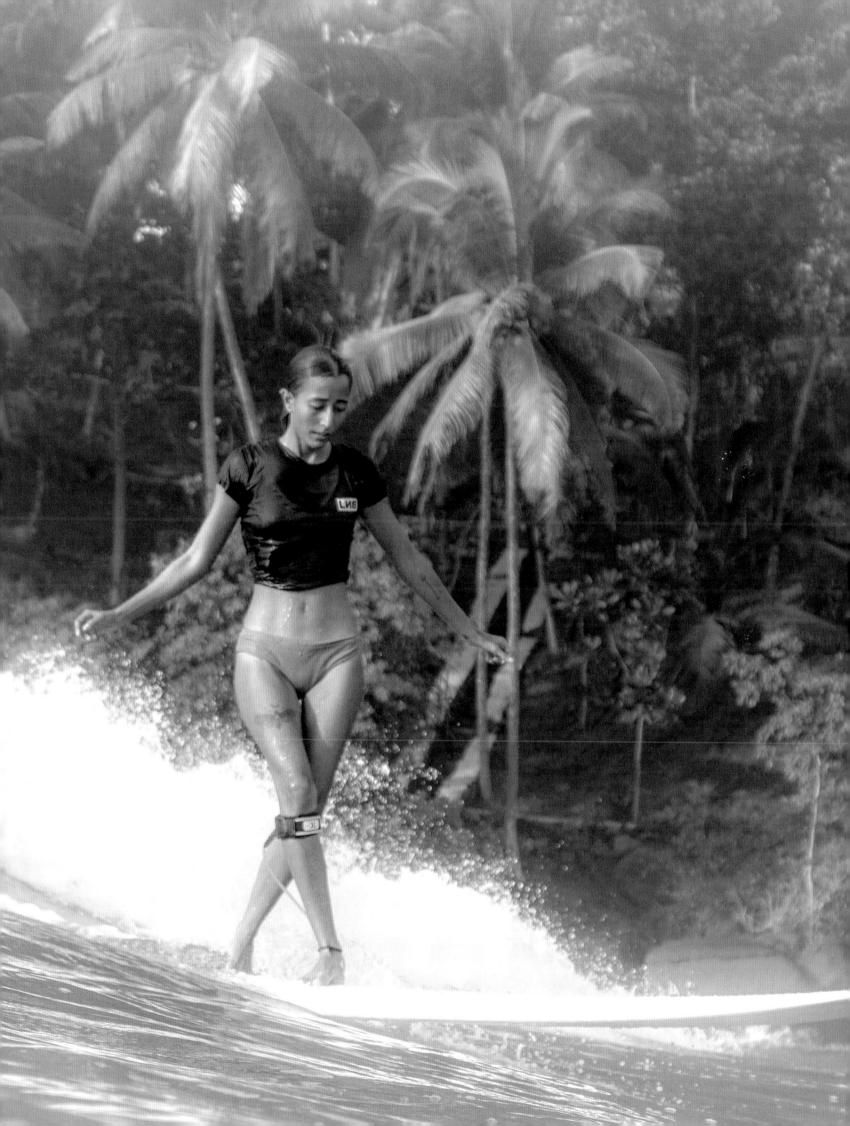

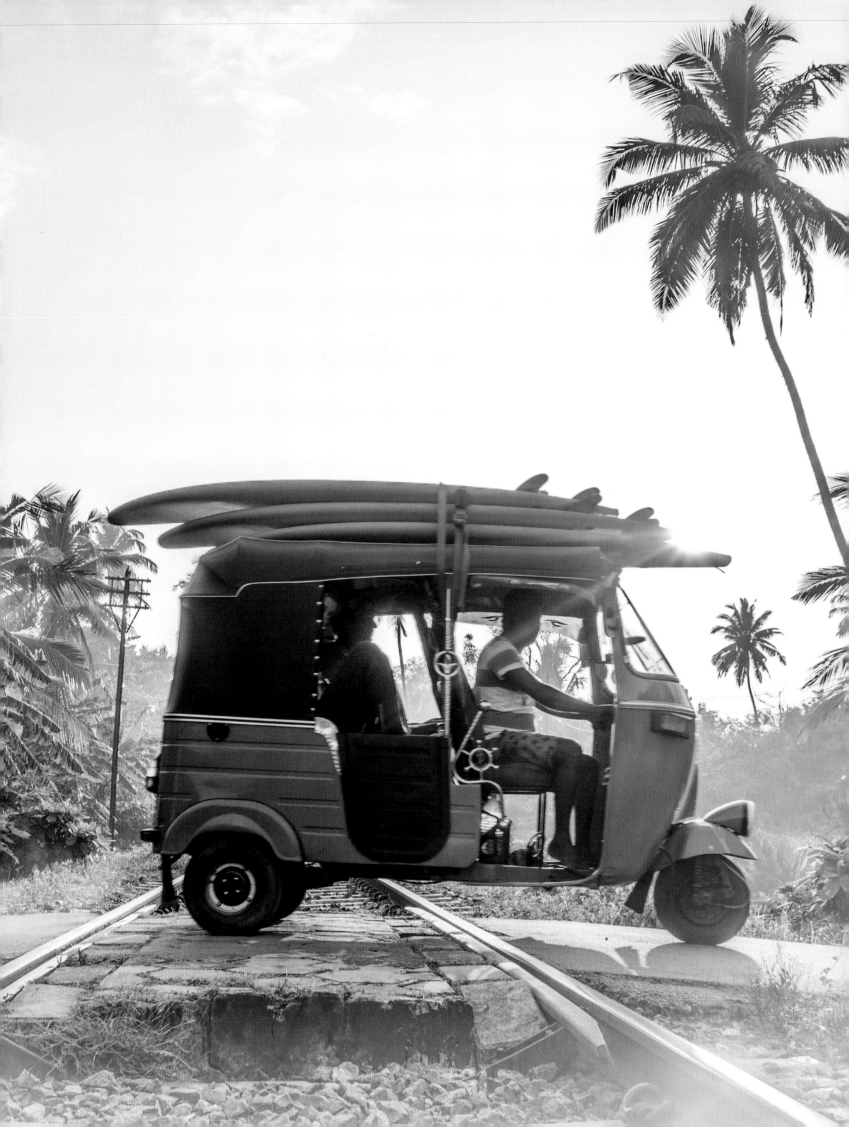

*Surf has made me who I am and will
shape me into the person I want to be.*

SAMIA LILIAN

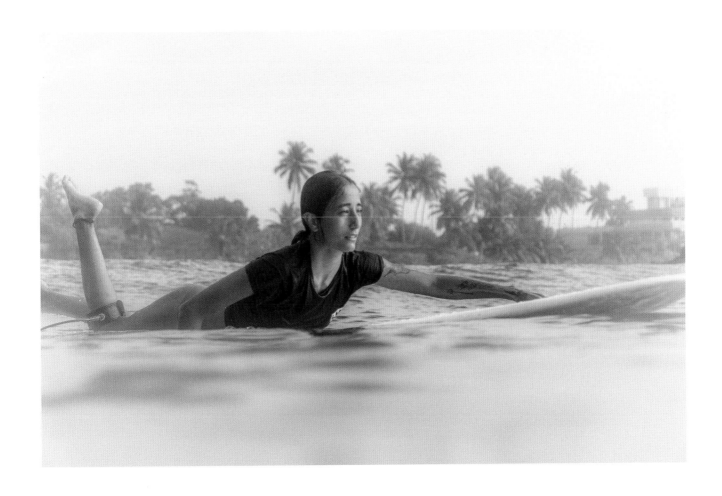

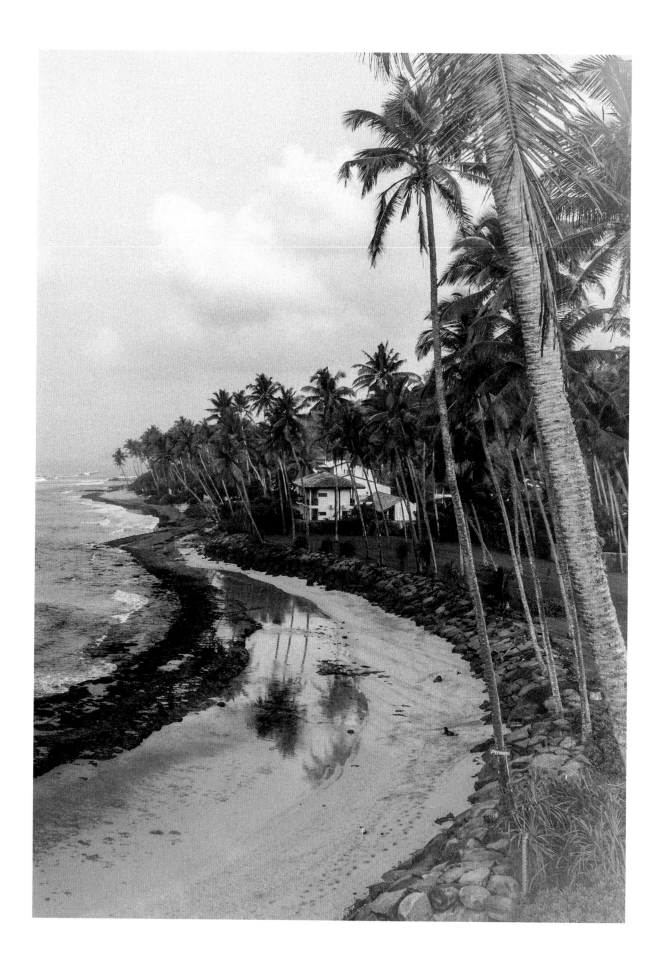

Madiha beach, Sri Lanka

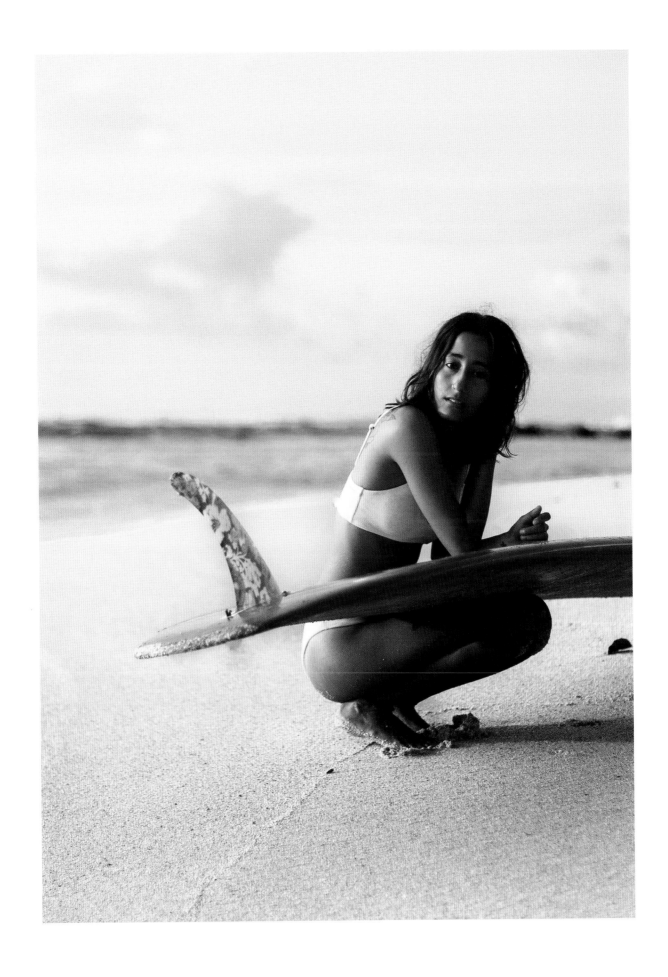

Vera Nording
Lifestyle photographer

@veranording
@photosbyveris

I grew up in Sweden, where surfing isn't really something you come in contact with—at least I didn't, until we went on a family vacation to Southern California. I was fourteen and I tried surfing for the first time—and loved it. It was a few years before I got back on the board, but after graduating high school I was determined to learn how to surf, so I packed my bags and went to Costa Rica. After that I was hooked, and I knew then that surfing was going to be part of my life. I traveled in between studies and worked as a surf instructor. It was wonderful to share my passion with others. Pretty early in my surf "career" I fell in love with longboarding, because of the style, the playfulness—everything, really—and even now, nine years later, single-fin logs are still pretty much the only boards I surf; it just makes me happy. One of my favorite things about surfing is all the amazing people, especially women, I get to meet and connect with. I find that there's a beautiful sisterhood among female surfers, and rather than competing with each other we support each other in the water.

After living in Bali I felt ready to settle down in Sweden for a bit. I got an amazing job working for Spotify, and although I did manage to squeeze in a couple of surf trips, I wasn't surfing nearly as much as before. So after two years, I left my job and decided to spend a few months surfing before starting a new one. I went to Sri Lanka, where I fell in love with surfing again, I fell in love with a dog, I fell in love with a guy, and I fell in love with the island. So I'm still here.

I didn't really have a plan when I decided to stay, and while it was definitely stressful at times not knowing how I would support myself, it also gave me the possibility to try something new and really figure out what I wanted to do. Photography has always been a passion of mine, and for years I've said, "In my next life, I'm gonna be a photographer." When I realized that this *was* my next life, a new chapter, I took an online course in photography and then just started shooting. I did my first job about six months ago, and while I still have that "fake it till you make it" feeling, my confidence is growing with every shoot. Most of all, it's an amazing feeling to know that you're following a dream that you've had for a long time but never thought you'd fulfill.

Moving to Sri Lanka and changing my career has definitely taught me, as corny it may sound, that you really can do anything you set your mind to. Take that leap of faith, move to another country, quit your job, learn to surf, try something you've always dreamed of. If it doesn't work out you can always go back, but if it does work out you might find you've created your dream life. That's what I feel like I've done, and I'm really proud of myself for doing it. Nothing is perfect, and I still have my struggles—I've been through depression and it's something I'll always battle with. But doing things that I love—surfing, rescuing dogs, being close to nature, and turning my passion into a career—has made me the happiest I've ever been.

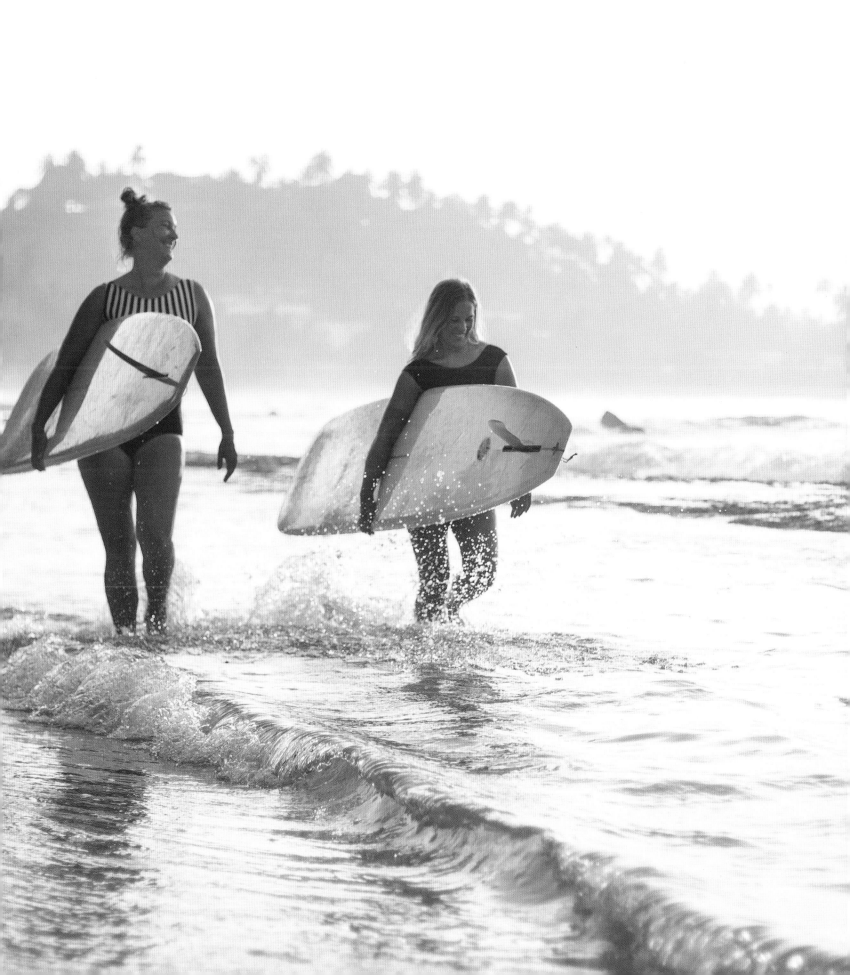

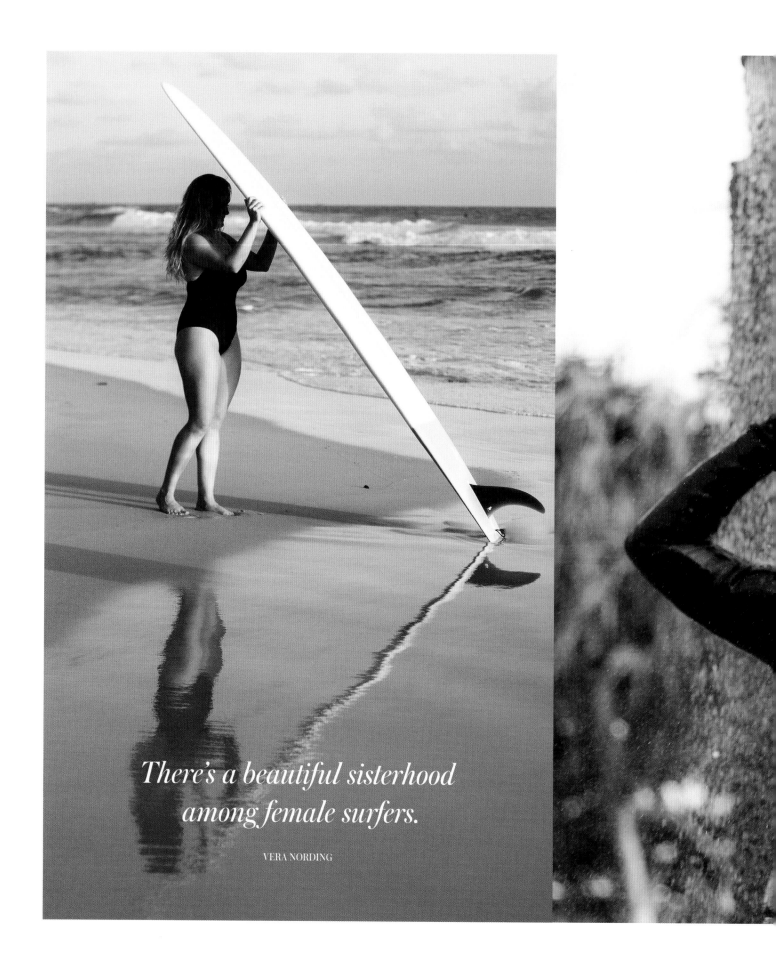

There's a beautiful sisterhood among female surfers.

VERA NORDING

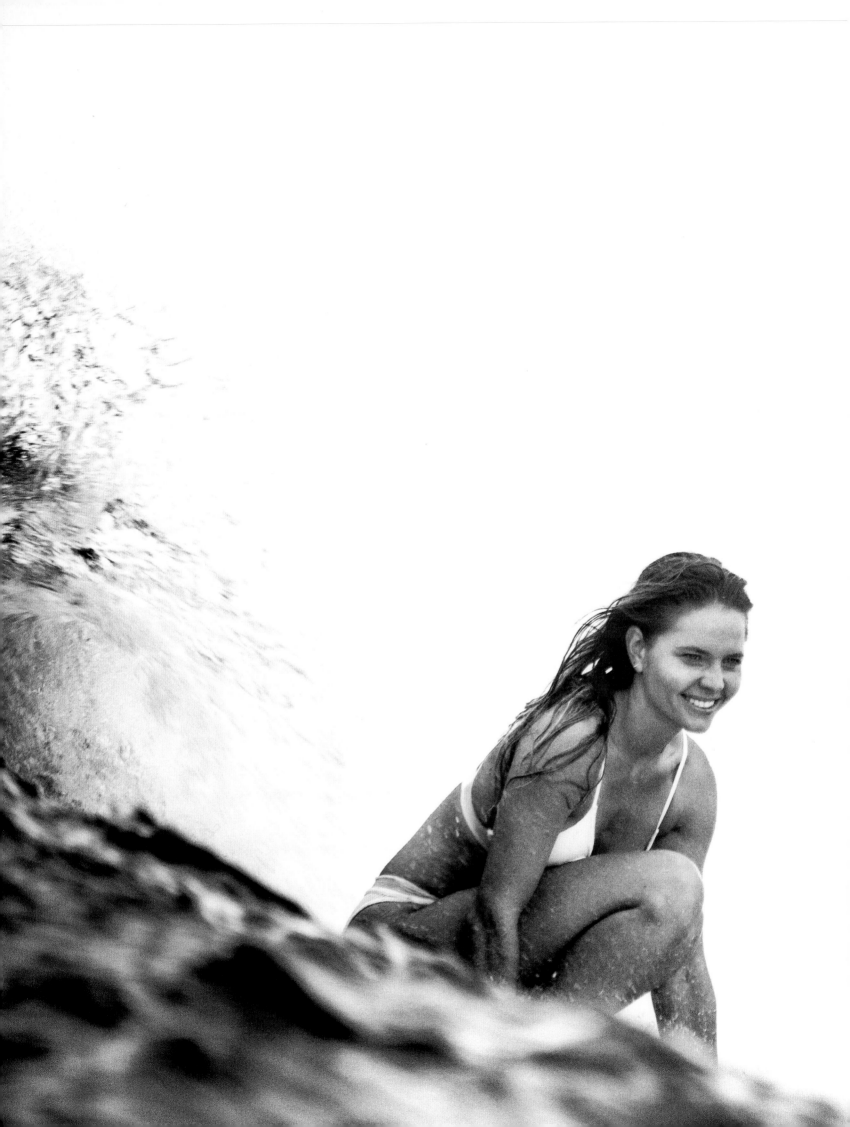

Séréna Lutton
Creative director, magazine maker,
image lover

@serenalutton

I'm currently based in Southern California but I was born in France in the middle of nowhere, in a part of the country where nothing happens. However, I was lucky enough to have the opportunity to spend half my time in Biarritz, in the southwest of France. Being close to the water opens your mind and gives you perspective.

I bought my first camera at the age of twelve and started to organize photo shoots with my friends. I'd buy clothes on the day and then take them back to the shop the next. It was fun!

At nineteen, after graduating with a degree in graphic design, I hit the road and went to Australia for a year,

alone and without knowing how to speak English. It turned out to be the best decision of my life. Today, here in California, I collaborate with many inspiring people, brands, and publications, and I'm so grateful for that. The light, the people, the culture, the different forms of typography you find in every corner—it's unlike anywhere else.

Photography is a magical medium for transcribing moments and feelings. Recently my photography has become more directed than in the past, but with the same aim in mind: to capture moments of purity and tell stories through my work. As someone I love once told me: "In life, the only chance you have is the one you give yourself."

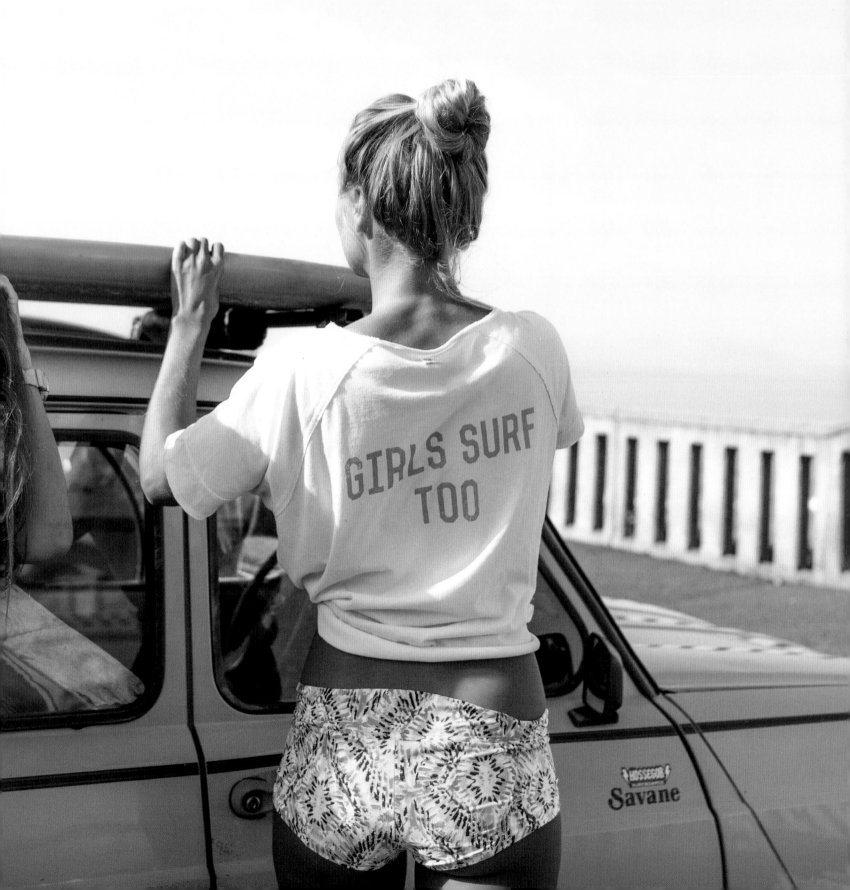

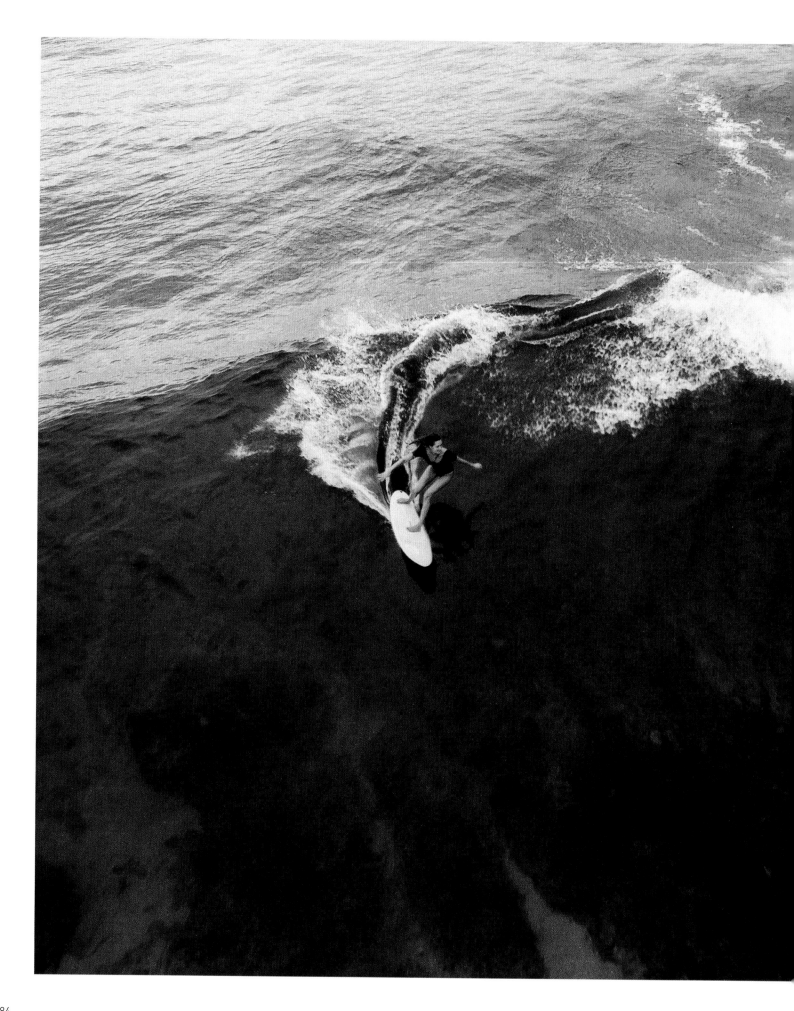

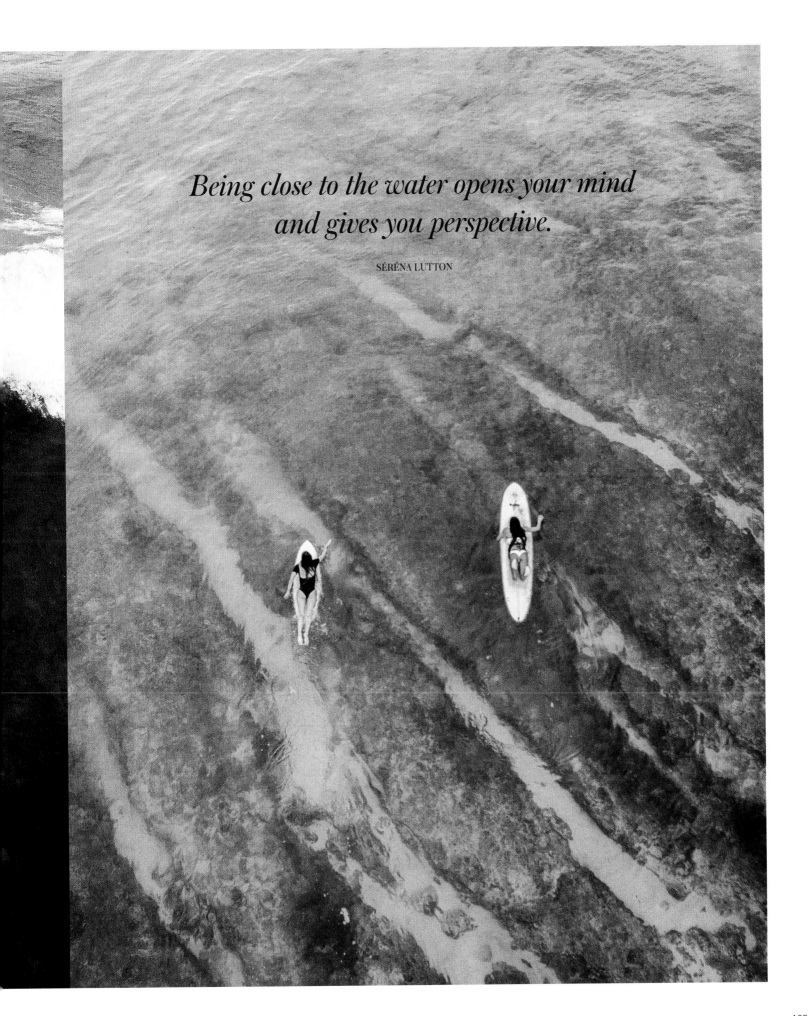

*Being close to the water opens your mind
and gives you perspective.*

SÉRÉNA LUTTON

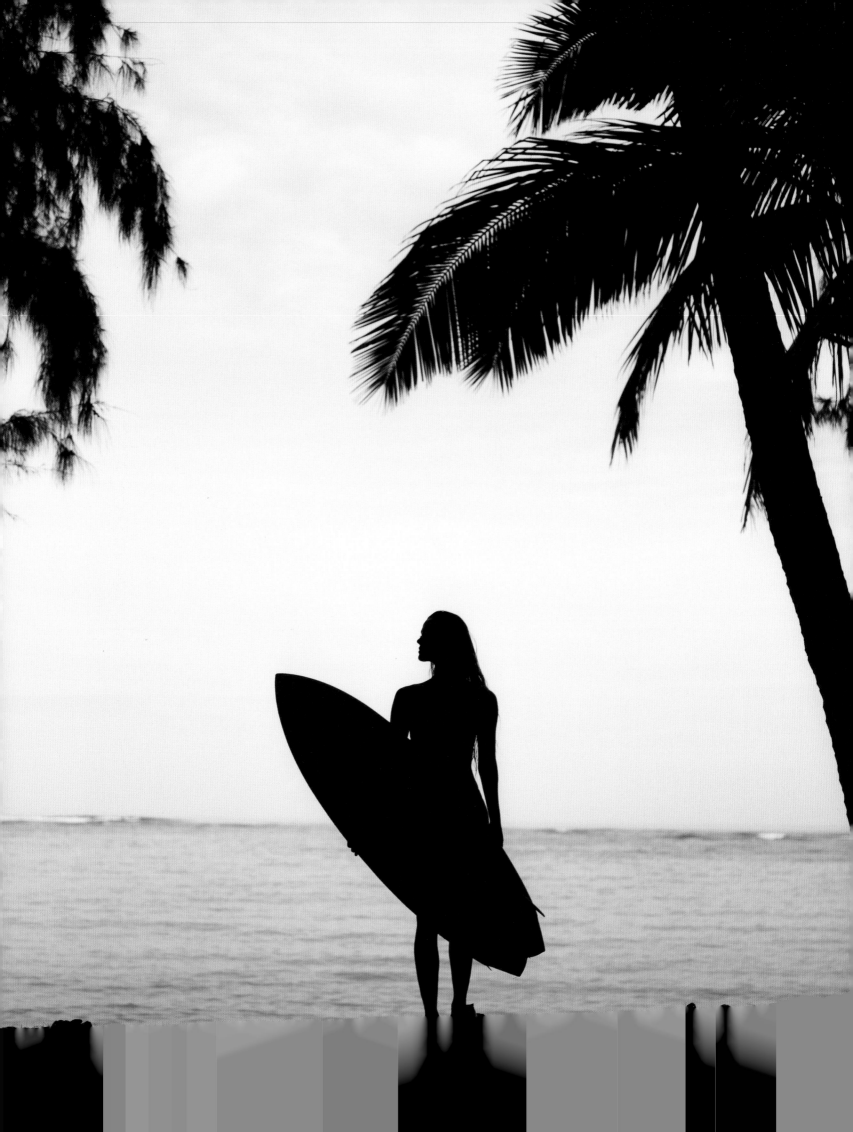

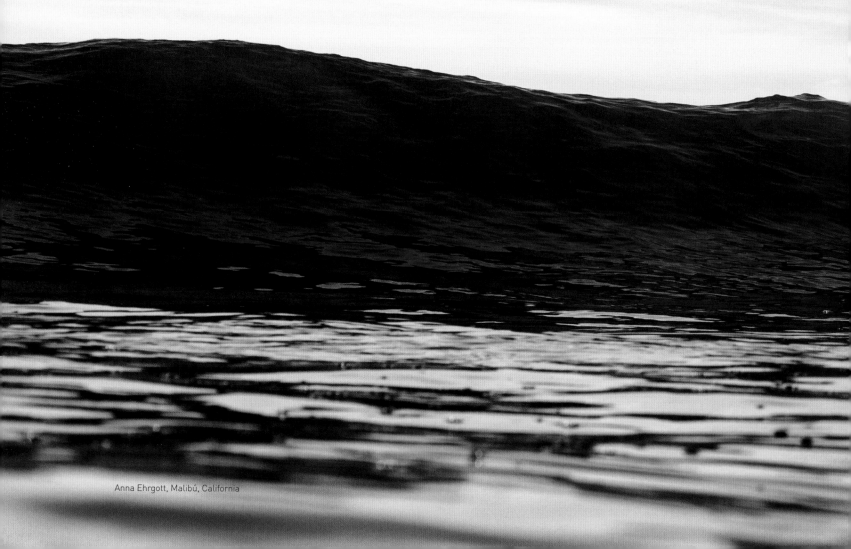

Gone surfing.

Anna Ehrgott, Malibú, California

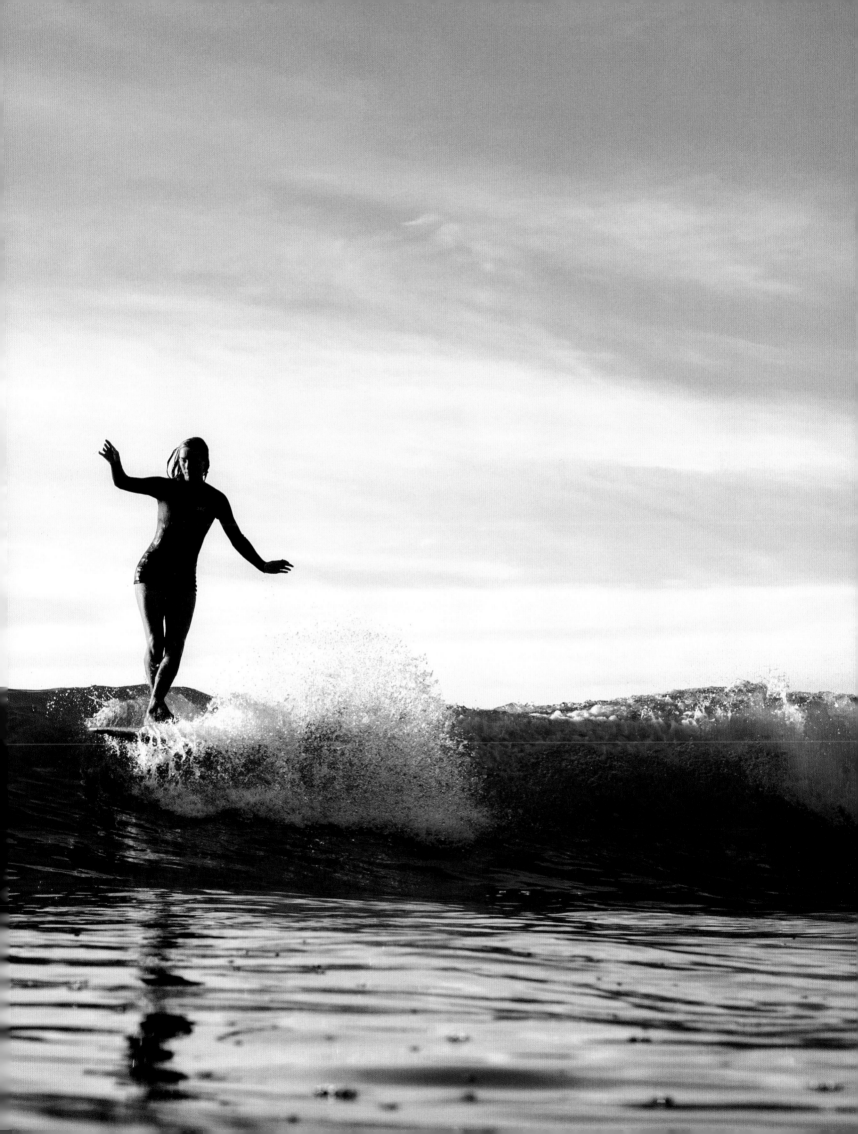

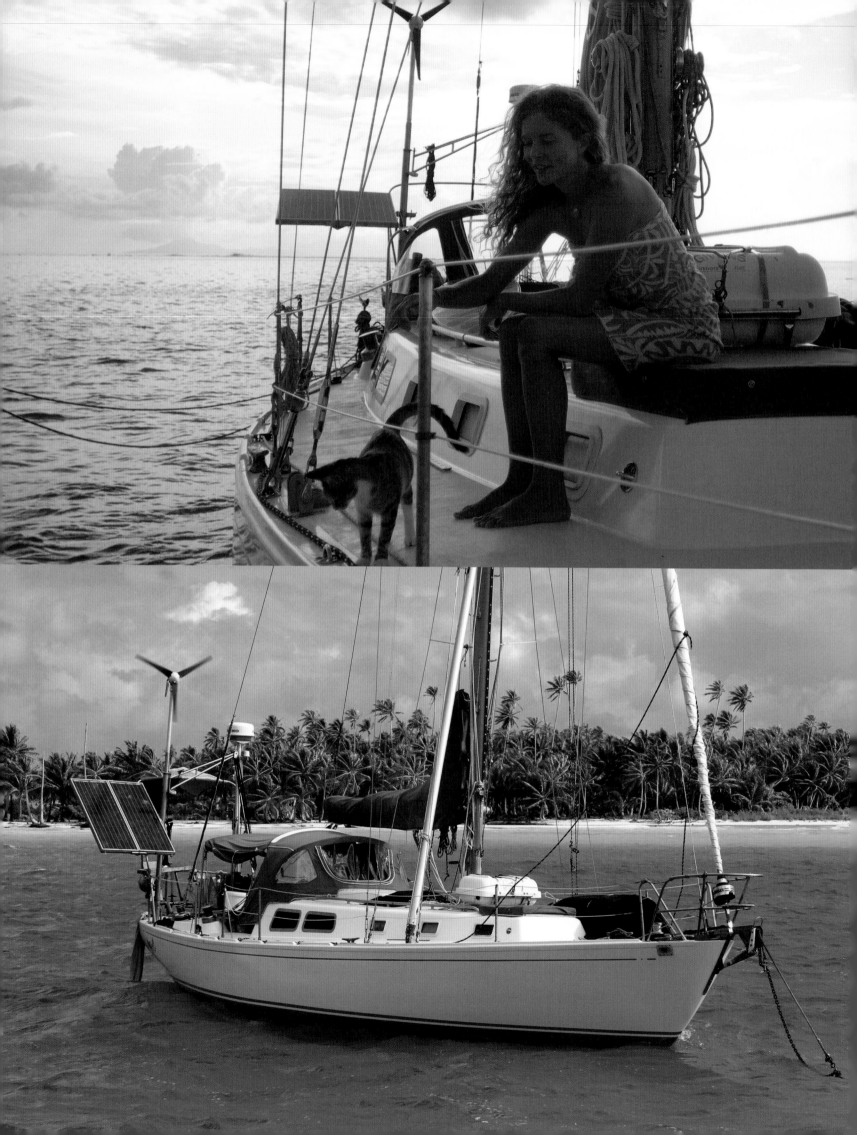

Liz Clark
Surfer and captain

@captainlizclark

I left California aboard my forty-foot sailboat, *Swell*, in 2006 and since then have covered over 20,000 nautical miles in the Pacific, searching for remote waves to surf, exploring new cultures, seeking truth, living simply from the sea, and sharing my adventures through writing and photography. As an environmental activist and captain of my dreams, I hope to inspire people to live their passions and to reconnect with nature and our inherent oneness.

You are here to live out your dreams. Follow what thrills you, work hard, choose love over fear—the universe will support you when you commit to your truest desires.

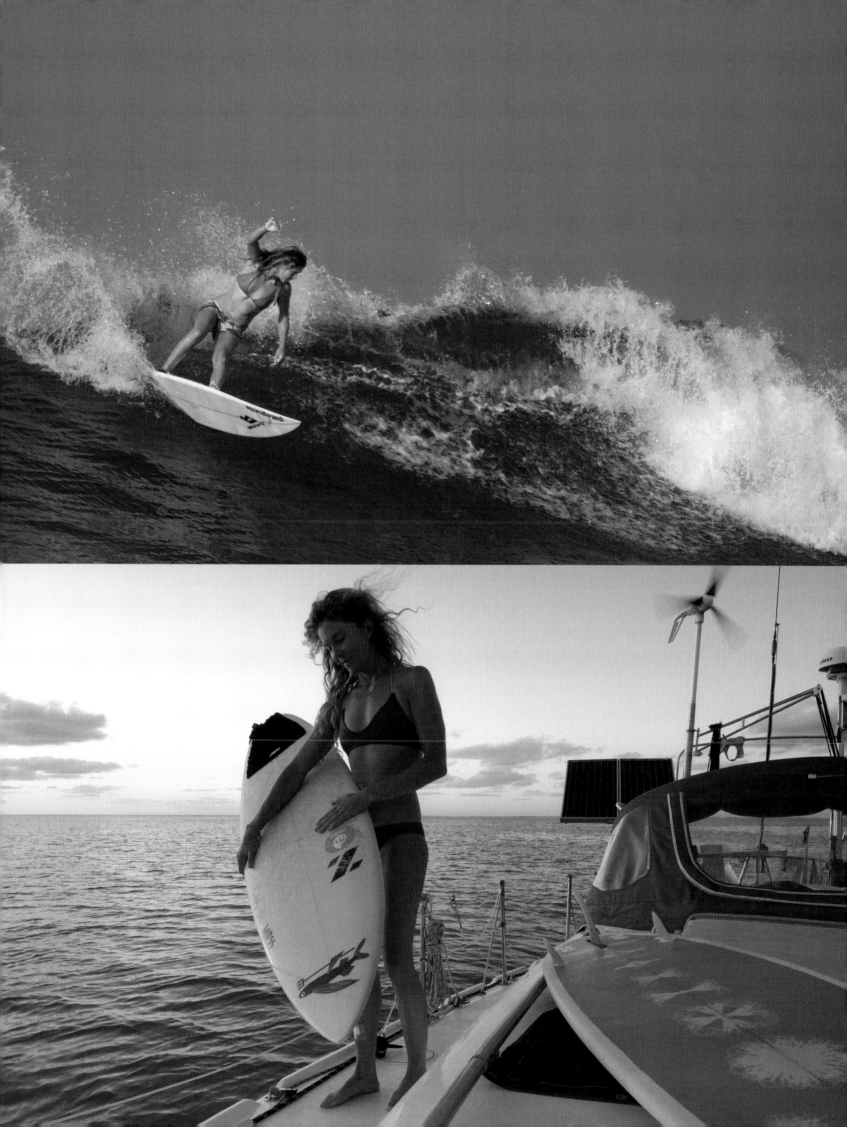

Follow what thrills you, work hard, choose love over fear—the universe will support you when you commit to your truest desires.

LIZ CLARK

Tiffany Carothers, Martina Burtscher & Amanda Prifti

Co-founders of
the Arugam Bay Girls Surf Club

@abay_girls_surf_club

We are three passionate surfers working to create positive change in Sri Lanka's surf communities.

Tiffany: I'm from the US, and since 2011 I've been working in community development through the volunteer-run organization Surfing the Nations. In 2015 I started leading weekly "Girls Make Waves" surf sessions for local women in Arugam Bay, encouraging and teaching them to surf.

Martina: I'm originally from Austria and came to Arugam Bay in 2017 to do research for my master's thesis on the potential of surfing for women's empowerment. Learning about the barriers that Sri Lankan women face in learning to surf, I returned here after graduating to help the local girls establish their own surf club.

Amanda: I came to Sri Lanka from the US in early 2018, while writing my master's thesis on environmental hazards in coastal areas. After falling in love with the country, I returned hoping to find a way to give back through my background in environmental protection and international development.

Alongside local women, the three of us established the Arugam Bay Girls Surf Club (ABGSC), Sri Lanka's first all-female surf club. It's run by its local members, and we support the club by providing swimming and surfing lessons, and assisting with marketing, social media, and fundraising.

In Sri Lanka, women who want to surf face many cultural barriers. We believe that everybody deserves to enjoy the waves, so we co-initiated the ABGSC to create a safe space for Sri Lankan women to learn to surf. With the ABGSC, we aim to empower women through surfing, restore the safety of the ocean following the 2004 Indian Ocean earthquake and tsunami, and spread environmental awareness.

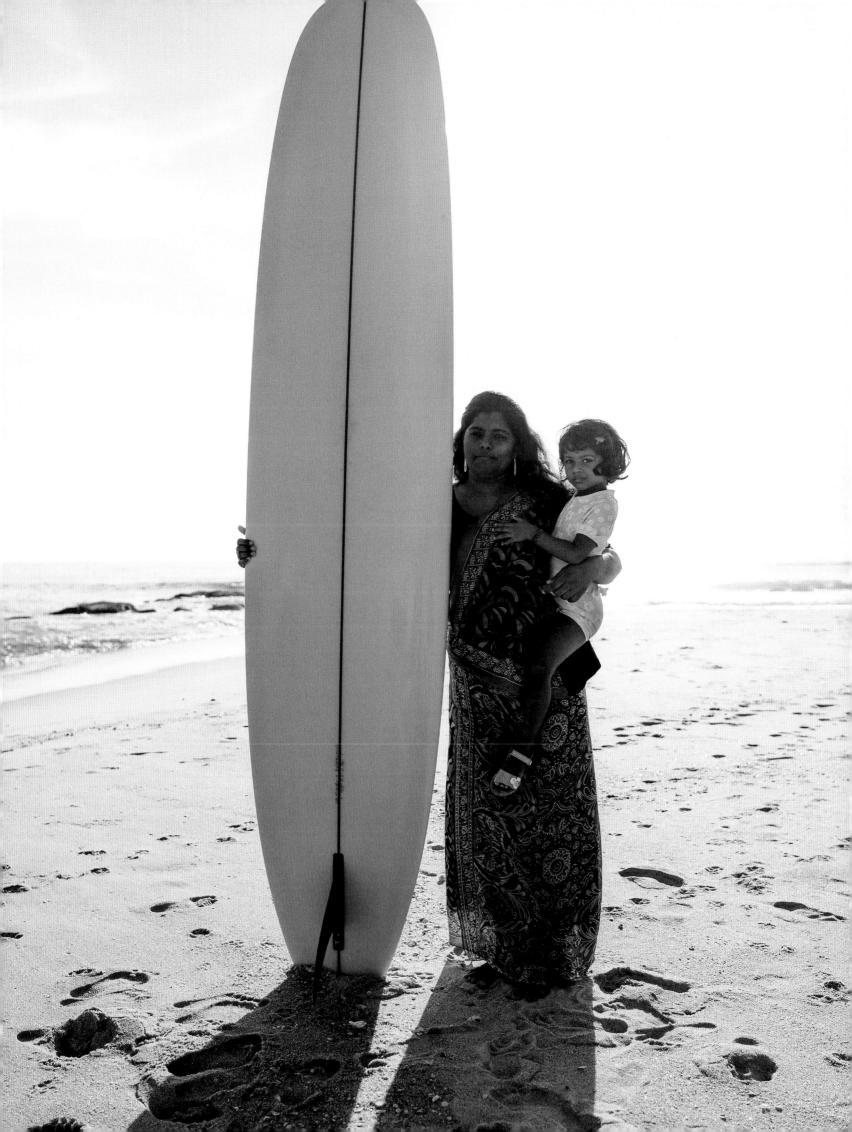

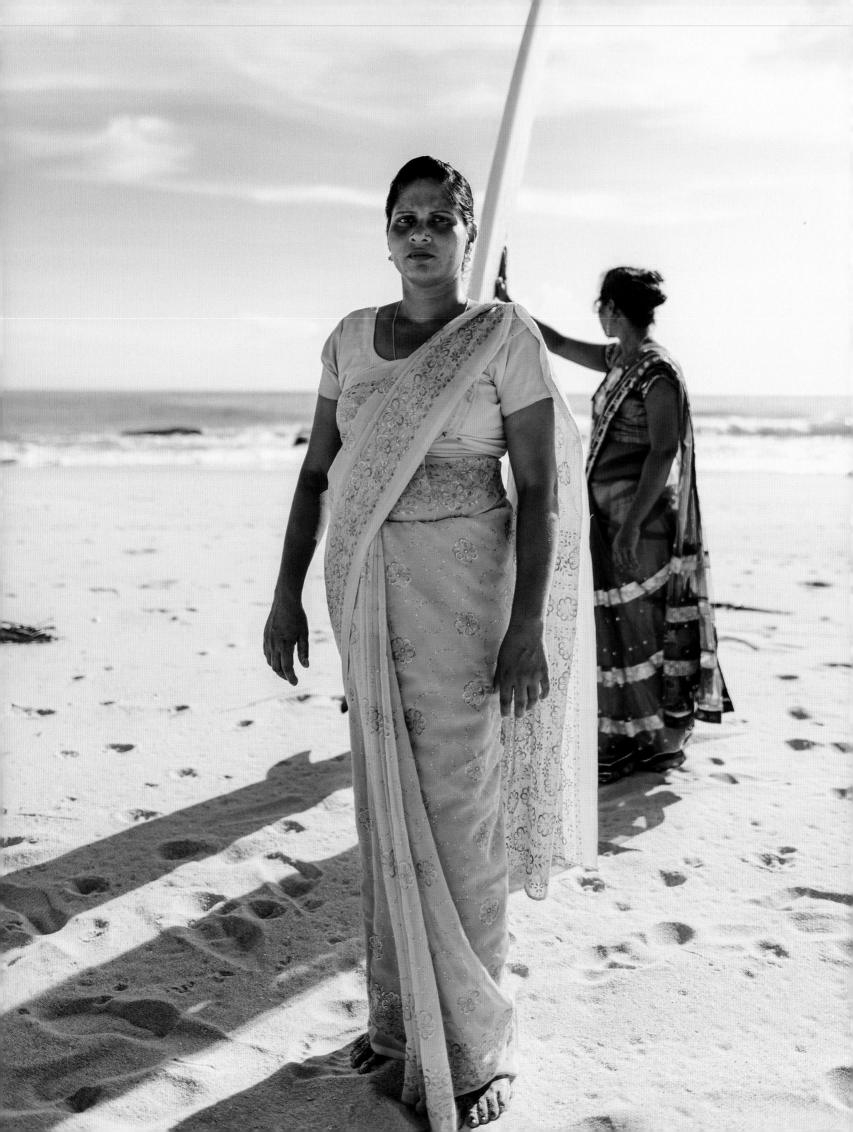

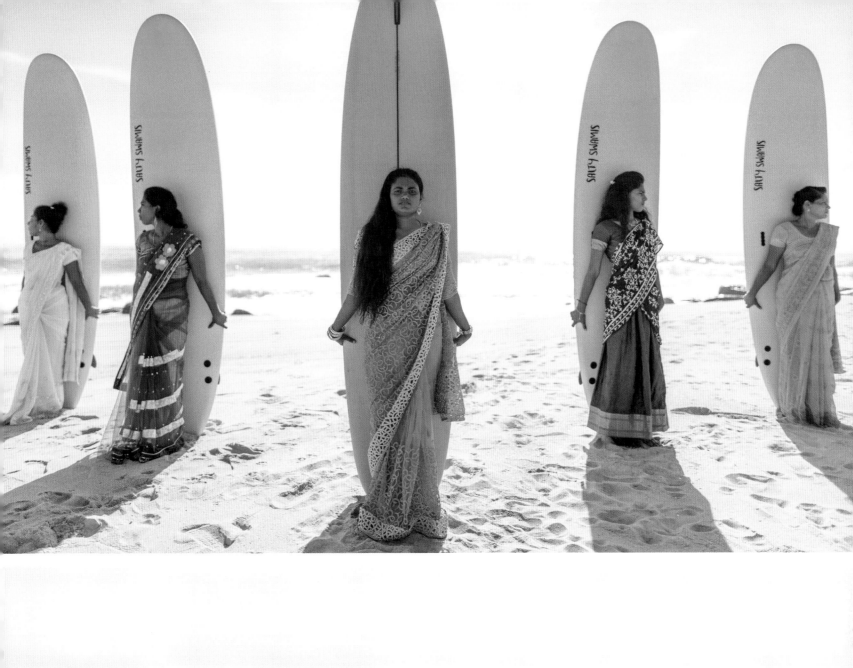
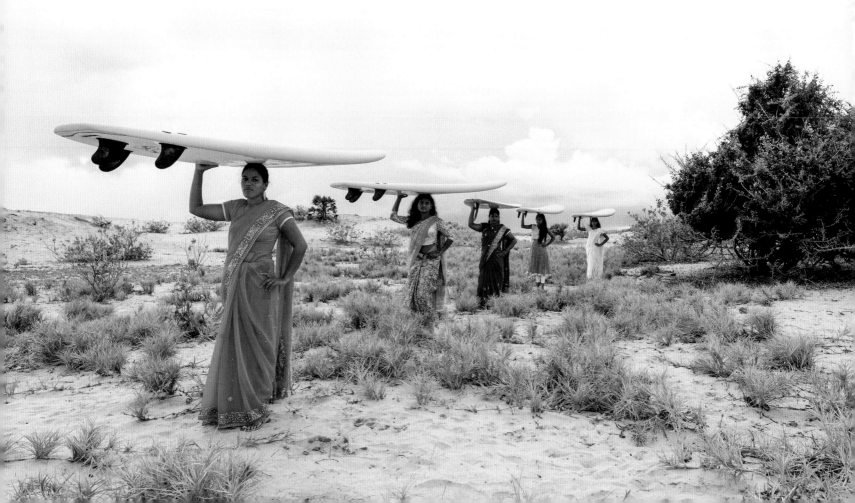

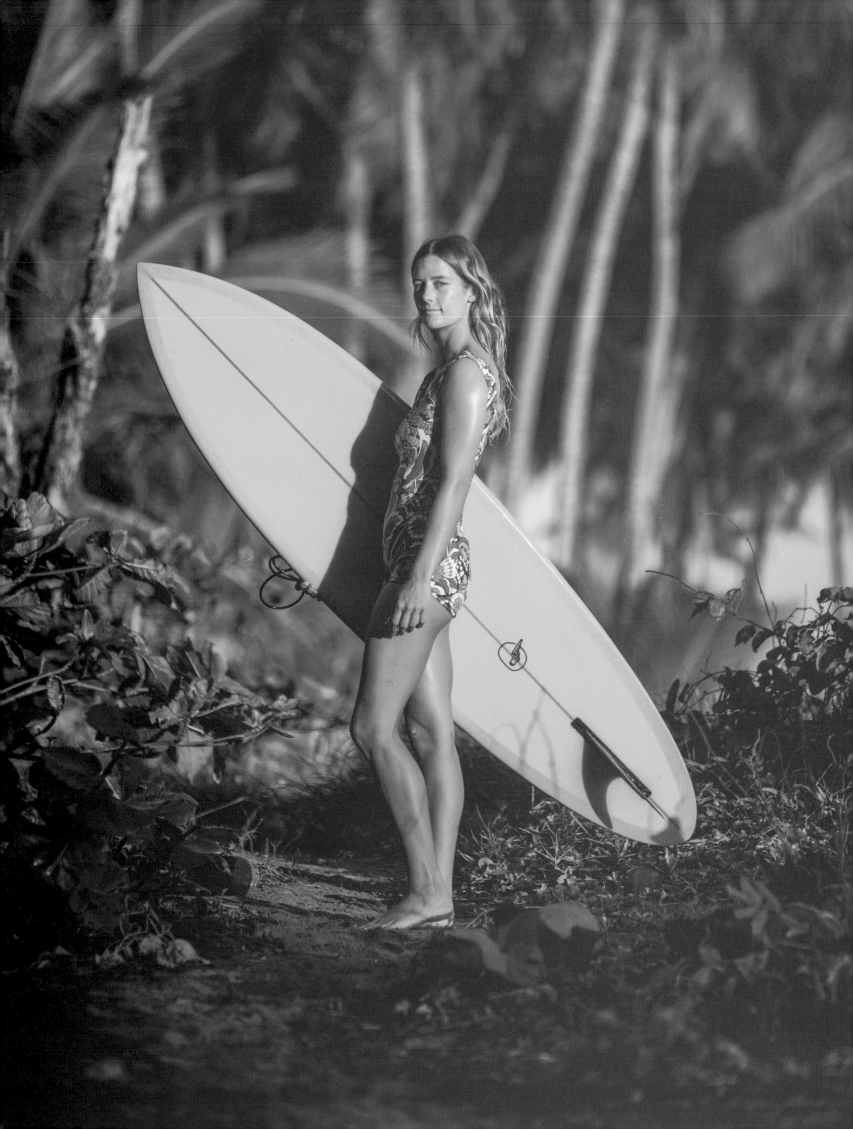

Sarah Brady
Surfer and activist

@sarahhbrady

I am a surfer, a student of sociocultural anthropology at the University of California, San Diego, and Environmental Research Associate and Community Organizer for a small nonprofit organization called Committee to Bridge the Gap, where I lead efforts for safer storage of the nuclear waste at San Onofre. I grew up just thirty minutes south of San Onofre, in Encinitas, and it's one of my favorite surfing beaches in Southern California. My dad first took me surfing with him when I was two and a half years old, and I fell in love with the ocean.

When I learned about the earth's environmental crisis and that humans were causing it, I felt compelled to do something that would help shift the global understanding of our relationship to nature from domination to reciprocity and reverence. I understood that there's a need for a major shift in consciousness, and I thought about my own life and how

I had been able to feel connected to nature through surfing. I began to see surfing as an avenue for connecting with other eco-conscious water women who want to create meaningful change in the world—and have fun at the same time.

A few years ago I met Becky Mendoza and Leah Dawson, co-founders of the Changing Tides Foundation, and immediately fell an affinity with their organization's mission to spread environmental awareness and support action in the global adventure sports community, especially focusing on women. About six months later I was delivering sustainable hurricane relief supplies to the Virgin Islands on their behalf, and then I joined Becky and Leah in the Dominican Republic, where we met the women and girls of the Mariposa DR Foundation. We surfed with them, and Leah made *Sameseas*, a short film about the Foundation's programs that is now traveling all over the US in the Women's Adventure Film Tour.

Surfing allows me to feel connected to nature.

SARAH BRADY

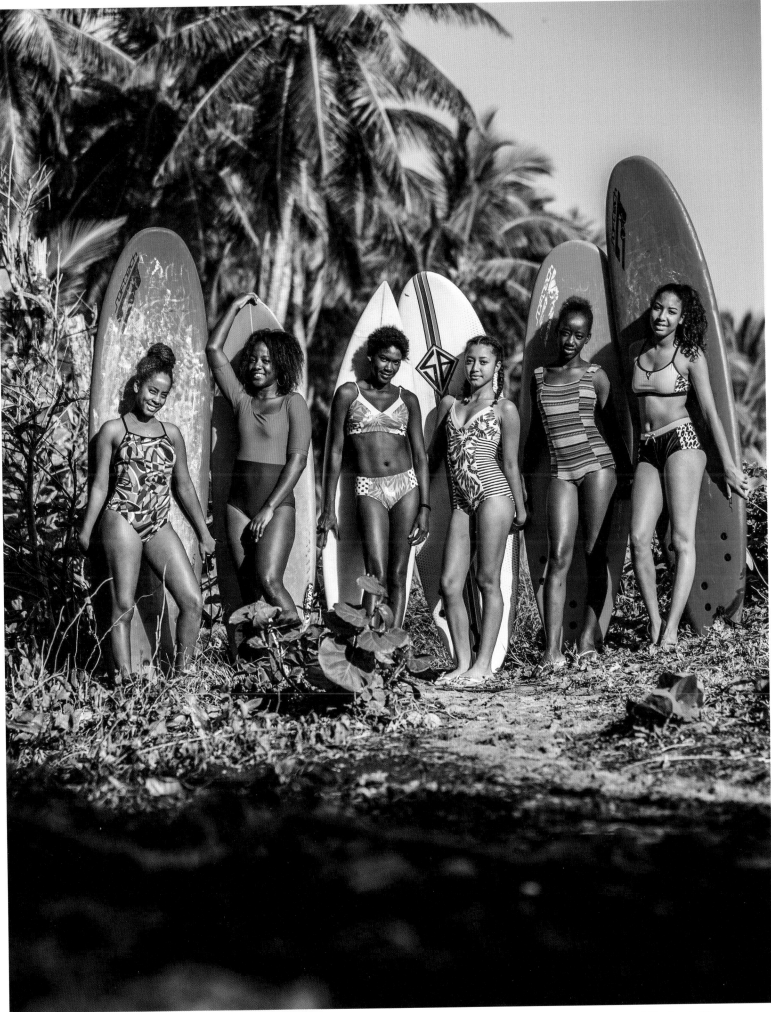

◁ Cloudbreak, Fiji

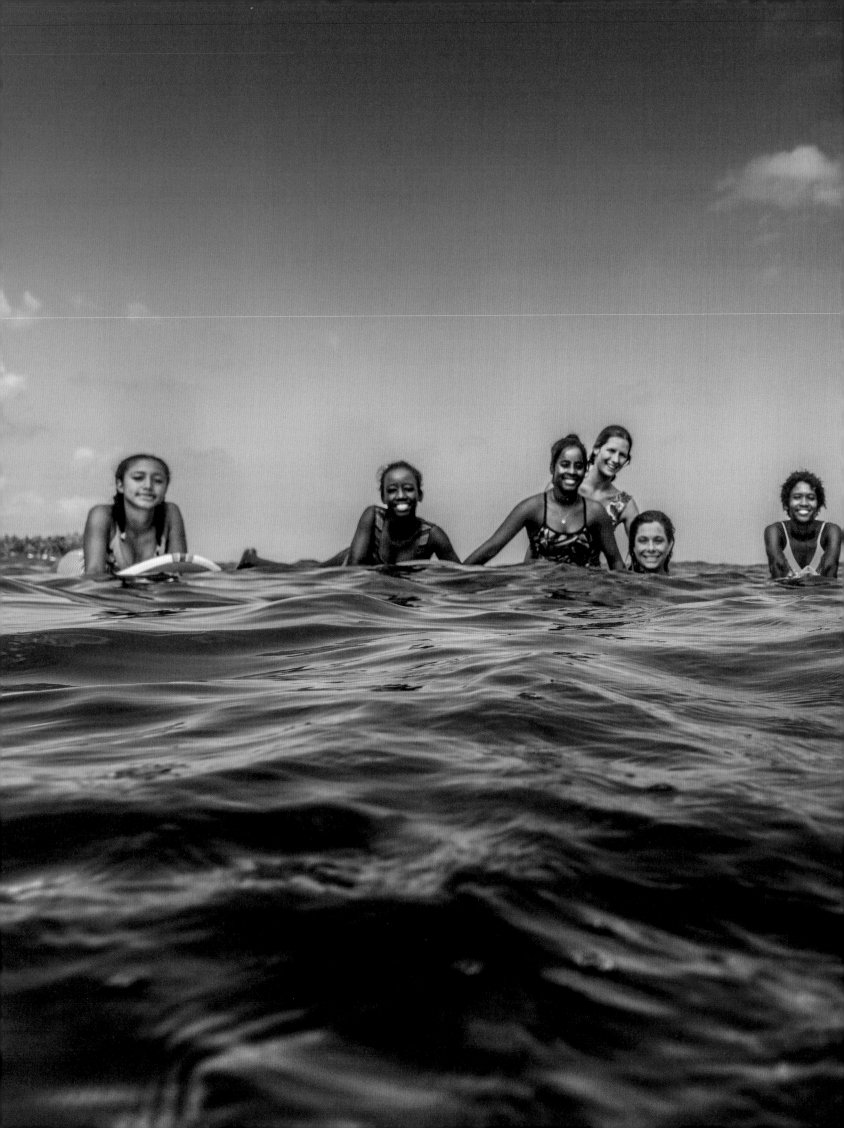

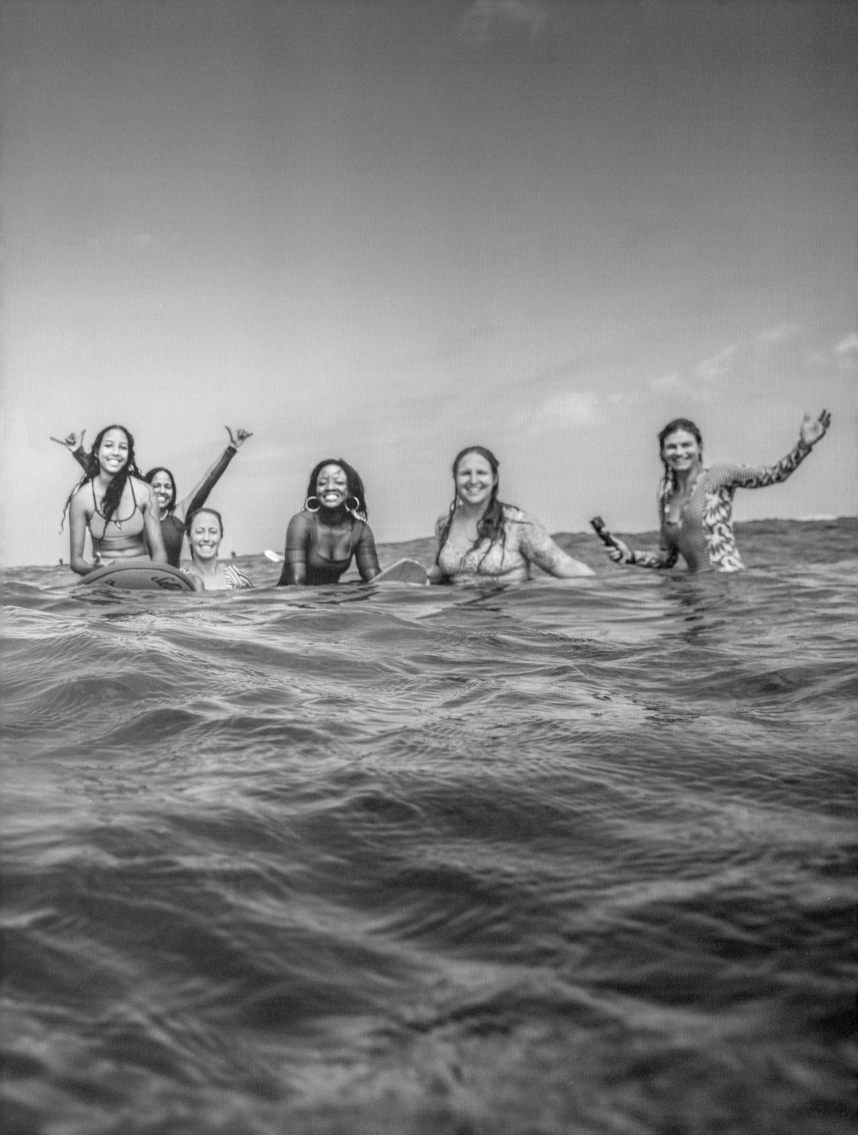

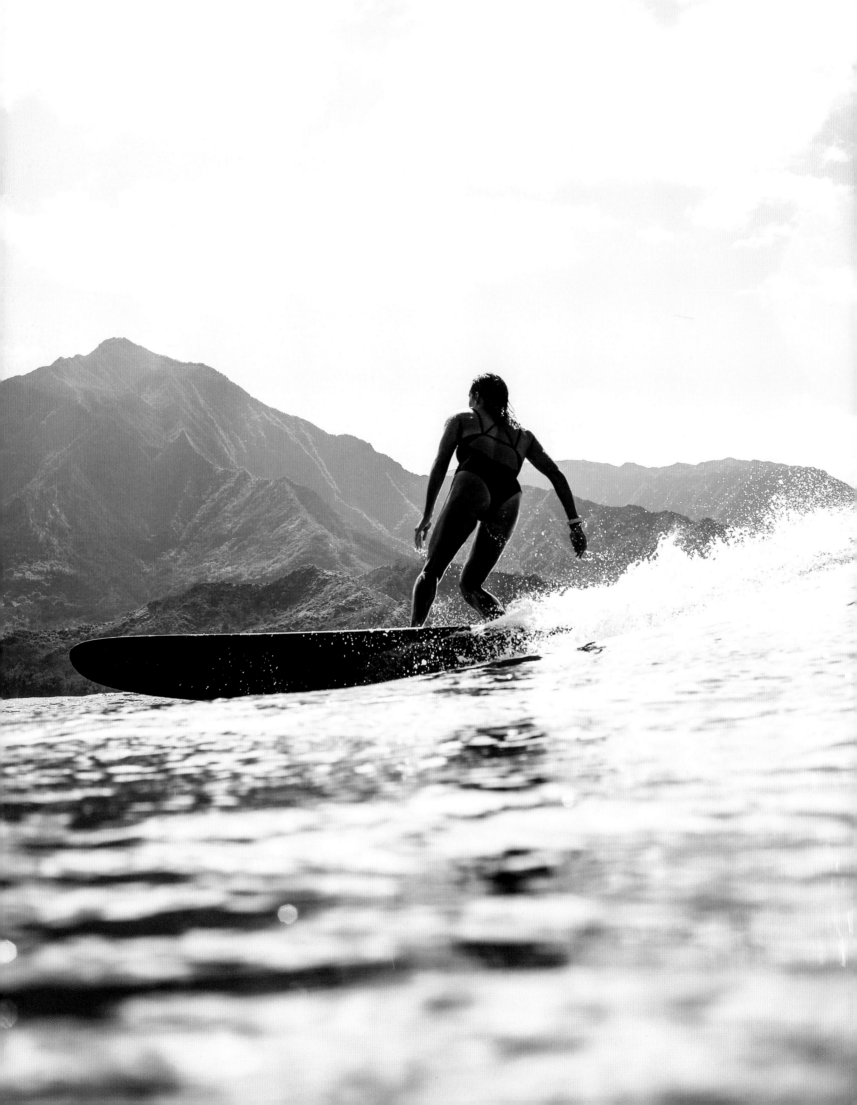

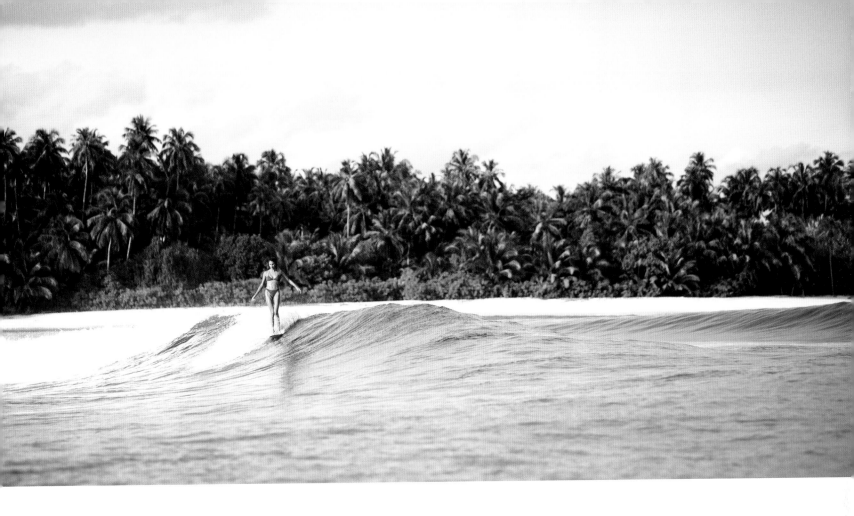

Tahnei Roy
Filmmaker, editor, photographer

@tahneinei

I was born and raised on the North Shore of Oahu, Hawaii. Growing up I spent my days playing in the waves or hiking in the mountains behind my house, and all of my friends were within a ten-minute bike ride away—I was always outside in nature.

Hawaii is the most beautiful and pristine place on earth, and it made for a pretty nice backdrop to the surreal moments that filled my childhood. At thirteen I bought my first camera and then soon afterwards a housing for it. It was a tiny Canon point-and-shoot that took both photos and video. I think I still have it somewhere. I started documenting the adventures I was sharing with my friends. I fell in love with

capturing raw moments, and being able to look back and remember how I felt at that time. That's really at the core of what I do today: I want people to see my photos and feel something.

I feel very lucky to have found something that I'm so passionate about early on in life. Creativity is one of the most essential aspects of life, and I think that everyone should harness it and hold on to it. We've all got it in one way or another—it's just a matter of getting in touch with it. If you find that thing you love, or something you gravitate toward, stick with it. Do what you love, and you will find a way to get it out into the world.

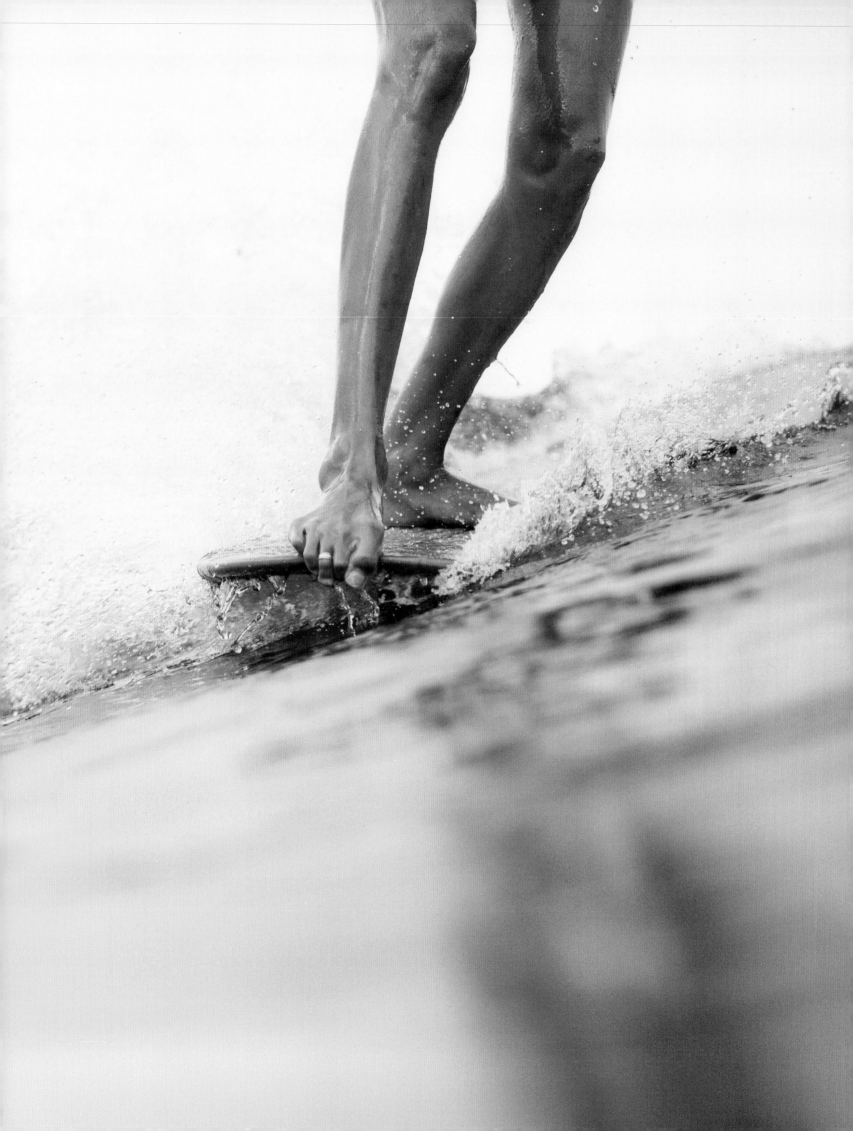

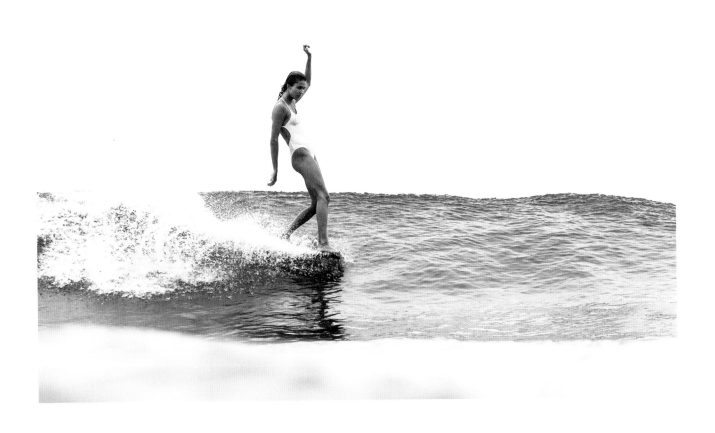

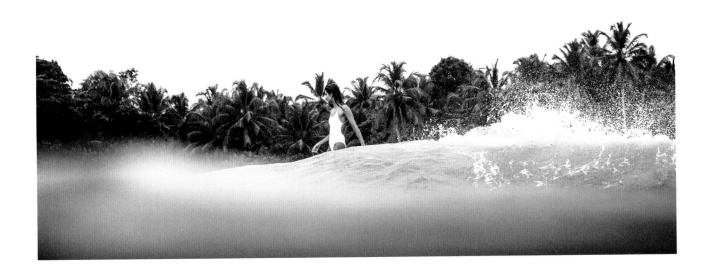

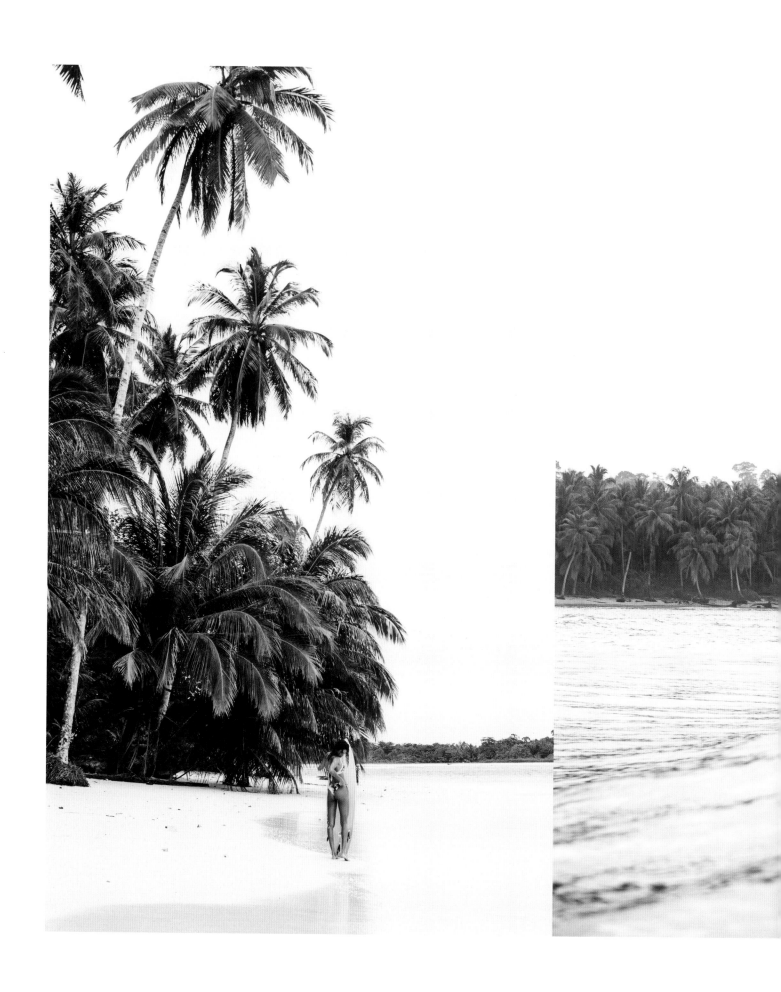

Victoria Vergara, Mentawai Islands, Indonesia Hawaii

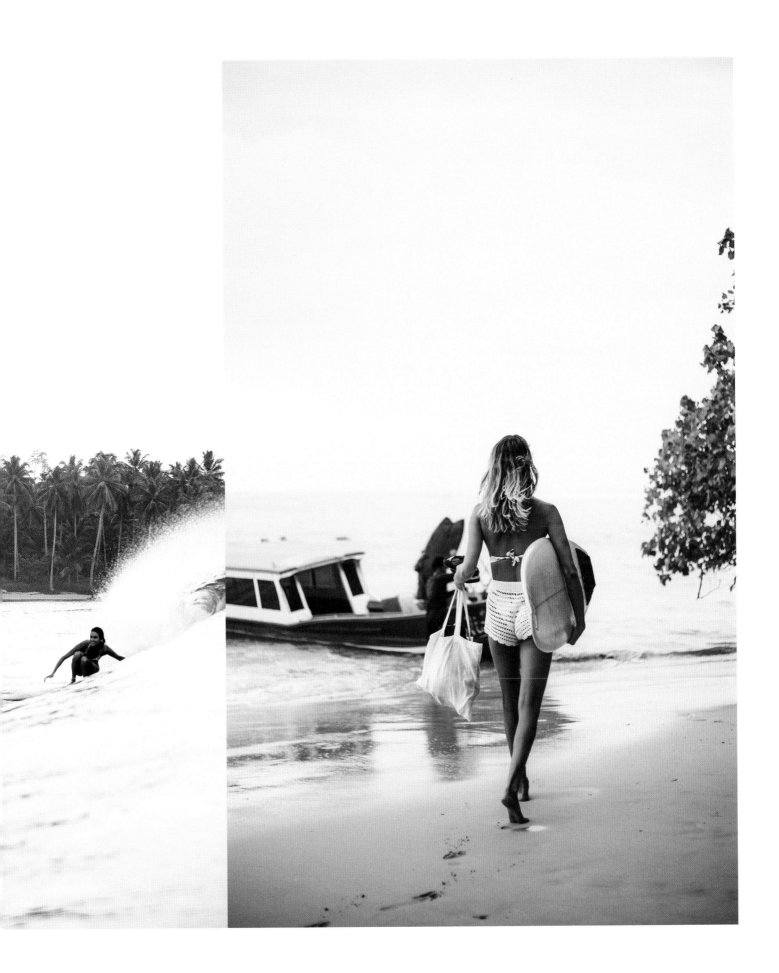

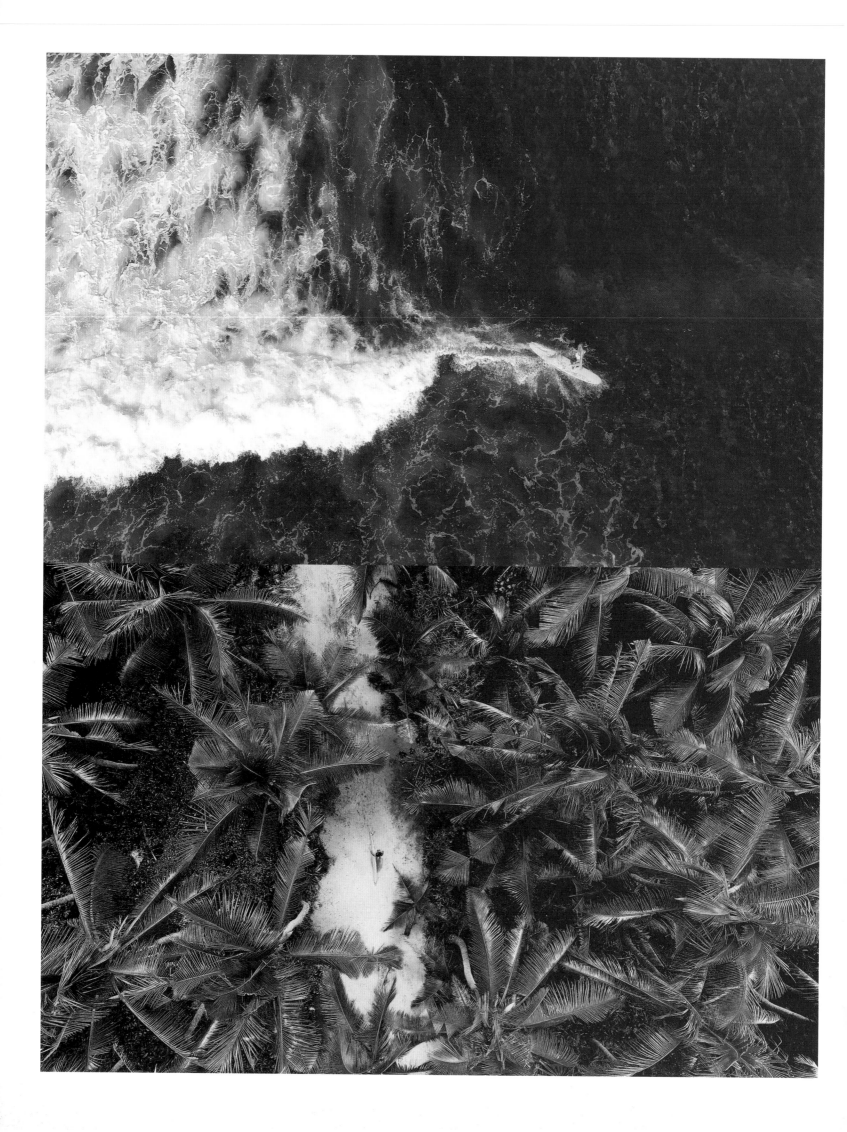

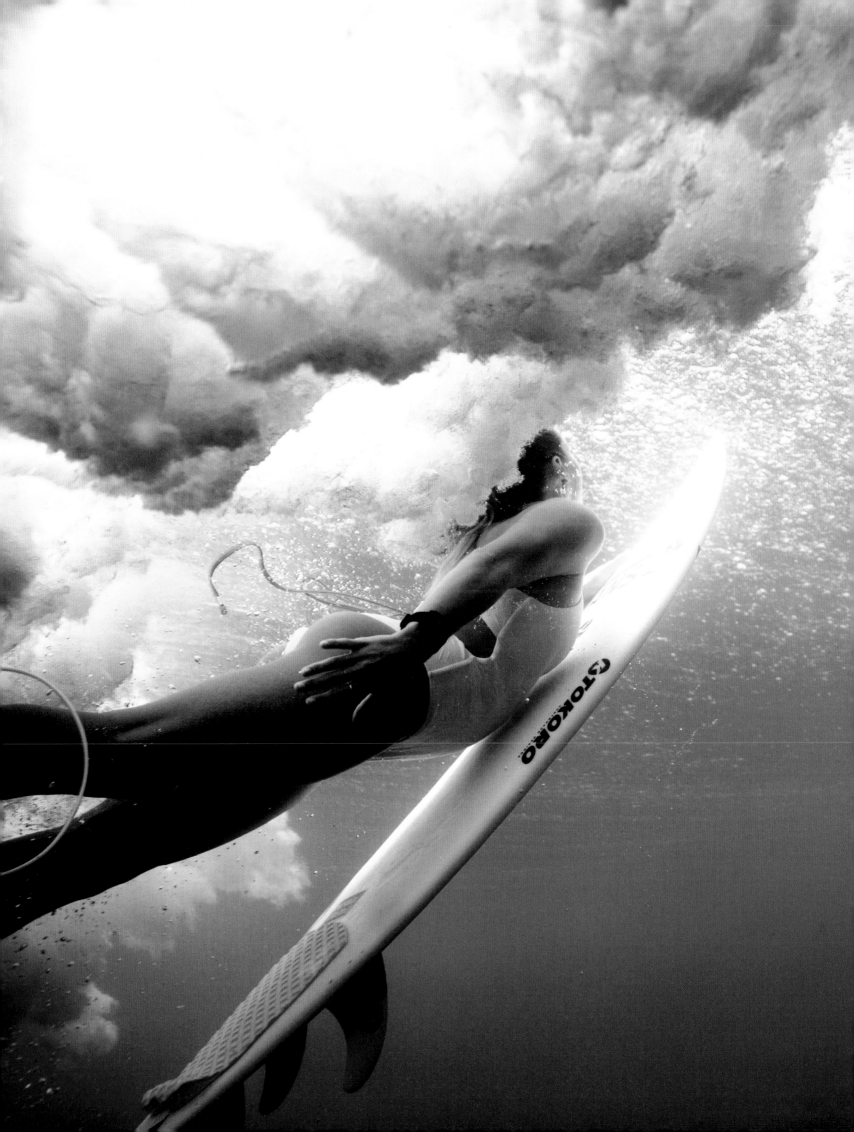

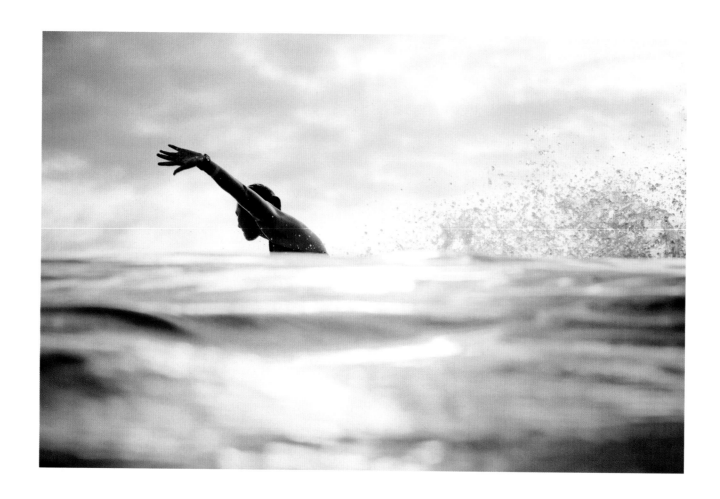

Sarah Lee
Find her in the ocean

@hisarahlee

I'm a photographer with a special love for anything in and under the water. I grew up in a small town nestled on the mountain about twenty minutes from the Kona coast of the Big Island of Hawaii, where I still live. The ocean has always been a big part of my life, but surfing became part of it a bit more recently, over the last ten years. My Hawaii roots have given me a lighthearted and carefree attitude. I like to keep things casual and go with the flow. Brands, athletes, and adventurers take up most of my camera time, but I love carving out time to shoot everyday people doing what they love.

My vision is to create images that capture and accentuate the beauty in what surrounds me. My hope is that my photographs express the magnificence of what it's like to live on this planet and really interact with it. When I'm not on projects that take me swimming around the globe, I like to call Encinitas, California, my second home.

△ Tina Fear, Kona, Hawaii ▷ Karina Rozunko, Oceanside, California

*My Hawaii roots have given me
a lighthearted and carefree attitude.*

SARAH LEE

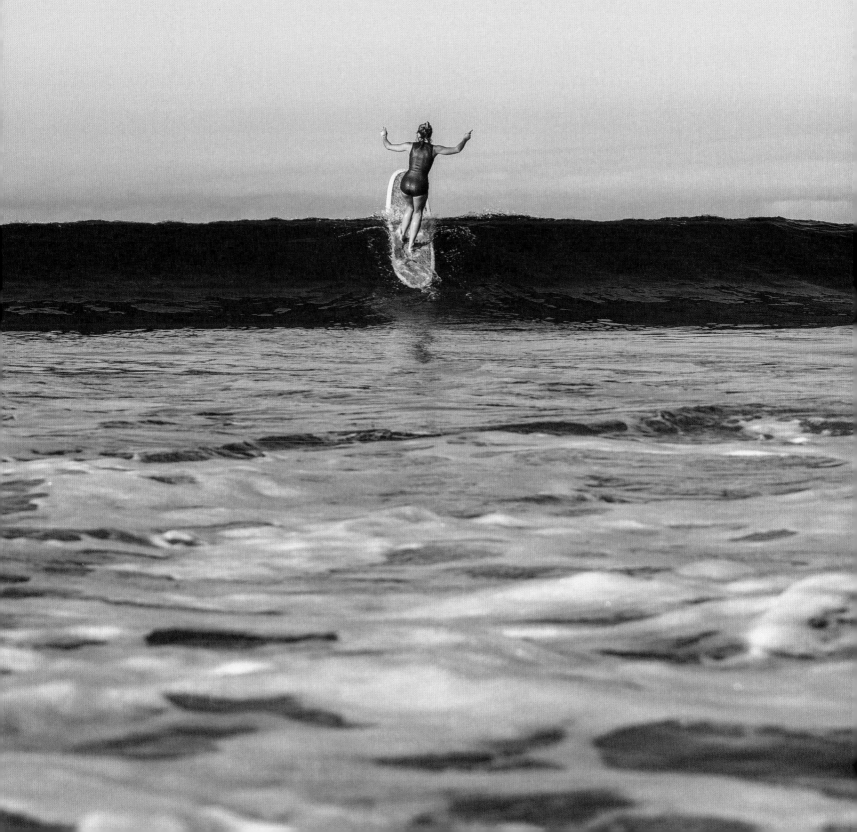

See you
on the next wave.

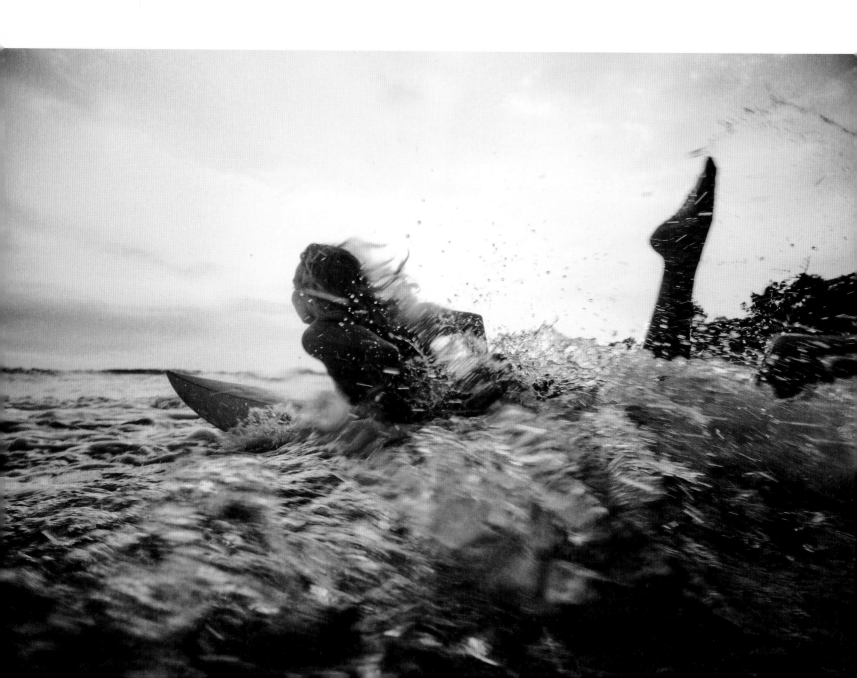

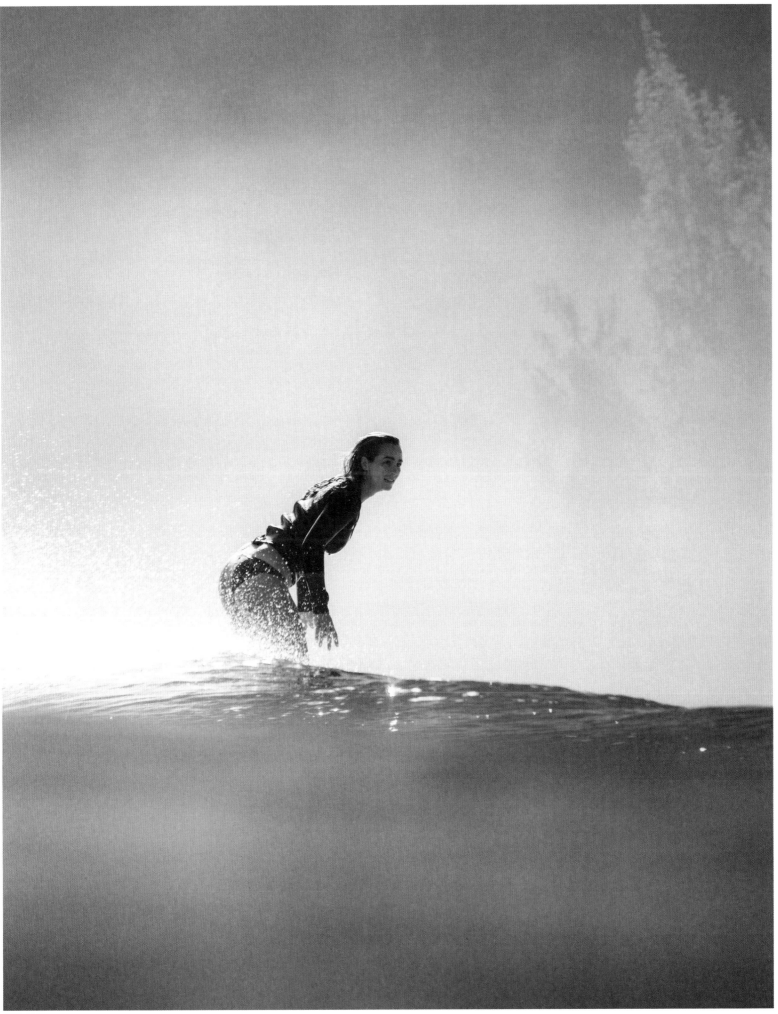

◁ Stephanie Boeckmann, Kona, Hawaii △ Anna Ehrgott, Big Island, Hawaii

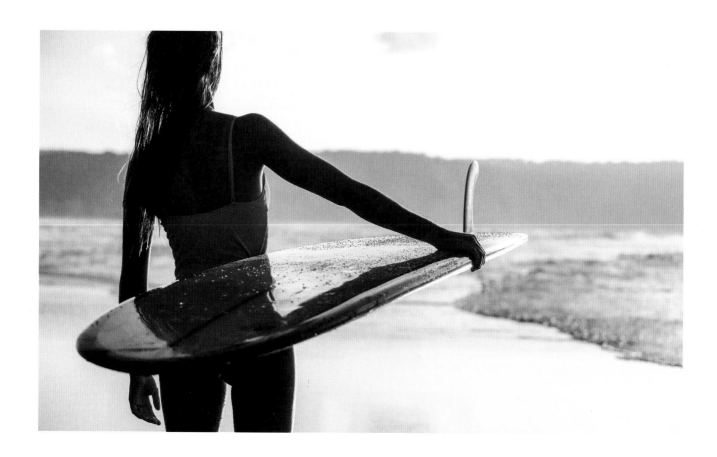

Cécilia Thibier
Surfer and photographer

@ceciliaphotographie

For a lot of people, being a photographer simply means being a person who takes pictures. I'd politely disagree: yes, I take pictures, but behind every one of my photographs is an intention, an emotion, a part of me. It's not just about pressing a button to get a nice image. It's capturing the beauty of the instant, and living each moment to the fullest.

I was born in Paris but moved to the beautiful Basque Country a couple of years ago. In Biarritz I found my personal paradise, my happy place where I could finally live my dream of being a photographer and a surfer. Although it meant leaving a promising career in an exhilarating city behind me,

it was a risk worth taking, and despite the struggle and the unknowns that awaited me I was finally able to free my spirit and follow my path.

Today I know that I chose the right path. I can truly say that I'm in love with what I do, and this fills me with joy and gives me the motivation to carry on looking for new inspiration and purpose. I'm obsessed with combining the mysticism of the ocean and waves with the beauty of women. Catching the perfect moment in the perfect light in the perfect second is what makes photography an everlasting adventure for me. I've found true happiness and satisfaction—for now at least.

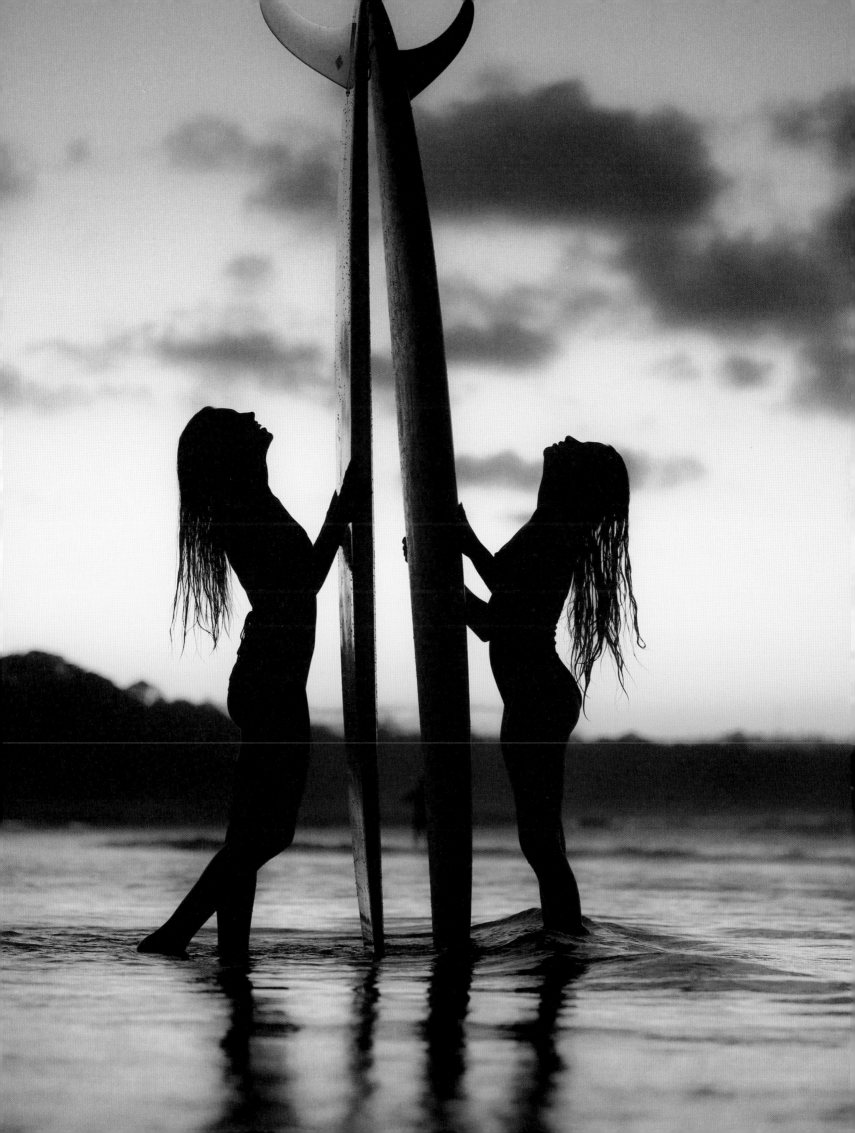

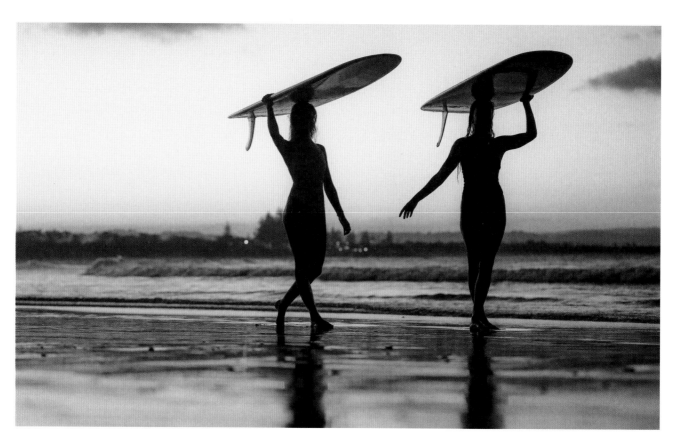

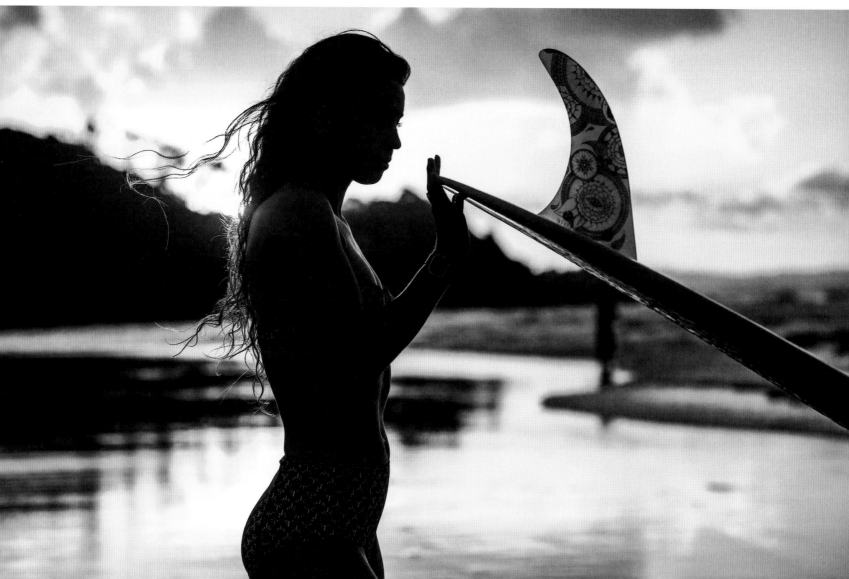

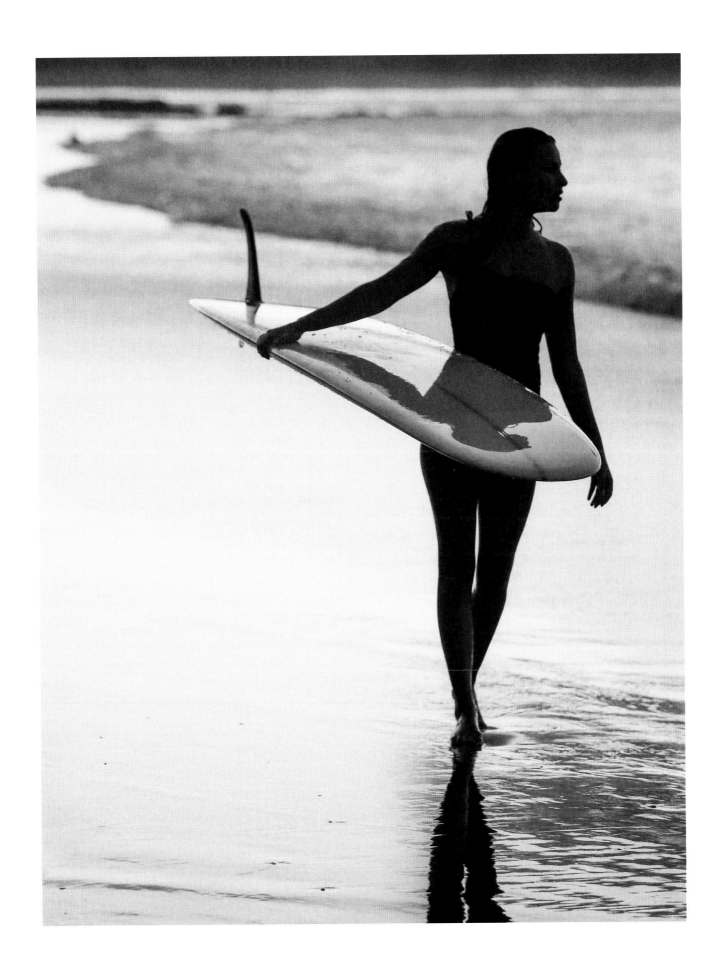

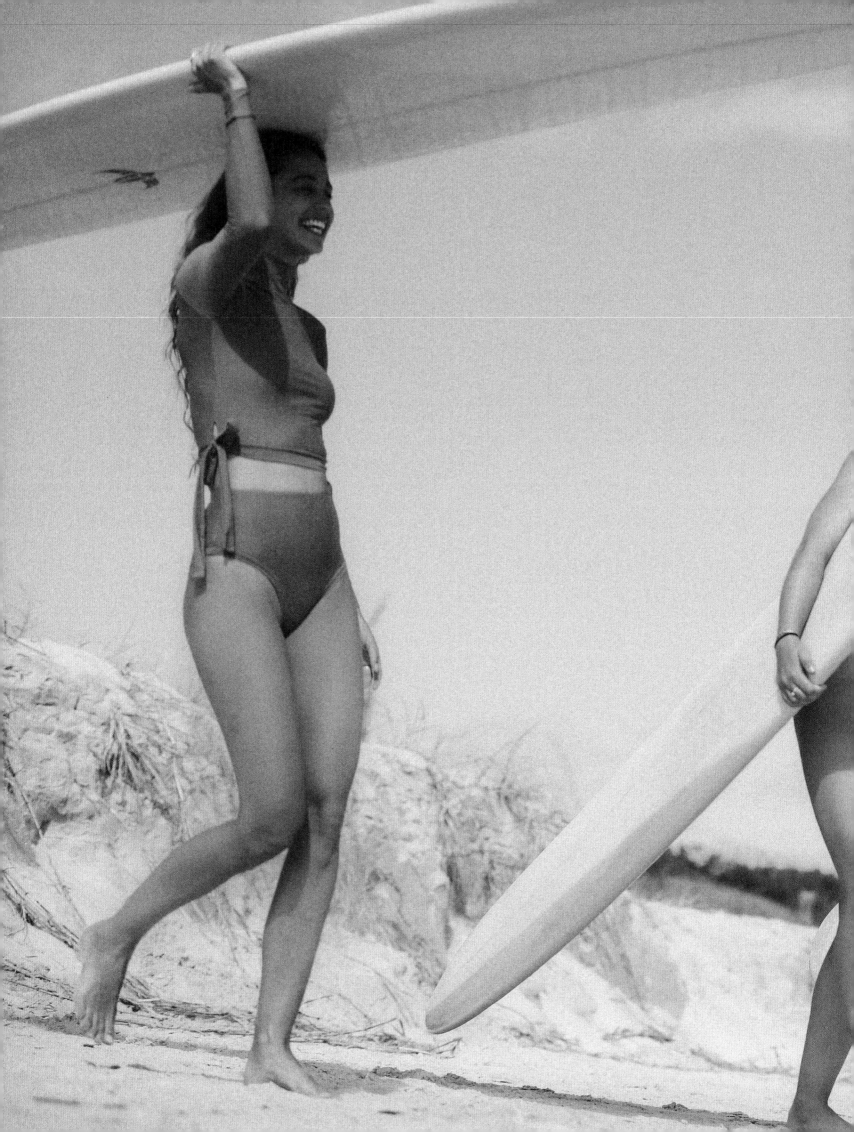

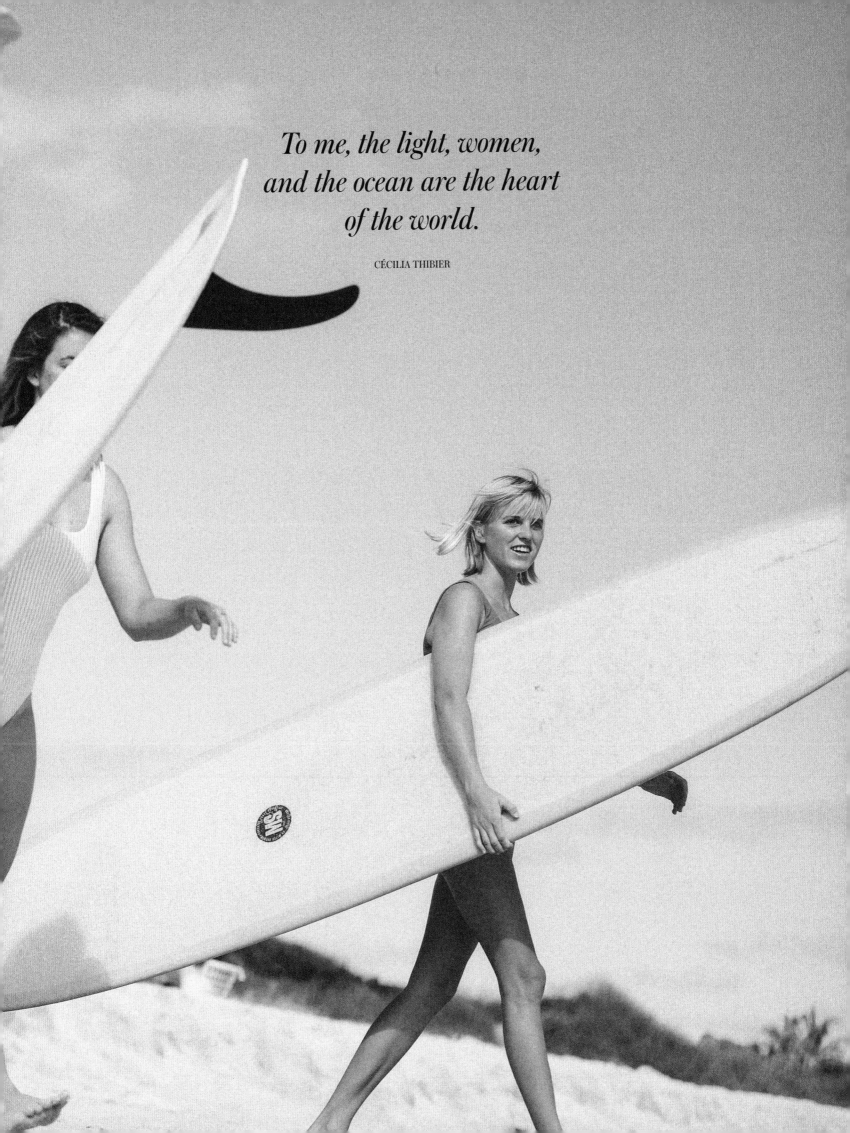

*To me, the light, women,
and the ocean are the heart
of the world.*

CÉCILIA THIBIER

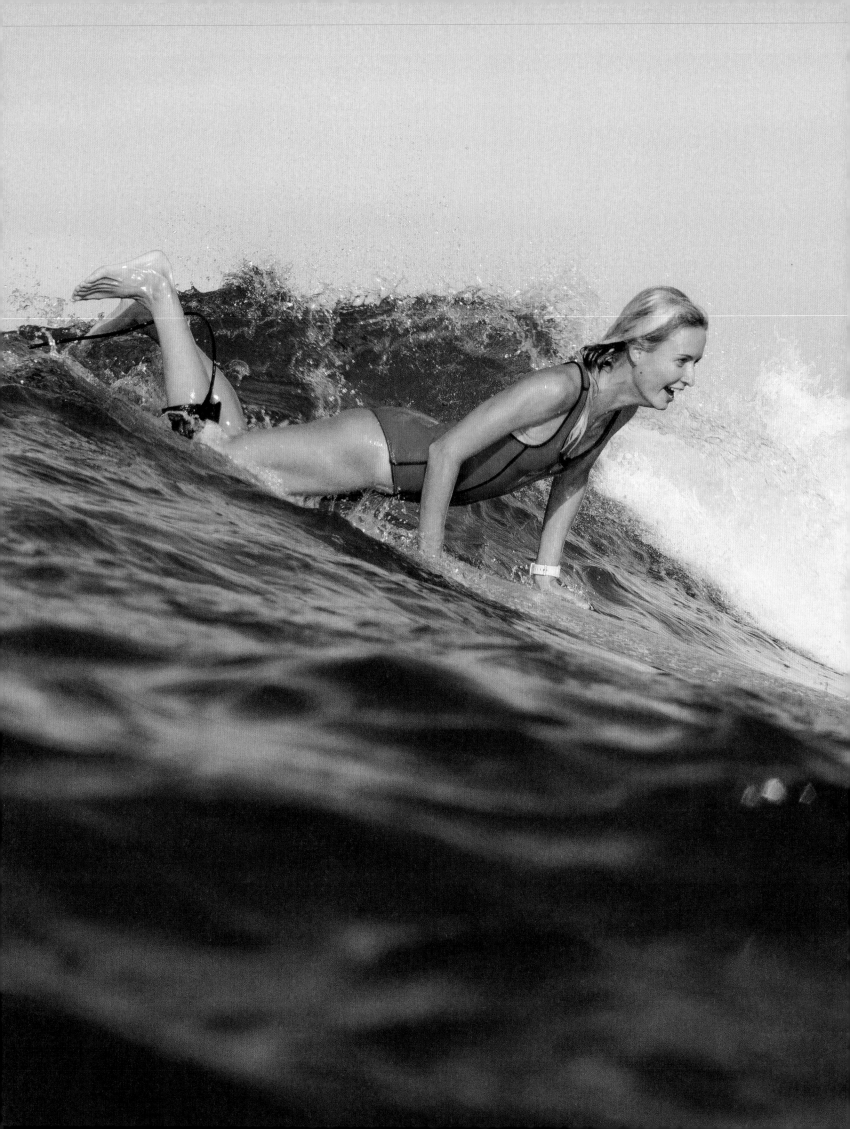

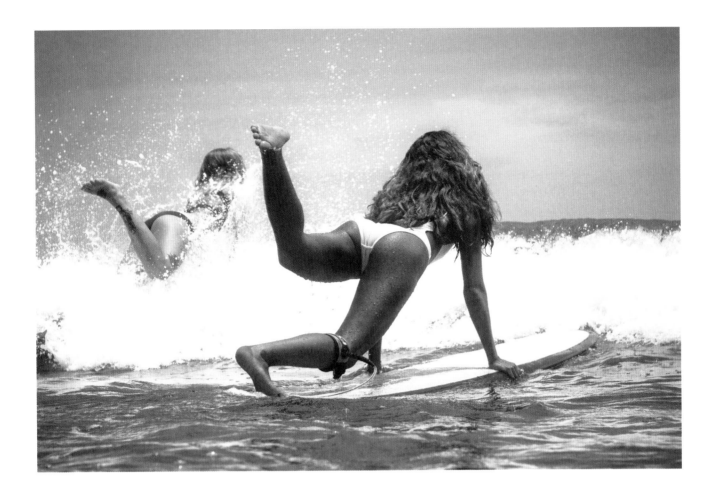

Sasha Golyanova
Water portraitist

@sashafr0mrussia
@fr0m_sasha_with_love

I began my surf photography career in Indonesia, while falling in love with the spirit of freedom that surfing and the ocean provide. I believe that surf shots should be honest in the good old documentary sense, but I don't mind a few little artistic touches, either.

I consider myself a water portraitist. What inspire me most are the style and attitude of the rider, their unique movements, their facial expressions, and their emotions.

I try to tell the story of a surfer's relationship with the ocean by revealing her personality.

Fear is an illusion. You just need to trust the universe and believe in your own powers. Be stubborn in a good way: I still tell myself this every time I go to the ocean. There's no real difference between me and any of the other women on this planet. I was 27 years old when I first saw surfing in the flesh—so if I made it, any other girl can too.

◁ Elena Bolysova, Lombok, Indonesia △ Flora Christin and Anaïs Pierquet, Bali, Indonesia 227

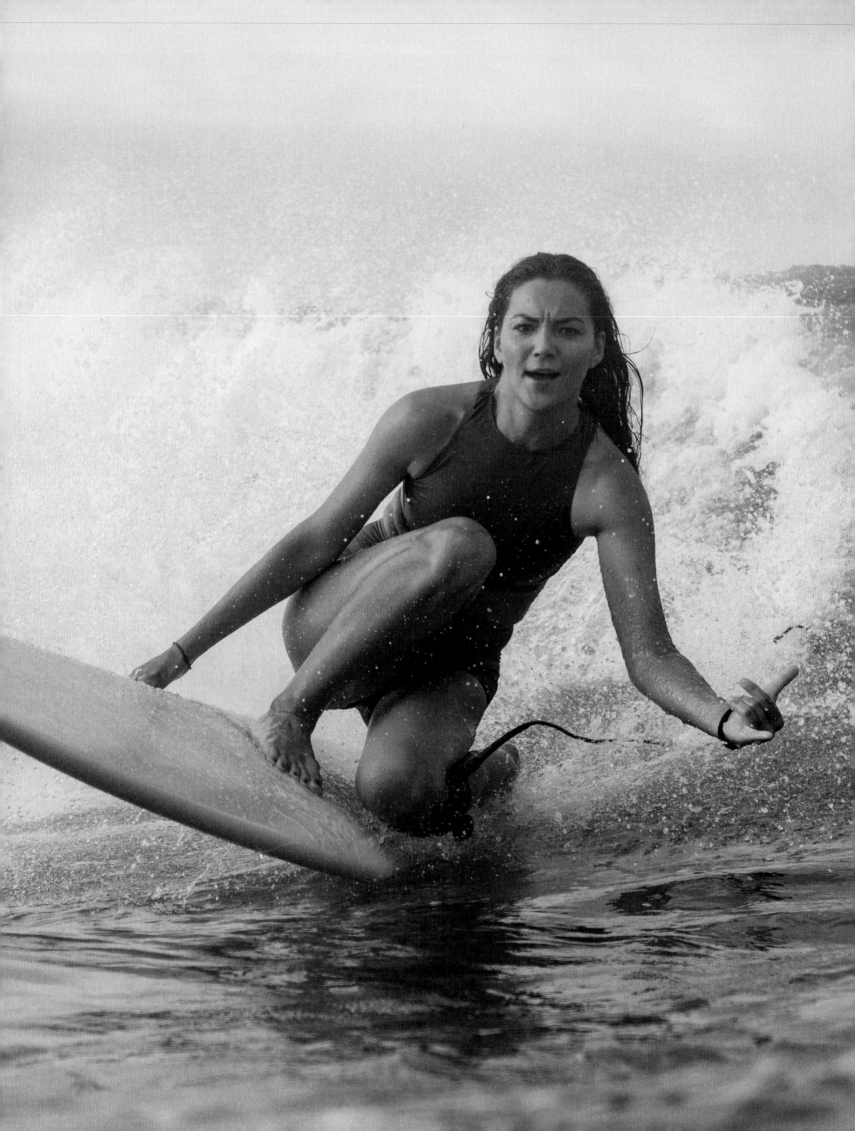

◁ Chulpan Galimova △ Victoria Mikheeva | Bali, Indonesia

Tara Rock
Ladyslider

@ladyslider

Ladyslider, my photography and creative business, started as a love affair with the ocean, a desire to see the world, and a little fling with fashion. I'm a child of the sea and a curious, creative type. I use photography and other forms of creativity to capture my perspective of the world.

I think it's very important, as a woman, to photograph other women. I try to portray a feminine perspective in all my images in a way I think only a woman can. I'm drawn to water photography in particular because of the spontaneous encounters and in-the-moment experiences it allows you to capture.

If I'm not trying to find my next travel destination or getting lost in a foreign country, you can usually find me in the water trying to perfect my cross-step.

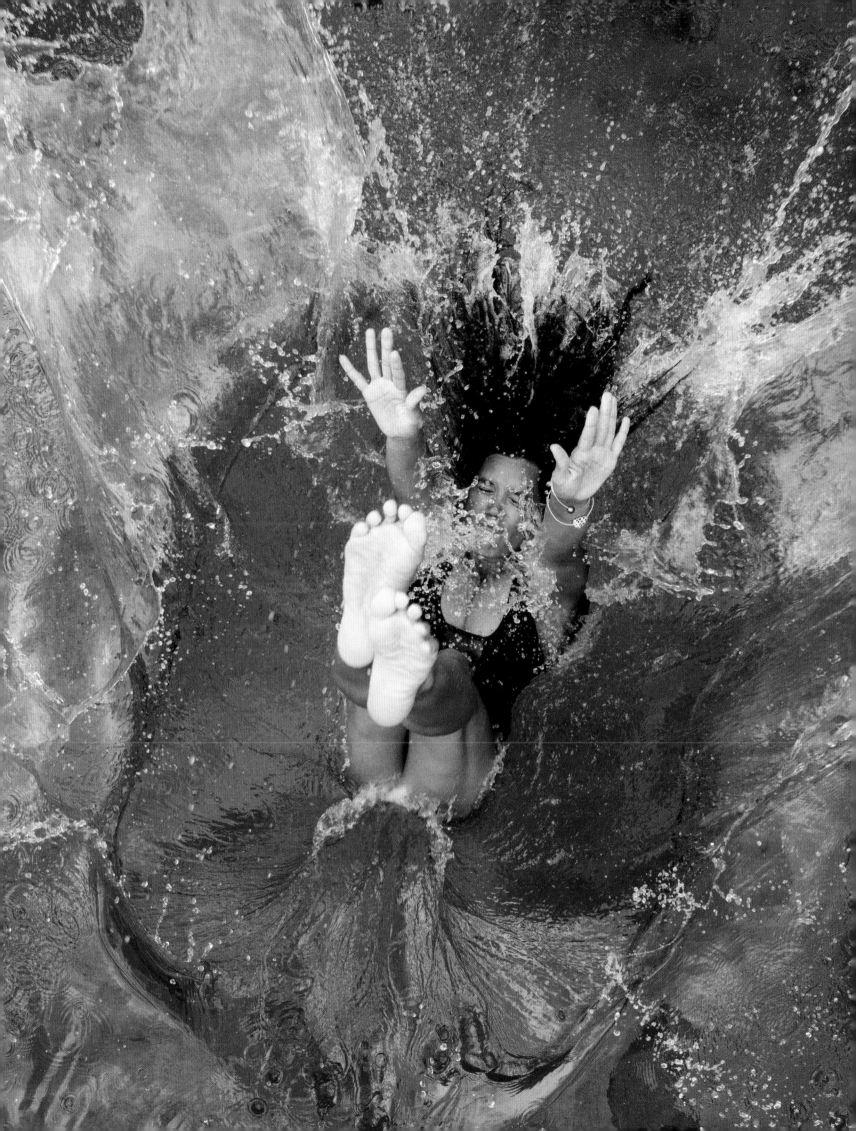

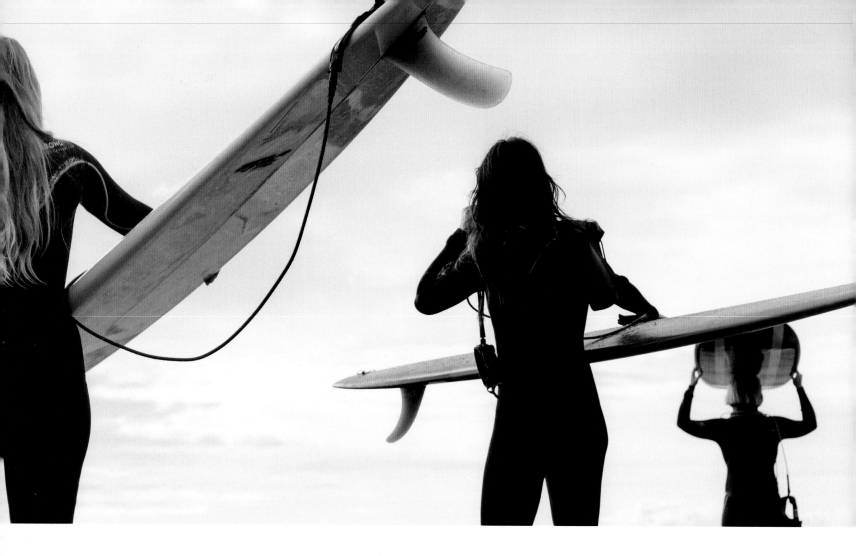

Cristina Gareau
Photographer with a PhD in cancer research

@cristinagareau

I live in the small town of Tofino, on the west coast of Vancouver Island, Canada. My path crossed the world of photography by chance, and I have to say it's one of the best things that have happened to me. It's so hard to find your path now in this world so full of possibilities. It becomes difficult to pick a direction, and most of the time you end up going in multiple directions and trying multitudes of fields. I strongly believe, though, that if you continue being curious and open to different things around you, you'll find your path. You'll find the thing that fills you with so much passion that time just seems to evaporate when you are doing it. Something that can become your work but that never feels like work; so that when people see you, they're never sure if you're working or having fun. Something that permits you to live the way you want. Be attentive to everything that piques your curiosity and it will show up, I promise.

It's never too late for a big change of path. I have a doctorate in cancer research but now reside in a quiet ocean town where I do surf, adventure, and lifestyle photography full-time.

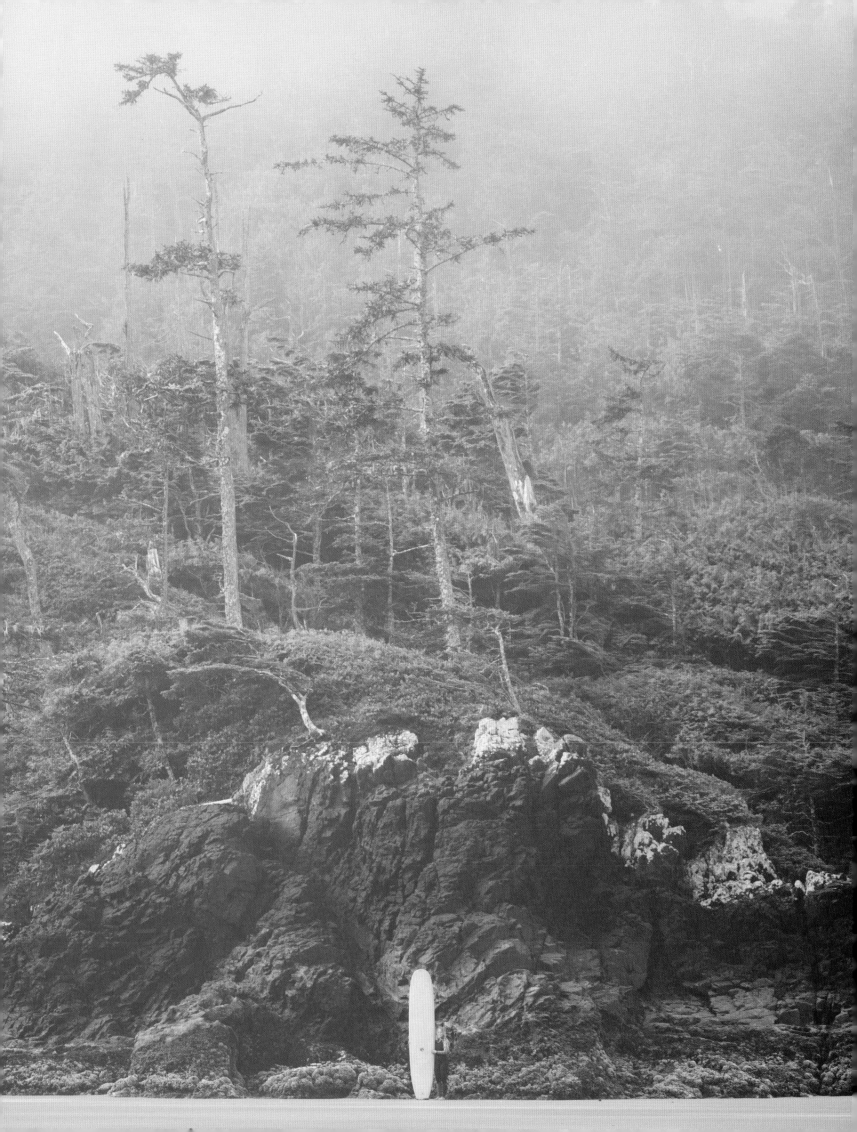

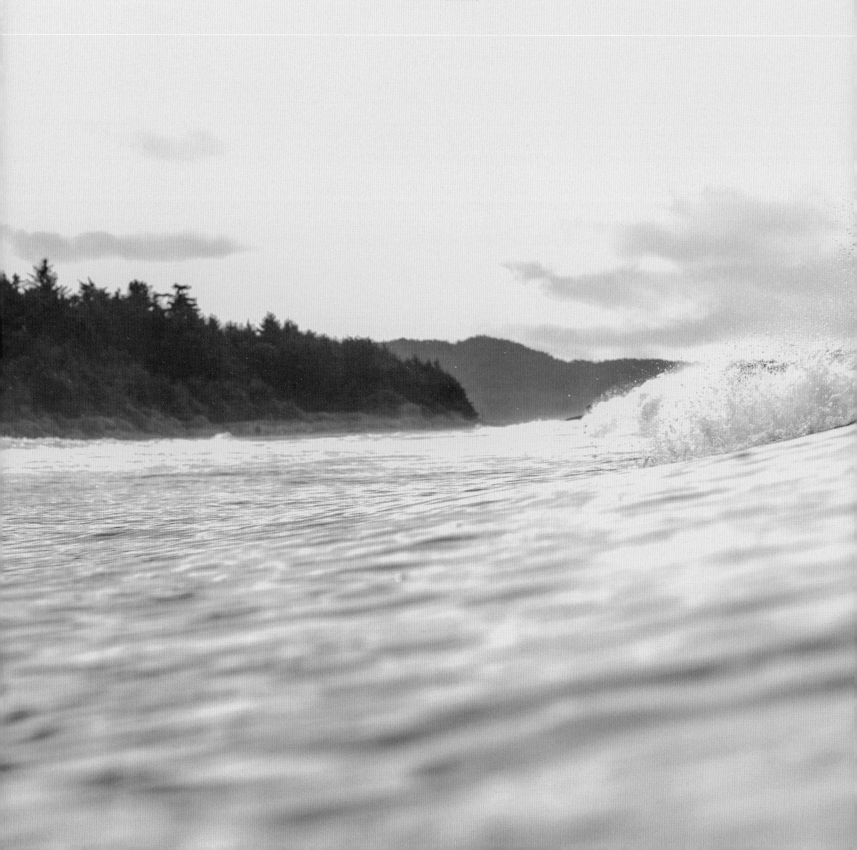

*Do what you love, and you'll find
a way to get it out into the world.*

CRISTINA GAREAU

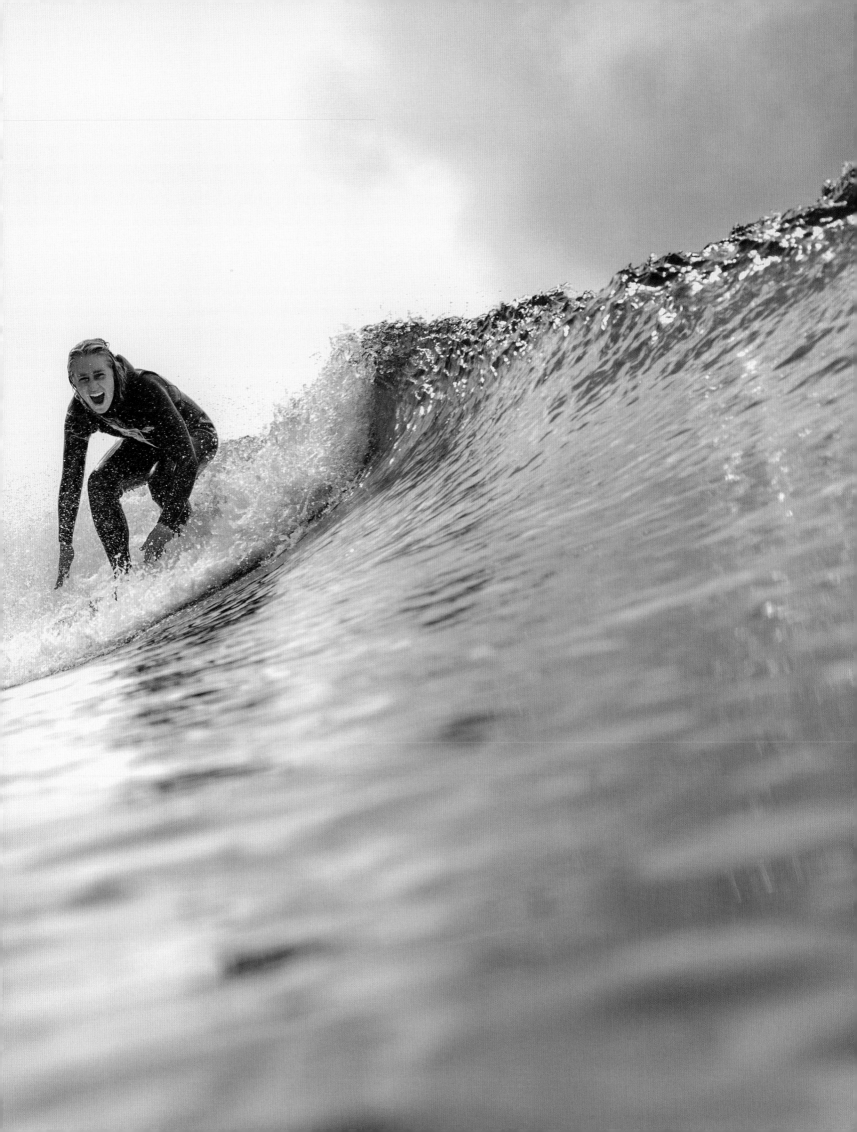

Marta Tomasini
Surfragette

@surfragette
surfragette.com

I was reflecting on stereotypes, especially in surfing, and how they affect people's perceptions and behavior. Surfer girls are described as magic creatures, exotic mermaids with toned bodies who walk along the beach spreading their aura of perfection, conscious that they're not within everyone's reach. In addition, they're extremely good at riding waves, taming these big giants with undiscussed grace. There's a pressure that comes with all this. We go to the gym, get hair highlights, and do a tanning session before hitting the beach to fit that perfect image. I'm not here to rain on people's parade, but I'd like to remind us all that the reality is quite different (but still awesome).

You see ads of beautiful surfer girls riding waves while wearing tiny fashionable bikinis. But who wants to end up naked in front of a whole lineup of surfers after a huge wipeout? Who wants to come home with rashes and scratches all over their body because of contact with surfwax? And what about the awkward feeling of your bikini bottoms being stuck where the sun don't shine? Luckily, many brands are creating more and more surfer-friendly bikinis that don't move. Still, I prefer to wear a wetsuit or a one-piece. I know many fellow surfer girls would agree.

A toned bottom? I prefer ice-cream! Surfing is amazing exercise for your shoulders and back, but not so much for the lower body. So not all surfer girls have a sculpted behind! Many of them go to the gym and work out regularly so that they'll perform better in the water and stay fit. But surfing alone won't give you the stereotypical model body. Even so, I'll still have dessert for lunch—because life's too short, right?

And why doesn't my hair look like Alana Blanchard's every time I come out of the water? I have long blonde hair too, but mine looks more like I've just stared the Loch Ness Monster in the face or been struck by a lightning bolt. Seaweed and sand don't help and can be a challenge in the shower after a session. The ugly truth is that mermaid hair doesn't exist for most surfer girls who don't have a hairstyling squad following them around. If you're like me, you'd better invest in good hair conditioner!

I've never seen surfer girls in ads or videos have an embarrassing wipeout. They mostly fall from the board with grace and a minimum of splashing. The reality is a bit different—you're taken aback and fall, landing on your tummy or with your legs in weird positions, or try to dive headfirst and fail dreadfully. Sometimes I even let out a cry. Yes, a cry!

And what about tan lines? Like me, most surfer girls wear a wetsuit every day and so don't have that envied endless-summer bikini tan. Our actual tan lines tend to involve a line under the neck and on our wrists and ankles. We basically have a tanned face, hands, and feet—sexy, huh?

I hope this has brought you down to earth and made you smile a little. Surfer girls, we don't need to take ourselves too seriously and act like models every time we reach the shore. We're there to have fun and enjoy our time in the water. It's okay to feel great in a new surf outfit, but we should also be a little more indulgent with ourselves and feel good about our flaws—which make us unique and beautiful, by the way. Because real surfer girls are the ones ripping in the lineup, not on the cover of a bikini magazine!

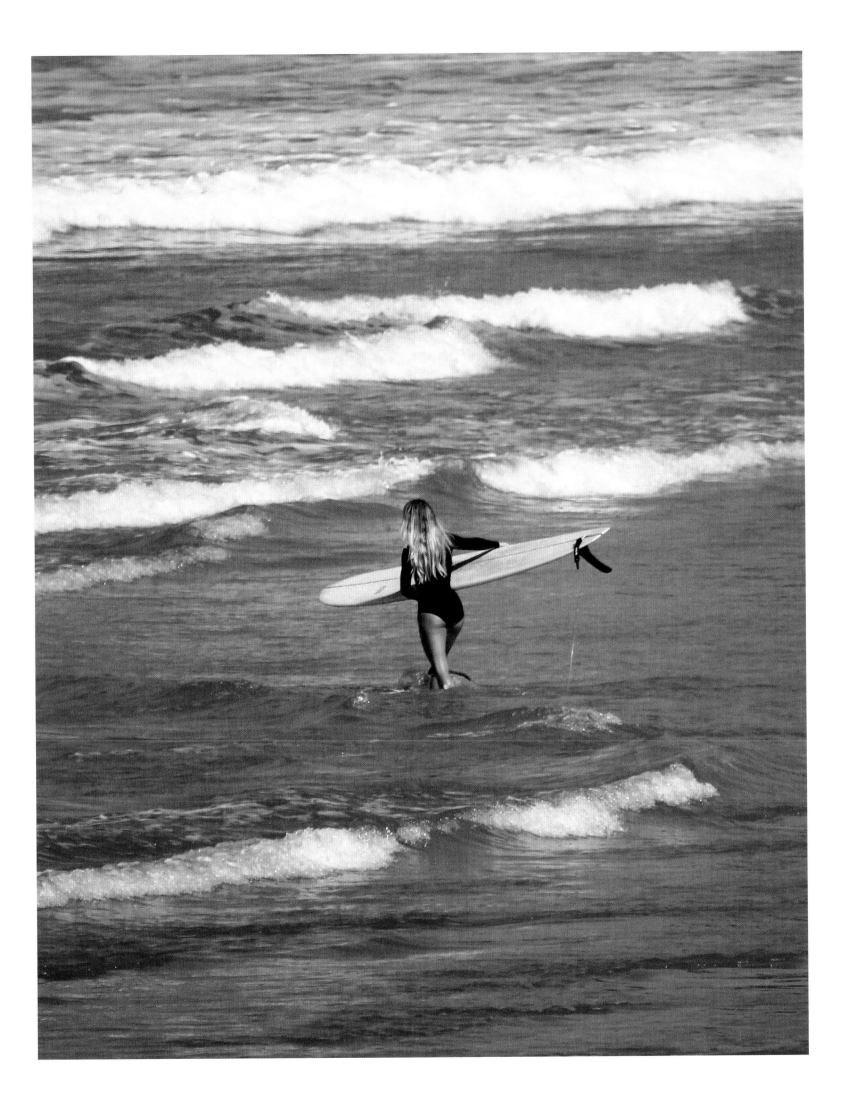

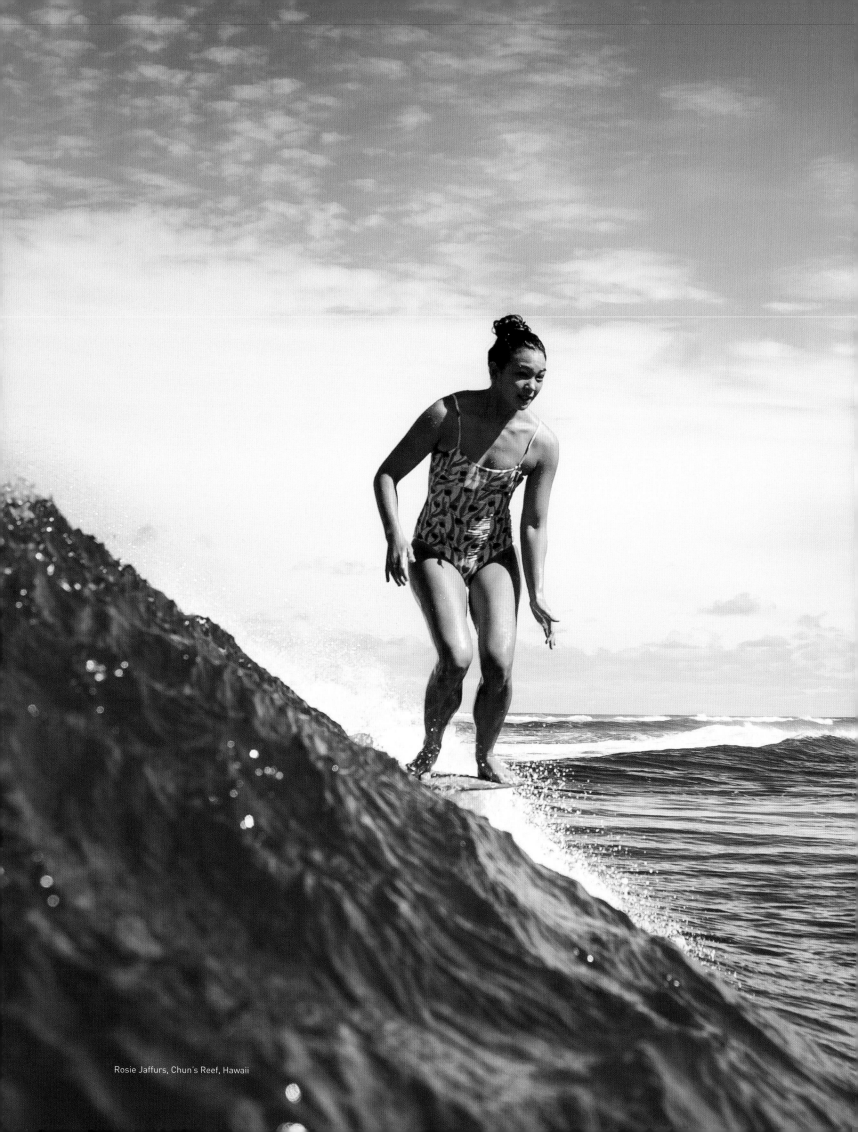

Rosie Jaffurs, Chun's Reef, Hawaii

Life's better when you surf.

· MINI GUIDE ·

Surf schools, holidays, and retreats

GIRLS ON BOARD
SURF SCHOOL
Encouraging girls to enjoy surfing

AUSTRALIA

girlsonboard.com.au
@girlsonboardsurfschool

Girls on Board offers personalized surf lessons for guys and girls of all ages on Phillip Island, Victoria. Their aim is not to exclude guys, but to encourage girls to get out there and enjoy surfing and the lifestyle that surrounds it.

SALTY GIRLS
SURF SCHOOL
Australia's premier
female surf school

AUSTRALIA

saltygirlssurfschool.com
@saltygirlssurfschool

Based on the Tweed coast in New South Wales, Salty Girls was Australia's first all-female surf school. Its founder Belén Kimble-Fuller's mission is to inspire women to overcome adversity and achieve their goals and dreams. She welcomes women of all ages, introducing them to the sport and spirit of surfing in an encouraging and fun environment. From first-time surfing experiences to professional coaching and fine-tuning, Salty Girls brings women and the ocean together, with group and private lessons, clinics, and yoga classes.

WALKIN ON WATER
Ladies-only lessons

AUSTRALIA

walkinonwater.com
@walkinonwatersurf

Walkin on Water are dedicated to getting girls together to surf in the gentle conditions at Greenmount, on Queensland's Gold Coast. You'll catch and ride the rolling waves off the point and kick back with the girls in a surf that's pretty hard to beat. If you want a relaxed, enjoyable time out in the waves, followed by a social coffee, and to do it all in an all-girl, laid-back, non-threatening environment, then their ladies-only sessions will be perfect for you.

SURF GODDESS RETREATS
Women's solo surf retreat

INDONESIA

surfgoddessretreats.com
@goddessretreats

Surf Goddess Retreats believe that the best times are had when you're simply hanging out in the surf with the "girls." Their women's retreats are designed to help you grow more confident in yourself, find new places in your soul, wash away your cares, and see the bigger picture. At Surf Goddess, surfing is more than simply a sport: it's a state of mind and way of being that stays with you long after you step out of the ocean.

SURF SISTAS
Encouraging girls to try surfing

BALI; COSTA RICA; FRANCE;
UK; JAVA; MOROCCO

surfsistas.com
@surfsistas

Surf Sistas have been organizing surf holidays and courses specifically for women for over fifteen years. There are no cookie-cutter packages here—they tailor each surf trip or retreat to the destination and the waves. You'll find them road tripping in Costa Rica, messing about in boats in Bali, painting by point breaks in Morocco, or cycling through France.

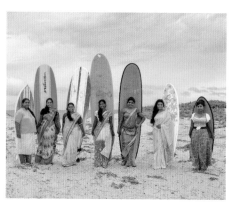

ARUGAM BAY GIRLS SURF CLUB
Sri Lanka's first all-female surf club

SRI LANKA

abaygirlssurfclub.com
@abay_girls_surf_club

Challenging the traditional gender norms that have kept women inside the home, a group of girls and women from Sri Lanka are proving that surfing is for everyone. In 2018 the Arugam Bay Girls Surf Club (ABGSC) became Sri Lanka's first all-female surf club. Joining over a dozen surf clubs for men, the seventeen members of the ABGSC are inspiring women across the country to learn to swim and surf too. By providing a safe space to enjoy the ocean, the club hopes to get more Sri Lankan women on the waves.

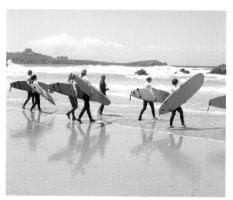

HIBISCUS SURF SCHOOL
Europe's first women-only surf school

UNITED KINGDOM

hibiscussurfschool.co.uk

Hibiscus Surf, based in Newquay, Cornwall, was Europe's first women-only surf school. They offer small-group classes for women, taught by other women. They've been schooling surfers since 2002 and have worked out the perfect formula for helping you get the most from your surfing, whether it's learning how to get to your feet, learning how to stay there, improving your length of ride, or getting to grips with turns. There are courses for everyone—they specialize in family fun lessons.

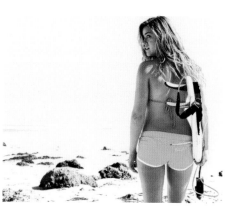

OUTER REEF SURF SCHOOL
Women's surf retreat

UNITED KINGDOM

outerreefsurfschool.com
@outerreef

Outer Reef Surf School runs women-only adventure workshop weekends in Pembrokeshire and west Wales. Their offerings are suitable for complete novices as well as more experienced surfers who want guidance or advice on any aspect of the sport, from performance analysis to the development of specific maneuvers, while, most importantly, having fun!

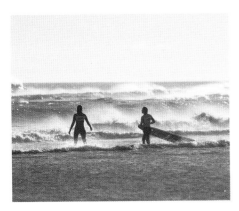

SURF YONDER
Surf camps, tuition and coaching
for adventure-loving women

UNITED KINGDOM

surfyonder.com
@surfyonder

Fueled by a passion for surfing and the independence, beauty, and lifestyle that accompany it, Yonder aims to pass on skills and confidence to other women looking to start or improve their surfing. This all-women's surf school runs regular lessons in the northeast of England as well as surf camps in the northeast, East Yorkshire and the southwest. Yonder is an ASI-accredited surf school and abides by its high international standards.

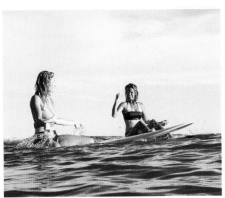

MOOANA
Become an ocean child
and soul surfer

PORTUGAL

mooana.com
@seasoulstories

Mooana, or *moana* in Polynesian, means ocean. Inspired by the sea, Concha Rössler, Mooana's founder, aims to share her passion and knowledge by providing holistically designed classes, retreats, workshops, and travel programs. Mooana retreats are designed to combine surf, soul, and well-being: you can fine-tune your surf skills, engage in yoga and mindfulness mediation, enjoy healthy meals, and learn to connect with the ocean.

AZRAC SURF MOROCCO
All the highlights of Morocco

MOROCCO

azracsurf.com
@azracsurfmorocco

The Azrac girls' surf and yoga retreats involve daily surf sessions, exploring the Moroccan coastline, delicious, healthy meals and beach snacks, and cosy Moroccan accommodation, topped off with blissful rooftop yoga sessions. They've combined all the highlights of Morocco into one retreat, created with global female surfers in mind.

SURF MAROC
Women-only coaching program

MOROCCO

surfmaroc.com
@surfmaroc

Surf Maroc has been an endorser of female surfing for ten years with its Girls Surf Maroc package—the first of its kind in Morocco. It's the ultimate girls' holiday, where every day is action-packed: there's sunrise yoga followed by daytime surfing, finishing with drinks at sunset. This women-only package provides a comprehensive surf coaching program that ensures you continue to progress even after you leave. There's a choice of oceanfront locations with stunning views, all walking distance from some of Morocco's best surf spots.

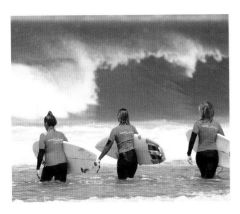

WAVESISTERS
Girls-only surf and yoga camps
and coaching retreats

LANZAROTE & PORTUGAL

wavesisters.com
@wavesisters_surfcamps

WaveSisters offer girls-only surf and yoga camps in Europe. They're dedicated to the idea of bringing female surfers of all ages together, to support each other in the water as well as in life. Their surf camps offer high-quality classes for all levels, while their yoga is specially adapted for surfers; life coaching is also available on request. Importantly, they aim to offer affordable holidays in order to encourage wide participation.

KELEA SURF SPA
Surf, yoga, massage, adventure

COSTA RICA & HAWAII

keleasurfspa.com
@keleasurfspa

Kelea Surf Spa, the first ever all-inclusive women's surf and yoga retreat, was pioneered in 2000 by professional bodyboarder Elenice Senn. Since then, hundreds of women have joined Kelea in the waves, surfing their dream vacations and having the adventure of their lives. Kelea combines the passion of the ocean, healthy living, adventure, exploring, and being active in nature. The retreat blends surfing with massage and yoga, so that your body is supported and your spirit uplifted.

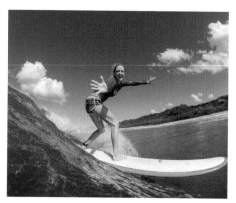

PURA VIDA ADVENTURES
Surf and yoga retreat
with substance and soul

COSTA RICA

puravidaadventures.com
@puravidasurf

At Pura Vida, they know the magic and joy that happens when ladies join the lineup. Their passion is teaching the transformative, fun, empowering sport of surfing to any woman who wants to learn, regardless of age or ability. From expert instructors with decades of experience, to perfectly crafted meals made from local ingredients, to beachfront luxury at one of the world's most beautiful coasts, these retreats combine the thrill of travel with the comfort of having every need met.

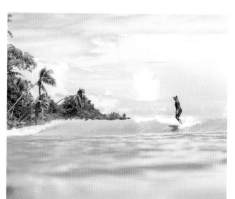

SIREN SURF ADVENTURES
Five-star waves and coaching

COSTA RICA; HAWAII; MEXICO

sirensurfadventures.com
@sirensurfadventures

Kristy Murphy's Siren Surf Adventures offers elite surf coaching on five-star waves. There's a maximum of four guests at a time, and you can choose from an amazing quiver of boards shaped by masters in California and Australia. Kristy, a former Women's world champion in longboarding, and Cat Slatinsky, a former professional longboarder and a surf photographer/videographer, do all the coaching in and out of the water.

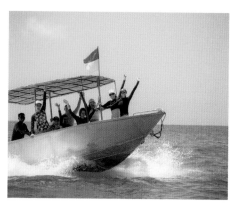

SWELLWOMEN
Surf and yoga retreats
in tropical destinations

COSTA RICA; HAWAII;
INDONESIA; SRI LANKA

swellwomen.com
@swellwomen

Surf, adventure, connection, and serious relaxation are what you can expect on a SwellWomen retreat. They host their signature surf and yoga retreats in spirited, tropical destinations across the globe. There, women (and men) have the chance to experience unspoiled surf destinations, while inviting in personal insight through SwellWomen's blend of surf, yoga, and presence. Return recharged, connected, and, above all, in love with life.

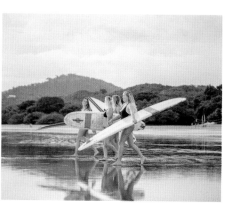

CHICA BRAVA
Empowering women
one wave at a time

NICARAGUA

chicabrava.com
@chicabravasurf

At Chica Brava—the first women's surf retreat in Nicaragua—the aim is to empower women through surfing and the genuine camaraderie that comes with sharing a lifestyle, a sisterhood, and a passion for the most rewarding sport on the planet. It's about a pack of women together in the lineup, united by what they love. Their retreats offer women the chance to let go, invest in themselves, and feel confident, invincible, and powerful regardless of size, strength, or stature. At Chica Brava, the past doesn't matter. It's about the here and now, and the boundless opportunities that embrace you in the water.

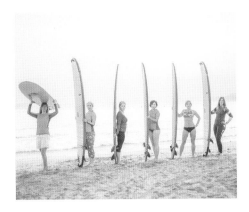

LAS OLAS SURFING FOR WOMEN
Making girls out of women

MEXICO

lasolas.surf
@lasolassurf

Las Olas is recognized as the world's premier surf and yoga retreat for women. Established in 1997, it has introduced thousands of women to surfing the warm-water waves in sunny Mexico through its surf safaris. Its mission is to empower women in a way that means they have fun at the same time. Believing that playing in the water takes you back to a childlike, simple, and carefree time, Las Olas offers you the chance to reconnect with yourself, develop an empowering relationship with the ocean, and gain a fresh perspective on daily life.

NORTHWEST WOMEN'S SURF CAMPS
Empowerment, connection, and transformation

USA

nwwomenssurfcamps.com
@nwwomenssurfcamps

Northwest Women's Surf Camps began in 2005 along the beautiful, pristine north coast of Oregon, in the Pacific Northwest. Their mission is to connect women of all ages (from thirteen to seventy years young) through surfing in cold water, to empower them with essential surfing skills, and ultimately to open surfing's transformative powers up to them. All Northwest's experiences are taught by exceptional women coaches whose experience and enthusiasm ensures the high quality of each event and lesson.

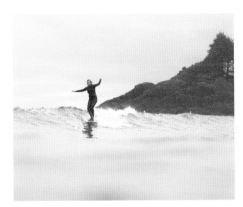

SURF SISTER SURF SCHOOL
Fun, safe lessons year-round

CANADA; EL SALVADOR; PANAMA

surfsister.com
@surfsister

At Surf Sister, an all-female staff offers fun, safe, and informative lessons year-round. A favorite program is their five-day Teen Camp, run every July and August. It's a great way for teenage girls to make new friends and develop their surfing skills. Their yoga and surf weekends for women, meanwhile, are offered throughout the year on select weekends. If Tofino is too cold, there are also yoga and surf trips to Panama and El Salvador every winter—a great chance to escape with your girlfriends and catch some warm waves.

MAUI SURFER GIRLS
Year-round longboarding school

HAWAII

mauisurfergirls.com
@mauisurfergirls

Maui Surfer Girls was established in 2001 to build self-confidence in women through surfing. What started as a teen summer camp almost two decades ago has now grown into Maui's top-rated attraction. Their co-ed surf school features small class sizes, uncrowded beaches, and dedicated instructors, and operates year-round. Their signature teen girls summer camps and quarterly women's camps are designed for both beginner and intermediate longboard surfers, and include oceanfront accommodation, professional surf coaching, healthy meals, and tropical adventures.

SUNSET SUZY
Twenty years of teaching experience

HAWAII & FIJI

sunsetsuzy.com

Suzy's surf camps and lessons take place on the North Shore of Oahu, Hawaii, where for many years she was the only female lifeguard. Although the North Shore may sound daunting, it can be a safe, super-fun place to surf—and if you're lucky, you might share the waves with sea turtles! After twenty years of teaching, it's still Suzy's love and passion to meet other inspiring surfer girls from around the world and use her knowledge of the ocean and waves to teach them where to surf safely in Hawaii, and to give them the thrill of a lifetime.

PHOTO CREDITS

A

ALEX ANDINO
andinocaptures.com
@andinocaptures
Page: 119

AMBER JONES
amberjones.com
@amberandfriendsphotography
Pages: 26 - 28 - 29 - 30

ANDREW KAINEDER
andrewkaineder.com
@kaineder
@beyond.the.noise
Pages: 59 - 60 - 62 - 63

B

BEN POTIER
benpotier.myportfolio.com
@benpotier
Pages: 98 - 99

BRANDON LIM
@brandonlimphoto
Pages: 134 - 136

BREN LOPEZ FUENTES
@brenstormin
Pages: 115b - 154

BRYANNA BRADLEY
www.bryannabradley.ca
@bryannabradleyphotography
Pages: 68 - 70 - 71 - 72 - 73
74 - 247 (Surf Sister) - back cover

C

CAMILLA FUCHS
camillafuchsphotography.com
Page: 247 (Las Olas Surfing)

CAMILLE ROBIOU DU PONT
camillerdp.com

@camillerdp
Pages: 118 - 140 - 142 - 143
144 - 146 - 147 - 148
150 - 151 - 152 - 153
156 - 157 - back cover

CÉCILIA THIBIER
thibiercecilia.com
@ceciliaphotographie
Pages: 220 - 221 - 222 - 223
224 - 254

CHRISTA FUNK
cfunkphoto.com
@instaclamfunk
Pages: 46b - 47 - 48 - 50
240 - back cover

CRISTINA GAREAU
cristinagareau.com
@cristinagareau
Pages: 234 - 235 - 236

F

FEDERICO VANNO
@liquidbarrel
Page: 246 (SwellWomen photo)

FILIPE NETO
filipeneto.com
@filipe_neto
Pages: 10 - 16 - 17
245 (Mooana photo)

FIONA MULLEN
fionamullenphotography.com
@fionakatephoto
Pages: 65 - 66 - 67

G

GAVIN SMITH
gavinsmithimages.com
@gav_smith01
Page: 116

GHANIA IRATNI
ghaniairatni.com
@ghania_iratni
Page: 100

J

JIANCA LAZARUS
jiancalazarus.com
@jianca_lazarus
Pages: 46t - 194 - 202 - 205
206

JIMMY GEKAS
jimmygekas.com
@jimmygekas
Page: 115t

K

KARO KRASSEL
karokrassel.com
@karokrassel
Pages: 20 - 21 - 24 - 25 - 121
122 - 123 - 124 - 125
127 - 128- 129 - 130
131 - 132 - 133 - back cover

KAT GASKIN
@ katgaskin
Page: 247 (Maui Surfer Girls)

L

LAURA BOIL
lauraboil.com
@lauraboilphotography
Page: 96

LAURENT CHANTEGROS
surfimagery.format.com
@laurent_imagery
Pages: 158 - 160 - 161 - 162

LEIA MARASOVICH
leiavitaphoto.com

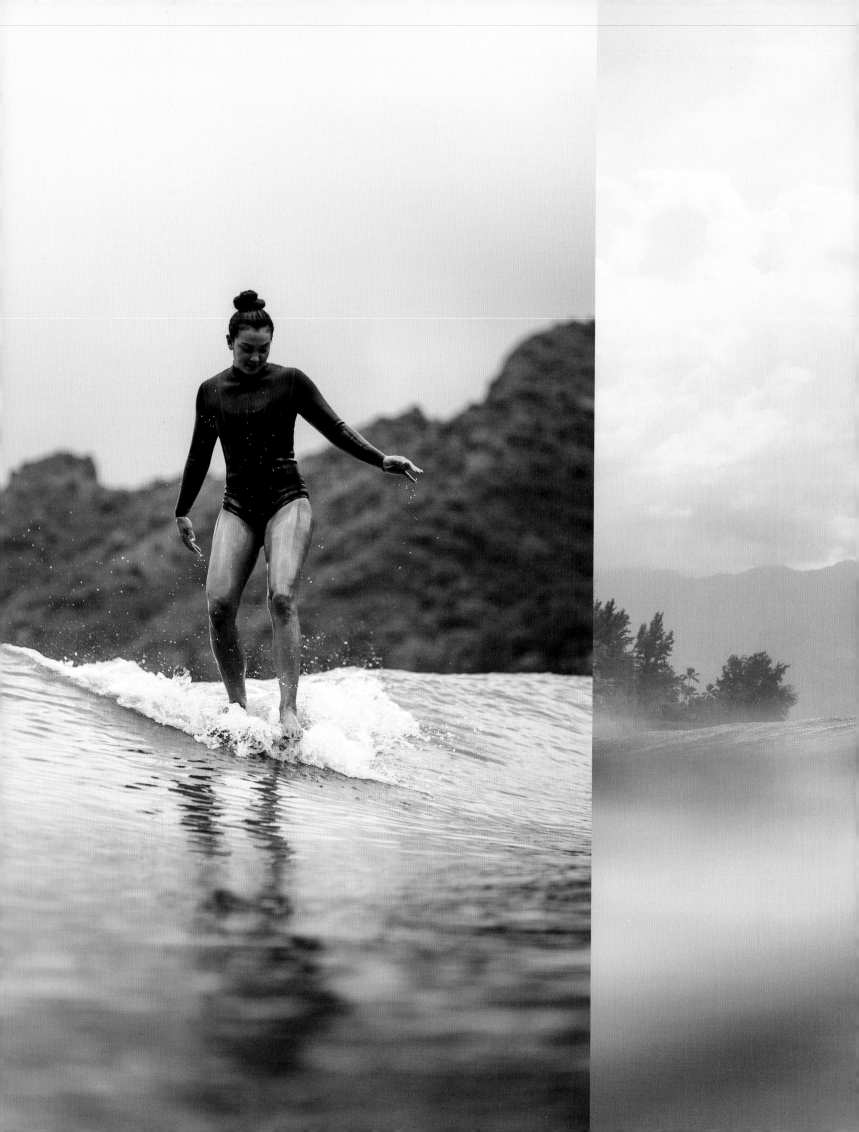

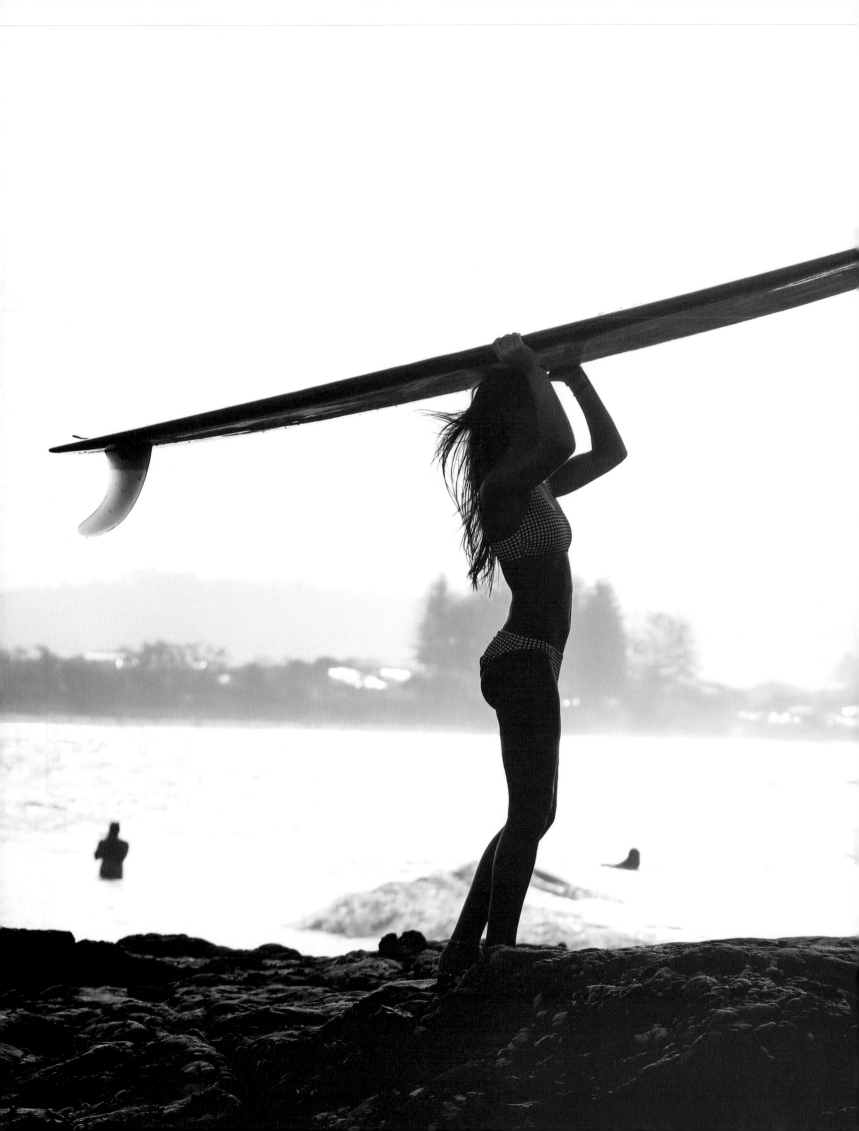

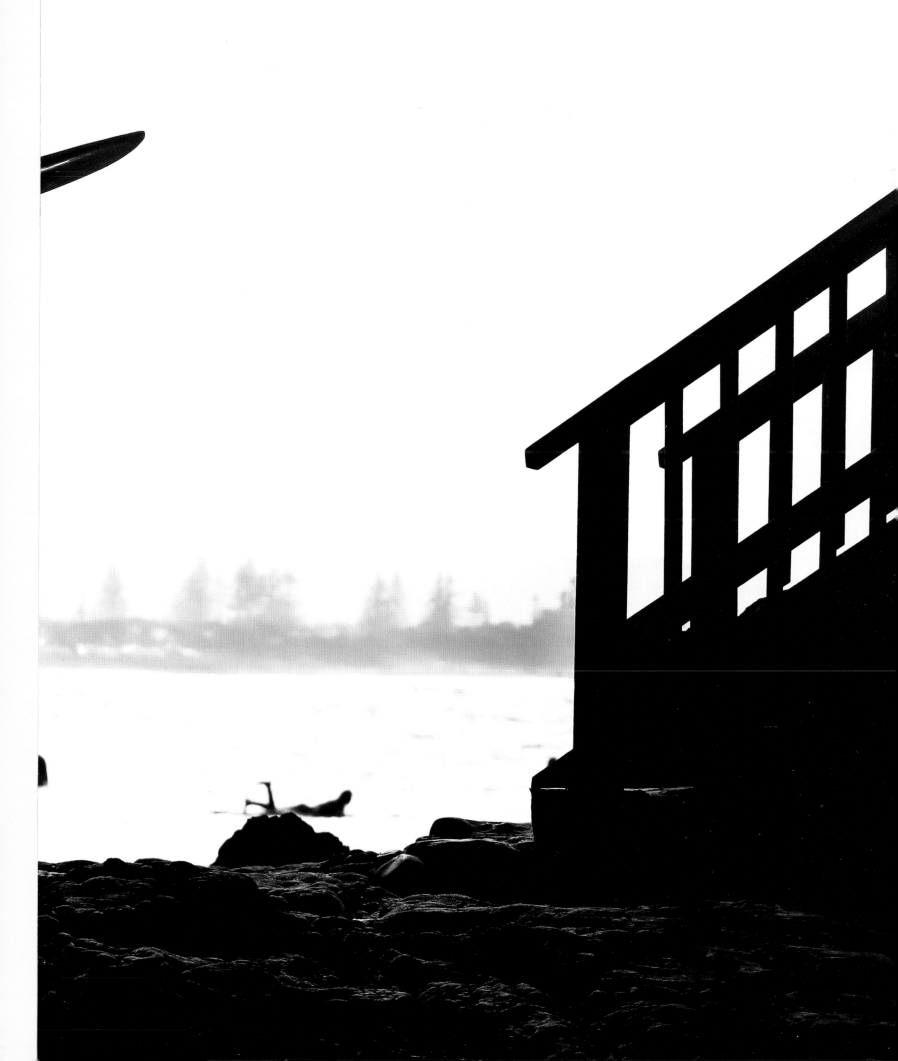